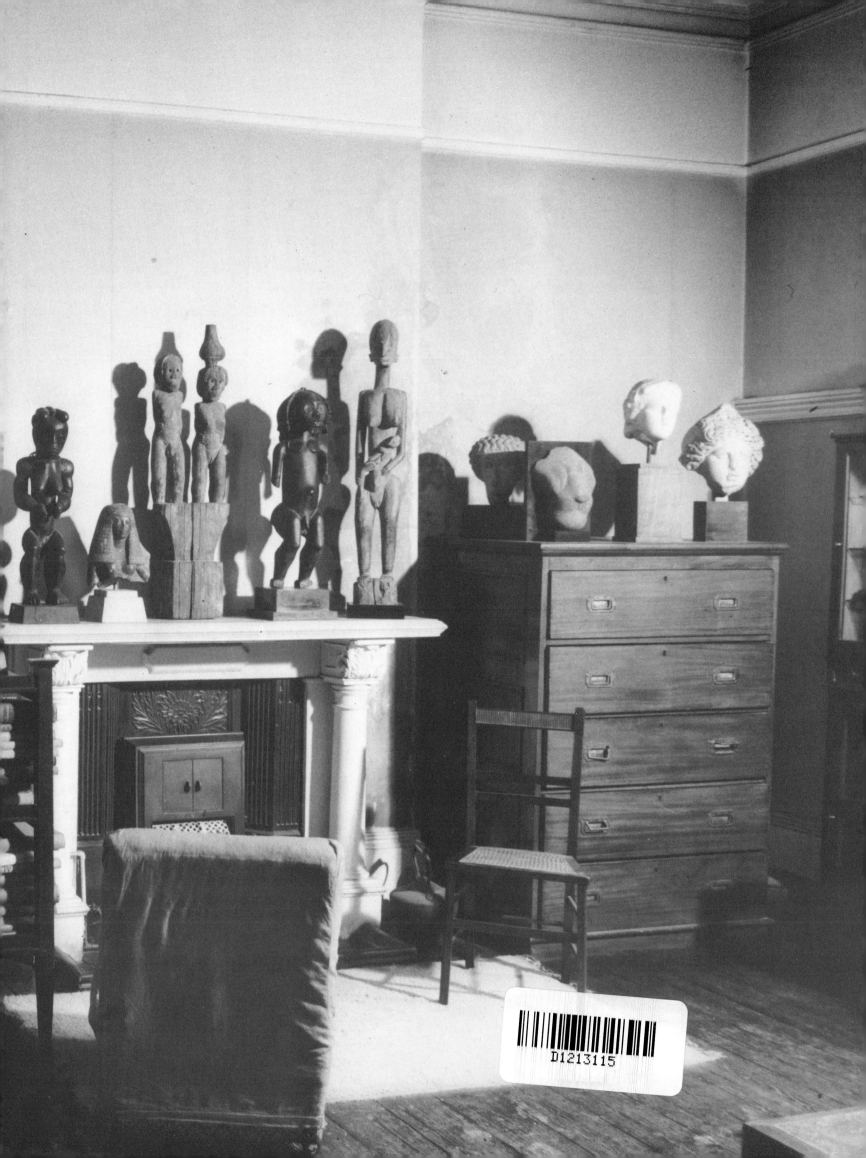

The Sculpture of
EPSTEIN

frontispiece *Epstein in the mid-1950s. To his right is an Indian figure, possibly early eleventh century*

The Sculpture of
EPSTEIN

with a complete catalogue

EVELYN SILBER

PHAIDON·OXFORD

Phaidon Press Limited, Littlegate House,
St. Ebbe's Street, Oxford, OX1 1SQ

First published 1986
© Phaidon Press Limited 1986

British Library Cataloguing in Publication Data

Silber, Evelyn
 The sculpture of Epstein: with a complete
 catalogue
 1. Epstein, Jacob, 1880–1959—Catalogs
 I. Title
 730'.92'4 NB497.E/

 ISBN 0-7148-2262-0

Printed in Great Britain by Butler and Tanner Ltd.,
Frome, Somerset

Endpapers: *Part of Epstein's collection of
'primitive' sculpture in an upstairs room at Hyde
Park Gate, c.1960. Among the pieces on the
bookcase (left) are the Fang 'Grand Bieri' head
and the 'Black Venus'. On the mantelpiece, are
(left to right) a Fang figure formerly in Derain's
collection, an XVIIIth Dynasty Egyptian head,
the Malagasy funerary pair, the de Miré head and
a Dogon mother and child.*

Half-title page: *Epstein in 1924*

Epstein working on Behold the Man

Contents

Modelling Isaac Myers

Acknowledgements

This book is the work of many hands. Its starting point was a modest exhibition, Rebel Angel, at Birmingham Museum and Art Gallery in 1980. During that centenary of Epstein's birth, which was also the year following the death of Lady Epstein, I met Miss Beth Lipkin, Trustee for the Epstein Estate, and Mrs Kitty Godley, daughter of Epstein and Kathleen. I am deeply indebted to them for their encouragement throughout this project. I am most grateful to Epstein's eldest daughter, Mrs Peggy Jean Lewis, not only for information and hospitality, but also for permission to reproduce excerpts of letters by her father.

I owe an equal debt of gratitude to many of my colleagues: to Dr Brian Seddon for his advice and assistance in the compilation of the catalogue, to John Cope for developing and printing photographs, and to Stephen Wildman for numerous references and for his comments on the draft text.

I thank the many people who knew or sat to Epstein, and have freely given information and shown me work in their possession, especially Lady Clifford of Chudleigh, Dr Martin Evans and his family, Professor and Mrs J. K. Feibleman, Mr Chaim Gross, Mrs I. Hughes, Mr D. L. Kreeger, the Hon. Mrs M. Lane, Dr and the late Mrs T. Laszlo, Mr L. Osman, Mr E. Phillips, Sir Robert and Lady Sainsbury and Mr A. F. Thompson.

Three previous writers on Epstein have been extremely generous with encouragement, information and photographs: the late Arnold Haskell, L. B. Powell and Richard Buckle. I am particularly grateful to Richard Buckle for lending me his archive on the Edinburgh Memorial Exhibition and on the preparation of his two books on Epstein. Richard Cork helpfully allowed me to consult *Art Beyond the Gallery* in typescript, and John Glaves-Smith generously gave me access to his unpublished paper, 'Epstein and W. H. Hudson', delivered at the Conference of the Association of Art Historians in 1982. I have also benefited from discussions with Dr Malcolm McLeod, whose catalogue of Epstein's ethnographic sculpture collection is currently in the press.

My warm thanks to Christopher Phillips for giving me access to the Leicester Gallery catalogues and lending photographs, to Geoffrey Ireland for information and for making his photographs of Epstein's work and collection available, and to Martin Silber for his comments on the text.

Research in the USA and Israel would not have been possible without considerable financial support from the Henry Moore Foundation, Dr Davide Sala and the Balfour Diamond Jubilee Trust. I am most appreciative of the help I have received from them and from curators and librarians throughout Britain, USA, Canada, Australia, New Zealand and elsewhere. I especially thank Lindsay Brookes, Dr Peter Cannon-Brookes, Dr Terry Friedman, Mrs Kathleen Gee, David Fraser Jenkins, Agi Katz, Mrs M. Keene, Edward Morris, Robin Paisley, Stephanie Rachum, Warren Robbins, Simon Wilson and Judith Zilczer.

My thanks for much assistance to Anthony d'Offay, Janet Green and Francis Farmar, the Fine Art Society, David Jones Gallery, Sydney, and the Weintraub Gallery, New York.

I have benefited from discussions with Elizabeth Barker, Judith Collins, Nigel Halliday, Sanda Miller, John Skelton and David Thistlewood. Professor Peter Ackroyd brought the resources of the University of Texas to my attention. Mr Charles Tarling of Adams Holden Pearson, the Dean of Llandaff, the Museum of the Royal Fusiliers, the Historical Society of Pennsylvania and the Royal Society for the Protection of Birds kindly allowed me to study unpublished material in their care.

Not the least of my debts are to my patient editor, David Morgenstern, to Peg Katritzky for her work on the photographs and to the designer, Jo Johnson. The mistakes are my own, and I can only apologize for any unintentional sins of omission or commission, and welcome any additions or corrections.

Last but not least, I thank all those whose friendship and hospitality has helped me so much: Teri Edelstein, Sheila Ffolliott, Jane Peirson Jones, Diane and Joel Karp, Jenny and Malcolm Lennox, Deborah Marrow, Francis and Sakiko Parr, Susan and Tony Roberts, and David Wertheim. Neville and Brenda Ebsworth's help and enthusiasm has lightened the research load.

I received unflagging encouragement and early assistance from Mavis Silber, in whose memory this book is dedicated.

Private view at the Leicester Galleries, 1939

[1] Brookner, p. 523.

[2] Cooper.

[3] Harrison, pp. 98–100, 204–9.

[4] *The Sunday Times*, 23.8.1959, reprinted in Moore 1966, pp. 194–7.

The Ironies of Fame

Epstein was the major British sculptor during the early part of this century. His achievements as a modeller and carver span the period between Rodin, from whom he drew lasting inspiration, and Moore, aspects of whose work his own anticipated and influenced. With Eric Gill and Henri Gaudier-Brzeska, he reintroduced into Britain direct carving, a technique central to twentieth-century practice. Some years before Roger Fry's influential writings, Epstein was one of the first to collect 'primitive' artefacts and encourage interest in African and Oceanic art in Britain. His admiration for the formal directness of 'primitive' wood carving and his intuitive, almost mystical response to what he understood of their function imbues the form, technique and feeling of his own carvings with an elemental dynamism. The originality of his early carvings can reasonably be compared with the contemporary work of Brancusi and Modigliani, both of whom were influential friends. As a portrait sculptor he is unequalled in this century and his finest portraits are amongst the best ever created. His few architectural commissions in stone and bronze establish him as an outstanding architectural sculptor, capable not only of innovatory structural and formal syntheses but also of handling religious subjects with transcendental gravity. Last, but not least, he introduced into the traditionally literary and genteel milieu of British art the disturbingly primal world of sexual instinct, rendered with a shocking immediacy that only Bacon has subsequently rivalled.

Far from assuring him recognition as one of the three or four most important British sculptors of the twentieth century—a century in which British sculptors have won international renown—these achievements have been widely neglected since the sculptor's death in 1959. During the last decade of his life he had been deluged with honours and grand public commissions: over 100,000 people flocked to see his memorial exhibition in Edinburgh during its four-week run in 1961. Yet by then he had been relegated to the minor leagues of art history, written off as a belated Romantic or a Jewish expressionist, and thus as 'a very old-fashioned sculptor indeed, picking up influences when other European sculptors had laid them to rest forever.'[1] Douglas Cooper, the great authority on Cubism, was still more crushing: 'Was Epstein a great sculptor?...The answer, it seems to me, is unequivocally "No". Why? Because Epstein's sculpture is the work of a man who could not make full or proper use of his medium, because it lacks depth, strength and invention, and because it is marred by cheap effects...He achieved little more than high relief.'[2]

In the context of the depersonalized formalism of most avant-garde art from 1930 to the 1960s, Epstein's figurative work did appear anachronistic. He was untouched by Surrealism, Constructivism and abstraction. Like his close friend, Matthew Smith, he could be seen as the exponent of a highly personal, humanistic style well outside the mainstream.

Though subsequent judgements have been less extreme, the consensus has been that Epstein's only significant work was done before the First World War with pieces such as the revolutionary *Rock Drill* (plate 12). Thereafter his carvings have been seen as an eccentric sideline to the erratic brilliance of his modelled portraits and monumental sculptures, which make up the bulk of his later work. Lacking followers, his only significance after 1920 was the public controversy that surrounded his work.[3]

The heated public debate aroused by many of his works leads to the other major aspect of Epstein's role in twentieth-century British art. The subjects and treatment of his monumental work were so controversial that they brought sculpture out of the discreet anonymity of reviews and on to the front page. The public became sculpture-conscious. Epstein became a household name, the butt of music-hall jokes, limericks and cartoons. For a large proportion of the British public he was The Modern Sculptor incarnate—Bohemian in dress and behaviour and flouting conventional standards of morality and beauty. It was in acknowledgement of Epstein's thankless role that Moore paid his famous tribute: 'He took the brickbats, he took the insults, he faced the howls of derision...and as far as sculpture in this century is concerned, he took them first.'[4] Though Moore himself did not escape scot-free, he, Hepworth and other artists of the younger generation were

to some extent sheltered by the media focus on Epstein.

His fate as an unwilling scapegoat for modern art was settled from that morning in June 1908 when members of the National Vigilance League, peering through their office windows at the new British Medical Association building opposite, discerned on the scaffolding an over life-size, partially draped and heavily pregnant figure, apparently contemplating her ripening body. Scandalized, they alerted the police and, more seriously, the *Evening Standard*, which proceeded to attack the work in vituperative terms.

From that time onwards, however much Epstein's style and technique might alter, the exhibition or unveiling of any of his large-scale works was the signal for a volley of mostly abusive comment in the popular press. Works as diverse as the bronze *Risen Christ*, the carved bas-relief, *Rima*, the carvings of *Night* and *Day* for the London Underground, the marble *Genesis*, and the alabasters *Adam* and *Jacob and the Angel*, all gave rise to violent controversy.

As early as 1924, P. G. Konody, reviewing Epstein's Leicester Gallery show for the *Observer*, reflected on the growing public awareness of modern sculpture:

> When Mr Epstein held his first exhibition in London, his daring departure from all classic models in an abstract marble figure of Venus brought a shower of abuse upon his head, but attracted to the Leicester Galleries thousands of people who, under ordinary circumstances, would not have crossed the street to see a newly discovered masterpiece by Pheidias or Michelangelo.

Notoriety does not necessarily imply importance. Much of the publicity that pursued Epstein was gratuitously sensational and did his reputation far more harm than good. Nor was he above courting publicity when it suited him. On the other hand the controversy surrounding his work marked the emergence of British sculpture from intense conservatism and stultifying dullness of Royal Academy exhibitions and public commemorative schemes. Whatever else Epstein was, he was not dull. His persistent and radical departures, both from cherished classical canons of beauty and from hallowed interpretations, brought aesthetic debate into the popular arena. At the same time, the regional exhibitions of his work and the provincial tours organized for *Genesis* and *Adam* meant that his work could be seen by a remarkably wide audience.

Epstein rarely had a good word to say for those who wrote about him. He preferred to 'rest silent in his work'. This book, therefore, would most likely have left him torn between pleasure at receiving some acknowledgement and profound disapproval of much that it says. The text which follows traces Epstein's evolution as a sculptor by dividing his career into broadly chronological and thematic sections, which deal with his activity as carver, portraitist and sculptor of monumental and architectural works. Discussion of the latter is complemented by the catalogue entries which include as much detail as possible on the commissioning and evolution of these large-scale works, though in some cases documentary evidence is scant. The influence of economic circumstances and his relationship with casters, dealers and galleries is outlined both in the text and in the catalogue introduction. The catalogue lists every known work, illustrating all those of which photographs can be traced. No book can substitute for the presence of the sculptures themselves. It is my hope that this book will make looking at them more rewarding and will begin the long-overdue reassessment of Epstein's contribution to twentieth-century art.

The Making of a Sculptor 1880–1907

New York 1880–1902

Persecution and poverty were the driving forces behind the great wave of Jewish emigration from Central and Eastern Europe during the later nineteenth century. Many of the emigrants came to America as to a promised land; its immensity and youthful vigour offered hope for a new life in a nation whose constitution guaranteed liberty and religious toleration. The burgeoning Jewish community in New York's Lower East Side was unlike any other, containing both transplanted Orthodox communities maintaining the customs and language of their old homes, and others intent on assimilating the manners and aspirations of their new country.

Both Epstein's parents had come to New York from Augustòw, in Poland. Mary Solomon had arrived as a child with her parents during the 1860s; her future husband came a few years later. He dropped his unmanageable name, Chatskel Barntovsky, and became Max Epstein, in imitation of his brother who was already in New York and had adopted his wife's name, Epstein.[1] After their marriage in 1876 or 1877, Max and Mary Epstein settled in the heart of the Jewish community in the Lower East Side, at 102 Hester Street, a crowded street lined with old tenement buildings and filled daily with market pushcarts.

[1] Babson, pp. 1–3.

[2] Louis (1877), Ida (1878/9), Hyman (1882), Chana (1884), Irving (1891), Sylvia (1895) and Harold (1899); Babson, p. 3.

[3] Epstein 1940, pp. 11–12. He attended PS Seven in Christie Street and the East Side Settlement School until he was thirteen; Hapgood, 1902, p. 256; Babson, p. 8.

[4] He enrolled for five months in 1894–5, ten in 1895–6, eight in 1896–7, five in 1897–8 and seven in 1901–2; Washington Archives of the Hirshhorn Museum of Art. According to Hapgood 1902, p. 257, he spent only two terms at the League.

[5] Epstein 1940, pp. 12, 19.

[6] Hapgood 1902, p. 259; Epstein 1940, pp. 12–19.

[7] Epstein 1940, p. 15.

[8] An early drawing, sold to but never published by the Century Magazine, was of A Political Discussion at the International Café in Grand Street' (Plaza Book Auction Corporation sale, 26–7 April, 1934, no.82, cutting in New York Public Library).

Starting as a tailor, Max prospered, invested in property and, by the 1890s, owned a large number of tenements, a grocery and a bakery.

Jacob was born on 10 November 1880, their second son and the third of the eight surviving children born between 1877 and 1899.[2] His early childhood was marred by an unspecified illness which meant he was carried about a good deal for two years or more. Its lasting effects were on his mind, not his body, for it introduced him to the solitary pleasures of reading and drawing. When he was able to attend school his passion for history, literature and anything graphic was already remarkable enough for his teachers to overlook his neglect of mathematics and grammar.[3]

His talent was apparent by the early 1890s when a prize in an art competition at the Cooper Union took him to the Art Students' League, where he attended classes sporadically for the next eight years.[4] There he 'drew from the model and painted a little', acquiring some basic technique, but he found the easy-going student atmosphere of the League downtown far less stimulating than the world outside his own front door.[5] He was overwhelmed by the richness of the source material all around him—the Jewish, black, Chinese and Italian communities, the saloons and brothels along the Bowery, the intellectual and political debates in the cafés, the dockers and sailors working on the wharves, the apprehensive groups of new immigrants, the swarming street life of market trading and children playing. He went everywhere, drew everything (fig. 1), often accompanied by his Russian artist friend, Bernard Gussow. He even seems to have thought of developing a school of artists using New York as their subject; around 1898 he organized an exhibition of work by local artists at the Hebrew Institute.[6]

During this period of intense exploration, what Epstein read and heard played as large a part as what he saw in shaping the convictions which became central to his life and his art. He was already a voracious reader, capable of burying himself in a book and ignoring the family babel around him. Often, as he recalled:

> I would go off to Central Park, find a secluded place far away from crowds and noise, and there give myself up to solitary reading for the day, coming back home burnt by the sun and filled with ideas from Dostoyevsky's Brothers Karamazov, or Tolstoy's novels. Also I absorbed the New Testament and Whitman's Leaves of Grass, all read out of doors, amongst the rocks and lakes of the Park.[7]

There is a notably political and social dimension to his literary taste at this period as well as a belief

1 Men with Mice and Birds, New York, c.1900, conté crayon, 59.7 × 41.3cm. (Walsall, Garman-Ryan Collection)

in individualism which perceptibly influenced his later life. From James Kirk Paulding, a close friend of Abraham Kahan, who edited the Yiddish socialist newspaper, Vorvärts, he learnt of Joseph Conrad's work. In the heady atmosphere of the cafés he could join in debates on socialism, trade unions, free love, the economy and international politics. He attended political meetings and was drawn towards socialism and the idealistic anarchism proposed by Kropotkin and Emma Goldman.[8]

His political and artistic interests led him away from the orthodox Judaism of his family and brought him into frequent conflict with his father, though he received surreptitious support from his mother. His sister, Sylvia, recalled a family row when Emma Goldman came to take Jacob to speak at a meeting during Passover and their father threw her out. Jacob respected the 'patriarchal simplicity' of his maternal grandparents and some aspects of Jewish custom while being irked by the narrow and conventional observance of his parents: 'certainly I had no devotional

feelings, and later, with my reading and free-thinking ideas, I dropped all practice of ceremonial forms...'[9]

While recognizing that Jacob had 'a special bent', the rest of the family, and especially his father, found his determination to be an artist incomprehensible; he seemed doomed to starvation. 'They put it down to the perversity that made me a lonely boy, going off on my own to the woods with a book, and not turning up to meals, and later making friends with negroes and anarchists.'[10]

When the rest of the family moved to a more respectable district uptown, at 1661 Madison Avenue, in 1899, Epstein remained in a rented room in Hester Street overlooking the market. He got a variety of jobs—as a physical education instructor, and as a tenement inspector, where he started by reporting conditions in some of his father's buildings. However, as he proudly reported, he was always able to sell his drawings and never had to work colouring enlarged photographs like some of his fellow students. None of Epstein's earliest work appears to survive, though Sylvia recalled 'grotesques, masks and caricatures'; much was lost when his Hester Street studio burnt down some time before his departure for Paris in 1902.

Sculpture had played no part in his early studies. It only dawned upon him that he must become a sculptor during a winter (1898?) spent in a remote, inbred community on Greenwood Lake in New Jersey where he and Bernard Gussow rented a cabin. When money ran low, they worked for a few weeks cutting ice on the lake, hard labour which Epstein found deeply satisfying. Later he explained:

> What turned me from drawing to sculpture was the great desire to...study form in its different aspects from varying angles, and also the love of the purely physical side of sculpture. I felt here a full outlet for my energy, both physical and mental, that was far more satisfying to me than drawing. The physical side of sculpture is a very important factor that is often overlooked.[11]

However keen Epstein's ambition, his chances of receiving a training, let alone earning a living, as a sculptor were distinctly limited. Several municipal societies promoting sculpture had been founded during the 1890s and the National Sculpture Society was founded in 1893. Nevertheless, the volume of sculpture being produced was small and did not begin to increase rapidly until after 1905, when a meagre thirteen sculp-

tures were exhibited at the annual exhibition of the National Academy of Design.[12] Epstein adopted a pragmatic approach; he got a job in a bronze foundry and, in 1900–1, began to attend an evening class in modelling, run mainly for sculptors' assistants, at the Art Students' League. Happily, the tutor was one of the best American sculptors of the period, George Grey Barnard (1863–1938), whose work was heroic in its scale and ambition. His *Struggle of the Two Natures in Man* (Metropolitan Museum of Art) had been one of the sensations at the Paris Salon in 1894. Epstein continued to refer to him as 'my old master' and was one of the few to protest in 1917 when Barnard's statue of Abraham Lincoln, intended for Parliament Square, London, was turned down in favour of St. Gaudens' monument.[13]

Epstein was also fortunate in being offered the chance to work with Thomas Eakins in Philadelphia, but Eakins' modelled reliefs were subsidiary to his painting and Epstein already found his approach 'too dry and scientific'.[14]

Paradoxically, it was Epstein's talent as an illustrator that soon gave him the opportunity, still essential to any aspiring American sculptor, to study abroad—in France or Italy. In 1901 he was commissioned by the non-Jewish writer Hutchins Hapgood to make illustrations for his pioneering study of the Lower East Side, *The Spirit of the Ghetto*. The fifty or so drawings, showing every aspect of life in the Jewish quarter, were a direct extension of the sketches and studies Epstein had being doing for several years (fig. 1). They included portrait studies of leading actors, writers and poets, but the majority were candid and informal glimpses of the everyday lives of the people—on their way home from work, in the sweat-shops, bent over a loom, consulting the rabbi, holding Friday evening prayers, composing type and loading barrows. Technically and stylistically they owe much to the example of French magazine and poster illustration, and especially to the work of Théophile Steinlen (1859–1923), whose illustrations appeared in a variety of periodicals during the 1890s. There is the same feeling for strong, idiosyncratic contours, cut-off viewpoints and crowded street scenes, although Epstein's drawings, lacking Steinlen's harsh satirical edge, are informed with great sympathy for his subjects. His figures have nothing of the underlying idealization of an academy-trained student but are soft and compact, worn clothes moulded to the shapes of working men and women. Already they reveal his eye for fleeting expression, characteristic gesture and the fall of light.

Armed with the money earned from his tribute

[9] Epstein 1940, p. 17. See Hapgood 1902, p. 257; Babson, p. 5.

[10] Epstein 1940, p. 16.

[11] Haskell, pp. 13–14.

[12] Tarbell in Marter *et al.*, p. 1.

[13] Epstein 1940, pp. 21–2, 250–2; *Encyclopedia Americana*, 3, 1976, p. 250.

[14] The date of this abortive offer is unknown. Epstein 1940, p. 22; Buckle, pp. 11–12.

[15] Epstein 1940, pp. 22, 146–53, 251–2.

[16] Epstein 1940, pp. 25–7. After the Hapgood money ran out he was dependent upon $75 a month sent him by his elder brother and sister, Louis and Ida, at the insistence of their mother; Babson, p. 8.

[17] Epstein 1940, pp. 26–7.

[18] Epstein 1940, pp. 27–8.

[19] Babson, p. ii, refers to photographs of early work, belonging to the late Abner Dean, son of Epstein's older brother, Louis, but their current whereabouts is unknown.

[20] Buckle, p. 17.

[21] Haskell, pp. 15, 88, compresses Epstein's accounts of Paris 1902–5 and 1912; Epstein 1940, p. 23.

[22] Epstein 1940, pp. 248–9.

[23] Epstein 1940, pp. 28–9. The unfinished relief, *Sun-Worshipper* (no. 27), may be a partial reminiscence of this group.

[24] Epstein 1940, p. 30; Gray, pp. 225–6; P. Hornstein to author, 1985.

to the community in whose life he had found his first inspiration but whose creed he had come to reject, Epstein sailed for France in September 1902. Within the next few years, he would dismiss the possibility of becoming a sculptor in America. Apart from a very brief visit in about 1906, he resisted opportunities to return; in 1926 he refused Barnard's invitation to assist on his unfinished masterpiece, the *Memorial Arch*, and in 1927–8, on his first visit home for twenty years, he carried out only a few portrait commissions (nos. 181–3) before returning to England.[15]

Paris 1902–1905

Epstein arrived in Paris on 3 or 4 October 1902, just in time to join, on his first stroll in the city, the funeral cortège of Emile Zola, writer and champion of Dreyfus. He shared a studio with Bernard Gussow in the Rue Belloni, a working-class district just behind the Gare Montparnasse, and was soon admitted to classes at the Ecole des Beaux-Arts. He spent the mornings in the life-modelling class, and the afternoons drawing after Michelangelo casts and carving. Disgust at being handed a greenish, severed arm in the anatomy class led him to abandon it at once, while the lack of proper instruction in carving meant that he felt he had learnt more from his fellow students than from the teachers. His studies there came to an abrupt end after six months when he refused to conform to the practice of having the junior students act as dogsbodies for those competing for the prestigious Prix de Rome. Faced with the repeated destruction of his own studies and determined to use his slender resources to the best advantage, he moved to the freer atmosphere of the Académie Julian.[16]

At Julian's he continued to model and draw, although he won no laurels from the master, Jean Paul Laurens, who took to referring to him as '*ce sauvage Américain*' from his habit of covering up his drawings to avoid Laurens' derogatory comments.[17]

In spite of his ambivalent attitude to studio custom, Epstein recalled his whole period in Paris being passed 'in a rage of work; I was aflame with ardour and worked in a frenzied, almost mad manner, achieving study after study, week after week, always destroying it at the end of the week, to begin a new one the following Monday.'[18] Regrettably, the absence of surviving work and photographs leaves us with only Epstein's retrospective and cryptic account of this key period in his development as a sculptor.[19] He seems to have maintained amicable but slightly distant relations with his fellow students and to have explored the

city and its museums largely alone. He revered Donatello and Michelangelo but appears to have been reluctant to approach them too closely. When he was able to visit Florence in 1903 or 1904, he remained only a few days before returning to Paris.[20] His instinctive preference was for the Egyptian, early Greek, Cycladic and Iberian sculpture he saw at the Louvre and for Chinese works he found at the Musée Cernuschi—art then regarded as 'primitive'. He may also have visited the Trocadéro and seen the collections of African sculpture, but tribal art exerted no perceptible influence on his work until about 1912.[21]

Amongst contemporary sculptors Rodin stood supreme; Epstein visited his studio and observed him closely and admiringly but, unlike his compatriot, Jo Davidson, made no attempt to study with him.[22] He also became familiar with work by Gauguin, Bourdelle, Maillol, Meunier, Despiau and Rosso, which he could see at large, annual exhibitions—the Salon d'Automne and the Société Nationale des Beaux-Arts—as well as in the dealers' galleries.

After about eighteen months at Julian's he tried without great success to work alone: 'I was at a loss as to how to work out my ideas'. He felt the urge to work on a large scale, but started on two 'heroic-sized' groups only to destroy them. A stylized, hieratic quality, prophetic of his later work, may already have been apparent as he subsequently realized that *Temple of the Sun* (no. 2), had resembled an Egyptian piece.[23]

Going to England offered him a possible way forward from this impasse. On a brief trip, probably in 1904, he was at once enthralled by the British Museum, and encouraged by the friendliness of his reception. It is likely that his future wife, Margaret Dunlop, played a part in setting up this visit, which convinced him to move to London. Margaret Dunlop, or Peggy as she was always called, was nine years older than he and married to one Thomas Williams when they met at the apartment of Victor Dave and his wife in Paris. Dave, a Belgian publisher, had been imprisoned for his anarchist sympathies. Evidently Epstein maintained some of the political contacts he had made in New York, and Peggy was a Scots Nationalist with socialist and even 'communistic leanings'.[24] After their marriage in November 1906, her single-minded devotion, intelligence and organizing abilities were to support him until her death in 1947.

Before Epstein left for England early in 1905, he appears to have destroyed the contents of the studio. He took with him only a portfolio of drawings in red chalk, pen and wash, and possibly two baby's heads (nos. 3, 4), modelled with a delicate

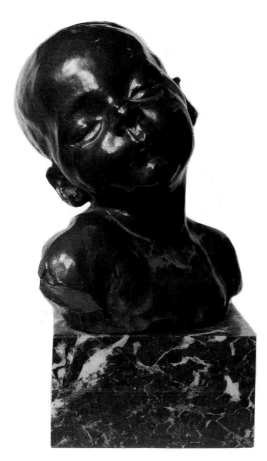

2 *Dalou,* Head of a Sleeping Infant, *c.1878, bronze, 19.7 × 17.5 × 14.3cm. (Pittsburg, Carnegie Institute, Museum of Art)*

naturalism which is strongly reminiscent of Dalou's *Head of a Sleeping Infant, c.*1878 (fig. 2). The similarity is probably coincidental since the latter was only exhibited in the Salle Dalou at the Petit Palais in July 1905, several months after Epstein had left.[25]

London 1905–1907

The arrival in London of this intense, passionate young man (fig. 3) soon became known to several influential figures. On 13 March 1905, George Bernard Shaw wrote to Robert Ross, the devoted friend and literary executor of Oscar Wilde, who also owned the Carfax Gallery:

> By the way there is a young American sculptor named Jacob Epstein, of 219 Stanhope Street, N.W. (therefore poor), who has come to London with amazing drawings of human creatures like withered trees embracing. He wants to exhibit them at Carfax, which is to him the centre of real art in London. He has a commendatory letter from Rodin; and when I advised him to get commissions for busts of railway directors he repudiated me with such utter scorn that I relented and promised to ask you to look at his portfolio. It is a bad case of helpless genius in the first blaze of youth; and the drawings are queer and Rodinesque enough to be presentable at this particular

moment. If you feel disposed to be bothered with him for ten minutes send him a card and he'll call on you. There may be something in him.[26]

The drawings were illustrations of Walt Whitman's poem, *Calamus* (fig. 4), celebrating the love of man for man and executed in a style reminiscent of Puvis de Chavannes. Shaw, who would prove himself a staunch defender of Epstein's freedom of expression in later years, may well have thought that Ross, who favoured the work of new artists, would be sympathetic to the sinewy grace of these drawings whose homosexual overtones would make them controversial elsewhere. Although no Carfax exhibition resulted, the introduction was momentous since it was Ross, acting on behalf of Mrs James Carew, who commissioned Epstein to undertake a figure for Oscar Wilde's tomb in Père Lachaise Cemetery, Paris, four years later.

Shaw also wrote to the painter, William Rothenstein, pressing him to see Epstein. Though Rothenstein found the drawings 'intense in feeling, if somewhat thin and tenuous', and felt that they would be more acceptable in Paris or Berlin than in London, he too proved a loyal and generous friend during the difficult early years in London.[27]

In spite of their encouragement Epstein was still under acute family, financial and emotional

3 *Self-Portrait, c.1901, red chalk, 29.5 × 22.5cm. (Walsall, Garman-Ryan Collection)*

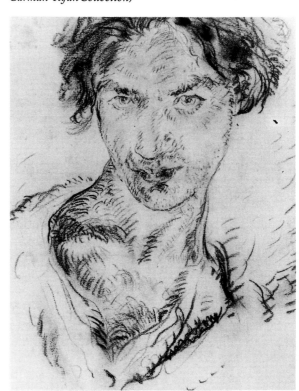

[25] The same study was seen by Brancusi, who used it as the basis for *Tourment.* See Fusco and Janson, no. 70.

[26] Ross, 1952, pp. 111–12.

[27] Rothenstein, 1932, p. 87, there dated 1907, though the context indicates early 1905.

[28] Babson, pp. 6, 8, also mentions a girlfriend in New York.

[29] Epstein 1940, p. 31.

[30] Epstein 1940, p. 31; Rothenstein, p. 87; Babson, pp. 8–9.

[31] Epstein 1940, p. 31; Rothenstein, p. 87.

[32] Significantly, Charles Dodd, Ambrose McEvoy, Will Rothenstein, Augustus John and Muirhead Bone were on the Jury.

[33] Beattie, *passim*.

4 *Drawing for 'Calamus' by Walt Whitman, pen, ink and wash, 30.5 × 20.2 cm. (Birmingham Museum and Art Gallery)*

pressure; his father continued to be utterly opposed to his choice of career, while Louis and Ida were reluctant to support him any longer.[28] Over and above this was his continuing anxiety about the direction and content of his work. Although he described himself as a sculptor, he had taken to show his first influential contacts in the British art establishment neither the baby's heads (if indeed these had been brought from Paris) nor photographs of work left in Paris, but drawings which, though marking a great change in style and approach from his New York work, were nonetheless illustrations. 'I felt extremely discouraged at this time and started destroying all that was in the studio,' he recalled.[29]

Assisted by a ticket sent from home and by aid from a Jewish society which Rothenstein had approached on his behalf, Epstein returned to New York. Whether he wanted simply to see his family and argue the cause of art, aided by an intercessory letter from Rothenstein, or whether he seriously considered returning to work in New York for good we cannot now tell. At any event he stayed only two weeks before returning to London and Peggy. His sister—then ten years old—thought it was 'because my father made life so miserable for him'.[30] Epstein settled himself and Peggy at Stamford Bridge Studios, nicknamed

'The Railway Accident', in Fulham, and on 13 November 1906 they were married at Chelsea Registry Office. Over the next few years commissions from friends, such as Francis Dodd (no. 32) and Ambrose McEvoy (nos. 18, 19) in the New English Art Club (NEAC) circle, and discreet small subsidies from Will Rothenstein enabled them to survive.[31]

Ironically the first work he exhibited in England was an oil painting, *Portrait of Konhong-Sara*, included in the NEAC show in November 1906.[32] Slowly, however, he was beginning to develop a personal style; just as candid observation had lent a vital realism to his New York drawings, so studies from life began to infuse modelled and carved sculptures still deeply indebted to Renaissance and contemporary French models.

Epstein's handling of the unfinished marble relief, *Mother and Child* (no. 5), is still tentative despite the tender realism in the relation of mother and child which enlivens this time-honoured theme. The foreshortening of the mother's legs, head and hands is uncertain, and the attempted *relievo schiacciato* technique looks back to early Renaissance exemplars, such as Donatello's *Christ giving the Keys to St. Peter* (Victoria and Albert Museum). This relief and the two studies of baby's heads (nos. 3, 4) are still in the tradition of Dalou and Rodin. It was only with the extraordinary head of *Romilly John* (no. 8) that Epstein first attempted to synthesize his intuitive grasp of character and mood with radically simplified organic form.

The burnished hemispherical cap extending down the back of the neck gives this head a completely abstracted form when viewed from the back. The expressive quality of the head, the epitome of infant grumpiness, is enhanced by the tension between cap and face, clearly visible from the front and profile views. This is scarcely a portrait; Augustus John's son is the pretext for a far broader sculptural statement. The smooth cap is a critique on the fussily decorative, pseudo-historical headdresses—turbans, caps and helmets—favoured by Victorian sculptors, such as Sir Alfred Gilbert (1854–1934), Alfred Drury (1856–1944), and Sir George Frampton (1860–1928).[33] Epstein strips away this decorative irrelevance to emphasize the essential structure and mass of the head, while at the same time exploiting the inherent qualities of bronze, without recourse to the ivory and semi-precious stones favoured by Frampton.

Rothenstein recalled 'the strange, uncouth power' of these early studies. Compared with the suave lyricism of Frampton and Drury, and the prevailing genteel classicism of French and Eng-

lish sculpture, studies such as *Italian Peasant Woman* (nos. 7, 12) and *Nan* (nos. 17, 36, 38) seemed almost savage in their realism.[34] The tension between idealized classical types and unabashed naturalism became even more marked in Epstein's first major commission, the eighteen figures for the British Medical Association Building in the Strand.

'Noble and Heroic Forms'

Charles Holden and the British Medical Association

During the spring of 1907 Epstein was commissioned by the young architect, Charles Holden, to carve eighteen over life-size figures on the new British Medical Association headquarters in the Strand (no. 9, plates 1–3). It was an amazing coup for a twenty-six year old, Polish-American Jew only two years in England, who had yet to exhibit a single sculpture. Architectural sculpture had enjoyed something of an Indian summer in Britain over the previous thirty years, so that Holden might have been expected to approach Sir George Frampton, Alfred Drury or F. W. Pomeroy, leading British sculptors with a proven record in architectural work. The low fee, less than £100 per figure, was undoubtedly a factor in the choice of a man without an established reputation; Drury's sixteen double life-size figures for the War Office (1904–5) cost £9,000.[1] But still more important was the impression made upon Holden by the Greek-inspired, life-size figure, *Girl with a Dove* (no. 6), upon which Epstein was working when he first visited the studio, and by the enthusiasm with which Epstein grasped the possibilities of the undefined, but ambitious, scheme.[2] As Holden recalled, Epstein responded within days with 'a programme as wide in scope as Whitman and which was in fact exactly what I was hoping to find in him.'[3] Epstein himself described his aim the following year: 'I have wished to create noble and heroic forms to express in sculpture the great primal facts of man and woman.'[4] The commission, with its elemental, Whitmanesque theme, was not only a great opportunity for the young sculptor but also provided him with a focus for his energy and imagination. He moved to a new studio, rented from C. R. Ashbee, at 72 Cheyne Walk, and succeeded in completing all the figures within fourteen months.

Charles Holden was to prove one of Epstein's staunchest supporters and, for many years, the only man in England willing to give him architectural commissions. Though his self-effacing,

tactful disposition was utterly at variance with Epstein's more volatile, argumentative character, they had a great deal in common. Both Holden, with his hard-working Quaker upbringing in Bolton, and Epstein, from the unfettered but even more competitive milieu of the Lower East Side, had had to struggle to follow their vocations. They shared a love of music and left-wing political sympathies, and both had been deeply stirred by the robust sensuality and prophetic vision of Walt Whitman's poetry.

Holden had been in London since 1897, first as an assistant to C. R. Ashbee, and from 1899 as chief assistant to Percy Adams, whose talent for planning complex, functional buildings brought him many hospital, school and library commissions. Taken into partnership in 1907, soon after his design for the BMA headquarters had been accepted, Holden became one of the leading architects of his generation.

The placing of the sculpture—single, over life-size figures in narrow embrasures on either side of the second storey windows—was one of the most innovatory aspects of the design. Sculpture carried out on recent buildings, such as the Chartered Accountants' Hall, Lloyd's Registry, the War Office and the Victoria and Albert Museum, comprised either spandrel and frieze decoration, carved in relief, or fully sculpted figures, placed in recessed lunettes or on top of pediments.[5] Holden had himself proposed a frieze for his Italianate market hall design for the RIBA Soane medal (1896), and commissioned conventional, historical reliefs for the lunettes at Bristol Central Library (c.1906–7), while two fully carved symbolic figures were inconspicuously sited in the recessed window lunette of his Law Court Library in Chancery Lane (1904).[6]

That Epstein had no intention of following these tame precedents and had Holden's full support is evident from the outset. Surviving photographs of the small model he prepared for the BMA committee show three nude figures, modelled in the round and bursting forward from their niches.[7] The project at this stage consisted both of symbolic figures, such as Aesculapius with his rod and serpent, and of Michelangelesque nudes representing the ages of man and woman. These figures were developed or transformed in the final scheme. Although he drew on his experience of working from Michelangelo casts in Paris, notably in some of the exaggerated musculature, the final carvings owe more to a Rodinesque naturalism than to Michelangelo.

It is now impossible to get any idea of the sculpture's original impact by looking at the building (now the Embassy of Zimbabwe); the mutilation

[34] Rothenstein, p. 87.

[1] Beattie, p. 114.

[2] Francis Dodd, probably supported by Muirhead Bone, who knew both men well, introduced them. Haskell, p. 16; Epstein 1940, p. 33; Holden, Memoir, 3.12.1940.

[3] Holden, Memoir, 3.12.1940.

[4] J. Epstein, 'The Artist's Description of His Work', *British Medical Journal*, 4.7.1908.

[5] Beattie, chap. 5.

[6] Beattie, pp. 80, 133, pls. 58, 121, 122; Cork 1985, pp. 10–11.

[7] Buckle, pls. 20, 21; Cork 1985, pls. 18, 19.

[8] Beattie, p. 120, pl. 100;
a stronger source of
inspiration than
Frampton's Lloyd's
Registry frieze suggested
by Beattie, p. 106.

[9] *Vanguard American
Sculpture 1913–39*, pl. 11
(whereabouts unknown).

of the figures in 1937 has destroyed not only the architectonic character of the sculpture, but also the rhythmic interrelation of pose and gesture. These can only be gauged from the photographs which show the building before completion with some of the Agar Street scaffolding still in place (see plate 1 and Catalogue no. 9, where the scheme is described in detail).

The eighteen figures fall into three main groupings. The two bays of the narrow Strand façade form a unit, linked to Agar Street by the mirrored poses of the fourth and fifth figures; the frontal figures—*Matter* (9.2) and *Hygieia* (9.3)—are flanked by the dynamic inward movements of *Primal Energy* (9.1) and *Chemical Research* (9.4). On the long Agar Street façade the frieze divides into three groups, the first, comprising three bays, begins on the corner with *Academic Research* (9.5), and ends with the profile figure of *Maternity* (9.10, plate 2). The second is the single bay with nude male and female figures (9.11 and 9.12), sited immediately above the main entrance, while the third group, comprising the last three bays and six figures, is made up of dancing and stretching male and female nudes.

Most traditionally treated are the static figures holding symbolic attributes, such as *Hygieia* (9.3) and *Mentality* (9.6). They are strongly reminiscent of Greek caryatids in their austere rectitude, but Epstein is also likely to have looked closely at the large figures recently completed by Frampton and Pomeroy on Vauxhall Bridge (*c*.1905), only a few minutes walk along the Embankment from his new studio. Like Epstein's carvings, these bronze allegorical figures were designed to be viewed singly in shallow pier-recesses. Drury's *Science*, holding a globe, is particularly close to *Mentality*, who holds suspended the winged skull which vividly symbolizes the mind's power to transcend mortality.[8] Though ostensibly conventional, the nudity of *Mentality* was a bold departure from the norm for public buildings.

More startling still to contemporary eyes was the unaffected nudity and realism of the old woman in *New-Born* (9.8, plate 3) and the pregnant mother in *Maternity* (9.10, plate 2). The head and body of the old woman, which is derived from the *Italian Peasant Woman* (no. 12), are handled with an unflinching but sympathetic honesty which recalls both Donatello's *St. Mary Magdalen* (Florence, Baptistery) and Rodin's *Celle qui fut la belle heaulmière*. In complete contrast to the dynamism of the preliminary model the old woman barely stirs, holding the recumbent baby in her hands as if entrusting it to future generations.

Several preliminary drawings for *Maternity* survive and Epstein considered a frontally com-

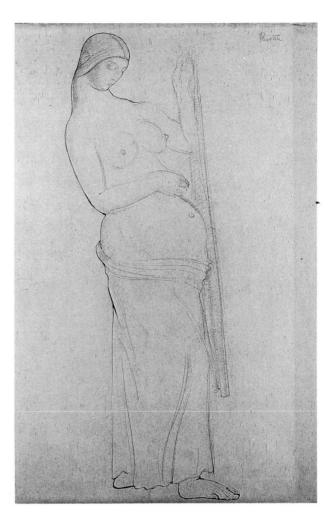

5 *Study for* Maternity, *pencil, 50 × 30.5cm. (Walsall, Garman-Ryan Collection)*

posed grouping, with the mother assisting her son's first steps, before choosing a profile view. A study of a woman twirling a distaff (fig. 5) approaches his final solution. It seems clear that Epstein was eager to include a child being carried somewhere in the scheme; having altered the old woman and child from his sketch model and rejected a plaster of a man holding a child in his arms (no. 11), he eventually hit on the simple, unrhetorical solution of having the mother cuddle her child. Alone in the series, these two are focused inwards upon one another. *Maternity*, with her head bent towards her child, is the least architectonic figure in the cycle as well as the most intimately informal. It would have worked wonderfully well as a single free-standing sculpture and, though Epstein never repeated himself, the theme of motherhood, treated with aggressively unsentimental candour, was to preoccupy him for much of his career.

The male figures are more predictably Rodinesque in their heroic naturalism, and they also show Epstein looking to the example of his first teacher, George Gray Barnard; the youth with his right leg bent and right arm raised (9.16) almost certainly echoes *Solitude* from Barnard's *Urn of Life* (1895–7).[9]

There are signs of haste in the repeated poses of the dancing girls (9.12 and 9.13) and only slightly varied poses of several of the male figures (9.15, 9.16, 9.17); because of this and their lack of individual identities, these figures have been the least photographed and the least discussed. This is a pity since the *Dancing girl* (9.12) shows the sculptor's relaxed command of movement within the narrow confines of the niche. Her slender body is even more naturalistically treated than the ponderously self-conscious *Nature* (no. 10). Prominently placed in the central bay of the Agar Street façade, she and her male counterpart embody the springtime eagerness and physical abandon characteristic of Whitman's rhapsodic style.

The classicism of Epstein's figures resides less in specific sources than in his profound understanding of their architectonic function. For the static, caryatid-like figures—the *New-Born* and *Hygieia*—he had looked to early Greek examples, such as the Erechtheion in Athens (*c*.420–413 BC). To convey vigorous movement within the confined space available he borrowed from Michelangelo's '*Slaves*' (Louvre), which had similarly expressed physical and spiritual yearning by the artful restriction of movement within the block. That the majority of the figures appear neither wooden nor contrived is due to their relative naturalism. The physical immediacy of each movement or gesture, most apparent in the dancing figures (9.11–18) and the poignant realism of *Maternity* and the *New-Born*, conveys the irresistible dynamic of human existence. Yet the structural integrity of each figure preserves its harmony with the adjacent architecture.

Though some commentators were disturbed by both the awkward space allowed for the sculpture and their restlessness, other influential voices praised their heroic gravity.[10] C. J. Holmes, Slade Professor of Fine Art at Oxford, thought they evoked the heroic mood of Pre-Pheidian Greece, while Sidney Colvin, Director of the British Museum, praised their 'spirit of primitive severity'.[11]

Where the critics differed was in their interpretation of that severity: one man's austerity was another's vulgarity or brutality. For the editor of the *Architectural Review* it was not enough for a nude to be frank and unlascivious; it must also be beautiful. The writer could accept that *Maternity* belonged to a long tradition of depicting pregnancy in the Visitation but 'when this aspect is reduced to the nude in the round, and used as an external decoration, we think the realism is somewhat too robust.' Similarly, 'no one would, for example, deny the immense power of Rodin's little figure...of the old woman with withered and pendulous paps, [*Celle qui fut la belle heaulmière*] but few would recommend so painful a *tour de force* for the external decoration of a public building.'

Prudery over public nudity was at the nub of the public furore which followed the removal of the scaffolding in June and July 1908. In a memorably sanctimonious article the *Evening Standard*, 19 June 1908, lambasted the 'five amazing statuary figures' so far revealed:

> They are a form of statuary which no careful father would wish his daughter, or no discriminating young man, his fiancée, to see. Nude statuary figures in an art gallery are seen, for the most part, by those who know how to appreciate the art they represent, and it is only in the most exceptional cases that they afford subjects for the vulgar comments of the inartistic...The difference between a nude figure in sculpture in a gallery and one exposed to the public gaze in a busy thoroughfare is too obvious to need emphasising.[12]

Artists and art establishment rallied to Epstein with remarkable unanimity; Augustus John, Muirhead Bone, Dr Cosmo Lang, then Bishop of Stepney, Walter Crane, Shannon and Ricketts, Eric Gill, Frank Harris and Sir Charles Holroyd, Director of the National Gallery, all wrote to defend him and, thus fortified, the BMA rode out the demands for the removal of the sculpture.

The public uproar to which the figures gave rise appears absurd if their conservatism is compared with Picasso's *Les Demoiselles d'Avignon* (1907) or contemporary work by Matisse and Derain. Within a few years they were seen as one of the finest examples of architectural sculpture in London. Epstein was attacked so bitterly primarily because sculpture, far more than painting, was dedicated to the public preservation of the status quo. He had used a permanent, public site for his challenge to accepted norms rather than the exclusive surroundings of an art exhibition whence the offending work could disappear discreetly into a private collection. The alleged immorality of showing male nudity, pregnancy and old age so blatantly and realistically in a public place caused the outcry. Unlike other recent buildings, where both the architecture and figure sculpture tended to be elaborately draped and decorated, Epstein's unadorned nudes showed stark against the planar masses of Holden's façade.

However, the battle waged over the moral issue generated more heat than light; it reveals as much

[10] *Builders' Journal*, 29, 1908, p. 8; *Architectural Review*, 24, 1908, pp. 2–3.

[11] Epstein 1940, pp. 37–9, 270–2.

[12] Quoted in full, Epstein 1940, pp. 35–6.

[13] Harrison, p. 33.

[14] Epstein 1940, p. 56.

[15] Epstein to Lady Ottoline Morrell, 22.10.1908 (HRC).

[16] Epstein 1940, pp. 56–7.

about social taboos in Edwardian England as it does about attitudes to sculpture. Nor was Epstein the only artist to be vilified on moral grounds; Sickert was reviled for the 'low-life' subjects of his *Camden Town Murder* pictures, painted only the year after the completion of the BMA building.[13]

The Aftermath

Epstein responded to the commotion caused by the BMA sculptures by returning to his studies:

> After so much that was large and elemental, I had the desire to train myself in a more intensive method of working...I began a series of studies from the model, which were as exact as I could make them...and followed the forms of the model by quarter-inches, I should say, never letting up on any detail of construction of the plane; but always keeping the final composition in view.[14]

Some of the studies develop those figures which had most interested him at the BMA—the voluptuous *Gertrude* (no. 31), who had probably been the model for the rejected plaster, *Nature* (no. 10), and *Euphemia Lamb* (nos. 13, 33), whose sensual grace is closely akin to the *Dancing girl*. However, work proceeded slowly since he was practically destitute; his advance payment for the Strand, which had seemed like riches, had rapidly been consumed by the unforeseen expenses of the project. Augustus John lent him a few pounds and appealed to that indefatigable patron, Lady Ottoline Morrell, who commissioned a sculpture for her garden for £25. In October 1908, Epstein wrote enthusiastically: 'a garden statue sounds delightful; sculpture outdoors amongst trees and shrubs; it is reminiscent of Italy and Greece.'[15] The outcome of this commission, *Fountain Figure* (no. 14), is a far more sensuous interpretation of the *Dancing girl* on the BMA building. Her balletic pose and 'Greek' robe—somewhere between the Ludovisi throne (fig. 21) and Fortuny—hovers between the naturalism of the life-drawings, from which the piece developed, and a lyricism still derived from classical sources. Technically he was still working in the Beaux-Arts tradition, making studies from life and then carving the figure with the aid of a full-size plaster model.

Nan Condron, a lanky gipsy model, was the subject of several highly naturalistic figure and portrait studies. In the *Bust of Nan* (no. 17, plate 14), he focuses on the woman's pride and intense reserve and, far from flinching at the marks of age and weariness, emphasizes the irreducible individuality of her features. In *Nan (The Dreamer)* (no. 36) and *Nan Seated* (no. 38), he defers to his model's native, angular grace, implicitly rejecting any fictional ideal of beauty.

During 1908–11, he received a small but growing number of portrait commissions, mostly from friends. Portraiture was to become central to his practice as a sculptor, but at this stage there is little uniformity in his style. Few were as experimental as *Romilly John* (no. 8). Most indicate Epstein's willingness to employ the expressive and naturalistic potential still latent in Renaissance formulae; *Mrs McEvoy* (nos. 18, 19) remains close to fifteenth-century models in format, modelling and expressive delicacy. Heads such as *Mrs Clifton* (no. 30) and *Hilda Hamblay* (no. 58) are experimental in the treatment of hair or eyes, but reveal areas of technical uncertainty; the eyes are often downcast, thus avoiding the difficulties inherent in the sculptural treatment of the pupil and iris; the eyelids are sometimes elongated to suggest the lashes, but this carapace-like effect was soon abandoned. In a few portraits, notably *Lady Gregory* (no. 24), he asserted a mood of spontaneous informality through asymmetrical pose and unadorned modern dress. Lady Gregory was irked by Epstein's refusal either to incorporate the frothier hairstyle she acquired during their sittings, or to depict her with bare shoulders in evening dress; the spirited determination and business-like manner which the portrait so powerfully evokes made Sir Hugh Lane exclaim, 'Poor Aunt Augusta. She looks as if she could eat her own children.'[16] Notwithstanding these reservations, Lane recommended in 1910 the purchase by Johannesburg Art Gallery of the marble *Mrs Ambrose McEvoy* (no. 19), the first work by Epstein to enter a public collection.

By 1909–10 Epstein's reputation was growing beyond the small circle of his friends and wealthy patrons, such as Lady Ottoline Morrell and the American collector, Mrs Emily Chadbourne (see no. 22). He was also becoming known outside London; the Liverpudlian artist, James Hamilton Hay, asked by the Curator of the Walker Art Gallery to name contemporaries whose work he would like to see in the collection, responded with a list in which Augustus John, Francis Dodd, Wilson Steer and Will Rothenstein headed the painters, and Epstein and Ricketts the sculptors. The selection represents moderately advanced taste; most were connected with the New English Art Club, which was by then a waning radical force. Hay himself exhibited there in 1909 and was a friend of both Augustus John and Francis Dodd, from either of whom he could have heard about Epstein. Ricketts' few small sculptures are

heavily indebted to Rodin but in England in 1909 they still passed as advanced work.[17]

Epstein, Gill and the Birth of Direct Carving 1909–1912

'I want to carve mountains'

Between 1909, when he was commissioned by Robert Ross to carve a monument for the tomb of Oscar Wilde (no. 40), and 1912, when he completed it, Epstein transformed his carving style and practice. He abandoned the traditional method of transferring his design from a full-size plaster model to stone in favour of carving directly into the block, aided only by a preliminary drawing. At the same time he began to incorporate into his work elements taken from the sculpture of the Ancient Near East and India, which he had long admired at the Louvre and British Museum.

'Primitive' art was an area of increasing public interest. Indian art, in particular, was beginning to be enjoyed for its aesthetic as well as its archaeological importance; E. B. Havell's *Indian Sculpture and Painting* and A. Coomaraswamy's *Medieval Sinhalese Art* were published in 1908. In 1910, when Sir George Birchwood, an admirer of Indian decorative art, fulminated against a Javanese Buddha displayed at the Royal Society of Art as 'an uninspired brazen image, vacuously squinting down its nose to its thumbs, knees and toes,' those who leapt to contradict him included two senior sculptors, Frampton and Lantéri, William Rothenstein and the illustrator, Walter Crane.[1]

Epstein's experiments were significantly stimulated by friendship with Eric Gill (1882–1940) who, from the very different starting point of calligraphy and letter-carving, was beginning to sculpt. Their friendship and its results are now barely documented since, after the arguments that terminated their relationship in 1912–13, their subsequent contacts were strictly business-like and neither refers to the other in later autobiographical accounts. This is particularly unfortunate since it has obscured their joint role in developing direct carving in England, a movement contemporary with but independent of developments in Germany and France.[2]

They had met over the Strand affair. Epstein called on Gill as early as 12 April 1908, before the sculptures were unveiled, possibly at the suggestion of Will Rothenstein.[3] On 23 June Gill went and saw the sculptures on the completed building, following this up with a spirited letter, asserting that Epstein was 'raising modern sculpture from the dead'.[4] A symbiotic relationship developed.

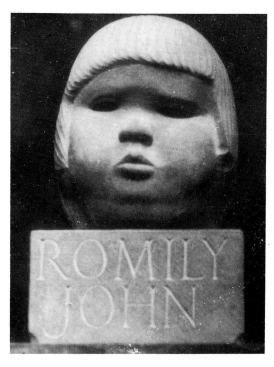

6 *Eric Gill,* Romily John, *1910, stone (whereabouts unknown)*

oped. Gill had already begun, tentatively, to carve directly; Epstein, the more experienced sculptor learnt from Gill's elegantly linear handling of stone while imparting something of his own monumental approach to form.[5] Still more important was their mutual obsession with uninhibited sexual expression in art and life.

Whether they were working together in 1909 is uncertain, given the absence of Gill's diary for that year, but it seems likely that their collaboration only developed in 1910, when references to Epstein in Gill's diaries become increasingly frequent. Their relationship was extremely close from June 1910 to mid-1912; the Epsteins spent several weekends with the Gills at Ditchling; during 1910 there were nude photography sessions in August and September, and they spent Christmas together. On one of these convivial visits 'Happy Family' cards were made, mostly by Gill, but a few by Epstein. Significantly one of Epstein's shows Gill as a nude, cross-legged Buddha figure with a child perched on each shoulder and the baby, Joan, in his lap; another shows Gill carving a seated idol-like figure.[6]

The two men appear to have worked side by side; both carved heads based on Epstein's modelled portrait of *Romilly John* (no. 8), Epstein's *Rom* (nos. 20, 25) and Gill's *Romily John* (fig. 6).[7] The relatively uninflected surface and helmet-cap of the bronze *Romilly John* made it an appropriate starting point; both Epstein's carved versions orientalize the head, broadening and flattening the features; the hair, carved in grooves, frames the face and neck just as the cap does in the bronze. Gill's version, smoothly finished and naturalistic, more closely resembles the bronze. Both heads were exhibited, Epstein's at the Allied

[17] Liverpool, Walker Art Gallery, *An Exhibition of the Works of James Hamilton Hay*, 1973, p. 6.

[1] Mitter, pp. 269–70.

[2] Zilczer 1981, pp. 44–9, credits Gill and Gaudier-Brzeska with originating the direct carving aesthetic in Britain.

[3] 'I sent Gill down to Epstein, thinking he might work with him for a time, and the two became friends,' Rothenstein, p. 195.

[4] Gill Diaries (Los Angeles, Clark Library); *British Medical Journal*, 4.7.1908; Speight 1966, p. 48.

[5] Shewring, p. 30. Gill related to Rothenstein, 22.1.1910, Count Kessler's and Maillol's response to a photograph of a statuette Gill had made, carving direct.

[6] London, Anthony d'Offay Gallery.

[7] Epstein's head was complete by July 1910. Gill's head, carved for Epstein, is datable 25 June to 4 July 1910, when Gill records a total of forty-two hours' work on 'Epstein (head)', for which Epstein paid him £8 on 22 July; Gill Diaries (Los Angeles, Clark Library); Epstein bank book (Private Collection).

[8] Chelsea, Chenil Gallery, January 1911, no. 8. *Head of Romily John* (carved from model by Mr Jacob Epstein, lent by same).

[9] Hind, pp. 65–71.

[10] Gill to Rothenstein, 25.9.1910, in Shewring, p. 32.

[11] Speight 1966, pp. 48–9.

[12] Hind, p. 67.

7 *Eric Gill, Ecstasy, 1910–11, stone, 137 cm. high (Tate Gallery)*

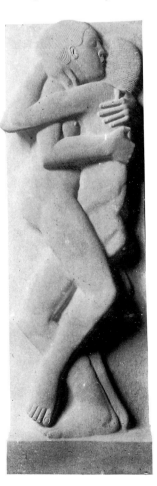

Artists' Association show in July 1910, and again at the National Portrait Society's exhibition at the beginning of 1911, which coincided with Gill's first one-man show.[8] One perceptive commentator, C. Lewis Hind, saw the common creative intention which united the two sculptors—respect for their materials and the mystical search for forms symbolizing 'a primal fact of life' which had led them to seek inspiration in Indian, Assyrian and Egyptian art.[9]

Epstein's part-Egyptian, part-African *Crouching Sun Goddess* (no. 28) can plausibly be dated to this period. This squatting figure has a presence out of all proportion with its modest size and retains the character of the block from which it was carved. Not only its planarity but also its formal hierarchy of head, knees, breasts, belly, ankles, vulva and feet, which result from the compression of the anatomy into the block, were effects Epstein was to develop further in his *Flenite Relief* (no. 44), *Flenite Figures* (nos. 45, 46) and *Venuses* (nos. 49, 56). Gill's *St. Simeon Stylites*, 1912, echoes it in scale, form and sexual display, though Gill's figure is elegant and contemplative where Epstein's has a brutal intensity.

United in their devotion to direct carving and their desire to celebrate human sexuality in art, Epstein and Gill decided to establish a rural artists' commune where they had a 'great scheme for doing some colossal figures together (as a contribution to the world), a sort of twentieth-century Stonehenge'.[10] In July 1910, they found Asheham House, with its farm buildings and six acres nestling in a valley, a few miles south-east of Lewes, Sussex. During October and November, applying for support to all their friends from the enthusiastic Augustus John ('the temple must be built') to Roger Fry, they strove to keep the idealistic project alive, even visiting quarries to select stone.[11] However, the cost was considerable—£50 a year for the fourteen-year lease, or £3,500 to purchase outright—and the scheme fell through (the house was to be leased two years later by Leonard and Virginia Woolf).

Only one drawing, a columnar group of an embracing couple inspired by Indian erotic sculpture (Anthony d'Offay), has tentatively been associated with the scheme, but several sculptures by both men, begun during 1910, indicate the pagan and openly erotic themes then preoccupying them and which would, no doubt, have found a place in their 'temple'; Gill worked on a relief carving of a couple making love, *Ecstasy* (fig. 7), during late 1910–11; the male splendour of Epstein's hieratic *Sun God* (no. 26, plate 6) is echoed on a small scale by Gill's *Cupids*, one of which Epstein owned. It is likely that other

8 *Epstein and/or Gill, Man and Child, c.1910, stone (whereabouts unknown)*

figures were started; early photographs from Gill's studio show a kneeling, bearded patriarch embracing a standing child (fig. 8), and a kneeling woman embracing a younger child who crawls up her lap. Both stone groups are unfinished and their authorship is unclear. They may have been collaborative works, but both the character of the figures and the rugged directness of the carving suggests Epstein rather than Gill. Epstein had told Hind of his dream that the temple would include the stone *Rom* 'the Eternal Child, one of the flanking figures in a group apotheosising Man and Woman, around a central shrine.'[12]

Epstein may also have intended to incorporate the monumental free-standing figure of *Maternity* (no. 23, plate 5) into the Asheham House project. Like the *Oscar Wilde Tomb* and *Sun God*, it is carved in Hoptonwood stone, but had progressed only down to hip-level when it was abandoned in 1911, and exhibited unfinished at the Albert Hall in 1912. Indian influences abound in the pose, ample breasts and stylized harness, while the handling of the hair and dreamily contented face

is reminiscent of Gill's work. Just as Gill's Mother and Child images in 1911–12 incorporate memories of Epstein's Strand *Maternity* (no. 9.10), the scale, pose and overall conception of this voluptuous figure clearly influenced Gill's *Mulier*, exhibited at the Chenil Gallery in 1914 (Los Angeles, Franklin D. Murphy Sculpture Garden).

The Tomb of Oscar Wilde

The most significant result of Epstein's close collaboration with Gill was his decision totally to rethink the *Tomb of Oscar Wilde* (no. 40) for Père Lachaise Cemetery in Paris, on which he worked from 1909 to 1912. At first Epstein tried to accommodate the wishes of Wilde's admirers who wanted a classical monument, and brought a freestanding figure, which can almost certainly be identified as the so-called *Narcissus* (no. 21), close to completion. That Epstein could have considered such a figure at the same time as he was working on Asheham House figures clearly indicates the pressure he felt to conform with Ross's expectations when producing a public memorial.

However, towards the end of 1910, he abandoned it abruptly and started again. In January 1911, Gill wrote to Rothenstein, who was in India, that Epstein was staying at Ditchling carving a large figure in stone, 'getting into the way of stone carving' because he 'has decided to do the Wilde monument in stone and to carve it himself too...'[13]

The figure Epstein now conceived was not an idealized youth but a flying 'demon angel', carved on three sides of a massive rectangular block, and mounted on a plinth to which it was connected only through the ground of the figure so that it appeared to be suspended in flight (plate 4). It was clearly inspired by the huge man-headed bulls which flanked the gate of the Palace of Sargon (721–705 BC) at Khorsabad (fig. 9) which, alone among the British Museum's array of Assyrian monumental sculpture, incorporates an abrupt transition between the vertical and horizontal flow of the wing feathers.[14]

Assyrian sculpture is characterized by its fusion of large masses with areas of refined surface detail. Employed in slow, curving rhythms, such pattern serves to enhance the sculptural mass while simultaneously emphasizing the hardness of the material surface. Epstein achieves an analogous tension between surface and mass through the play of the shallow, linear relief of the wings against the mass of the block. The wing feathers—apparently conceived as stylized phallic forms—take on an abstract dynamism which repetition and variation serves only to reinforce;

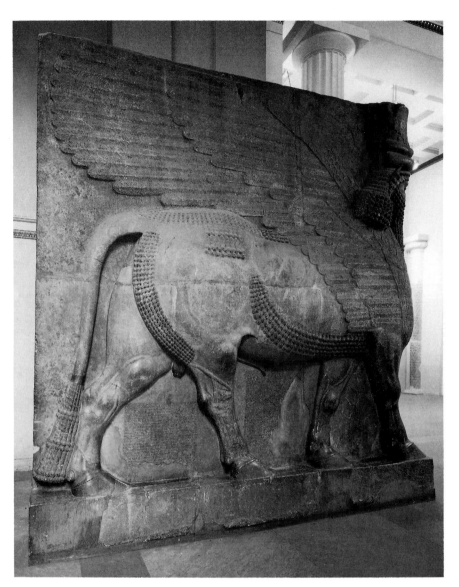

9 *Man-headed Bull, from the Palace of Sargon, Khorsabad (British Museum)*

the two wing-tips, projecting beyond the edge of the block, echo each other and are echoed by the angel's toes. The contrast between the unitary mass of the figure and its apparent weightlessness above the deeply recessed plinth strikes at the very basis of sculptural language.

For the symbolic figures of Intellectual Pride and Luxury on the headdress Epstein employed, for the first time, those titanic, square-shouldered, brawny-armed figures which he was later to use for *Night* and *Day* (no. 189) and *Primeval Gods* (no. 218). They owe their origin not only to Egyptian sculpture but to the tautly posed figures in Assyrian reliefs. The central winged motif of the headdress, within which the trumpet-blowing Fame is placed, is taken from the winged disc representing the god, Ashur, in *Winged Men and*

[13] Shewring, pp. 36–7. Rothenstein later asserted that 'it was Gill who turned Epstein's attention to stone carving, as is shown by Epstein's Memorial to Oscar Wilde'; Rothenstein, p. 195.

[14] Buckle, p. 63; Wilson 1975, p. 726; Wilkinson, p. 170, fig. 54, wrongly illustrates one of the bulls of Ashurnasirpal, also in the British Museum.

[15] *Evening Standard,* 3.6.1912, reprinted in Epstein 1940, pp. 276–7; *Observer,* 6.6.1912, p. 7.

[16] Gaudier-Brzeska to Dr Uhlemayr, 18.6.1912, reproduced and quoted in Cole, pp. 21–2.

[17] Reid, p. 130.

[18] Reid, p. 203.

[19] Gertler, p. 43.

[20] Holroyd, pp. 508–9; Cork 1976, p. 82.

[21] Epstein 1940, p. 61; one head, now in the Barnes Collection, Merion, Pennsylvania appears to retain traces of wax!

[22] Epstein 1940, p. 61.

Kings making Offerings by Sacred Tree (*c.*880 BC) also in the British Museum (124531).

Gill's role was apparently not confined to designing the inscription. Though he makes no reference in his diary, at least one visitor to the studio saw him at work carving the wings (see no. 40). Epstein also borrowed an important motif, the angle of the angel's leg, from *Ecstasy* (fig. 7) upon which Gill had been working during the latter part of 1910.

The completed work was exhibited in Epstein's studio in June 1912, where it was greeted with enthusiasm, even his former enemies on the *Evening Standard* praising 'Mr Epstein's regard for his material and purpose' in this 'dignified sculpture', and noting 'there is nothing to destroy the effect of a rectangular block of stone that has felt itself into expression'. The reviewer here shows a surprising understanding of the truthful handling of material and direct, non-descriptive language which Epstein was seeking and for which early and non-European art provided a wealth of sources. Looking at the work more negatively, P. G. Konody in the *Observer,* found it excessively archaistic, and thought that public taste had reached a point where disillusion with academic idealism or realism resulted in acclaim for anything archaic and non-naturalistic.[15]

A more enthusiastic visitor was the young French sculptor, Henri Gaudier-Brzeska, who was meeting Epstein for the first time. A few days later he wrote:

> A Russian sculptor Jacob Epstein also works here—he has just finished a tomb (sarcophagus) for Oscar Wilde in Paris...I saw it in the studio last Sunday—Oscar Wilde is flying slowly into space, his eyes shut. The whole work is treated—strongly, filled with insuperable movement and delicate feeling, in the expression and the medium—a piece of sculpture which will live for ever, only the total effect seems to be too small.[16]

After the BMA débâcle Epstein had high hopes of the Oscar Wilde memorial; in March 1912, he had written optimistically to the American collector, John Quinn, 'I don't want to rest with the Oscar Wilde but go on and do new things; no work no matter what the scale would appal me, the larger the better; I want to carve mountains.'[17] Later that year Quinn sent £50 to help him stay in Paris to fight the censorship of the tomb by the cemetery authorities, but the sorry upshot of the whole affair (see no. 40) left the sculptor dispirited; late in 1915 he wrote to Quinn: 'I dream of great commissions, works of heroic di-

mensions, but after the Oscar Wilde monument I don't think I will get anything of that sort to occupy me.'[18]

Epstein's interest in Egyptian and Assyrian work was at its height in 1912; Egyptian motifs, such as 'the heads of hawks, cats and camels' adorned his caryatid pillars for the Cave of the Golden Calf (no. 39) in May–June 1912. In the following month the young Jewish artist, Mark Gertler, wrote excitedly to Carrington: 'Epstein took me to the British Museum and there revealed to me such wonders in works of art that my inspiration knew no bounds and I came to the conclusion that Egyptian art is *by far, by far, by far* the greatest of *all* art.'[19] Though the focus of Epstein's interest was to change dramatically over the following year as he became interested in African and Oceanic art, his fascination with Egyptian and Assyrian sculpture was continued in his famous collection of 'primitive' and early sculpture (see endpapers), and a small Egyptian piece is said to have been buried with him.

'Primitivism' and the Avant-Garde

In spite of the frustrations attendant on the installation of the Oscar Wilde tomb, Epstein made the most of his time in Paris during the latter part of 1912, and spent more time there in 1913, when his presence is documented in January, June and August.[20] Though he met many leading members of the avant-garde, including Picasso, he became most friendly with Brancusi and Modigliani. For Modigliani, a fellow Jewish sculptor who had left family and home and adopted a Bohemian life-style, Epstein felt a deep sympathy and, when in Paris, saw him daily. Years later he could still vividly recall his 'miserable hole' of a studio: 'It was then filled with nine or ten of those long heads which were suggested by African masks, and one figure. They were carved in stone; at night he would place candles on top of each one and the effect was that of a primitive temple.'[21] Modigliani showed seven of these heads grouped together as 'Heads, a decorative collection' in the Salon d'Automne of 1912. The idea of creating a sculptural ensemble akin to an ancient temple is a recurrent theme in Epstein's early work. Irresistibly reminded not only of his own student efforts (nos. 1, 2), but also of the abortive Asheham House project, Epstein entertained hopes of starting another communal project with Modigliani: 'we thought of finding a shed on the Butte de Montmartre where we would work together in the open air, and spent a day hunting round for vacant grass plots for huts, but without result.'[22]

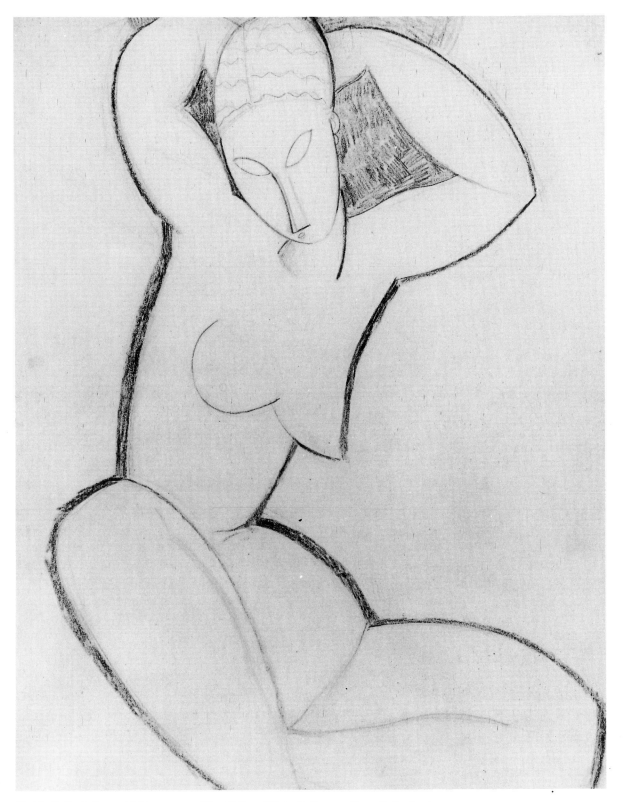

10 *Modigliani,* Caryatid, *blue crayon, 55 × 41.5cm. (Walsall, Garman-Ryan Collection)*

Modigliani's figures, like Epstein's, were architectonic, but more radically conceived than anything he had yet attempted. The directness and integrity of Modigliani's handling of the stone—the head flowing upward from the squared block from which it is carved—has much in common with *Rom* (no. 25) and the *Crouching Sun Goddess* (no. 28). He acquired from Modigliani a superb *Caryatid* drawing (fig. 10) which remained one of his most prized possessions; its absolute lucidity of form anticipates the direction of his own sculpture and Modigliani's distinctive draughtsmanship was, with Wyndham Lewis's, the main influence upon the transformation of Epstein's drawing style between 1913 and 1915. The graininess of texture and direct, unfinished quality of Modigliani's carving appealed to him; but *Sunflower* (no. 42, plate 7) is almost the only one of Epstein's sculptures to reflect his influence.

The more extreme reduction and perfect finish of Brancusi's work exercised a stronger influence in the short term. Brancusi had been carving

[23] Epstein 1940, pp. 63–4.

[24] Geist, 1978. The Arensburg *Kiss* (Philadelphia Museum of Art) was exhibited at the Salon des Indépendants in March–May 1912, no. 496, and was not sold to John Quinn until 1916. There is no early documentary evidence to date the Cracow version.

[25] Holmes to Ross, 19.2.1912, in Ross, p. 224.

[26] For another version than that reproduced see Beckett, p. 58.

[27] S. Sitwell, 'Epstein on himself', *Listener*, 19.12.1940, p. 873.

direct since late 1907 and his early experiments, such as *La Sagesse* (1908), are analogous to those of Epstein and Gill, although there is no evidence that the British sculptors were aware of his work before 1912. At Brancusi's austere studio, with its rows of milk bottles 'maturing' in the passage outside, he could see two of Brancusi's marble birds—*Three Penguins* (Philadelphia Museum of Art) and the *Maiastra* (New York, Museum of Modern Art)—and the recumbent marble head, *Prometheus*.[23] None of these works affected him so profoundly as *The Kiss* (fig. 11). He certainly knew the version of about 1909, installed since December 1910 in Montparnasse Cemetery on the grave of Tania Rachevskaia, and may well have seen the Cracow (1908?) and Arensburg (1912) versions as well.[24] The Montparnasse carving treated the theme of physical love far more overtly than Epstein had so far dared, yet with a witty economy of gesture and a discretion which camouflaged the subject to such an extent that it had caused very little outcry at its unveiling, unlike the *Oscar Wilde Tomb*.

Though there is no evidence that Brancusi was interested in African art at this stage in his career,

11 *Brancusi,* The Kiss, *stone (Philadelphia Museum of Art, Arensburg Collection)*

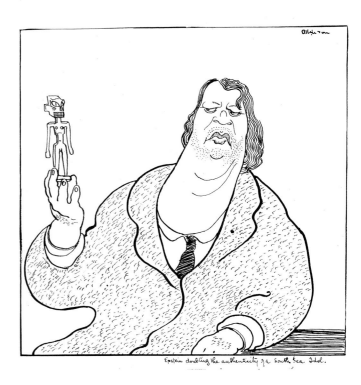

12 *Adrian Allinson (1890–1959), 'Epstein doubting the authenticity of a South Sea Idol', pen and ink, 20 × 20 cm.; a variant on the cartoon published in* Colour, *November 1914, p. 142*

Modigliani and other avant-garde artists, notably Derain, Picasso and Vlaminck, were picking up a variety of primitive artefacts. Irrespective of the variable calibre of the pieces acquired, they suggested new formal and expressive possibilities at a time when the younger artists were working against the grain of the western classical tradition. Even before his temporary immersion in the ferment of Parisian artistic life at this period, Epstein was already looking at 'primitive' cultures outside Europe and the Near East for his inspiration. As early as January 1912, C. J. Holmes, then Director of the National Portrait Gallery, wrote to Robert Ross: 'I was going to write to you to say how relieved I was that Epstein had actually done the greater part of the monument, and that before his Neo-Papuan enthusiasm had been born. I think it is not unworthy.'[25]

Almost certainly Epstein began collecting seriously in 1912. His interest and claims to expertise were sufficiently well known in 1914 for Adrian Allinson to lampoon him in the magazine, *Colour* (fig. 12).[26] Sachaverell Sitwell who met Epstein during this period, probably at Harold Munro's Poetry Bookshop, recalled the sculptor carrying round 'little ivory masks of African workmanship' in his pockets.[27] Apart from these cryptic allusions, there is no hard evidence about when Epstein acquired specific pieces until the

1920s. The first piece he owned, according to Lady Epstein, was a half-length Gabon (Fang) sculpture cut off at the waist, but any suppositions about the influence of such sculpture on his work from 1913 to 1915 must depend upon what was visible at the Trocadéro, the British Museum, artists' studios and at the new dealer-collectors, such as Joseph Brummer and Paul Guillaume, from both of whom Epstein subsequently purchased important Fang pieces. It was in 1913 that Epstein first saw the famous Brummer Fang head which he purchased in 1935.[28] It is possible that Epstein also saw in Derain's studio the Fang reliquary figure which he subsequently bought in about 1933. However, the impression made upon him by African and Oceanic sculpture and by the work of Modigliani and Brancusi only began to show in his work after his return to England. Although he took a studio in Paris and tried to start some work there, he seems to have found it just as difficult to concentrate as he had in 1904–5 and returned to England, in search of 'some solitary place to work' away from 'rows and continual interruptions'.[29]

The Pett Level Years 1913–1916

'Mad about sex' (Eric Gill)

On his return from Paris at the end of 1912, Epstein and Peggy settled, not in London, but in a small cottage, Bay Point, in the secluded village of Pett Level on the Sussex coast, a place dominated by the sea and enclosed by the steep hill which rises behind the village. Epstein worked in a shed in the back garden and wished he could have stayed there forever: 'I could look out to sea and carve away to my heart's content without troubling a soul.'[1]

The fourteen or so carvings and the *Rock Drill* (no. 53) which he produced during the next three years were some of the most original of his career. A profusion of influences, both from African sculpture and from Modigliani and Brancusi, were rapidly absorbed into a personal vocabulary already adumbrated in his earlier work. He continued to prefer the unitary approach to the block —with dominant views from the front, back and sides—typical of Egyptian and Assyrian sculpture. But the African and Oceanic sculpture which was now preoccupying him combined a comparably reductive, conceptual approach to form with a simple acceptance of human sexuality. At the same time Brancusi's rigorous formal method prompted him to examine the relation of masses in his carving far more subtly and analytically. In

Paris he had seen how Modigliani and Brancusi worked repeatedly on a single theme in order to refine their sculptural language, something he himself had only attempted as a technical experiment with *Romilly John* (nos. 8, 20, 25) and *Mrs McEvoy* (nos. 18, 19). Now he too began to work in series, producing two *Figures in Flenite* (nos. 45, 46), several works on birth themes (nos. 43, 44, 51), two *Venuses* (nos. 49, 56) and three groups of *Doves* coupling (nos. 48, 50, 55). There is no established chronology for the works produced during this immensely fertile period, but the drawings indicate that several pieces were being worked on simultaneously. One sheet (fig. 13) contains studies related to the Hirshhorn *Doves* (no. 48), *Sunflower* (no. 42) and the *Rock Drill* (no. 53), all of which were finished or near completion by the end of 1913.

Though spending much of his time at Pett Level Epstein was far from leading a hermit-like existence. For visits to London, he rented a tiny attic room above Harold Munro's Poetry Bookshop in Devonshire Street, and used a nearby garage as a studio.[2] The successful showing of the *Tomb of Oscar Wilde* in his studio and his work on the Cave of the Golden Calf (no. 39), during summer 1912, had brought him into contact with younger artists, notably Henri Gaudier-Brzeska and Wyndham Lewis. Now, fresh from Paris, he was able to pass on news of Modigliani, Brancusi,

[28] Wilkinson, p. 432, also refers to J. Donne's verbal communication that Epstein purchased his first African piece from Guillaume in 1912; Epstein 1940, pp. 60, 215–16, ill; there is an early drawing after the Brummer head (London, Private Collection).

[29] Epstein 1940, p. 64.

[1] Epstein 1940, p. 64. In June 1913, Quinn declined to lend him £200 to buy the place and instead asked Epstein to buy African sculpture for him in Paris; Reid, p. 160.

[2] Epstein to Munro, 21.6.1914, asks if he and Peggy can stay for three or four days during the Allied Artists' exhibition (HRC); Epstein 1940, pp. 64, 136; Grant, 1967, p. 67, suggests he stayed there for months.

13 *Study for* Rock Drill, Venus *and* Doves, *c.1913, pencil and crayon, 45.5 × 58.5 cm. (Anthony d'Offay)*

[3] Pound to J. Quinn, 10.3.1916, in Pound 1951, p. 122.

[4] Cork 1976, pp. 37–42; Farrington, nos. 4A, B.

[5] E. Pound, 'Affirmations III', *The New Age*, 21.1.1915.

[6] Draft review of the Twenty-One Gallery show (Tate Archive, 8135, 35), parts of which were incorporated into Hulme's 'Mr Epstein and the Critics', *The New Age*, 25.12.1913, reprinted in Epstein 1940, pp. 78–84.

[7] Gaudier-Brzeska to Sophie Brzeska, 8.10.1913, in Ede, pp. 246–8.

Picasso and others. Not only did this enable him to act as a catalyst to the headlong development of Gaudier-Brzeska's sculpture from 1912 to 1914, but it also brought him, for the only time in his career, into close association with an avant-garde group.

By the end of 1913, Epstein was closely associated with the painter and, later, writer, Wyndham Lewis, the philosopher, T. E. Hulme, the American poet-entrepreneur, Ezra Pound, and those artists more interested in Cubism and Futurism than in the aspects of post-Impressionism fostered by Sickert and the the Camden Town Group, or by Roger Fry and the Omega Workshops. Hulme rapidly became Epstein's closest friend and confidant, but the example of Wyndham Lewis's draughtmanship was probably as important as Hulme's ideas in helping to shape the new direction of his work.

Epstein and Lewis had probably met in 1912 while they were both working on Madame Strindberg's Cave of the Golden Calf. Two such temperamental characters could not be expected to agree for long, but they respected one another's work. It was Epstein, in about 1912, who made Ezra Pound look at Lewis's work afresh by pointing out that 'his drawing has the quality of sculpture.'[3] Both men were represented by substantial works at the Allied Artists' show in July that year, Epstein by *Maternity* (no. 23) and Lewis by a nine-foot square canvas showing three frenzied dancers, *Kermesse*, whose angular, primitivistic style seems to have anticipated *Rock Drill* (no. 53).[4] Lewis's example, subsequently reinforced by Modigliani's, led to a rapid evolution in Epstein's drawing style during the following year. The naturalism of the BMA studies gave way to the rhythmic energy of abstracted forms in which straight lines and uninflected curves predominate. Figures are surrounded by Vorticist lines of force or mysteriously receding orifices (figs. 13, 14).

Epstein's innovatory formal approach to sculptural problems also impressed Ezra Pound who recalled, 'so far as I am concerned, Jacob Epstein was the first person who came talking about form, not the *form of anything*'.[5]

However, abstract relationships of volume and mass are always at the service of an aggressive primitivism. Even the choice of dark green serpentine for the three flenite pieces (nos. 44, 45, 46) is revealing in this respect. 'Flenite', Epstein's own amalgam of flint and granite, is redolent of a prehistoric past and of almost impenetrable density. The dark stone absorbs the light, thus apparently increasing its density and emphasizing the sharpness of its contours, while the smooth, polished surface throws off reflections which

14 *Study for* Rock Drill, *c.1913, crayon, 63.5 × 47cm. (Anthony d'Offay)*

simultaneously affirm and deny subtle transitions in its surface. T. E. Hulme, who bought the *Female Figure in Flenite* (no. 45, plate 11), defined this as 'a certain quality of finality, of inevitableness which makes them seem like things discovered rather than things constituted.'[6]

The formal and psychological focus of both the *Figures in Flenite* (nos. 45, 46) is the invisible life which dominates not only the mother's stance but her entire consciousness, as her mature form is subsumed into that of the foetus. Both Gaudier-Brzeska and Hulme associated these carvings with Oceanic art; Gaudier, who saw Epstein working on them when he visited his studio on 7 October 1913, wrote the following day: 'He's doing the most extraordinary statues, absolute copies of Polynesian work with Brancusi-like noses.'[7] Epstein undoubtedly knew the wooden, Polynesian figure in the British Museum (fig. 15) and seems to have taken from it the head with its almost flat nose and sharp jawline. However, the S-curved stance of the *Female Figure in Flenite*

15 *Society Islands Figure, wood, 53 cm high (British Museum)*

(no. 45) is uncannily close to the ductile styliz-ation of pregnancy in some West African (Asante or Senufo) gold weights already known in west-ern Europe at this period.

Flenite Relief (no. 44) is a far more direct, emblematic treatment of birth. One side shows a female torso, the breasts stylized to circles and the arms crossed; on either side, forming the termi-nals on the narrow edges of the relief, are unmis-takably erect phallic forms which the woman includes in her embrace. On the other side, a baby with a spherical head and splayed limbs, appar-ently holding an egg, emerges from between the thighs of its mother. Its symmetry and playfulness are clearly derived from Brancusi's *The Kiss* (fig. 11), but the latter's romantic symbolism is rejec-ted in favour of the physical mystery of procre-ation. The shallow relief carving, inviting tactile exploration, reinforces the sculptor's denial of the taboo surrounding the acts of love and birth.

The emergence of the infant from the womb was the subject of one unfinished work, the stone relief, *Birth* (no. 43), and two lost works, the monumental granite *Mother and Child* (no. 67) and *Cursed be the Day Wherein I was Born* (no. 51), in which the violence and symbolic dynamism of the act of birth are more strongly developed. The sharply angled limbs of the screaming child in the latter, the most unequivocally 'African' figure Epstein ever produced, were almost certainly inspired by the extreme stylization of Kota reli-quary guardian figures from the Gabon.[8] Com-menting on a related drawing, *Birth*, Wyndham Lewis wrote: 'symbolically strident…like a Pathé cock, a new born baby, with a mystic but puissant crow.'[9]

A considerable component in Epstein's pre-occupation with sexual imagery was his deter-mination that it should be possible to sculpt this fundamental aspect of life as unselfconsciously as anything else. Typically he took a traditional symbol of love, such as a pair of birds, or Venus, and entirely reworked it to carry its essential meaning in fresh, unambiguous language. Bran-cusi's *The Kiss* played some part in stimulating the form of Epstein's experiments, but his earlier interpretations of an angel (no. 40), the *Sun God* (no. 26) and the Mother and Child foreshadow this trend in his work long before his visits to Paris in 1912 and 1913. The exquisite *Mother and Child* (no. 52, plate 10) fuses the elegant austerity of Brancusi's carving with the more characterful simplification of natural form Epstein had ob-served in Fang sculpture.

In the mating *Doves* (nos. 48, 50, 55) he devel-oped forms the lucidity of which rivals Brancusi's lovers, while their air of tranquil permanence epitomizes a union which is psychic as much as physical. It has been suggested that a primitive artefact, such as the pair of wooden mating turtles from Yam-Yutu Island in Papua New Guinea (British Museum), was their source, but one need look no further than Brancusi's *The Kiss* and *Three Penguins* (Philadelphia Museum of Art) for their ultimate inspiration.[10] The Jerusalem *Doves* (no. 50, plate 9) are the most successful of the three pairs, observation distilled into a design of subtly refined simplicity which profoundly influenced Gaudier-Brzeska's marble *Dog* and *Bird Swallow-ing a Fish* in 1914.

The final pair of birds made for John Quinn (no. 55) is far less naturalistic and more geometric. The body of the female bird has become a boat, her back a plane on which the curved body of the male may rock. The implied movement is held in stasis, both by the downward thrust of the male's tail feathers and by the upthrust of the vertical,

[8] See Vogel and N'Diaye, no. 63, ill., and Paudrat in Rubin, p. 128.

[9] W. Lewis on an Epstein drawing, possibly that published in *BLAST*, June 1914, exhibited in 'The Cubist Room', *The Egoist*, I, 1.1914, pp. 8–9.

[10] Wilkinson, p. 435.

[11] Geist 1968, p. 149, ill., suggests that Epstein could have shown him photographs of these works.

[12] K. Lechmere interviewed in Cork 1976, p. 125, note 85.

[13] Gill Diaries, 9.12.1913 (Los Angeles, Clark Library).

[14] The New Age, 26.3.1914, p. 65.

phallic heads. The suppression of the beak into the unity of the neck and head is particularly close to Brancusi's *Three Penguins*, but, unlike the Romanian, Epstein's concern for form is balanced by his interest in depicting the moment of physical union with the greatest possible intensity; the male's grip upon the female's back, indicated by carving in low relief in the previous versions, is here reduced to a Vorticist spray of incised lines radiating down from the point of maximum stress. The degree of abstraction may reflect Epstein's response to the increasingly advanced taste of John Quinn, who had begun to buy from Brancusi, but it may also indicate his willingness to explore the geometric rationalization of form advocated by his friend, T. E. Hulme.

Brancusi's work confirmed and stimulated Epstein's development towards a style of carving whose formal economy owed little to the western European tradition, but it would be wrong to see Epstein simply as his follower. Though the carvings of 1913–15 are characterized by a crisp smooth finish inspired by Brancusi's craftsmanship, they also bear the hallmark of Epstein's intuitive, direct style. Nor was the influence a one-way affair; Sidney Geist has suggested that Brancusi may have been influenced by photographs of Epstein's work; there is a remarkable congruity between the plaited back of Epstein's *Maternity* (no. 23, plate 5) and the back of Brancusi's *Caryatid*, 1915, as well as between *Sunflower* (no. 42, plate 7) and Brancusi's *Adam*, 1917.[11]

During the same period, Epstein was revitalizing the archetypal western embodiment of love and beauty, Venus, in two figures (nos. 49, 56), poised on the backs of coupling birds just as Botticelli's Venus is borne on her shell. In material, scale, technique, style and title, *Venus* is a gauntlet cast at the feet of the art establishment, Victorian Pygmalions, who had admired Beauty on a pedestal embellished with classical prototypes. The first *Venus* (no. 49, plate 8) is undeniably an African goddess; her proportions, bent-knee stance and sharply pointed, pendulous breasts can be paralleled in wood carvings from a variety of areas, while her head is Fang in character. Here, as in the *Flenite Figures*, the implied sphere of her fruitful womb forms the sculpture's core. The simplified shapes of the birds' beaks and eyes are echoed by the stylization of her head. Viewed from the front such echoes multiply in a series of descending V-shapes within the parallel lines created by the marble block and the pierced void between the legs—the head, breasts, the deeply incised W of the pudenda, and the paired birds' beaks. From the side a lapping sequence of curves, the contours of head, breast and belly, are countered by the line of back, buttocks and arm before being gently arrested on the static rocking motion of the birds.

The second *Venus* (no. 56), double the size of her sister, can be seen as the summation of Epstein's work since 1910. More slender than her predecessor, she is also less African; her neat hemispherical breasts, her belly, pudenda and thighs are all less emphatically treated. The goddess appears chastely remote, yet the whole tapering column is phallic, the forms of her head and neck made to echo the heads of the birds. Still more suggestively the cock's comb presses between her slightly parted legs.

The insistent sexuality of Epstein's subject matter, as much as his radical change in style, came as a shock to many who admired the conventional bronze portraits and the earlier carvings. The second *Venus* was not exhibited until 1917, but at least two versions of the *Doves*, the flenite pieces and several studies for *Rock Drill* were exhibited at the Post-Impressionist and Futurist Exhibition in October 1913, at Epstein's first one-man show at the Twenty-One Gallery, and at the Brighton exhibition, The Camden Town Group and Others, in December 1913. Not all reactions were as extreme as Lord Drogheda's: when his wife arranged for a small selection of Epstein's work to be shown at their home in Wilton Crescent, in 1914, he declared, 'I won't have those fucking doves in here—I'll throw them out of the window.'[12] After seeing the Twenty-One Gallery show, Eric Gill noted in his diary (with splendid irony in view of his own obsessional interest) that Epstein was 'mad about sex'.[13] Epstein was not the only offender as Sickert's attack on 'the Pornometric gospel' makes clear:

We hear a good deal about non-representational art. But while the faces of the persons suggested are frequently nil, non-representation is forgotten when it comes to the sexual organs. Witness Mr Wyndham Lewis's 'Creation' exhibited at Brighton, Mr Gaudier-Brzeska's drawing in last week's *New Age* and several of Mr Epstein's later drawings.[14]

However, there was a reluctant acceptance of the virile intensity of Epstein's work, even from some of the more conservative critics; following the exhibition of *Group of Birds*, *Carving in Flenite* and *Bird Pluming Itself* at the London Group exhibition in March 1914, Sir Claude Phillips wrote:

Mr Jacob Epstein infuses a certain vital power proper to him even into such a subject as the

marble 'Group of Birds' here displayed. In his weird 'Carving in Flenite' we again feel something of this peculiar power, though the subject is deliberately made indecipherable and the thing as a whole is unworthy of a serious artist.[15]

Like many of his contemporaries from Gill and Sickert themselves to D. H. Lawrence, Epstein was reacting against the prudishness and humbug of Victorian attitudes to sexuality. His personal inclinations, in sex as in music and conversation, were for uninhibited self-expression, but, over and above this, there is implicit in the obsessive frankness of his imagery a preoccupation with the mystery of creation as intense as that of a medieval worshipper meditating on the miracle of the Virgin birth. The art of tribal peoples, of which he remained a passionate and knowledgeable collector all his life, frequently combined acceptance of human sexuality with respect for its rites—birth, coming of age and mating—in connection with which some of their artefacts were made. It was Wyndham Lewis, rather than the more analytically inclined T. E. Hulme, who was more perceptive about this essentially romantic and expressionist aspect of his work; reviewing The Cubist Room at Brighton, he said of the Epstein drawings shown there: 'He finds in the machinery of procreation a dynamo to work the deep atavism of his spirit.'[16]

Epstein, Hulme and Vorticism

Throughout the frenetic and highly politicized artistic activity of these pre-war years, the philosopher, T. E. Hulme, was Epstein's closest confidant and defender, so much so that Wyndham Lewis warned Kate Lechmere that 'Hulme is Epstein and Epstein is Hulme.'[17] Hulme had been deeply influenced by the ideas developed in Germany by Riegl and Worringer (whose Abstraction and Empathy was published in 1908) that geometric, decorative styles in art, long dismissed as inferior to the sensuous, organic art of the Greeks, were the result not of incompetence but of a different intention. Rather, such art answered a different spiritual need, and so deserved to be put on an equal footing with Greek or Renaissance art, instead of being denigrated as the inevitable consequence of primitive artistic ability.

Such an outlook shed an entirely new light on the apparently barbaric preference of so many contemporary artists for the art of the Indians, Byzantines, Egyptians, Africans and other peoples outside the western European tradition. Hulme was one of the first to perceive a connec-

tion between Riegl and Worringer's academic theories, formulated to deal with late Antique and early Christian art, and current trends in Britain and Europe. He had abruptly realized, on seeing the Byzantine mosaics in Ravenna in 1911, 'how essential and necessary a geometrical character is to endeavouring to express a certain intensity.'[18] What he singled out about such art was neither its flatness nor its decorative use of colour, but its angularity: 'curves tend to be hard and geometrical...the human body distorted to fit into stiff lines and cubical shapes of various kinds.'[19] Hulme credited Epstein with having opened his eyes to this trend in contemporary art: 'finally I recognised this geometric character re-emerging in modern art. I am thinking particularly of certain pieces of sculpture I saw some years ago, of Mr Epstein's.'[20] He was probably referring to the Tomb of Oscar Wilde (no. 40, plate 4) and other works of 1910–12, since Epstein later recalled that, on first seeing the tomb, Hulme 'immediately put his own construction upon my work, turned it into some theory of projectiles'.[21]

The archaism of works such as the Tomb of Oscar Wilde represented, for Hulme, a necessary transitional stage in the emergence of 'a new constructive geometric art'. While this new art, with its hard, definite forms, was the antithesis of romantic nostalgia, it still drew strength from the art of the distant past, using it as a foothold in the painstaking climb towards an essentially modern art, embodying intense vitality and abstracted, geometric forms.[22]

Hulme's ideal of 'a new constructive geometric art' vividly evokes Epstein's most radical work, Rock Drill (nos. 53, 54, plate 12), but the extent of their mutual influence is difficult to assess since Hulme was at his best in conversation, and published little. His address on 'Modern Art and Its Philosophy' to the Quest Society in January 1914, in which he outlined his theories, postdates most of Epstein's preparatory drawings and much of the construction of the Rock Drill. If Epstein's work seemed to confirm the direction in which Hulme logically considered modern art should be moving, Epstein was almost certainly influenced by his discussions with Hulme to develop the abstract dynamism of his drawings and to try out a more geometrical approach in his sculptures. Both the third Doves (no. 55) and the second Venus (no. 56) seem to support this suggestion. Technically and aesthetically, Rock Drill, constructed from a ready-made drill and plaster, goes much further towards the creation of an essentially modern art.

The virile intensity and sheer energy of Rock Drill also apparently typifies the aggressive mod-

[15] Daily Telegraph, 10.3.1914. His description of the flenite piece may indicate that the Flenite Relief was exhibited.

[16] Lewis, p. 57.

[17] Jones, p. 123.

[18] Lecture to the Quest Society, 22.1.1914, in Hulme 1924, p. 81.

[19] Ibid.

[20] Ibid.

[21] Epstein, Foreword to Hulme 1924.

[22] 'Modern Art, I: The Grafton Group', The New Age, 15.1.1914, pp. 341–2, reprinted in Hulme 1955.

[23] Epstein might have contributed more to the Brighton show in December had it not coincided with his own first one-man show at the Twenty-One Gallery, from which, surprisingly, everything was sold. (Information courtesy of a letter from Mrs Bernhard Smith, owner of the gallery, to Richard Buckle, c.1961.)

[24] Anonymous review, Nevinson Cuttings, Tate Gallery Archive.

[25] Farr and Bowness.

[26] It was lost with him in France, only a set of photographs surviving in Hull University Library.

[27] Hulme 1924; Haskell, pp. 151–64; Epstein 1940, pp. 78–84.

[28] Many illustrated in Buckle; Cork 1976; London, Anthony d'Offay Gallery, *The Rock Drill Period*, 1973.

ernity and linear dynamism of works created and exhibited under the Vorticist banner. However, Epstein was never, strictly speaking, a Vorticist. He exhibited only a couple of drawings alongside Lewis, Etchells, Nevinson, Hamilton and Wadsworth in The Cubist Room at the Brighton show, The Camden Town Group and Others, in December 1913.[23] *Rock Drill* was well advanced before Ezra Pound had even coined the term, the Vortex, to sum up the frenetic and disparate energies being expressed in poetry and art by new structural languages. When Lewis's Rebel Art Centre was established in March 1914, neither Epstein nor Hulme was present. Unlike Gaudier-Brzeska, Epstein never signed the Vorticist Manifesto, contributed only two drawings to *BLAST*, and did not exhibit in the Vorticist Exhibition in June 1915, having by then had a row with Wyndham Lewis. Indeed, he appears to have been reluctant to exhibit with any doctrinaire group.

In October 1913, Epstein showed the Jerusalem *Doves* (no. 50, plate 9) at the Post-Impressionist and Futurist Exhibition at the Doré Galleries. The latter received mixed reviews, being reproduced alongside Nevinson's *The Departure of the Train de luxe from the Gare St. Lazare* and Delaunay's *Cardiff Football Team* in the *Daily Mirror*, while another report, entitled 'The Confetti School of Painting' and 'Sculpture gone crazy', commented: 'About Mr Jacob Epstein's "Group of Birds" the less said the better. One good thing is that he hasn't messed the marble up much, so that it can come in nicely to make something else.'[24]

In the following month both the Camden Town artists and the Futurist wing of the avant-garde— Wyndham Lewis, David Bomberg, Christopher Nevinson, William Roberts and Edward Wadsworth and Epstein—joined forces to form a new exhibiting group, which Epstein is credited with christening the London Group.[25] Soon it succeeded the Allied Artists' Association as the main forum for the exhibition of advanced work. Though Epstein was on the AAA's management committee in 1914, he exhibited not there but at the first London Group exhibition, which was held in the Goupil Gallery in March 1914, showing his most adventurous work—*Group of Birds, Carving in Flenite* and the lost *Bird Pluming Itself*. The following year he showed the marble *Mother and Child, Rock Drill, Cursed be the Day* and one of the flenite carvings, while in 1916, he showed the truncated *Torso from the Rock Drill*.

Within this always loosely knit and divergent alliance of artists and writers, Epstein's real allegiance was to Hulme, their relationship cemented by their similarly argumentative, ebullient temperaments. When Hulme was killed in France

in September 1917, Epstein lost not only a friend, but a perceptive and passionate defender who was planning a book on his work.[26] At the sculptor's insistence Hulme's article, 'Mr Epstein and the Critics' was reprinted in several books on his work, and he contributed the foreword for the first edition of Hulme's *Speculations*, published in 1924.[27]

Rock Drill

Like Epstein's relationship with Vorticism, *Rock Drill* (no. 53) has been widely misunderstood, partly because the artist's own account was heavily retrospective, but also because the sculpture, created before the First World War, was exhibited only after its mechanized slaughter had dented faith in the machine age.

More than a dozen drawings and photographs of this lost work survive (fig. 14, see no. 53).[28] These indicate the extent to which Epstein drew together the primitive, geometric and dynamic elements from his recent work into a new synthesis, buoyed up by his short-lived ardour, more Futurist than Vorticist, for machinery as such. Although the only naturalistically treated element of the whole design is the foetal shape protected within the vice-like grip of the ribs, the sculpture represents neither abandonment of organic art nor complete emergence from the influence of primitive art; the visored head has been plausibly

16 *Man Woman, c.1913, pencil and wash, 61.6 × 41.3cm. (British Museum)*

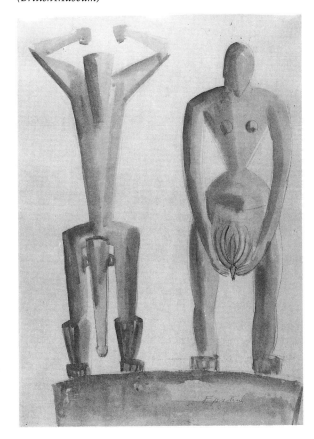

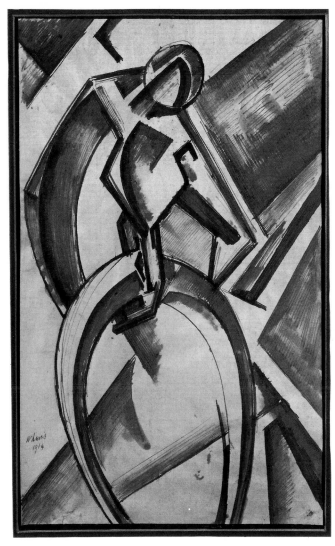

17 *Wyndham Lewis (1882–1957)*, Arghol, *1914, pen, ink and brown wash, 33 × 20.5cm. (Private Collection)*

related to certain Baule and Bambara animal heads.[29]

At least one drawing related to its development reflects the impact of an African sculpture seen in Paris; the broad shoulders, narrow waist and the sexual connotation of the drill-bit have evolved from the stylized masculinity of *Man Woman* (fig. 16).[30] The prominent sex and arrangement of figures on a convex plinth clearly derives from a Malagasy funerary post recently acquired by the Trocadéro. Epstein so much admired these figures that he subsequently acquired for his own collection of primitive art the only other known pair of this type.[31] All the studies for *Rock Drill* incorporate the drill—it was the prime element of the design—but the driller is at first sketchily indicated with a few straight lines and cubic forms, surrounded by Vorticist lines of force (fig. 14). In the more developed studies (see no. 53), new elements are incorporated; the tension of the body is conveyed by a judicious use of semi-organic forms akin to the stripped muscles of an anatomical textbook or armour. The segmentation of the legs and body realize the latent sculptural qualities of Lewis's 1912–13 drawings. Lewis himself seems to have responded to Epstein's

robot figure in his own drawing of 1914, *Arghol*, hero of his play *The Enemy of the Stars* (fig. 17).[32]

Rock Drill was, at the time of its making, a supremely optimistic statement, the translation of Epstein's metaphors of creation into a heroic, modern figure. On one level the driller epitomizes man's command of more than human power, on another it symbolizes his generative power—sexually and materially. If Adam was shaped by God from the earth, man can now shape the earth through his own ingenuity. Thus, the rock driller becomes a metaphor for the carver-sculptor. When it was exhibited at the London Group exhibition in March 1915, Wyndham Lewis put aside his recent differences with Epstein to say it was 'one of the best things he has done. The nerve-like figure perched on the machinery, with its straining to one purpose, is a vivid illustration of the greatest function of life.'[33]

Looking back at the horrors of the First World War from the crisis of the Second, Epstein interpreted his mechanistic totem from a negative and somewhat rhetorical standpoint:

> It was in the experimental pre-war days of 1913 that I was fired to do the rock drill, and my ardour for machinery (short-lived) expended itself upon the purchase of an actual drill, second-hand, and upon this I made and mounted a machine-like robot, visored, menacing, and carrying within itself its progeny, protectively ensconced. Here is the armed, sinister figure of to-day and to-morrow. No humanity, only the terrible Frankenstein's monster we have made ourselves into.[34]

In retrospect it came to be regarded as prophetic of the horrors of mechanized war. In 1915, however, there was general incomprehension; the popular press ridiculed the 'locust' figure—'a futurist abortion of indescribably revolting aspect'.[35] Several critics, including Lewis, were disturbed by the juxtaposition of the black drill and the white robot-man. Konody, who, only the previous year, had written a sympathetic account of Hulme's lecture to the Quest Society, and had praised Eric Gill's recent work, thought *Rock Drill* had 'only the remotest connection with the art of sculpture' and 'the whole effect unutterably loathsome'.[36] The *Manchester Guardian* reviewer was almost alone in admiring the sculptural qualities of the drill:

> the three long, strong legs, the compact assembly of cylinder, screws and valve, with its control handles decoratively at one side, and especially the long, straight cutting drill like a

[29] Wilkinson in Rubin, p. 439.

[30] Possibly a study for a sculpture, *Man Woman*, referred to as a work in progress by Mrs Epstein in a letter to John Quinn, May 1915. Reid, pp. 258–61.

[31] Wilkinson, p. 440, wrongly suggests the later dating of this drawing since he assumes it must depend on the pair in Epstein's own collection; ACGB, *The Epstein Collection of Primitive and Exotic Sculpture*, 1960, no. 45, pl. III.

[32] Christie's 9.3.1984, lot 49, ill.; Farrington, no. 32.

[33] W. Lewis, 'The London Group', *BLAST*, no. 2, July 1915, p. 78.

[34] Epstein 1940, p. 70.

[35] *Evening News*, 13.3.1915.

[36] 'The New Geometric Art', *Observer*, 1.2.1914, p. 7; 'Mr Eric Gill's Stone Carvings', *ibid.* 18.1.1914, p. 7; 'The London Group', *ibid.* 14.3.1915.

[37] *Manchester Guardian*, 15.3.1915, quoted more fully by Cork 1976, pp. 476–7.

[38] Shown at the Whitechapel Art Gallery, Twentieth Century Art, May–June 1914.

[1] He was granted a certificate of naturalization on 22.12.1910, not 1907 as stated by several sources, e.g. Farr, p. 82; Nairne and Serota, p. 251.

[2] Epstein 1940, p. 64.

[3] John to Quinn, 3.4.1915, quoted in Reid, p. 203. See Reid, *passim*, and Zilczer 1978, for Quinn's purchases.

[4] Verbal communication to author from His Grace the Duke of Hamilton. See no. 64.

proboscis—it all seems the naked expression of a definite force…it is a real piece of invention, a synthetic shape which has a swift, significant interest, even beauty, all its own.

However, even he found the synthesis of the two parts hard to take: 'even if this figure is to be cast in iron, the incongruity between an engine with every detail insistent and a synthetic man is too difficult for the mind to grasp.'[37]

Epstein cannot have been entirely unprepared for the savagery of the public and critical response. Technically and formally the work was extremely audacious, more so than any sculpture seen in Britain at that date except perhaps Gaudier-Brzeska's *Hieratic Head of Ezra Pound*.[38] Its use of a real drill and mechanistic forms can be compared with the most advanced work of his European contemporaries—Duchamp's *Bicycle Wheel*, 1913, Duchamp-Villon's *Horse*, 1914, or Boccioni's *Unique Forms of Continuity in Space*, 1913. But, having considered its potential, which included attaching a motor to set the figure in motion, he turned his back on it. Figurative subjects and an essentially humanistic viewpoint were always central to his work. Abstraction as such held no interest.

When he exhibited the work again in 1916, it had been radically transformed; without the drill, the legs and the active arm, the metal *Torso from the Rock Drill* (no. 54, plate 12) is impotent, armoured in futility.

Transfigured by War 1915–1919

'The only sculptor in England' (J. B. Manson, 1917)

The outbreak of war had no immediate impact on Epstein. Until conscription was introduced in 1916, he carried on more or less as usual. But as Augustus John had remarked to David Bomberg, when they heard the news in the Café Royal, 'this news…is going to be bad for art'. Epstein had become a naturalized Briton in 1910 but there is no sign that he felt in the least involved by the conflict or by the wave of patriotism it provoked.[1] However, its effects could not be ignored for long. Epstein was amongst those at Charing Cross to see Henri Gaudier-Brzeska off on his way back to France to enlist. He was killed on 5 June 1915, aged thirty-one.

Though Epstein was later somewhat grudging about the cultish enthusiasm the books by Pound and Ede created for Gaudier's barely fulfilled promise, there can be little doubt that he was shocked and grieved by such a catastrophic waste of talent. His own work was just reaching fruition after years of struggle; he had built up the impetus and sense of direction he had sought ever since his arrival in England, and as call-up came closer he became desperate to avoid the wasteful interruption of his best creative powers that military service would inevitably entail.

He was now in London most of the time, having moved in 1916 to 23 Guildford Street. Life on the coast at Pett Level had become difficult; apart from Zeppelin bombing raids, Epstein's German-sounding name, foreign accent and irregular lifestyle brought him under suspicion of being a spy.[2]

Money was short, despite the dedicated support of the great American collector, John Quinn, most of whose twenty-four Epsteins (including *Venus—second version*, *Doves—third version*, *Mother and Child*) were purchased between 1915 and 1917. He purchased three, and would have taken all four, of the works shown at the London Group in 1915 had not Augustus John put him off *Rock Drill*: 'He's turning the handle for all he's worth and under his ribs is the vague shape of a rudimentary child, or is it something indigestible he's been eating? Altogether the most hideous thing I've seen.'[3]

However, Epstein had also been offered a one-man show at the Leicester Galleries, one of the most active and liberal exhibiting galleries in London. He had met the proprietor, Oliver Brown, in 1913 or 1914 at Dan Rider's Bookshop in St. Martin's Court, and Brown had promptly purchased *Baby Asleep* (no. 3). It was the beginning of a partnership that lasted, with only occasional aggravation, for the rest of Epstein's life. The show took place in February 1917 and comprised twenty-six works, three carvings and twenty-three modelled works, all but one of which were portraits.

He was already acquiring a reputation for portraiture, in spite of the sometimes unflattering acuity of the results. Through Francis Dodd's intervention, he had obtained a commission for a bust of Admiral Lord Fisher (no. 63) for the Duchess of Hamilton. He produced two versions, in one of which the cutting away of the arms leaves the sitter's combative head rising from the arched and bemedalled carapace of his uniform like an old tortoise's head from its shell. As a response to Fisher's uncompromisingly pugnacious character, it was as intense and perceptive as any of his ghetto drawings. Fisher was so impressed that he wrote at once to the Duchess of Hamilton, urging her to employ 'the genius. For God's sake, get him!'[4]

Other portraits were the result of collecting faces which attracted him from the lively Café Royal society he frequented: *Lillian Shelley* (nos. 65, 109), *Billie Gordon* (no. 66) and, above all, the seductively elegant *Meum* (nos. 73, 76, 89–91), of whom he made four portraits in 1916–18. Friends were frequent subjects; Hulme sat early in 1916 while he was stationed at Portsmouth on leave (no. 69). Anonymous soldiers, typical of those who were fighting and dying in such numbers, also attracted him. He persuaded a battle-weary American at the Café Royal to sit for *American Soldier* (no. 84) and depicted a typical Tommy in *The Tin Hat* (no. 71). These two and the study for a war memorial (no. 78), included in the show, may well have been intended for the eyes of those charged with wartime propoganda, since two of Epstein's friends, Muirhead Bone and Francis Dodd, had already received appointments as war artists, and he hoped for a similar job.

The show was a moderate success financially, but a *succès de scandale* on account of the second *Venus*, which appeared on the poster (and was promptly purchased by John Quinn). Oliver Brown recalled: 'We were...immensely impressed, and perhaps surprised, by the great crowds that visited the exhibition and the earnest and serious attention it received from strangers who came in.'[5]

The volume of reviews for what several writers took to be his first one-man show indicates the extent to which Epstein had broken through to wider public recognition. Konody was full of praise for the ruthless candour of the female portraits and suggested that the bronzes, even more than the carvings, drew inspiration from the vigour and formal directness of 'Chaldaic, Egyptian and Assyrian art': 'the sitters, most of whom are are well-known characters in Bohemian London, are cruelly stripped of all superficial prettiness and of all the conscious charms and graces with which they try to hide the real beauty of undisguised character.'[6] However, the carvings remained more or less incomprehensible to public and critics alike. Only Epstein's friend, the composer, Bernard van Dieren, who seems to have stepped into the absent Hulme's shoes, succeeded in grasping Epstein's intentions. He stressed that both the carvings and the bronzes were essentially abstract and imaginative: 'that they also represent existing beings is of secondary importance.' He described *Venus* as:

a beautiful tower of white marble which the sculptor has modelled so that a wonderful rhythm of three conspicuous planes and a base, so arranged as to suggest great light-

ness and elegance of pose, convey a single artistic emotion. He has gone even further, and the rhythm of planes and curves has become suggestive of a human form in which the very arms, hands and breasts are indicated...the soft voluptuousness of the beautifully finished material and form further suggests things lovable and seductive. This and a suggestion of physical virginity and sterility coupled with lasciviousnesss constitutes what in an exalted sense the word Venus means to us.[7]

The next day Epstein wrote:

Many thanks for writing what you did...your article is the first that has put the matter clearly. That you should point out the fact of there being no discrepancy between the portraits and the more sculptural and imaginative conceptions is what was really necessary. Your characterisation of Venus pleases me immensely. Few will see what I've expressed or aimed to express in it; and if they did they would be unholily shocked. What sacrilege to present to public view that work which I for a long summer privately and almost in secrecy worked at for my own pleasure...[8]

Epstein's insistence on the expressive consistency of his portraits and carvings may appear surprising, since subsequent criticism of his work has tended to contrast them. However, even before his espousal of direct carving, Epstein's work had been based on the conviction that sculptural language could be purified without being rendered sterile. In early portraits, such as *Romilly John* and *Lady Gregory*, physical resemblance had been secondary to an empathetic reading of personality or mood. Such an approach was far from the remote stillness of classicism but also went beyond the impressionistic bravura of the transient expression. It was an abstracted naturalism without the life drained out of it. He said as much only a month before to John Quinn, who was now buying avant-garde British and European work from Brancusi and Gaudier-Brzeska to Matisse and Picasso:

I think you are inclined to over rate what you call advanced work; not all advanced work is good, some of it is damn damn bad. I say this because there is a tendency to slight work that has any resemblance to natural objects. My own essays into abstract art have always been natural and not forced. I make no for-

[5] Brown, pp. 52–3.

[6] P. G. Konody, 'Mr Epstein's Sculpture', *Observer*, 18.2.1917, p. 5.

[7] *The New Age*, 7.3.1917, pp. 451–3.

[8] Epstein to van Dieren, 8.3.1917 (HRC).

9 Epstein to Quinn, 11.2.1917?, Reid, p. 299.

10 W. Sauerlander, *Gothic Sculpture in France, 1140–1270*, 1972, pl. 11.

11 Posted to 39th Battalion, 4.4.1918, and to 42nd, 13.4.1918 (information courtesy of the Ministry of Defence).

12 Gray, p. 212, cites a letter from Epstein immediately after he had received his call-up papers.

mula, and only when I see something to be done in abstract form that better conveys my meaning than natural form then I use it. There is a solidity in natural forms though that will always attract a sculptor, and great work can be done on a natural basis.[9]

The letter coincides with a dramatic change of emphasis within his work. He stopped carving for several years and modelling became central to his practice. Just as the frenetic, jingoist fervour of the pre-war years was cooled by war, so the aggressive dynamism of the *Rock Drill* (nos. 53, 54, plate 12) was succeeded by the stillness of the compassionate, Donatellesque *Risen Christ* (no. 97, plate 13), which he had almost completed before his conscription, and which developed from a study of Bernard van Dieren, lying ill in bed.

Yet it would be as misleading to call the *Risen Christ* simply a portrait of van Dieren developed into a figure, as it would be to see in *Rock Drill* merely a mechanized symbol of virility. The head of the Christ is, as a comparison with the *First Portrait of Bernard van Dieren* (no. 74) reveals, less a portrait than a mask of sorrow and compassion. The conception of the standing figure with its columnar stillness, spare gesture and clinging winding sheet reveals his study of Romanesque portal sculpture; there are strong connections with the mid-twelfth-century, Old Testament figures in the west portal at Chartres (fig. 18).[10] In spite of the change of medium, he had not abandoned the primarily planar composition characteristic of his carvings. The static figure retains the hieratic quality of much Egyptian, early Greek and Romanesque sculpture. This is attributable in part to the depth of his rejection of the Hellenistic and post-Michelangelesque tradition of European sculpture, and to his reaction against elements in Rodin's work. But it can also be seen as evidence of the continued formal influence of 'primitive' art on his modelled sculpture.

The completion of the *Risen Christ* was rudely interrupted by his enforced enlistment, on 29 September 1917, as a Private in the Jewish 38th Battalion of the Royal Fusiliers.[11] From mid-1916 Peggy and Epstein himself had conducted a vigorous and increasingly desperate campaign to get delay or exemption from military service. Early in 1917, he received three months' exemption which was extended in June or July, but this was not well received; Lewis, Nevinson, Gill and many others were now serving, whether as soldiers, clerks or orderlies. Epstein was in excellent health and, unlike several of the Bloomsbury artists, was not a conscientious objector. Epstein subsequently

18 *Old Testament figures, left jamb, centre door, West Portal, Chartres Cathedral, 1145–55*

blamed Augustus John (who was employed as a war artist by the Canadians) for the campaign that led to his conscription, though John's friend, Horace de Vere Cole, seems to have done the major damage by approaching in person the military tribunal to which Epstein's plea for exemption had been submitted.[12]

'My decease as an active artist'

The appointment of Robert Ross as Art Advisor to the newly founded Imperial War Museum in December 1917, the establishment of the Ministry of Information under Lord Beaverbrook in February 1918, and the setting up of the British War Memorials Committee with Muirhead Bone, Robert Ross and P. G. Konody among the artistic

advisors, raised Epstein's hopes that his imprisonment in army life would be brief, and that he might be employed as an official war artist. In the meantime he was in barracks at Crownhill, Plymouth, exasperated by the boredom and discipline. A photograph of him being instructed in musketry drill appeared in the *New York Times* on 23 December. About this time he wrote to van Dieren from Musketry Camp at Tregantle, Cornwall, thanking him for his efforts to obtain his release:

I'm in a kind of gin that admits of escape or amelioration only by fixed channels...It is a life of mental rot and for me a peculiar kind of exasperation, knowing as I do the forces that have worked against me and that have been so successful in achieving their object: my decease as an active artist. I'm not sorry for the change to this place [from Crownhill] which is in itself a very fine part of the Cornwall coast, isolated and very beautiful. Life here is also a little easier than in barracks. We live in huts and I prefer them as there isn't a prison-like air about them as barracks have with their gates and sentries. Also we have had wild, stormy weather...no sargent [sic] can bawl the wind into silence or form fours with the rain. So far I've heard nothing from those I've approached: and I feel like leaving them alone altogether. I am told there is a very special opposition to me at the War Office; this is a compliment.[13]

This was a fact. In December 1917, Sir Martin Conway, Director-General of the Imperial War Museum proposed that, following the success of *The Tin Hat*, Epstein should 'make a series of typical heads of private soldiers serving in the various contingents which make up the British Army...Jews, Turks, infidels, heretics and all the rest.'[14] It is interesting that Conway sensed Epstein's potential to explore the ethnic diversity of the army since the sculptor had not, at that date, tackled the range of Indian, Oriental and black sitters for which he was later to become well known. Unfortunately, Conway's suggestion that Epstein should be attached to Major-General Donald's establishment in France, though approved by Haig on 31 December, met with resistance not only from Donald but also from the Inspector of War Trophies, who thought Epstein could just as well carry out such work in Britain. Finally, there was an apparently damning letter from the distinguished sculptor and Royal Academician, Sir George Frampton, which seems to have scotched Epstein's chances of employment.

19 *Sergeant-Major Mitchell, June 1918, pencil, 43 × 30.5cm. (Private Collection)*

The removal of the letter from the files of the Imperial War Museum by the Curator in 1919 indicates the sensitivity of the contents, but they are unknown.[15] In March 1918, Beaverbrook's request for Epstein to be transferred to work for the Ministry of Information was also flatly refused. The scheduled departure of the regiment for the Middle East precipitated a crisis; Epstein, absent without leave on the embarkation date, was found wandering on Dartmoor.[16] Soon afterwards he wrote to van Dieren:

I am at present imprisoned in the detention room. I hope not for long. I have passed through a severe mental crisis as you can imagine and am under observation of the medical officer...How horrible that what amounts to my incarceration for an indefinite future should be looked upon as right, almost a fit punishment for my sins as an artist. I have got into a wretched state of nerves, so much so that I cannot sleep and feel an incessant desire for movement. I walk about almost like a caged animal incapable of sitting down for even a few minutes.'[17]

[13] Epstein to van Dieren, undated (HRC).

[14] Conway to Robertson, 13.12.1917 (London, IWM Archive, 213–16); Harries, p. 127.

[15] Harries, p. 127; their suggestion that Frampton might have written to protest about the *Risen Christ*, then still being worked on, is highly unlikely.

[16] H. D. Myer, *Soldiering of Sorts* (unpublished memoir, Museum of the Royal Fusiliers), p. 98.

[17] Epstein to van Dieren, undated (HRC).

[18] Reid, p. 374.

[19] Letters from Epstein and Margaret Epstein to van Dieren, 9.1919–1.1920 (HRC).

[20] Harries, pp. 94, 127–8.

[21] Epstein to van Dieren, 27.1.1920 (HRC).

[22] Epstein to van Dieren, 11.1.1920 (HRC); *The Sunday Times*, 8.2.1920, p. 6.

[23] Brown, pp. 70–1.

[24] *Observer*, 27.1.1924, p. 8.

[25] M. Gertler to Carrington, 9.4.1920; Gertler, pp. 178–9.

[26] Gray, p. 207. The date and duration of Epstein's visit is unknown. Gray states only 1920–1, Buckle (p. 104) gives 1919. The chronology is complicated by the timing of Epstein's portraits of Peggy Jean.

[27] Vickers, p. 174.

He was transferred to Mount Tovy hospital, Plymouth, in May and remained there until he was invalided out in July. Several portrait drawings of his fellow patients survive from this unhappy period (fig. 19). He had 'a complete breakdown', he confessed to Quinn, 'I haven't been allowed to see letters and my state has been a bad one altogether.'[18]

Freedom

During 1919 Epstein's life began to resume its pre-war routine, though with the vital distinction that he was now entirely adrift from the artistic groupings to which he had been tenuously attached before. Both Hulme and Gaudier-Brzeska were dead and other friendships—with John and Lewis—severed. His work was no longer to be seen regularly in London Group exhibitions, but in one-man shows at the Leicester Galleries. His closest friend was the Dutch composer, Bernard van Dieren, with whom he collaborated closely on the first book about his work (undoubtedly designed to take the place of that lost with Hulme) which was published in 1920.[19]

Some of his first post-war portraits were of his wife (nos. 92, 93, 94) and his new daughter, Peggy Jean (nos. 98, 107, 108), but there were also one or two commissions, such as the portrait of Clare Sheridan (no. 99), and an abortive effort on the part of Muirhead Bone to commission a large bas-relief, similar to those officially commissioned from Charles Sargeant Jagger and Gilbert Ledward for the projected Hall of Remembrance.[20] Bone was quietly trying to make up for the official refusal to employ Epstein as a war artist by purchasing suitable work himself: *Admiral Lord Fisher* (no. 63), *The Tin Hat* (no. 71) and *Sergeant D. F. Hunter, VC* (no. 100) were all presented by Bone to the Imperial War Museum. A bas-relief, about two metres high, was to show the Moeuvres incident at which Sergeant Hunter had won his VC, but a misleading report in the *Dundee Advertiser*, suggesting that the work had been commissioned by the Imperial War Museum, led to a hasty denial and the project was abandoned.

Shortly before the publication of van Dieren's book, Epstein's one-man show at the Leicester Galleries, in February 1920, caused as much controversy as the Strand sculptures had done thirteen years before, and brought him back into the limelight. He feared sensational treatment; writing to van Dieren the week before the show's opening, he told him the press were already anticipating 'some astounding eccentricity', though he himself was anxious that the show

should be a success financially: 'I earnestly hope that I will sell things as I've had no commissions of any sort for months and I've had advances made to me by the Leicester Galleries on future sales.'[21]

The portraits were greeted by a chorus of praise. Frank Rutter, the art critic of *The Sunday Times*, whom Epstein had castigated as 'backboneless' in a letter to van Dieren a month before, announced: 'After long years of neglect, of unintelligent and abusive depreciation, of misdirection and misunderstanding, Jacob Epstein has become recognised and respected.'[22]

The *Risen Christ* (no. 97, plate 13) was another matter altogether. To those accustomed to the gentle Jesus meek and mild portrayed by Victorian artists, Epstein's figure was extraordinarily shocking. Not only conservative clerics and journalists in pursuit of good copy, but also professional art critics, such as Rutter, Clutton-Brock of *The Times* and Konody of the *Observer*, found it difficult to disentangle their conditioned emotional and literary response to this hallowed subject from their appreciation of its formal qualities. The sensationalism of the press reaction brought large crowds to the show; the Leicester Galleries were unique in having penny turnstiles and Oliver Brown recalled that on many days more than 1,000 people visited the show, the numbers even rising to 1,500 on one or two occasions.[23] Looking back to the exhibition a few years later Konody realized that 'the real sensation was not the untraditional and debatable gaunt figure of Christ in his winding sheet, but the fact that the public had awakened to an appreciation of sculpture.'[24]

Enjoying the temporary affluence the show afforded him, Epstein went abroad; in April he was in Paris, renewing old friendships.[25] Soon afterwards, at his urgent request, a friend, the musician Cecil Gray, accompanied him to Italy. Regrettably Epstein left no account of their visit to Florence and Rome. It is clear from Gray's account that Epstein intended to return to carving, since they visited Carrara where he tried unsuccessfully to find a studio near the quarries.[26] They made their way along the coast, via Livorno, La Spezia and Genoa to Nice where Epstein stayed a week with Gladys Deacon. This American beauty, shortly to become Duchess of Marlborough, had been the subject of a stylized, 'archaic' portrait (no. 86) during the war, when she had been active in trying to prevent his call-up.[27]

The trip encapsulates the direction his work was to take during the twenties. Carving became a rare, perilous challenge, while his brilliance as a portrait modeller brought him deserved celebrity

and became the mainstay of his existence. On the other hand he had renewed his contact with the European sculptural tradition, and especially with Donatello, whose intuitive realism was close to his own, never more so than in the *Visitation* (no. 162) of 1926.

The Great Portraitist

'The greatest modeller since Rodin' (Frank Rutter)

In 1920, Epstein was the leading avant-garde sculptor in Britain. Even though he had turned away from the formalism of the pre-war period, the controversy aroused by his work and the innovatory character of both his portraits and large figure studies, *Risen Christ* (no. 97, plate 13), *Visitation* (no. 162) and *Madonna and Child* (no. 175, plate 16), still placed him in the forefront of contemporary sculpture. He was one of the artists the young Henry Moore and Raymond Coxon hastened to visit during their first term at the Royal College in 1921. Appreciation of his work was spreading; the explorer, Apsley Cherry-Garrard, who already owned Rodin's *Walking Man*, bought *Risen Christ*. Two years later, the Contemporary Art Society purchased *Visitation* for presentation to the Tate Gallery. His portraits were beginning to be acquired by art galleries throughout England and Scotland, while several pieces from John Quinn's collection entered public collections after his death in 1924.

However, Epstein received only two architectural commissions during the twenties—*Rima, Memorial to W. H. Hudson* (no. 147, plate 17), and two carvings on the London Underground headquarters (no. 189, plates 18, 19). He submitted a design to the American architects of Bush House in the Aldwych, London (no. 155), but this was rejected in favour of the American sculptor Malvinia Hoffman's allegorical figures of the Youth of England and America. In 1928, the proposed monument to Thomas Hardy—a statue of Tess with a medallion portrait of the author on the plinth—seemed an obvious commission for Epstein. Approached informally, he offered to make a maquette for the committee, but they, remembering no doubt the hullabaloo over *Rima* (see p. 45), rejected the idea.[1]

Another blow was his rejection as a candidate for the vacant Chair of Sculpture at the Royal College in 1924. His name was urged both by Henry Moore, who had just graduated there, and by the Principal, Epstein's long-standing supporter, Sir William Rothenstein. The row over *Rima* had yet

to occur, but the Permanent Under-Secretary at the Board of Education was sure that so controversial a Bohemian was not the man for the job. 'To appoint Epstein would be a very perilous experiment and might cause us considerable embarrassment. For a Professor we would want not only a genius (as to which I am no authority) but also character; and I am not sure that character in a place of this kind is not of greater importance.'[2] He was never to receive any teaching post.

It became increasingly apparent that, whatever the sculptor's private inclinations, portraiture must supply his bread-and-butter. New commitments involved heavier expenses. At Guildford Street he had Margaret and Peggy Jean, the expenses of a studio and a rapidly expanding collection of primitive sculpture to support. In August 1921, he met Kathleen Garman, an art student sharing a flat in Regent Square with her sister, Mary. It was a momentous encounter. Epstein was to do seven portraits of Kathleen (nos. 123, 130, 213, 222, 262, 316, 399) between then and 1948. Hers was the rapt gaze originally intended for the Cavendish Square *Madonna and Child* (no. 438). Their children, Theo, Kitty and Esther, were the subjects of numerous drawings and sculptures (nos. 355, 356, 387, 398, 407, 508). The maintenance of two homes and two families was not without its tensions and difficulties, but the love and support both women gave him were of considerable significance for his work. Peggy organized his household, found and often housed suitable models, and struggled with his always chaotic finances. Kathleen's distinctive face and presence embodied Epstein's ideal of beauty, so far impressing itself upon his consciousness that her imprint is apparent in portraits of other women.

In 1922 he rented a modest cottage at 49 Baldwyn's Hill, Loughton, then as now, on the edge of Epping Forest. Though not as isolated as Pett Level, the place provided a retreat where he could work in peace; it was too far for casual visitors but still within easy reach of town. *Marble Arms* (no. 136) and *Rima* (no. 147), as well as many drawings and watercolours of the forest, flowers and Old Testament scenes were done there. In 1928 he moved a few doors away to Deerhurst, a larger house, which he only relinquished in the 1940s.

Making a living from sculpted portraiture was by no means an easy matter, especially for an artist who would not flatter. A painted portrait cost less in time and materials, but might easily sell for more than a bronze; G. B. Shaw bought his portrait by Augustus John for £300 in 1915. John Quinn did pay £400 for the second *Venus* (no. 56), which was a whole summer's work, but he pur-

[1] Epstein 1940, pp. 88–9; John, pp. 152–3.

[2] J. Russell, *Henry Moore*, London, 1973, p. 35.

[3] *The Sunday Times*, 8.2.1920, p. 6 and 20.1.1924, p. 7; *Observer*, 8.2.1920, p. 11 and 27.1.1924, p. 8; *The Times*, 7.2.1920, p. 14 and 19.1.1924.

[4] Haskell, pp. 65–6.

[5] Already recognized by Konody, *Observer*, 27.1.1924, p. 8.

[6] See no. 99. Sheridan, p. 124; Epstein 1940, pp. 103–4.

chased five bronzes for £490 in April 1917, and that only after an argument about the number of casts which Epstein might make. The multiplication of casts could greatly increase the sculptor's income, but even if the sitter was famous or beautiful, the demand was unpredictable. Epstein was extremely fortunate, in the face of the closure or collapse of many galleries in the postwar years, that he had established a good relationship with the Leicester Galleries. His one-man shows in 1920, 1924 and 1926, consisting mainly of portraits, consolidated his reputation as an outstanding portrait sculptor, often called the most brilliant modeller since Rodin. Paeans of praise greeted most of his portraits during the 1920s; Konody, Rutter and Clutton-Brock had been praising the strength, delicacy, versatility and honesty of the portrait sculpture since 1917 and continued to do so in enthusiastic terms.[3]

As his reputation grew, the pattern of his production gradually changed. During the decade 1911–20 he produced about sixty portraits, many of people who sat at his request; during 1921–30, he carried out seventy-five portraits, of which one third were commissioned. During the 1930s and 1940s the percentage of commissioned portraits rose from 50 to 66 per cent of the ninety to one hundred portraits he produced in each decade. Even during the last eight years of his life, when he was working on numerous large-scale public commissions, he still made over sixty portraits, nearly all of which were commissioned.

This represents an astonishing level of output, since a portrait usually took between ten and fifteen morning sittings. As one might expect, there are failures, but the sustained quality is far more remarkable than its variability, especially when it is compared with the output of other artists, like Orpen and John, whose livelihood depended on portraiture. Epstein's total professionalism and his continuing fascination with the technical aspects of his art go some way to explain this consistency. As he told Arnold Haskell:

I have never found commissioned work uninteresting. Often when I have seen the sitter for the first time I start the work without any real urge or enthusiasm, but finally I always find myself interested in the various problems involved, the modelling of the face, the shape of the skull. The only impossible sitters are those who pretend to be something different from what they are. [4]

However, during the twenties and early thirties, it was the success of his uncommissioned portraits that enabled him to make a living while choosing subjects who attracted him. His ability to create superb portraits of more or less unknown people and compel wide public interest in them as sculpture constitutes one of his most distinctive achievements.[5] During the 1920s, Epstein frequently used portraiture as a vehicle for studies of feeling and experience which transcend individual identity. That he should perceive the suffering Christ when visiting van Dieren's bedside, and transform his statuesque Kashmiri model, Sunita, into both the *Madonna* (no. 175, plate 16) and *Lucifer* (no. 362, plate 32) reveals a visionary strain, reminiscent of Mark Chagall and Stanley Spencer rather than the superficial flamboyance of Augustus John. *Old Pinager* (no. 138), *Old Smith* (no. 129) and the *demi-mondaines* of the Café Royal are the descendants of the rabbis, mystics and garment workers Epstein had drawn in New York. *Old Pinager*, uniquely recognizable as he is, conveys a universal sense of patient resignation in the face of age and hardship. Especially when working with models he himself chose, paying more heed to diversity of race, mood and age than to social status, Epstein could distil personality and underlying spirit through penetrating observation and empathy, backed by superlative modelling technique.

The physicality and concentration of Epstein at work is vividly recalled by many who sat to him. Clare Sheridan who, as an aspiring portrait sculptor trained by Bayes and Lantéri, was an ardent admirer of Epstein (a sentiment which he did not reciprocate) remembered sitting in 1918 (no. 99):

Epstein at work was a being transformed... the man himself, his movement, his stooping and bending, his leaping back, poised, then rushing forward, his trick of passing clay from one hand to the other over the top of his head while he scrutinised his work from all angles, was the equivalent of a dance.

He wore a butcher-blue tunic and his black curly hair stood on end; he was beautiful when he worked...He did not model with his fingers, but built up his planes slowly by means of small pieces of clay applied with a flat, pliant wooden tool.[6]

The most perceptive account of Epstein's surgical objectivity and of his instantaneous transformation from diffident host into dexterous creator was given by the actor and playwright, Sir Emlyn Williams, who sat to him in 1934 (no. 231):

He took up a palette filthy with the stains of old clay and slapped fresh stuff on to it which he rolled briskly into more snails and slapped

on to the mess on the stand...After studying my face with the cold, absent stare of an adversary, he set to work with lightning dexterity: no sound but a rapid breathing which I was to hear for nine more mornings, alternating with the sharp unconscious grunts of creation...As the end approached, the hammer-gossamer hands took to hovering stealthily above the work as if about to pounce and destroy it, while the eyes bored into my face and then into the clay, darting with increasing speed from one to the other.[7]

Other sitters recall his stimulating and often provocative conversation which often had the ulterior motive of making the sitter's face responsive and unselfconscious.

Since 1915 or so, his modelling technique had undergone a gradual transformation; the smooth, unitary mass of his early portraits gave way to a more broken surface which fragments reflections, enhancing the animation of the head and suggesting the endless subtle modulation of forms.

> It is the rough surface which gives both character and likeness to the face, not just the rough surface as such, but the particular individual treatment. No face is entirely round and smooth. The face is made up of numberless small planes and it is a study of where those planes begin and end, their direction, that makes the individual head...The texture is a definite and inseparable part of the whole; it comes from inside so to speak; it grows with the work.[8]

It may well have been the war which first stimulated Epstein to abandon his earlier comparatively smooth finish in favour of a far more spontaneous, impressionistic technique. On one level this was a logical progression from his desire to convey the character of the clay and the cumulative, direct relationship between artist, sitter and material. On the other hand, when Lord Fisher was telling him, 'war is terrible and should be terrible', he may have felt that the finish appropriate to the portrait of a society lady or of his philosopher friend, Hulme, was entirely wrong when portraying men whose faces still betrayed the stress of action. Both *The Tin Hat* (no. 71) and *American Soldier* (no. 84) have a loosely modelled surface but roughest of all is his portrait of the Scottish VC, *Hunter* (no. 100), who looks as if he has barely emerged from battle.

Informal naturalism, long apparent in painted portraiture, soon became a dominant trait in some of his female studies, such as *Hélène* (no. 103),

Miriam Plichte (nos. 120, 121), and *Visitation* (no. 162). None of these models have the upright carriage or self-conscious pride usually found in portrait sculpture. They appear to have been caught unawares and their posture is harnessed to the mood of the head or figure, making the whole body speak.

Since his first Renaissance-inspired heads and busts, he had acquired confidence and fluency. Eyes, downcast in his earlier portraits, were now treated freely—left blank in his impersonal *Self-Portrait in a Cap* (no. 88), given an incised iris and pierced pupil in *Sibyl Thorndyke* (no. 161), or, like his portrait of *Enver* (no. 157), endowed with a wide-eyed innocence by deeply recessing the iris. The modelling of hair now followed the 'flow and rhythm of life'. He told Arnold Haskell as they looked at his portrait of Peggy Jean, *The Sick Child* (no. 186): 'Twenty years ago I would have simplified the hair of the child into what critics call "true sculptural form" while to-day I find a rhythm in the hair of each individual head that I must capture.'[9] The arms and hands also became integral to his expressive purpose. In *The Sick Child* the arms, resting idly, locate the figure while balancing the drooping head. In more dramatically conceived studies, such as the *Fifth Portrait of Kathleen* (no. 262), gesture and facial expression evoke the graceful spontaneity of Renaissance half-lengths like Verrocchio's *Bust of a Lady* (Florence, Museo Nazionale).

His revision of Renaissance prototypes is equally apparent in the many male portrait busts cut off in a straight line across the chest and characteristically fully clothed. Epstein, though notoriously casual about dress himself, reveals a tailor's sensitivity to the way in which the banal geometry of a tailored suit (so frequently disparaged as undignified and sculpturally impossible) could enhance presence and personality.

Throughout his fifty-year span as a portrait sculptor Epstein adopted a flexible approach to format and technique, matching his means to the physique and character of his models. His autobiography yields some insights about how this was done; much naturally depended on the mutual sympathy or even guarded respect between artist and sitter. The qualities of character and temperament which Epstein's finest portraits reveal—idiosyncratic intelligence, forthright courage, pride to the point of arrogance, humility, resignation, spontaneity, sensuality, visionary intensity, suffering, duality of intellect and feeling—were all aspects of Epstein's own personality.

Many of these were present when Epstein went to Oswalds, near Canterbury, in March 1924, to

[7] From a wonderful account too long to quote here; E. Williams, *Emlyn, an Early Autobiography, 1927–1935*, 1973, pp. 238–41.

[8] Haskell, pp. 78–9.

[9] Haskell, pp. 61–2.

[10] Epstein 1940, pp. 89–94.

[11] *New Statesman*, 26.1.1924, pp. 450–1. It was twice reprinted within the next two years and was thus widely read by a substantial section of those interested in the arts.

[12] See Fry 1912 and 1913; R. Fry, 'Mr Dobson's Sculpture', *Burlington Magazine*, 41, 1925, pp. 171–7.

sculpt the Polish-born writer, *Joseph Conrad* (no. 148, plate 15), whose writings he had long admired and whose head, 'massive and fine', attracted him. Fifteen years later, Epstein recalled these sittings more vividly than any other. Though the atmosphere of the place depressed him and he was slightly in awe of Conrad, who was ill and cantankerous, he soon became completely absorbed by his subject and was greatly encouraged by the sympathy and respect Conrad showed for his work:

> I already had a fairly clear notion as to how I should treat the bust. A sculptor had previously...represented him as an open-necked, romantic, out-of-door type of person. In appearance Conrad was the very opposite. His clothes were immaculately conventional, and his collar enclosed his neck like an Iron Maiden's vice or garotter's grip. He was worried if his hair and beard were not neat and trim as became a sea captain. There was nothing shaggy and Bohemian about him... Conrad gave me a feeling of defeat, but defeat met with courage...[he] had a demon expression in the left eye, while his right eye was smothered by a drooping lid, but the eyes glowed with a great intensity of feeling. The drooping, weary lids intensified the impression of brooding thought. The whole head revealed the man who had suffered much. A head set on shoulders hunched about his ears. When he was seated, the shoulders gave the impression of a pedestal for the head.[10]

A comparison between the sculpted head and photographs of Conrad reassures us as to the accuracy of Epstein's portrayal, but its psychological and sculptural quality far transcends mere physical likeness.

He trod a delicate line between his ruthless eye for the character of individual sitters and his instinctive allegiance to those 'primal facts' which are the emotional, essentially humanistic, core of his work. On one side lay caricature, on the other portentous gravity, but they are comparatively rare in his work. There is an underlying melancholy behind many of the portraits—from the flamboyance of *Dolores* (nos. 131, 132, 134, 135) to the stately reserve of the Indian woman, Amina Peerbhoy, known as *Sunita* (nos. 159, 160, 166, 199)—but it is their candour and vitality which places some of them among the finest portraits produced this century.

Much of the pleasure Epstein might have taken in the growing public and critical recognition of his work was dashed by a powerful and influential attack on the very elements of his portraiture that others were praising. The assault took the form of a review of his show at the Leicester Galleries in January 1924, contributed to the *New Statesman* by Roger Fry.[11] The watered down post-Impressionism of Roger Fry and his Omega Workshop friends had been a favourite butt of Hulme and Lewis during the heady Vorticist days of the Rebel Art Centre and *BLAST*. However, Fry was widely respected as the most authoritative writer on modern art; his admiration for the abstract formal qualities of African sculpture and insistence on the aesthetic importance of 'truth to materials' were views Epstein shared, but Fry had never felt any personal sympathy for Epstein's work, even before the war. During the 1920s, he promoted Frank Dobson's carvings, which had first been exhibited at the Leicester Galleries in 1921, as 'true sculpture and pure sculpture'.[12]

Fry's attack was all the more damaging in that it picked up and accepted nearly all the characteristics Rutter and others were applauding, only to deny both their validity as criteria for good sculpture, and the response they evoked from those who saw them as proper aesthetic emotion:

> What miraculous gift was this which could make bronze reveal to us definite, singular, vivid human beings—human beings more definite, more emphatically personal, more incisive in the accent of their individuality, more invasive, at a first glance, of our own consciousness than the individuals of actual life?...when we realise the astonishing assurance, the indisputable completeness and efficacy of these works, the brilliant resourcefulness and certainty of technique, we must call Epstein a master.
>
> But a master of what?...Of the craft of sculpture undoubtedly...but even so, one can imagine a finer, more penetrating, less clamant kind of interpretation of character. One might tire perhaps of the element not only of caricature...but of its direction...If I examine my own sensations and emotions, I am bound to confess they seem to be of quite a different nature when I look at good sculpture from what I feel in front of Mr Epstein's bronzes...They come from the recognition of inevitable harmonic sequences of planes, of a complete equilibrium established through the interplay of diverse movements, and a perfect subordination of surface and handling to the full apprehension of these and similar qualities.

Though Fry admitted that the weight he gave to purely formal characteristics as the criterion of quality in sculpture was a minority view, and that Epstein's portraits did give the majority 'genuine pleasure', his views carried weight. They may not have reached a wide public, but they did influence other critics and commentators who themselves were read by the art-consuming public. Casson substantially follows Fry's line, suggesting that Epstein was first too eclectic, and then too personal in his sculpture, substituting 'mud-pie finish' and overwrought emotion for a sense of mass and line.[13]

It has since become a critical commonplace that Epstein, after a brief flirtation with a formalist approach during the pre-war period, simply reverted to his natural taste for heroic Romanticism and Expressionism in portraiture and monumental bronzes. In the broader context of Modernism, with its stress on abstract form and technical innovation, bronze portraits and figurative pieces could be seen as a postscript to nineteenth-century sculptural ideals and practice, but it does not do justice to the sculpture. The pre-war carvings are no more concerned purely with abstract formal relationships than the bronzes are solely with expressionistic realism. An unromantic, even brutal, intensity of expression and a concern for elemental human experience are common to both, however much the means of expression may vary. Epstein was a profoundly instinctive artist in whom feeling worked like intellect; Hulme's intellectual rigour had impressed him because it was combined with robust warmth, whereas Fry explicitly sanctioned only aesthetic and not simple human emotions or associations as proper to art. To Epstein they were inseparable, but Fry was as blind to the value of what else Epstein's portraits might contain as Epstein was to the isolated value of 'pure form'.

The Later Portraits 1930–1959

During the thirties and forties Epstein's output was dominated by portraiture and watercolours. His watercolours of flowers and his Epping Forest landscapes sold, to his sardonic satisfaction, like hot cakes, making more money with less effort than his portraits. He found them an enjoyable and useful source of emergency revenue, particularly when the income tax authorities were pressing, or when an irresistible tribal artefact came up for sale.

During the thirties, many models, apart from his immediate family and friends, were chosen, as they had been in the twenties, for their physiognomic or psychological interest. The arrival of

the Blackbirds revue had introduced a vogue for black performers in night-clubs and revues. Just as one of Epstein's most important models had been the Indian woman, 'Sunita', many of his models at this period were black jazz singers or dancers, such as Lydia (nos. 193, 209, 245), Daisy Dunn (no. 177) and Rose (no. 229), and he also did studies of oriental models, such as Rani Rama (no. 251) and Chia Pi (no. 319). Each had her own distinctive beauty. Epstein's disregard for the cant and hypocrisy surrounding race was as complete as his contempt for sexual humbug. The lessons and beliefs instilled in him during his youth resulted in an uninhibited openness on both counts.

Sexuality is a far more obvious aspect of his female than of his male portraits, and far more female portraits were uncommissioned. With few exceptions, his eminent male sitters were quite old, and few were known primarily for their looks, while female sitters were often celebrated for no other reason. Epstein's susceptibilities are evident, yet his sculptural response is extremely diverse. The self-assertive challenge of the *Second Portrait of Isobel* (no. 232, plate 25) and the more sulkily blatant sexuality of *Louise* (nos. 223, 281) can be contrasted with the elegant poise of the *Third Portrait of Oriel Ross* (no. 210, plate 26) and proud sophistication of *Pola Givenchy* (no. 278). Dealers often begged Epstein to produce small nude studies for which they could guarantee thriving sales, but, apart from the nude studies he undertook between 1939 and 1945 (nos. 341–53), he never responded to this demand. In the portrait busts, however, he could freely explore the feminine mystique without ignoring either the individual personality or the unconventional beauty of his models. On the other hand, some of his finest female portraits are of women in whom the eternal 'it' was either lacking or was subordinated to other qualities; *Professor Lucy Donnelly* (no. 214) is a superbly subtle portrait which conveys intellectual integrity, alertness and authority with just a leavening of dry humour.

The trenchant vitality typical of his portraiture stemmed firstly from a systematic construction of the head which was based on constant, acute observation, and secondly from an ability, akin to that of the cartoonist, to select and emphasize the salient characteristics.

My aim, to start with, is entirely constructive. With scientific precision I make a quite coldly thought out construction of the form, giving the bony formations around the eyes, the ridge of the nose, mouth, and cheek-bones, and defining the relation of the different parts of the skull to each other. As the work

[13] Casson 1928, pp. 111–18.

[14] Epstein 1940, p. 85.

[15] Epstein 1940, pp. 202–5.

proceeds, I note the expression, and the changes of expression, and the character of the model begins to impress itself on me. In the end, by a natural process of observation, the mental and physiological characteristics of the sitter impose themselves upon the clay. The process is natural and not preconceived.[14]

He was perhaps disingenuous in claiming that he did not start a portrait with preconceptions about his sitter's character since, as many anecdotes testify, he was capable of instant likes and dislikes.

Children are the least self-conscious though most demanding of subjects, and Epstein's portraits of children are among his most spontaneously joyful and attractive works. His early portrait of *Romilly John* (no. 8) already indicated his natural sympathy, and he did numerous drawn and sculpted portraits of his children and grandchildren. In 1940 he dreamt of being able to concentrate exclusively on children. He felt that they had been rather neglected by sculptors since Donatello and his contemporaries.[15] The mischievous gaiety of *Jackie* (no. 309) is captured as shrewdly as the wistfulness of *Roland Joffe* (no. 419) and the gentle steadiness of *Isobel Hughes* (no. 432). He could treat babies with equal naturalness, *Victor* (no. 414, plate 35) and *Babe with Arms* (no. 412) being two of the most appealing.

Technically the later portraits show small but significant changes in procedure. As early as 1928, Stanley Casson had criticized his rough 'mud-pie' finish, but the degree of finish or smoothness varied considerably with the physique, character and dress of the sitter. *Einstein* (no. 234) is the roughest and most impressionistic of all his portraits, partly as a result of the speed with which the work had to be done, but also because of a conscious decision to play up the Rembrandtesque humanity of his head. The intense contrasts of dark and light, the deeply broken surface, in which every fragment of clay and each modelling gesture is distinctly visible, results in a sculptural impasto. He never attempted to repeat the extreme roughness of *Einstein* and employed a much less broken finish for many of the male as well as most of the female portraits. During the 1950s, for *Lady Anne Tree* (no. 447) and the *Third Portrait of Esther* (no. 407), he developed a subtle smoothness quite different from his early portraits, which makes the skin appear a fragile shell.

He was not without tricks and mannerisms, as Fry and others were assiduous in remarking. The inclusion of the arms and hands of the sitter were often vital to the suggestion of character; the folded arms in the *Third Portrait of Oriel Ross* (no. 210, plate 26) and *George Black* (no. 323) are integral to their form and expressive vitality. However, in *Jeunesse* (no. 228) they seem a pointless artifice, while the cutting off of half-projecting arms in the *African Mother and Child* (no. 303), so that the inner edge of the cast becomes visible, is superfluous and distracting. The enlargement of the eyes, a slight broadening of the cheek-bones and lips, can detract from, rather than enhance, the vitality of a portrait. There are a number of female portraits, especially during the late 1940s and 1950s, in which these mannerisms become obtrusive.

On the other hand there are also portraits, like those of *Lydia laughing* (no. 245) and of *Ernest Bevin* (no. 363, plate 30), where the sculptor used the same techniques of subtle exaggeration to convey the warmth, humour or strength of faces many called ugly. It is in this least likely area of his work that he seems to have found inspiration not only in the tradition of Donatello and Rodin, but also from the great portrait sculptors of the ancient world; there is a striking analogy between Epstein's head of Bevin and a Sumerian stone head in his own collection.

Towards the end of his career, when almost all his portraits were commissioned, there are signs that he was jaded and overworked, but even then a particularly sympathetic sitter, such as *Marion Abrahams* (no. 425), *Professor McInnes* (no. 515) or a child, could elicit a portrait of unforced distinction.

It is primarily as a portrait sculptor that Epstein was and is celebrated. The exceptional response which these studies provoke stems from more than their verisimilitude or vivacity. The immediacy of the modelling forces on the viewer an awareness of the creative miracle which has taken place and of the infinitely vulnerable process which the artist has gone through to get there. The endlessly reactive permanency of bronze preserves the fragile creative act which unites artist and sitter through the life of the clay.

The Architectural Carvings of the 1920s

Rima

Epstein's status as a portrait sculptor was sufficiently well established by November 1922, when a memorial to the naturalist and writer, W. H. Hudson, was being planned, that even opponents of his work, such as John Galsworthy and Sir George Frampton, put up only a token resistance to his employment on a medallion-portrait

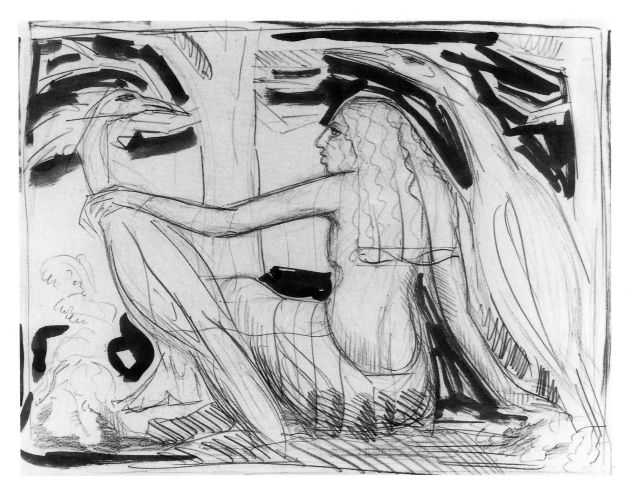

20 *Study for* Rima, *pencil and wash, 59 × 46cm. (Leeds, Henry Moore Sculpture Study Centre)*

[1] The detailed history of the commission is given in catalogue nos. 146, 147.

[2] Haskell, p. 28.

intended to adorn the proposed fountain and bird bath.[1] The commission was very welcome. It was Epstein's first public sculpture in Britain since the BMA building in 1907–8, and it was to be prominently placed—in the bird sanctuary in Hyde Park. But Epstein's employment was soon placed in jeopardy by the rejection of his portrait model (no. 146) owing to the protocol banning portraits in the Royal Parks. His retention to undertake the revised scheme, for a bas-relief carving of *Rima* (no. 147, plate 17), the nature-spirit heroine of Hudson's most popular book, *Green Mansions*, was entirely due to Cunninghame Graham (no. 145) and Muirhead Bone (no. 75), whose handling of their fellow committee members was masterly.

From the first Epstein accepted the pictorial emphasis implicit in the theme and medium, while recognizing the degree of simplification necessary for legibility from a viewpoint some twenty to thirty metres distant (plate 17). The *Rima Sketchbook* (fig. 20) is unique in his oeuvre, both in the quantity and range of preparatory drawings. The sketches vary enormously in format, composition and style but the basic elements —the dryad Rima, the birds and the South American forest—are constant. Those most illustrative of Hudson's story show Rima, as she first appeared to the narrator, reclining near the roots of a tree, her hand extended to receive a bird. Although Epstein later recalled that he had been much struck by Hudson's account of Rima falling to her death from the burning tree 'like a white bird', neither he nor the committee provided an explanation of his subject at the time, and it is most unlikely that he would have chosen for Hudson's memorial the moment at which the narrator's love and belief in the creative partnership of man and nature were tragically destroyed.[2]

Rather he interpreted the story symbolically, taking only the essence of Hudson's tale. The great Portland stone slab, which the architect had chosen for the memorial's centrepiece, resembles an altar; Epstein's design (plate 17), showing the girl with her head thrown back and her arms outstretched, as if in welcome or in a dance, contains more than a hint of apotheosis. Its composition, as a contemporary critic noticed and as Epstein subsequently acknowledged, is indebted to the ancient Greek masterpiece, *The Ludovisi Throne* (fig. 21). In his hands, it takes on an infinitely starker and more abstracted form; the angular column of the girl's body and her heavy welcoming arms resemble a tree round which the birds play. For the birds' wings he employed a decorative vocabulary originally developed for the *Tomb of Oscar Wilde* (no. 40); boldly carved feathers, stylized waves of hair and the textured, deeply recessed ground act as a foil to the smooth mass of Rima's body.

Rarely discussed except in the context of the

[3] Cork 1985, chap. 6.

[4] Fry 1925, pp. 370–3.

[5] *The Times*, 20.5.1925, p. 11 and 21.5.1925, p. 11.

[6] *The Sunday Times*, 24.5.1925.

21 The Birth of Aphrodite *(?), known as* The Ludovisi Throne, *c.470–460 BC (Rome, Terme Museum)*

public response it provoked, Epstein's achievement in resolving the spatial and technical demands of the site, as well as satisfying the conflicting demands inherent in the Hudson memorial, have been underestimated. *Rima* showed how a directly carved bas-relief could contain a wide range of plastic effects and still carry from a considerable distance. His work was evidently studied by Gill and the younger sculptors entrusted with directly carved bas-reliefs of the winds on the London Underground headquarters three years later.[3]

During the astounding public controversy that broke out after the unveiling in May 1925, and which continued into the winter, even Roger Fry felt compelled to speak up for the abstract qualities of Epstein's design:

I am not going to pretend that has converted me into an enthusiastic admirer of Mr Epstein's sculpture, or that it causes me any profound emotional reaction, but it has certain qualities which are almost always absent from our public sculpture. As a decorative arrangement of forms within a rectangle it shows a real inventive ingenuity and sense of proportion. The qualities of relief and hollow, the relative proportions of light and shade are admirably balanced, and the linear rhythm of the design is well carried through.[4]

Criticism turned not only on the beauty or ugliness of the carving but also on its compatibility with Hudson's work; the atavistic element of nature worship, which Epstein had chosen to emphasize, conflicted with the sentimental, nature-loving Hudson enjoyed by his fans. Cunninghame Graham's speech at the unveiling ceremony compared Hudson with St. Francis preaching to the birds, while Prime Minister Stanley Baldwin stressed his role as a pioneer conservationist. The shudder that was observed to run down the latter's spine as he unveiled the memorial was noted. The first protest letter, complaining that 'a distorted nude figure appears to be battling with monstrous birds', actually appeared as a tailpiece to *The Times* report of the event the following day, and more than outweighed the art correspondent's reserved praise for the design and 'chisel-cutting'.[5] Frank Rutter was therefore treading a discreet middle path when he praised both Hudson and Epstein but felt that they were irreconcilable: 'to Hudson, birds were feathered songsters filling the air with twittering melodies: to Epstein a bird is an eagle that swoops upon its prey.'[6] Though efforts to get the sculpture removed from the Park failed, thanks largely to Muirhead Bone who organized effective resistance, the sculpture was subsequently daubed with green paint and fascist insignia.

'A Cathedral of Modernity'

During the twenty years since Epstein and Holden had worked together on the BMA building, Charles Holden had established himself as one of the leading architects of his generation, and was making a distinctively modern contribution to post-war London with his designs for Underground stations. He had evolved a severe style, characterized by functional, unadorned, architectural masses. However, he still preferred traditional materials and retained his Ruskinian faith in the life-enhancing possibilities of architecture and architectural sculpture. When he received the RIBA medal in 1929, he told his audience of fellow professionals: 'I have visions of an architecture as pure and true to its purpose as a Bach fugue; an architecture telling of joy in plan, structure and material; joy too in all the human and even mechanical activities which make up architecture today.'[7]

After the criticism that had flown round his ears after the BMA affair, to say nothing of the recent outcry over *Rima*, on which his firm had also been employed, it was brave of Holden to press for Epstein's employment yet again. He was designing the new headquarters for the Underground Electric Railway Company, which combined offices with access to St. James's Park Underground Station at 55 Broadway, Westminster (no. 189). The cruciform design of the new headquarters building bore out his reputation for resourcefulness, but did not necessarily provide an appropriate setting for sculpture. Only after Holden had persuaded Frank Pick to overcome his misgivings at employing the author of *Rima*, was Epstein given the prime sites over two main entrances for his two monumental figures (plates 18, 19). Five young sculptors—Moore, Aumonier, Rabinovitch, Wyon and Garrard—under the direction of Eric Gill, were to undertake eight relief panels of the Winds (each about twice the size of *Rima*) which were to be placed high on the cruciform tower.

Once he had chosen the suitably elemental subjects of *Night* and *Day* Epstein's conception of the massive figures evolved rapidly. A discernible influence upon *Day*, which the sculptor described as 'a figure of the father in nature, with the man-child facing the light but still holding to the father', was his life-size bronze *Madonna and Child* (no. 175, plate 16), 1926, based on Sunita and her son, Enver.[8]

Night too developed readily enough from an existing project for a Pietà; the bent head and gentle gesture of the woman enfolding the recumbent figure in her mantle, in the *Maquette for Night* (no.

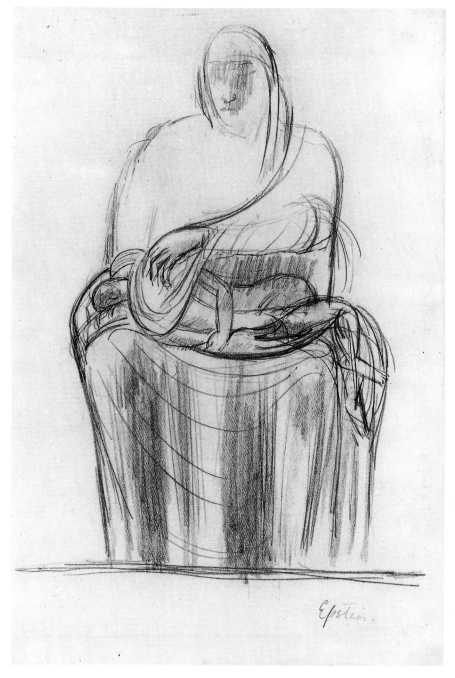

22 *Study for* Night, *pencil, 56 × 38.2cm. (Birmingham Museum and Art Gallery)*

188), is a Pietà in all but name. One drawing, which shows an embracing couple asleep in the lap of Night (fig. 22), was surely put aside as too provocative. Epstein explained that *Night* was 'a mother-figure with her child-man exhausted and sleeping under her protection and benediction'.

Both the ponderous figures are geared to their architectural function, their mass and the interplay of vertical and horizontal elements echoing the character of the building. Each figure forms a stepped pyramid, ascending from the square base to the head, set immovably on massive shoulders. As he had with *Rima*, Epstein took pains to allow for the angles and distances from which the sculptures would be seen, having a small window placed in his work-hut so that he could judge the effect from street level. The orientation of the figures was also taken into account; he explained to James Bone that the carving was much deeper

[7] Holden, Address to the RIBA, 1929.

[8] This and following quotation from Epstein, interviewed by James Bone, *Manchester Guardian*, 3.8.1929.

[9] *The Architect*, 29.5.1929.

[10] Cork 1985, pl. 354.

on *Night*, which receives no direct sun and no harsh shadows, than on *Day*, which is in full sunlight.

Day (plate 19) betrays signs that the sculptor was still thinking primarily in terms of bas-relief; examined head-on, the figure has a certain flatness; the double embrace of father and child bridges the gap between the parallel planes, but the result is not totally convincing. There are fine passages of carving, especially in the draped legs of the father and bare ones of the son, which relate to the architecture of the doorway below; the strangely delicate hands flank the child with a protective tenderness and there is unexpected subtlety in the great, disc-like face which smiles as it frowns at the bright light.

In *Night* (plate 18) the figure's outstretched arm and the sleeper's body create a far more effective interplay between the broadly handled masses. Deeply incised folds of shadow score the swelling forms, their slow downward curves 'expressive of sleep and rest descending on tired mankind'. The emphasis on broad masses and repose is broken only by the over-bent leg and expressionistically taut foot of the sleeping figure, elements transferred without modification from the maquette.

Not without reason, the sculptures were greeted by many architects and critics as a major achievement in the still underrated field of architectural sculpture. R. H. Wilenski, writing in the *Evening Standard*, declared the figures, 'the grandest stone carvings in London'. An editorial in *The Architect* commented on how the Strand, Hyde Park and Westminster commissions showed the 'deepening intensity of his conception' of the architectural environment; *Night*, 'the best in every way', more than lived up to the building, making it act as a foil to the sculpture.[9]

The opposition lobby, led by R. R. Tatlock in the *Daily Telegraph* and Sir Reginald Blomfield, a past President of the RIBA, was far more vociferous. The attacks mounted on the two sculptures were aimed only partly at the alleged obscenity of the child's genitals; the broad, simplification of the figures and primitivistic heads, which gave the figures the appearance of pagan deities, served to underline Epstein's apparent perversity in employing such methods on a composition hallowed by its Christian tradition and exemplified by Michelangelo's *Pietà* in St. Peter's, Rome. Both *Night* and *Rima* were vandalized during the autumn, and on Guy Fawkes night (5 November) 2,000 students rallied in front of the sculptures.

At intervals throughout Epstein's career, it is impossible to avoid a sense of *déjà-entendu*. With the BMA sculptures he made people aware that

architectural sculpture could be more than billowing rhetoric or innocuous decoration. With *Rima*, *Night* and *Day* he had brought sculpture to the attention of a vast public who, however tentatively, began to question the meaning of beauty or ugliness in art. He paid heavily for the privilege since he received no further public commissions until 1950. Worse still, the architectural work he had already done suffered; between 1935 and 1937 the BMA sculptures (no. 9) were first saved from destruction and then savagely mutilated in the name of public safety without the sculptor himself being allowed to lift a hand to repair them. Both *Rima* and *Night* and *Day* were vandalized at intervals. Holden, who would have employed him again on the Senate House of the University of London in 1938, had it made clear to him that if he was to have the job Epstein must have nothing to do with it.

Nevertheless, the London Underground building also demonstrated Epstein's influence on the younger sculptors charged with the Tower of the Winds reliefs. Several of them appear to have learnt from the large masses and coarsely incised pattern of *Rima*; Rabinovitch even included a stylized bird beside his *West Wind*. He also, like Moore and Aumonier, gave his figure a rigidly outstretched arm, apparently taking the motif from the flying angel on the *Tomb of Oscar Wilde* in order to solve the compositional problem of articulating a monumental figure in a narrow space while enhancing the effect of headlong movement. Henry Moore, whose invitation to take part was the result of Epstein's recommendation, was also keeping an eye on what the older man was doing, sketching the composition of *Day* on the wall beside his *West Wind* as he worked.[10]

Postscript—The TUC War Memorial

Epstein returned to the Pietà theme twenty-five years later, when a carved war memorial was commissioned in 1956 for the Trades Union Congress (TUC) headquarters in Great Russell Street (no. 490, plates 45, 46). There were many similarities with the Underground setting, since the work was to be seen from across a courtyard and was to be elevated on a high stone plinth against a great pyramidal wall of green marble slabs (recently and disastrously replaced by tiles). In keeping with the plinth, all the forms are squared and greatly simplified; the standing figure of the mother grows out of the slab from which the lower part of her body is distinguishable only by the foot she advances over the edge of the plinth. Her implied movement and basilisk stare spell out a message of horror rather than repose or

mourning. The hanging arm and legs of the dead son, whose entire weight is supported by the incisive vertical and horizontal axes of the mother's hands, lend the figure a density even greater than that inherent in its material and scale.

Typically the sculptor yields nothing to patriotic sentiment; this is neither a tribute to military valour nor even a symbol of grief. Though carved when Epstein was in his seventies and suffering from an unacknowledged heart condition, this too little regarded and woefully neglected masterwork conveys through its disturbing unity of form, idea and feeling, a fearful indictment of the pitiless indifference of war.

Carvings in the 1930s and 1940s

Apart from his two architectural commissions for the Hudson Memorial and the London Underground, Epstein had carved only one piece during the 1920s—*Marble Arms* (no. 136). This curious piece, a private symbol of the love between the sculptor and Kathleen Garman, hovers between the almost academic realism of its technique and the primitivism of its conception, which recalls the detached fragments of Egyptian *colossi* in the British Museum.

Late in 1929, prompted perhaps by working on the Underground headquarters, he began to carve a great white block of Seravezza marble he had bought in Paris into a monumental icon of fecundity, *Genesis* (no. 194, plate 21). In 1931, he resumed work on *Sun God* (no. 26, plate 6) which he had left untouched for twenty years, and, on the reverse of the same panel, carved *Primeval Gods* (no. 218, plate 24) which recapitulated sculptural themes adumbrated in the *Birth* carvings and in the *Tomb of Oscar Wilde*. During the 1930s he usually had a carving in hand—*Genesis* from 1929 to 1931, *Primeval Gods* from 1931 to 1933, *Chimera* (no. 224, plate 20), *Elemental* (no. 225, plate 22) and *Woman Possessed* (no. 226, plate 23) in 1932, *Ecce Homo* (no. 246, plate 28) 1933–4, *Adam* (no. 288, plate 27) in 1938 and finally *Jacob and the Angel* (no. 312, plate 31) in 1940. None of these works was commissioned or done with any client in mind; nor, when they were exhibited, did any of them find either a ready sale or an encouraging critical response. The immense labour, undertaken in the intervals between portraits, stemmed solely from the sculptor's inner compulsion and indomitable will.

The year 1929 was an extraordinary moment to embark on such arduous and financially unrewarding work. In addition to his other commitments, he had recently (1928) moved from Guildford Street to 18 Hyde Park Gate, a far more prestigious area. Although he was receiving a steady flow of portrait commissions, and also selling drawings and watercolours with ease, his finances were always precarious and in 1939 he had to sell his collection of paintings by his lifelong friend, Matthew Smith, to pay his income tax.[1]

The collection of 'primitive' sculpture had become an obsession, and he had been collecting keenly throughout the 1920s. By the time Arnold Haskell met him in 1929–30, there were 'some two hundred pieces in one room', covering shelves, filling corners, and spilling over every available surface, as well as a constantly changing selection in the drawing room, though 'the Marquesas idols, too large to be moved, remained in their place.'[2] Haskell, like Cecil Gray and others, recalled being introduced to individual pieces from the treasure trove, handled with knowledge as well as sculptural understanding.

During the 1930s Epstein acquired many of his finest and most costly African pieces—the de Miré head, the Fang reliquary figure (Metropolitan Museum of Art, New York), which had been Derain's, in 1933, the Fang 'Black Venus' and the long-coveted Brummer head in 1935. He purchased from dealers, notably Charles Ratton, Louis Carré and Ernest Ascher in Paris, and at auction, where his reckless bidding to secure a desired object is recalled by fellow collectors, such as Sir Robert Sainsbury (no. 320). His collection included Egyptian, Greek, Sumerian, Indian, American and Oceanic artefacts, but the West African sculpture, and particularly the Fang heads, formed one of the finest private collections anywhere in the world. Whatever his financial straits there is no evidence that he ever sold one, and when he bought the unique Lake Sentani figures collected by Viot in 1929, he confessed, 'I so desired them that I mortgaged my future earnings for a long time to be able to obtain them.'[3]

For Epstein non-European sculpture contained lessons which go 'to the root of all sculpture'. While he thought that many tribal sculptures were more realistic than was generally realized, there was a considerable romantic and mystical component in his appreciation of their formal qualities; he believed, not altogether correctly, that the majority had been created for ceremonial, religious purposes: 'The directness and simplification are a result of this necessity of producing a feeling of awe and fear.'[4] Epstein's carvings of the 1930s contain motifs distilled from his extensive knowledge of non-European art, and these are absorbed into his mature style. The primitivism of his work in the thirties is at a far deeper level

[1] Retrospective Exhibition of Paintings by Matthew Smith: the Collection of Jacob Epstein, Leicester Galleries, no. 692, January 1939.

[2] Haskell, pp. 87–90. A catalogue of Epstein's collection by M. McLeod and E. Bassani is in preparation.

[3] P. Peltier in Rubin, p. 112, illustrating the expedition find; Epstein 1940, p. 218.

[4] Haskell, p. 90.

[5] Hulme had been buying by instalments. The two flenite pieces were lent by a Mrs G. E. Rogers to Epstein's Leicester Galleries show in 1933, though the sculptures were in Epstein's possession (mislaid at the bottom of a trunk) in 1959.

[6] Moore 1981, p. 10.

[7] *Evening Standard*, 31.1.1929, quoted in Cork 1985, p. 279; Sculpture and Drawings by Henry Moore, Leicester Galleries no. 511, 1931; sculptures reproduced in Read.

than that of 1912–15; the ritualistic awe evoked by certain African or Oceanic sculptures had pervaded his work. The carvings of this period can also be seen as his response to the changing definitions of sculpture being explored both by the younger generation of British sculptors—Henry Moore, Barbara Hepworth, John Skeaping, Maurice Lambert and Leon Underwood—and by writers, such as Wilenski. For the new generation, influenced by Roger Fry's writings and by the formalism of Gaudier-Brzeska's and of Epstein's own pre-war work, sculpture was identified with direct carving and relationships of line and mass.

However, most of Epstein's early carvings could be appreciated only from photographs, since so many had been sold to Quinn before the war. Apart from the early BMA building, he was known mainly for his portraits, post-war bronzes and carvings. Thus, though Epstein might be regarded by the younger generation with respect, as an adventurous artist suffering for his boldness, he was also the senior avant-garde sculptor on the British art scene, just as Rodin had been the dominant sculptor on the European scene during his own youth. One might admire him but still seek to escape his influence; in Epstein's fate as avant-garde sculptor and household name, a young sculptor might see both a role-model and object lesson.

Epstein and Moore

Moore, the only one of the younger sculptors to have close contact with Epstein, had called on him during his first term as a student at the Royal College; after 1924 he got to know him well. At Guildford Street, and later Hyde Park Gate, he could see primitive sculpture, portraits, and also earlier work which had not been bought by Quinn, such as *Venus—first version* (no. 49, plate 8), *Maternity* (no. 23) and possibly the two flenite pieces which had reverted to Epstein after Hulme's death (nos. 44, 45).[5]

The voluptuously ample *Maternity*, one of Epstein's first directly carved works, perceptibly influenced Moore's *Maternity* of 1924 (fig. 23) and it is possible that the compressed forms of Moore's early *verde di prato* carvings were affected by his knowledge of the flenite works. Like Epstein, Moore found in the relationship of mother and child an enduring source of inspiration.

Moore was far more deeply affected by Ezra Pound's book on Gaudier-Brzeska and by Roger Fry's *Vision and Design*, but Epstein was important to him nonetheless. Not only had Epstein been one of the pioneers of direct carving, but he had

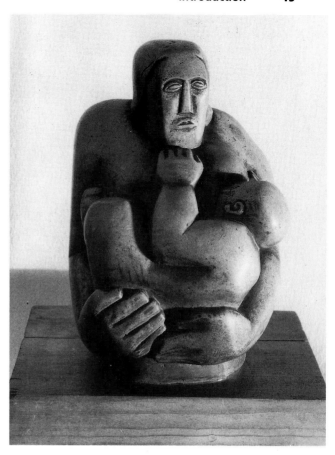

23 *Henry Moore,* Maternity, *1924, Hoptonwood stone, 22.9cm. high (Leeds City Art Galleries)*

also expressed his ideas in monumental form. Further, he had been one of the first to appreciate the British Museum collections of Assyrian, Egyptian and ethnographic material, where Moore himself was spending a great deal of time. He recalled: 'I came to know Epstein quite well, and have never forgotten him taking me to his bedroom to see his collection of primitive carvings—it was so overflowing with negro sculptures etc., that I wondered how he got into bed without knocking something over.'[6]

Epstein gave Moore active encouragement, recommending him for work on the Underground building and singling out his *West Wind* for praise in a newspaper interview. He wrote the catalogue preface for Moore's second one-man show and purchased three works—*Half Figure*, 1930, a *Mother and Child*, 1931, in Cumberland alabaster, and *Composition*, 1932, in dark African wood.[7] He praised Moore's 'integrity to the central idea of sculpture...the relation of masses':

> What is so clearly expressed is a vision rich in sculptural invention, avoiding the banalities of abstraction and concentrating upon those enduring elements that constitute great sculpture...For the future of sculpture in England Henry Moore is vitally important.

This outspoken and unqualified praise, from one who rarely had a good word to say for his contem-

poraries, stemmed not only from his recognition of the quality of Moore's work, but also from what he saw as their common concern for 'the robust expression of secret forces ready to burst forth on earth.'

This last phrase seems more appropriate to his own recent work, *Genesis* (no. 194, plate 21), which had been exhibited at the Leicester Galleries in February 1931 and was subsequently sent on tour, in aid of charity, by its new owners.

Primal Themes

Still one of the strangest and most disturbing of all his works, *Genesis* (no. 194, plate 21) shared with recent works by Frank Dobson, Mark Gertler, Leon Underwood, Matthew Smith and, looking further afield, Léger and Picasso, a massively monumental treatment of female form. Indeed, the colossal hips and thighs, cut off above the knees, are strongly reminiscent of Dobson's *The Man Child* (Tate Gallery), which had been exhibited unfinished at the Leicester Galleries in 1921. Several drawings of pregnant women as well as portraits of black models, such as *Betty (Esther)* (no. 196), underline the naturalistic basis from which this expression of 'the profoundly elemental in motherhood...which seems to rise from the earth itself', developed. Like the flenite figures, *Venus* and *Visitation*, but with far less formal subtlety, this figure embodies fecundity.

There was a calculated element of shock in the bravado with which genteel conventional orthodoxies were thrown out of the window. *Genesis* is totally unsentimental and unerotic, but its descriptive banality conflicts with the mystery it is supposed to embody. His intention was the portrayal of a state of mind, 'the calm, mindless wonder' of expectant motherhood, but the areas of stylization jar against the overblown realism of the whole body, which in turn overwhelms the more delicate naturalism of the collar-bones and the arm folded so tenderly across the full-term pregnancy. The apparently caricatured, even mongoloid, features gave rise not only to predictably hysterical outbursts in the press but also to criticism from those who had hitherto praised his architectural carving. Wilenski, whose *The Meaning of Modern Sculpture*, published in 1932, is an extremely balanced and thoughtful view of how and why contemporary sculptors were creating 'a new creed', found *Genesis* important but flawed. His commentary brings out exceptionally clearly the conflict between sculpture considered as abstract relationships of form to which a cursory title might be added, and Epstein's approach which was not literary in the conventional sense,

but to which the interpretation of a subject was central:

Colossal in size, staring white in colour, this mass of marble shocks us in the first place because it calls up a rush of emotive ideas with which the object before us is usually associated...[these] are not irrelevancies in the contemplation of this work...it is in fact an embodiment of a genesis idea.

To appreciate this statue therefore, we can, and must, retain our initial emotive ideas and *reconsider them* in the light of the experience provided by the statue. That the work enforces such reconsideration is a sign...of its unusual merit. It is not often that an artist can drive us to re-examine our deep-seated attitudes to the solemn facts of life and birth and death...

The truth is that we cannot begin to appreciate this *Genesis* until we have forgotten our habitual environment, until the Leicester Galleries and our rival theories of sculpture, our civilisation of steel, speed and comfort, the Prime Minister and 'Miss 1931' have all faded from our minds. As sheer sculpture, in the modern sense, this carving... is a failure; the forms are not homogeneous, the plastic language is diverse, the flow of the lines downward suggests a falling body rather than an organisation rising upward from the ground. But this sculpture must not be considered as sheer sculpture. It must be considered as *Genesis*, and, thus considered, the divergencies of the forms, the contrasts of lightness and weight, and the downward forward movement of the lines contribute to a significance which is undeniably primeval and profound.[8]

Kineton Parkes was more extreme in his response; Epstein's carvings were 'non glyptic' and betrayed the sensibility of a modeller rather than a carver, while Leon Underwood was so outraged that he carved his wooden *Regenesis* in response.[9]

Wilenski recognized that all Epstein's carvings had formal meaning, but not to the exclusion of all else: 'Epstein's carvings are heroic attempts to *fuse two types of intense meaning without lessening the intensity of either*.'[10]

Recognizably, Epstein's carvings of the 1930s continue the preoccupations of his Pett Level years; expressive intensity was as important in 1930 as it had been in 1914 under the influence of Hulme and Futurism. However, the formal primitivism of *Venus* had been replaced in *Genesis* by a

[8] Wilenski 1932, pp. 146–7, reprinted from the *Observer*, 8.2.1931.

[9] Parkes 1931, pp. 134–5; Neve, pp. 139–40, pl. 97.

[10] Wilenski 1932, p. 104.

[11] Haskell 1931, p. 93.

[12] Birmingham Museum and Art Gallery. See Buckle, p. 192, dating the performance 1929. MacDonald, who reproduces one of the drawings, states that Epstein was present at the première in 1921; N. MacDonald, *Diaghilev Observed*, London, 1975, p. 265.

spiritual primitivism in the service of a primarily naturalistic approach to form.

However self-confident Epstein's ostensible reaction to the avalanche of adverse comment on *Genesis*, he appears to have acknowledged its possible incongruities by renewing contact with his own pre-war work; he deepened the relief of *Sun God* (see nos. 26, 218, plate 6), and then, on the reverse of the panel, carved another symbolic generative theme, *Primeval Gods* (no. 218, plate 24), which takes up the pre-war birth themes. The infants, resembling Maori tikis, which leap and tumble before the immutable deity, suggest the Creation myth of a lost tribe. The god's protuberant round eyes, nose and down-turned mouth are closely based on Fang heads in his own collection, but the brawny, square-shouldered idol can be traced back to the vices on the *Tomb of Oscar Wilde* (no. 40, plate 4) and the figure of *Day* on the Underground building (no. 189, plate 19).

Chimera (no. 224, plate 20) is a transposition into alabaster of a small and hitherto unidentified piece in his 'primitive' collection, which can be seen in one of the photographs taken by Geoffrey Ireland around 1960. Its disquieting atavism reminds one of Gauguin's *The Spirit of the Dead Watches* or the work of Redon.

Elemental (no. 225, plate 22) and *Woman Possessed* (no. 226, plate 23) are far less closely related to any specific 'primitive' source, though the tense foetal posture of the first and the orgasmic ecstasy of the second are profoundly primordial. In these two works, Epstein achieved that balance of form and meaning which Wilenski rightly recognized as his aim in carving. *Elemental* contains a multiplicity of possible meanings; by adapting the foetal posture, which Epstein believed, erroneously, to be a Gabon burial posture, he created an ambiguous tension expressive of the latent dynamism of unborn life, or of the frozen tension of terror, or of the impersonal grip of death.[11] The curving and interlocking ovoid forms of back, shoulders, arms, knees and head possess the symmetry and compression that characterizes the best of Epstein's carvings. Matt and unpolished, the veined, roughly filed surface, with the unfinished chisel strokes still visible on the half-made face and hands, reinforce the figure's timelessness. Its formal and expressive unity is even more intense than the finest of his pre-war work. Surprisingly it does not seem to have been included in his Leicester Galleries exhibition in 1933 and it was virtually unknown until its inclusion in the Edinburgh Memorial Exhibition in 1961. It can now be seen as one of his finest works.

The extroverted torsion of *Woman Possessed* (no.

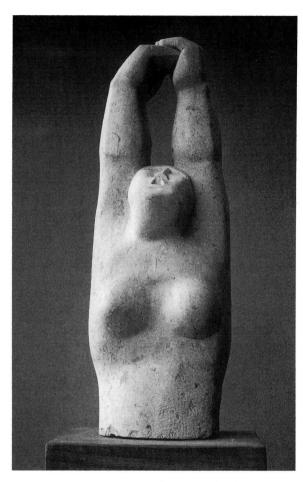

24 *Henry Moore,* Woman with Upraised Arms, *1924–5, Hoptonwood stone, 43.2 cm. high (The Henry Moore Foundation)*

226, plate 23) is at the opposite pole from the introversion of *Elemental*, yet both convey to the spectator a kinaesthetic sense of physical and psychic energy barely kept in check by gravity. Its starting point may have been the climactic moment in Massine's choreography for Stravinsky's *Rite of Spring*, when the chosen maiden consummates her sacrificial union with the tribal god in death. Epstein saw the ballet at Covent Garden in 1921 and made repeated sketches of a woman spread-eagled over the back of a stooping man.[12] It is tempting to see the dynamic *Woman Possessed* as a response to Moore's expansive *Reclining Figure 1929* (Leeds City Art Gallery); certainly it is at this point that Moore's and Epstein's monumental carvings are most closely analogous, but where Moore's work is directly inspired by an Aztec source, Epstein's represents the complete synthesis of diverse sources which is characteristic of his maturity. The expressive stylization of the head is akin to Moore's *Woman with Upraised Arms*, 1924–5 (fig. 24), probably as a result of their mutual debt to a variety of African sources, in-

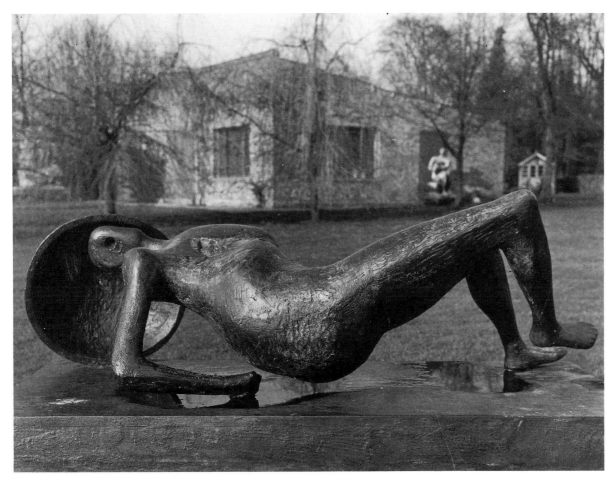

25 *Henry Moore,* Falling Warrior, *1956–7, bronze, 147 cm. long*

cluding art of the Ivory Coast and Zaire (Songye and Chokwe).

One of the strengths of Moore's *Reclining Figure 1929* is its tranquil harmony with the natural world; its relaxation contrasts with the palpable energy of Epstein's figure. In *Woman Possessed* suspense informs the empty space beneath the body and the hard, flat plateau formed by belly, hips and thighs. The low arch of stone, supported at its three extremities, thrusts its weight upwards against the gravitational pull of the earth from which it came and to which it must return. Angular clenched fists, flanking the crisply carved, mask-like face, create a symmetrical rhythm of incised lines and planes. Twenty years later, Moore's *Falling Warrior*, 1956–7 (fig. 25) may unconsciously echo *Woman Possessed*, but the battered bronze figure is poignantly crumpling in defeat, where Epstein's expresses the ecstasy of momentary victory.

When Epstein exhibited *Woman Possessed*, the double relief panel and *Chimera* at the Leicester Galleries in May 1933, he also showed *Doves—second version* (no. 50), the *Flenite Relief* (no. 44) and *Female Figure in Flenite* (no. 45). These were

being seen for the first time since their relatively restricted exhibition before the First War. By 1933 it was apparent that stone, not bronze, was the medium of the modern sculptor, and Epstein may well have felt that it was necessary to bolster his own claims as a carver. The star of younger artists, who were mostly carvers, was in the ascendant. Moore, once considered Epstein's protégé, was named as the leading sculptor in Britain alongside Epstein in Paul Fierens's *Sculpteurs d'Aujourdhui*, published that year, and Adrian Stokes praised Moore and Hepworth in an important article in *The Spectator*. However, the presence of Epstein's early works passed almost unnoticed, the press attention being concentrated on the 'sensation' of *Primeval Gods* and on the portraits which were, as usual, praised.

Religious Themes

With *Behold the Man* (no. 246), *Consummatum Est* (no. 275), *Adam* (no. 288) and *Jacob and the Angel* (no. 312), Epstein turned from primitive to ostensibly orthodox religious themes. His treatment of

[13] L. Morris and R. Radford, *The Story of the AIA, 1933–1953*, 1983, *passim*; Epstein to Stephen Spender, 6.6.1938 (HRC).

[14] Epstein 1940, p. 20.

[15] Epstein 1940, p. 166; Buckle, p. 189; exhibited in 1932 at the Redfern Gallery where they sold for 20 guineas apiece.

[16] Epstein 1940, p. 195.

them was no more conventional than his *Risen Christ* (no. 97, plate 13), so that he continued to encounter accusations of blasphemy; *Behold the Man* remained in his studio until after his death; two of the others were sold during a period of particularly dire financial need to W. Cartmell, the showman, so that Epstein suffered the partly self-inflicted indignity of seeing the works used as a Blackpool sideshow at Louis Toussaud's. *Adam* was sold first to a showman, who exhibited it on tour, and then to another promoter who used it as a peep-show in New York, before it too went to Blackpool.

This dismal history reinforces the impression of Epstein's isolation and sensationalized reputation during the 1930s. He was untouched by Surrealism and openly contemptuous of Constructivism. It was a period for artistic manifestos and alliances to none of which he subscribed, though during the later thirties he was associated with the anti-fascist cause of the Artists' International Association, and expressed his willingness to join a group investigating conditions in Spain in 1938.[13] To most of the younger sculptors Epstein was primarily a portrait modeller in the Romantic tradition. Herbert Read started his career as a critic predisposed in Epstein's favour through his study of T. E. Hulme, whose *Speculations* he published, with a foreword by Epstein, in 1924. When, however, he began to write seriously about contemporary art during the 1930s it was to Moore and Hepworth he turned. Epstein continued to forge his own independent path, the expressive, figurative content of his work increasingly divorced from the concerns of the mainstream avant-garde. He derived much quiet support from Matthew Smith, whose art was equally isolated by virtue of its radical individualism.

An orthodox Jewish upbringing had left Epstein with a genuine reverence for the true ascetics and holy men whom he encountered in his wanderings in the Lower East Side, and an admiration for the 'patriarchal simplicity' which characterized the household of his maternal grandparents. He had abandoned all conventional observance in his youth and never returned to it. Nevertheless as he himself acknowledged: 'I imagine that the feeling I have for expressing a human point of view, giving human rather than abstract implications to my work, comes from those early formation years.'[14]

During the early thirties while staying at Deerhurst, he read and reread the book of Genesis and began a series of unconventional watercolours on Old Testament themes.[15] They were evocations of patriarchal and tribal society rather than illus-

trations, their blend of hieratic authority and eroticism recalling Epstein's interest in Assyrian art and the awe-inspiring *terribilità* of *Night* and *Day*, as well as the brooding sensuality of his portraits of *Sunita*.

A similarly ambitious rethinking of Biblical themes in terms of patriarchal tradition and ancient ritual underlies his interpretation of *Behold the Man* (no. 246, plate 28) and *Consummatum Est* (no. 275). The traditional iconography of the scene in which Pilate shows the bound and beaten Christ to the people, who proceed to condemn Him to death, is familiar from innumerable paintings and prints. Many artists had used a close up of the tormented Christ alone as a devotional image. Epstein transforms this instantly recognizable composition, ideally suited to his direct carving of the tough block of Subiaco stone, into a potent symbol of man's inhumanity to man. Articulated in geometrically simplified planes, it is essentially a high relief carving whose contrasts of mass and stark pattern recall the *Tomb of Oscar Wilde* and *Maternity* as well as the recent elemental carvings. The figure is a totem of suffering endured with calm acceptance of its injustice.

Iconographically *Consummatum Est* is far more original; the words, 'It is finished', come from the crucified Christ in St. John's Gospel (19.30), but this is an Assyrian- or Egyptian-bearded Christ ready for entombment. The idea of the figure grew from prolonged consideration of the vast alabaster block as it lay flat on the floor of the studio, and was directly inspired by the distant solemnity of the 'Crucifixus' of Bach's B Minor Mass. Alabaster was a material much employed in medieval funerary sculpture but the inspiration for the austere, concave composition may well be Egyptian, stemming from the hieratic figures of the dead incised into the concave floors of their stone sarcophagi.

With the exception of the convulsive ecstasy of *Woman Possessed*, none of Epstein's large direct carvings had suggested movement; indeed their massive immobility was inherent to their totemic character. Only the great pre-war metaphor of artistic creativity, *Rock Drill* (no. 54, plate 12), which Epstein had thought of endowing pneumatically with the power of actual movement, was innately dynamic. However, the Promethean *Adam* (no. 288, plate 27), striving for some almost unattainable goal, can also be seen as a metaphor for the perpetually redefined and ultimately unassuagable creative ambition of the artist. 'Into no other work had I merged myself so much,' he recalled.[16]

Gaudier-Brzeska had written in *BLAST*, 'sculptural energy is the mountain', but *Adam* seems to

bring this rhetorical claim into being. Its form recalls not only the more literal desire to carve mountains which Epstein had confided to John Quinn in 1912 (a wish that others were realizing during the 1930s at Mount Rushmore), but also his admiration for the unabashed and joyous physicality of Whitman's poem, 'Children of Adam'. The prodigious phallus, nobly supported, sings what Whitman called 'the song of procreation', maintaining the rhythm and tension of the figure's inexorable advance.

Epstein was particularly pleased with the amount of movement he had conveyed within the compass of his relatively narrow block; despite its vigour, the massive density of every portion of the colossus enabled him to retain the boulder-like quality of the alabaster block. The fearlessly naked, striding figure seems to have been intended as the male counterpart of *Genesis* in his readiness to people the world: the contemplative placidity—even passivity—of the female, content in the fulfilment of her biological function, contrasts with the restless physical dynamism of the male.

The last of these anachronistic but immensely powerful works was also the most enigmatic. *Jacob and the Angel* (no. 312, plate 31) transforms the epic, night-long struggle between Jacob and the stranger whom he took to be God (Genesis, 32. 24–32) into a disturbingly ambiguous embrace between titanic, male figures. The subject had long fascinated him and probably held deep personal associations. A watercolour, *Jacob's Wrestling*, had been included in his 1932 show at the Redfern Gallery, and he had included another related drawing in Oyved's *Book of Affinity* in 1933. In one of the surviving preparatory drawings for the sculpture (fig. 26), man and angel grapple so closely that, whether standing or rolling on the ground, they seem to kiss. Although neither version was suitable for translation into the discipline of stone, the ambivalence of their struggle is retained and even intensified in the carving; the angel is rapt and tense, the victor at the climactic moment of the struggle, but it is Jacob who stands relaxed and gasping with head thrown back and eyes closed.

The Herculean proportions of the figures permitted the sculptor to generalize and balance the relationship of masses while simultaneously maintaining the impact of their embrace. True to his usual practice in carving, the primary views reflect the mass of the original block, but the interlocked arms also encourage the viewer to move around it. Some areas, such as Jacob's back and the angel's wings, can be read abstractly; Epstein's habitual relish for the subtle interplay of

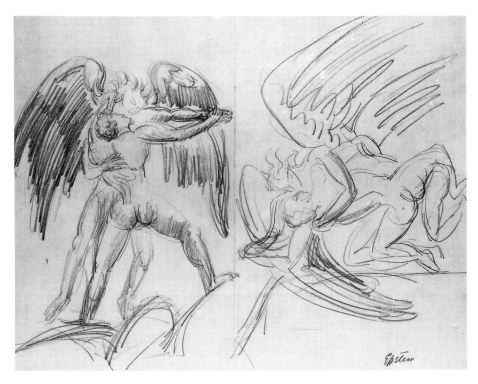

26 *Studies for* Jacob and the Angel, *pencil, 44.5 × 57.5cm. (Liverpool University)*

barely perceptible asymmetries manifests itself in the rhythmic cadence of back, buttock, thigh and calf. By carving boldly into and through the soft, pinkish alabaster, he created areas of deep shadow to contrast with the translucency of the polished surface. It is perhaps not accidental that the fierce embrace contains echoes of Gill's stone relief *Ecstasy* (fig. 7), for it is to Epstein's early work, especially the *Flenite Relief* (no. 44), and to Brancusi's *The Kiss* (fig. 11), that this figure seems to refer. Only a couple of years earlier Epstein had returned to Paris to get the atmosphere for his illustrations to Baudelaire's *Les Fleurs du mal*; he visited the ascetic Brancusi whom he had always admired and defended, but now found his work repetitious and arid.[17] It may not be entirely fanciful to suggest that one factor in the creation of this group may have been Epstein's desire to demonstrate the continuing variety he could give to the theme which had dominated so much of his own and Brancusi's career. He might choose a time-honoured subject and remain true to its traditional iconography (even to indicating Jacob's injured leg) but in essence it is still the mysterious carnal and spiritual duality of the creative act he is celebrating.

[17] Epstein 1955, p. 223.

Lazarus

Seven years later the element of competitive striving and spiritual tension had gone. His last

[18] Now in the British Museum (Af1 1); W. Fagg, *The Tribal Image*, London, 1970, no. 27, ill.

[1] Haskell, *Balletomane at Large*, London, 1972, p. 61.

[2] Epstein to P. Hornstein, May 1948.

[3] D. Sutton, 'The Significance of Epstein', *Country Life*, 112, 1952, p. 1194.

majestic, free-standing carving, *Lazarus* (no. 391, plate 33), draws into a triumphant synthesis formal and expressive elements from works as diverse as the second *Doves* (plate 9) and the *Risen Christ* (plate 13). *Lazarus's* monolithic form is imbued with a poignant tranquillity; still swathed within the bands that cling to the contours of his body, his upturned head, held within the rigid cradle of his collarbones, is turned at an acute angle. The life-giving link between thought and action seems to be broken even as the fall of light on the face offers the hope of resurrection. Though the motif of the sharply turned head seems to stem from the twisted head of a child carried upon its mother's back in a Nigerian carving he owned, this faint echo fades into insignificance along with others—from Michelangelo and Donatello—in the resolution of this moving work.[18]

Late Harvest 1940–1959

By the end of the Second World War, Epstein was sixty-five and could be regarded as the Grand Old Man of British sculpture. However, he was still far from being an establishment figure; neither a Royal Academician nor a member of the Royal Society of British Sculptors, his last public commission had been the London Underground building in 1928. It was only during the 1950s that he received belated recognition in a deluge of official commissions, prestigious portraits and honours. By that time he could scarcely believe it. Typically, he nearly put the offical envelope informing him of his knighthood aside unopened, thinking it was an income tax demand.[1]

Once again he was not an official war artist, though the War Artists' Advisory Committee commissioned six portraits (nos. 324, 331, 361, 367, 368), including one of his neighbour in Hyde Park Gate, *Winston Churchill* (no. 371). During these years he had been busy with the completion of *Jacob and the Angel* (no. 312), some portrait commissions, his small *Nude Studies* (nos. 341–53) and his two large bronzes, *Girl with Gardenias* (no. 336) and *Lucifer* (no. 362). He also contributed a note of exuberant colour and optimism to the drabness of wartime London with his watercolours of flowers and Epping Forest landscapes. When *Lucifer* was exhibited in November 1945 it met with a mixed reception and was turned down as a gift by both the Tate Gallery and the Fitzwilliam Museum. Even his great carving, *Lazarus*, first exhibited in 1948, was only sold four years later. There were personal troubles too. In 1947 Peggy Epstein died, having been in bad health for some years. Epstein undoubtedly missed both

her devoted companionship and her management of his business affairs, especially as he was still struggling with the legal and financial difficulties of purchasing 18 Hyde Park Gate. His twelve-year-old, younger son, Jackie, was sent to stay with Peggy Jean in the USA. Kathleen Garman soon came to lend him her affection and support, but the insecurity of this period is reflected in his letters to Peggy Jean. In May 1948, he wrote: 'My main anxiety is that I do not feel secure in any way, although I am currently selling things and working at portraits.'[2]

However, the tide was beginning to turn. In 1949, *Youth Advancing* (no. 423) was commissioned as part of the Festival of Britain exhibition on the South Bank, and this was soon followed by the lead *Madonna and Child* (no. 438, plate 34) for a prominent public site in Cavendish Square. This was a vital commission. When it was unveiled in May 1953, it became abruptly apparent that Epstein was the only British sculptor willing and able to infuse traditional Christian themes with freshness and conviction. Commissions for the Llandaff *Christ in Majesty* (no. 475, plate 44) and *St. Michael and the Devil* (no. 503, plate 48) for the new Coventry Cathedral followed, as well as a number of ecclesiastical portraits and memorials, ranging from the Blake Memorial (no. 498) in Westminster Abbey to a bust of the Archbishop of Canterbury (no. 516). The other major project was a monumental group, *Social Consciousness* (no. 451, plates 39, 40) for Philadelphia, the only large commission he had received from the country of his birth.

In the meantime there were other significant signs of official recognition; a retrospective exhibition of his work at the Tate Gallery in 1952 confirmed his status as the senior British sculptor. One contemporary assessment saw Epstein as 'a traditional artist in the sense that Barlach is one, concerned with the broad problems of human existence. It may be felt that the spiritual intensity has not always matched his intentions, but in certain works—among them the *Lazarus* 1949—he has created some of the most moving sculpture of our time.'[3]

In 1953 he was finally offered membership of the Royal Society of British Sculptors. He refused it; they had given him no backing when he needed it in 1908, and turned him down for membership shortly thereafter, and he had not forgotten. He was far more delighted by his honorary doctorate from Oxford University in 1953, and by the knighthood he received from the hands of the Queen Mother in 1954.

Having been an outcast for so long, he was touched and surprised by the warmth of his welcome at the Royal College of Art, where he had

been lent a huge studio to work on *Social Consciousness*, *Liverpool Resurgent* and *Christ in Majesty*. Repeatedly he wrote to his daughter of how well he was being treated: 'I see many young people working away, boys and girls who are not at all bad. There is quite some talent here and they seem to like my being here.'[4] The Office of Works commissioned a statue of *Field Marshal Smuts* (no. 483, plate 43) for Parliament Square; Epstein may well have had mixed feelings about this commission since he had always been unmercifully rude about public monuments. Certainly the figure, often known as 'The Skater' is not entirely successful. In 1955, on a visit to Washington soon after the completion of *Smuts*, he told reporters who asked his views on the public sculpture of the capital, that it was 'all so official, generals on horseback, generals on foot, generals looking important. But there was nothing I saw that was really sculpture.'[5]

New commissions poured in. He had to turn down a request from the John Lewis Partnership who wanted a sculpture for their new Oxford Street store: 'I don't see how I could do them in two lifetimes,' he wrote in December 1954.[6] Fortunately Epstein had always been robust; his dealer Oliver Brown recalled:

He was a man of great physical strength, whose broad shoulders and powerful limbs retained signs of vigour to the end of his life. Indeed he changed very little and never seemed to grow old. I have seen him carry heavy pieces of stone and large bronze busts in a way that not only astonished a small man like myself but surprised our staff at the galleries who were used to heavy burdens.[7]

Since he had always employed an assistant only for plaster moulding and otherwise carved and handled all his clay alone, such strength was essential. However, he was now in his mid-seventies and working even harder than before. Despite the honours he received, 1954 was a terrible year, marked by the tragic deaths of two of his children—Theo, whose talent as a painter had already been recognized with an exhibition at the Redfern Gallery, and his youngest daughter, Esther (no. 355, plate 29, nos. 398, 405). Though outwardly stoical and continuing to work, Epstein was deeply distressed and Kathleen was distraught. On 27 June 1955, shortly before Epstein left for America to see *Social Consciousness* installed, he and Kathleen were quietly married. Now, for the first time, Epstein's letters betray exhaustion; in May, he, who would never normally take a holiday, confessed to his daughter how much he was looking forward to getting

away: 'I am worn out with work and only want to rest and not think of sculpture heaps of which will await me to be finished on my return.'[8]

Soon after his return he embarked on the carving of the *TUC War Memorial* (no. 490, plates 45, 46), which involved working in winter in the middle of a building site, and on the modelling of *St. Michael and the Devil* (no. 503, plate 48) for Coventry Cathedral: 'I am inundated with requests for work on buildings, large works which I don't know I will ever be able to accomplish. I was for so long without any commissions, I don't feel like turning down anything that comes my way: but it is all coming too late I'm afraid.'[9]

In March 1958 he was seriously ill with pleurisy and thrombosis, and it was thought unlikely he would recover, but he did, spending part of his convalescence on a tour of northern Italy and of French cathedrals. Kathleen forced him to take more rest, but he was undeterred in his appetite for new work. Late in 1958, he began work on the huge *Bowater House Group* (no. 522, plate 47) which was completed on the day of his death, 19 August 1959. Amongst his projects for new work had been designs for stained glass and an *Ascension* (no. 513) for Crownhill Church, Plymouth, and a Crucifixion, commissioned by Louis Osman for Ely Cathedral.

Monumental Bronzes

Epstein's output after 1945 is dominated, for the first time since before the First World War, by large symbolic works. All these sculptures, with the exception of *Lazarus* (no. 391, plate 33) and the *TUC War Memorial* (no. 490, plates 45, 46), were modelled. Two, *Lucifer* (no. 362, plate 32) and *Girl with Gardenias* (no. 336) were free-standing bronzes made with no particular location in mind. But the rest—the Cavendish Square *Madonna and Child* (no. 438, plate 34), the Llandaff *Christ in Majesty* (no. 475, plate 44), *Liverpool Resurgent* (no. 476, plate 42), *Field Marshal Smuts* (no. 483, plate 43), *Social Consciousness* (no. 451, plates 39, 40), the *Bowater House Group* (no. 522, plate 47) and *St. Michael and the Devil* (no. 503, plate 48)—were commissioned for specific sites.

Epstein was never closer to being a Romantic sculptor in the Rodin tradition than when he created his monumental *Lucifer* (no. 362, plate 32). Easily the largest of his uncommissioned bronzes, it is also the only work with a literary, as opposed to Biblical or symbolic, theme. The scale and subject are Rodinesque and it may well have been intended as his riposte to *Balzac* (fig. 27) and *The Gates of Hell*, though its immediate stimulus was more probably the Second World War. Since the

[4] Epstein to P. Hornstein, 23.3.1955.

[5] Haskell, pp. 98–104; Epstein 1940, p. 148; Obituary, *Washington Post*, 22.8.1959, B2.

[6] Epstein to P. Hornstein, 12.12.1954.

[7] Brown, p. 55.

[8] Epstein to P. Hornstein, 19.5.1955.

[9] Epstein to P. Hornstein, 30.4.1956.

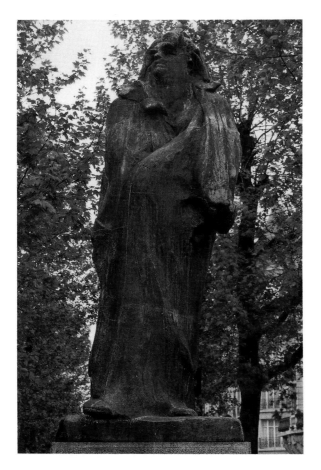

27 Rodin, Balzac, 1897, bronze (Paris, Musée Rodin)

late thirties he had been planning a large-scale piece on some subject connected with man's fall from grace, but it was only gradually that his original idea of a group sculpture or bas-relief was succeeded by the monumental, free-standing figure. Drawings indicate that he experimented with a bas-relief of Adam and Eve's expulsion from Eden, as well as making maquettes of *Adam and Eve* and the *Burial of Abel* (nos. 291, 292). Once he had chosen Milton's epic account of the fall of the rebel angels in Book One of *Paradise Lost*, he produced maquettes for a group and a bas-relief; the latter, *Fall of Lucifer* (no. 361), shows Lucifer standing, arms raised, above the surging bodies of his tumbled host. The composition of the threshing mass allies it to traditional iconographies of Hell and to Rodin's *The Gates of Hell*, a vision of Dante's *Inferno*. The maquette, *Lucifer, Belial and Beelzebub* (no. 338), makes a dramatic and powerful design in its planar frontality, which is reinforced by the pattern of the angels' wings, and balanced by their 'skirts'. The dynamic silhouette was conceivably inspired by an Antique model, such as the *Nike of Samothrace* (Louvre), though the drapery is not intended to amplify form or movement.

The general stance of the angel is retained in the final version, *Lucifer*. Apart from the genitalia, the figure is markedly androgynous; the head is based on Sunita's in *Israfel* (no. 199) and the hips and legs are also distinctly feminine. The breadth of the pelvis is emphasized by the straps round the figure's loins and by the restrictive chest-band, a motif surely taken from Michelangelo's 'Slaves' (Louvre). Unlike the rhetorical movement of *Girl with Gardenias* (no. 336) and *Youth Advancing* (no. 423), the supple, almost dance-like step of *Lucifer* and the powerfully modelled, asymmetric wings endow the figure with springy strength.

A comparison between the maquette, the final sculpture and the *St. Michael* (nos. 502, 503), to which both are closely related, is revealing of the compositional difficulties which beset Epstein in developing his first thoughts to monumental scale. The *Lucifer* maquette, like that for *St. Michael*, indicates Epstein's reliance upon strong, compact silhouettes. Significantly none of the figures in the *Lucifer* maquette have arms; the insistently planar quality of the composition suggests that the arms should remain contained by the plane and area of the wings in order to simplify the silhouette. In the final work, the mannered, up-turned hands weaken the dramatic impact of the whole. Unlike *Risen Christ*, where gesture is spare and clear, the meaning of this gesture is unclear but is given undue formal emphasis by being the only element which breaks the unity of silhouette and plane.

In *St. Michael* (plate 48), this dilemma is partly solved by having the warrior saint grasp his spear; his victorious stance with clenched fists and arms outspread, though still rhetorical, makes a lively and dramatic appeal, in contrast to the hard rectilinear expanse of the rest of the building.

There is a pictorial and theatrical element in Epstein's large bronzes which is least successful when it is most physically dynamic. Epstein's grasp of anatomy, so brilliant in his portraiture, frequently failed when it came to articulating the whole body. The studies of *Nan* (nos. 37, 38) and the *Nude Studies* of 1943–5 (nos. 341–53), indicate that this was not always the case, but the stricture does apply to many of his nude drawings and to several of the large bronzes. His articulation of figures in forward movement is rarely entirely successful; *Lucifer* works much better in this respect than *Girl with Gardenias* (no. 336), *Youth Advancing* (no. 423), *Liverpool Resurgent* (no. 476, plate 42) and parts of the *Bowater House Group* (no. 522, plate 47). All of these are variants on the same striding stance, and all lack organic flexibility, a sense of the natural *contrapposto* of the body in

motion; their stylized rigidity can, all too easily, appear mere rhetoric.

The other two large-scale single figures of his later years—the lead *Madonna and Child* (no. 438, plate 34) for the Convent of the Holy Child Jesus at Cavendish Square, and the aluminium *Christ in Majesty* (no. 475, plate 44) for Llandaff Cathedral —are outstandingly successful architectural sculptures. The acclaim which greeted the unveiling of the *Madonna and Child* in 1953 did more than anything else to rekindle appreciation of Epstein's work. The small, extended hands of the Christ child barely interrupt the flowing contour which links the Madonna's veil to her shoulders, and her draped, outspread arms to the descending folds of her robe. The outline and mass of the figures is related to the wall upon whose surface they appear to float. That the figures have a certain immaterial lightness while not appearing papery or flat is due to Epstein's highly developed technique of using the thin, clinging draperies and swaddling bands to model the essentially naturalistic bodies while minimizing the anatomical detail. This apparently simple method can be traced back to the *Risen Christ* and was employed to superb effect in *Lazarus* (plate 33) and *Social Consciousness* (plates 39, 40). Behind it lies not only Epstein's study of early Greek sculpture and the work of Donatello, but also his appreciation of the ethereal character of his treasured Lake Sentani figures which 'seem to reject the very quality by which sculpture exists, solidity of form'.[10] One is reminded of the ghostly corporeality of the swathed figures in Moore's underground drawings during the war, and of the draped seated figures he did during the later fifties, where the timeless simplicity of the garments similarly lends them a classical permanence. As a corollary to the generalization of the body, Epstein concentrated on the symbolic expression of the head and hands. Gesture is emphatic and clear, integrally related to the sculpture as a whole: the Madonna's gesture presents her son to the world while accepting the fate which He foreshadows by dual pose of welcome and crucifixion.

The Llandaff *Christ in Majesty* (no. 475, plate 44) has a flatter, more decorative quality evocative of Byzantine Pantocrator figures, as several contemporary critics noted; the contrast between the simplification of the torso and 'the remorseless naturalism of the head, face and hands' seemed appropriate both to its setting high in the dimly lit nave, and to its central message of 'the humanity and grandeur of Christ'.[11] The extent of Epstein's debts to the architectural sculpture traditions of medieval Europe serve as an important reminder that the critical cliché which depicts him as a Romantic sculptor in the Rodin tradition is over-simplified.[12]

Rodin's reputation was at its height in Europe and America during Epstein's youth, though he fell from favour during the 1920s and 1930s. Epstein always admired his work, even from 1912 to 1915, when Rodin's oeuvre could be classified with 'the sloppy dregs of the Renaissance' which Hulme wanted to sweep aside. In 1920, van Dieren sought to elevate Epstein by criticizing Rodin, but Epstein, who read the text in draft, wrote twice to his friend, reproving him for his injustice to the French master.[13] Clearly Rodin influenced his technique. His soft, impressionistic modelling, which fragments form and enlivens the material surface, was the basis upon which Epstein developed his own astounding technique. For Epstein, like Rodin, 'modelling became interesting and individual for its own sake; an element of imagination entered sculpture which included the grotesque.'[14] As the supreme modeller of the twentieth century Epstein was the heir of Rodin and acknowledged him: 'without dispute the greatest master of modern times'. He recognized *Balzac* (fig. 27) as his masterpiece; *Lucifer* and, still more impressively, the monolithic simplicity of *Lazarus* pay it homage. But the tectonic element, so important in Epstein's work, is lacking in Rodin, whose *Gates of Hell* 'even from a little distance have all the appearance of an anthill in commotion'.[15]

Epstein's exemplars for architectural sculpture were the cathedrals and churches of medieval France and fifteenth-century Florence. Not only did such work combine realism with a monumental gravity, but it was also designed for relatively restricted viewpoints. The columnar forms and commanding gestures of Romanesque portal sculpture, which had been a major influence on the *Risen Christ*, also inspired the Cavendish Square *Madonna and Child*, and the Llandaff *Christ in Majesty*. Donatello's work, especially the Florence Cathedral sculpture and *St. Mary Magdalen*, was also important for its dramatic intensity and for its setting—in niches or against plain masses of masonry.

Monumental Groups

New sculptural problems faced Epstein for the first time in creating groups of figures for *Social Consciousness* (no. 451, plates 39, 40) and *Bowater House Group* (no. 522, plate 47). Much earlier in his career, he had begun to work on a Deposition group (see nos. 119, 126) but he had never completed it, and his *Slave Hold* group (no. 318) was also abandoned half-finished. Several projected

[10] Epstein 1940, p. 218.

[11] T. Mullaly, *Daily Telegraph*, 8 and 11.4.1957.

[12] It became common from the 1920s onwards to see Epstein as a Rodinesque Romantic, and Dobson as a classicist in the tradition of Maillol, e.g. Ramsden, pp. 15–18.

[13] Epstein to van Dieren, 11 and 27.1 or 6.1920 (HRC).

[14] Epstein 1940, p. 247.

[15] Haskell, pp. 125–8; Epstein 1940, pp. 247–8.

[16] Marceau to Ingersoll, 22.10.1953 (FPAA).

[17] Tancock, p. 269, sees the figures as portraits to which the bodies are subsidiary.

[18] It is interesting to note that Henry Moore was employing similar means in his draped seated and reclining figures in 1956–7.

groups of figures for which maquettes were made, were similarly unrealized (nos. 291, 292, 376, 383).

The democratic idealism and grandiloquence which typified the themes chosen for the Samuels Memorial in Philadelphia, was also the spirit of Epstein's youth, captured in all its moral high-mindedness and muscular energy by Walt Whitman's poetry. Social Consciousness was, therefore, a subject to which Epstein, with his lifelong love of Whitman's poetry, could respond with complete conviction. The Fairmount Park Committee's response equally demonstrates that he had more than fulfilled their expectations of what the abstract theme should convey; after visiting the studio in October 1953, Henri Marceau, a member of the committee and Director of the Philadelphia Museum of Art, wrote to his colleague, Ingersoll:

> you will be delighted to hear that Epstein's Social Consciousness is magnificent—a really great and impressive, deeply moving work...I was completely overwhelmed by its impressive scale, its dignity and power and by a quiet tenderness I had not expected to find. To my mind it completely tells the story of a rather difficult and abstract theme.[16]

The vast Samuels Memorial placed the sculptures on terraces facing the river; both the staged grouping Epstein adopted and the exaggeration of the torsos and bent heads, to allow for perspectival distortion when viewed from below, were predicated by the monumental scale and frieze-like *mise-en-scène* of the Memorial scheme. The boldly simplified faces are similarly designed to carry from a distance and have moved a long way from the portraits from which they ultimately stem.[17]

Epstein's immediate choice of a seated, maternal figure for the centre of the group was a natural one. Not only was maternity a recurrent theme in his own work but several of Whitman's poems, such as *America* and *Thou Mother with thy Equal Brood*, personify America as an infinitely creative mother, welcoming people of every race and creed. She is perceived as a Madonna enthroned, her arms outspread to welcome all who approach her; Epstein called her 'The Eternal Mother' and 'Destiny'.

However, it is evident from his correspondence with the commissioning committee that he began work on the huge figures knowing only that they would form a triadic composition with the seated mother at the centre. He had not worked out their interrelations or even decided that the flanking figures should consist of pairs rather than the single figures envisaged by the maquette (no. 450). As a result, although the individual figures are powerful, *Social Consciousness* comprises three separate sculptures grouped together, rather than a unified group of individuals like Rodin's *Burghers of Calais*. The mother's gesture and the outward movement of the flanking figures supply the compositional links between them. Inconsistency creeps in, notably in the contrast of scale between the legs of the recumbent man and those of the central and right-hand group.

The slender limbs of the seated mother appear all the more delicate against the rock-like mass of her body. Though apparently influenced by the distortion of works such as Donatello's *St. Mark* for Florence Cathedral, the disproportion between different parts of the same figure is disturbingly large. On the other hand the figure projects unflinching compassion through its formally antithetical suggestion of unyielding strength and human frailty.[18]

The pair on the left is both the most original and most successful part of the composition; instantly recognizable as a variant on the Good Samaritan, the 'Consoler' steps forward to support the naked, fallen figure symbolic of 'the afflicted and downhearted of the world'. The interlocked pose and gestures create a spiral movement as the strong diagonal created by the Consoler's stride forward and outstretched arms is carried through the fallen man's left arm, shoulders and bent legs. Their restrained dynamism is balanced by the strong vertical accents of the afflicted man's right arm and body, and the Consoler's columnar, robed figure.

The group on the right, which Epstein originally intended to convey 'gladness and optimism', but which ended up symbolizing the peace of death, compounds themes and motifs from earlier work. The hanging body of the dying man, facing forwards but with his arms draped backwards over the shoulders of the standing figure, is a reworking of the boy in *Day* (no. 189, plate 19), while the tip-toe movement and cowled head of the supporting figure recall the *Girl with Gardenias* (no. 336) and the Cavendish Square *Madonna and Child* (no. 438, plate 34). Compared with the naturalistic stance and gestures of the other figures, this pair looks contrived and unbalanced, the weight of the huge, swaddled torso appearing particularly unstable above the floating and, by comparison, very spindly legs.

Epstein succeeded in creating a far more complete synthesis of naturalism, movement and design in two of the three bas-relief panels, *Children Playing* and *Children Fighting* (no. 478, plate 41),

which he added at his own suggestion to the doorway of Lewis's Store in Liverpool, immediately below *Liverpool Resurgent* (no. 476, plate 42). Exploiting his sympathetic and shrewd observations of his children, grandchildren and many child models, Epstein compresses their diverse activities into a series of overlapping planes and accelerates the careless abandon of their exuberance by repeated linear accents on arms, legs or flying hair. The spirit of Donatello's dancing children in the Cantoria of Florence Cathedral pervades these unpretentious pieces, which should rank among his finest work. They bring back into his late work the indomitable energy and linear strength that characterized his early sculpture.

An analogous attempt to infuse natural form with a spirit of abstract dynamism informs his last major work, the variously named *Bowater House Group* (no. 522, plate 47). It bears closer analysis than it has hitherto received for its response to the problems of its site. Its location, backed by a building, fronted and flanked by roads, means that it is viewed mainly by those approaching from either side and does not function as the kind of iconic, frontal group Epstein preferred. In the maquette (no. 521), he grouped his five figures—Pan, the music of whose pipes urges the others onward, father, mother, boy and dog—into a syncopated unit moving forward towards the park. His first thoughts about the group may well have been influenced by the dynamism of the recently completed *Marine Corps War Memorial* (fig. 28) near Arlington Cemetery, Washington, which had been based on the Pulitzer Prize winning photograph by Joe Rosenthal.[19] Epstein is unlikely to have missed this newly completed and celebrated work, which had been unveiled in November 1954, only a few months before his visit to Washington. Just as he had in his *Children Playing*, but with far greater directional force, to which the Washington sculpture may have contributed, Epstein uses the reiterated line of limbs at full stretch to give co-ordinated, upward and forward thrust. Even in the rapidly modelled maquette, the abstract dynamism of the group is implied in the exaggerated dimensions of the woman's body and arms. To maintain impetus—to leap, as it were, over the road which forms the physical and spiritual boundary separating the family from the freedom of the park—her outstretched hands spearhead their headlong flight. In the maquette there is a natural cadence and rhythm to the group, but the finished work does not live up to its promise, the impetus of the group acquiring a hard uniformity while losing its rhythmic subtlety, and the Pan figure, in particular, becoming grotesque. These faults not-

withstanding, the theme of the group, with its musical emphasis and physical abandon, is highly personal.

Music had always been one of Epstein's chief pleasures. Many of his closest friends were musicians and a grand piano, often played by friends and visitors, took pride of place with sculpture in the drawing room at Hyde Park Gate. His autobiography contains a perceptive chapter on music, and he related the evolution of several of his sculptures, notably *Consummatum Est* (no. 275), to the inspiration of Bach and Beethoven. He described Toscanini, conducting Beethoven's *Mass in D*, as 'a wonderful sculptor...moulding and conjuring the material in its varied and intricate shapes, lengthening out, scooping with tremendous curves, evening out great planes, broad sides of sound, compelling the advance and retreat with beckonings of the left hand, his expression determined, with dark eyes glowing with the profound emotion of the work.'[20]

If music brought Epstein repose and stimulus, so too did the life outside the city. Some of his earliest memories of personal freedom had been days spent reading in Central Park. His stay in the wilderness near Greenwood Lake had determined him to become a sculptor and, later, much of his best work was done in the tranquil surroundings of Pett Level or 'Deerhurst'. In its intense yearning for escape and repose, the *Bowater House Group* was as deeply felt a work as any he had created.

Conclusion

Outside the field of portrait modelling, where his technique was carefully studied and often imitated, Epstein lacked followers, but within the last few years his work has begun to attract the attention of other artists. Sculptors such as Elizabeth Frink, Glynn Williams and Anthony Gormley have found their own lessons in his daringly direct relationship with his materials and in the humanistic core of his work. With the recent return to figurative art and the raw use of media pushed to their functional limits, Epstein's disturbingly expressive power and careless virtuosity have taken on a new significance.

It has been the aim of this book to reassess Epstein's sculpture as a whole. Though a full biography of Epstein has yet to be written and much remains to be done on specialized aspects of his work, I have attempted to indicate the links between the sculptor's private preoccupations and the evolution of his art.[21]

What emerges is a powerfully intuitive artist of lasting stature whose resistance to artistic fashion

[19] J. M. Goode, *The Outdoor Sculpture of Washington, D.C.*, 1974, pp. 189–90.

[20] Epstein 1940, pp. 233–8.

[22] A biography by Stephen Gardiner is in preparation.

28 *Marine Corps War Memorial, Washington, DC, 1954*

and all group ideologies will keep him beyond the reach of glib period generalizations. Always ready to take risks and working compulsively hard throughout his fifty-year career, he produced many failures as well as masterpieces. Notwithstanding the eclecticism of his early career, his originality and continuing power to stimulate and disturb lies in his ability to touch the deeply rooted tension between individual and universal experience. Just as his best portraits transcend the individuals he portrays, the expressive impact of his carvings endows them with far more than formal or symbolic meaning.

The diversity and expressive depth of works such as *Doves*, *Rock Drill*, *Risen Christ*, *Visitation*, *Joseph Conrad*, *Woman Possessed*, *Behold the Man* and *Lazarus* should assure him a prominent place in the history of sculpture. The elemental themes which recur throughout his career—birth, love, maternity and death—have been crucial to many artists though few have treated them with the raw dynamism he did. Yet even when he is at his most abrasively direct, in *Rock Drill* and *Adam*, he is clearly in love with the act of creation, making new life, whether it be a new-born child or a new-born sculpture.

Dr Hewlett Johnson with his completed portrait at the Hyde Park Gate studio

PLATES

List of Plates

1 *British Medical Association Building, Agar Street and the Strand, London; photographed in 1908 (Charles Holden architect, 1906–8) (no. 9)*

2 Maternity *(detail), British Medical Association Building, London; 1908, Portland stone (no. 9.10)*

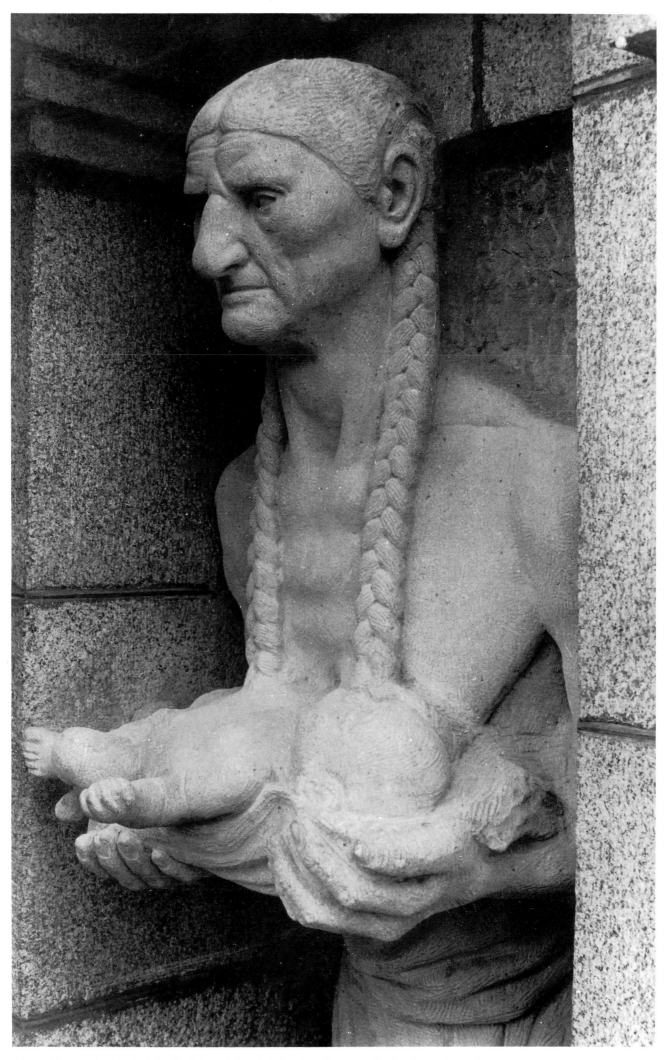

3 New-Born *(detail), British Medical Association Building, London; 1908, Portland stone (no. 9.8)*

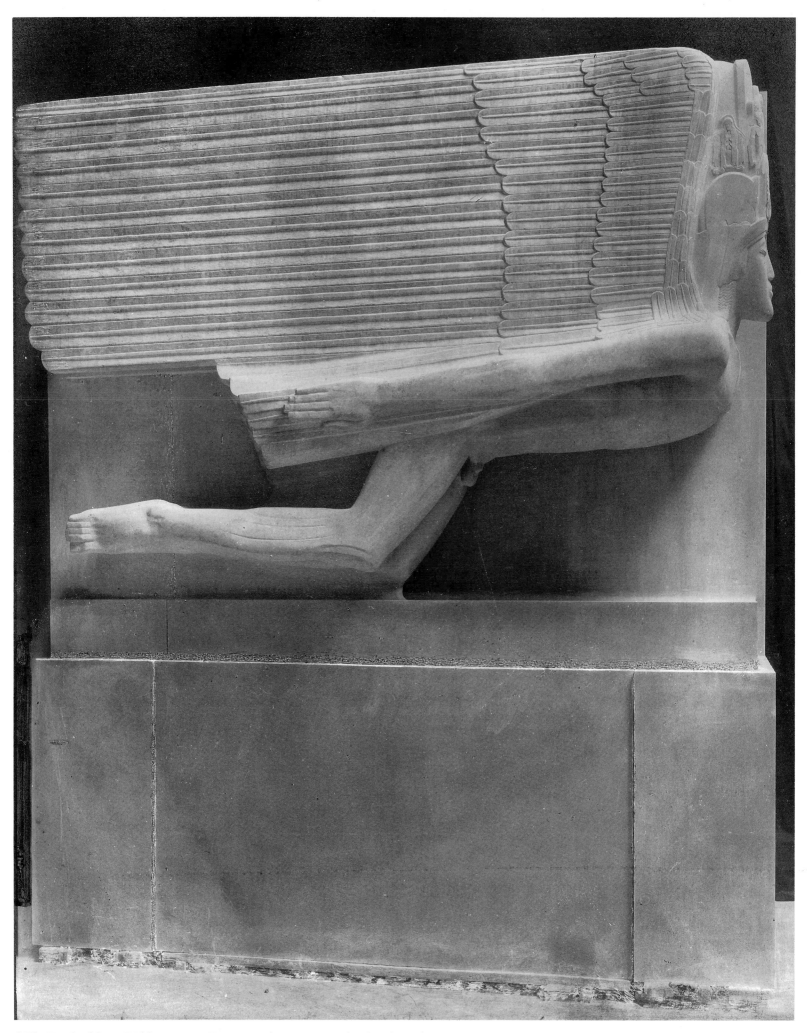

4 The Tomb of Oscar Wilde, *1909–12, Hoptonwood stone; as reproduced in* The New Age, *6 June 1912 (no. 40)*

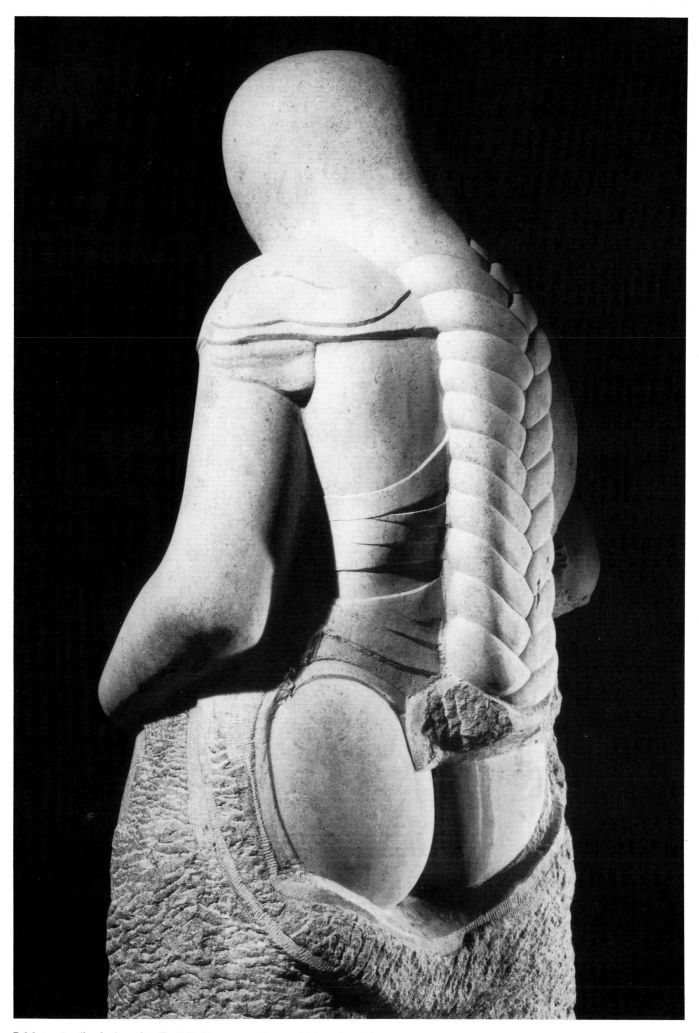

5 Maternity *(back view, detail), 1910, Hoptonwood stone, 206 cm. (no. 23)*

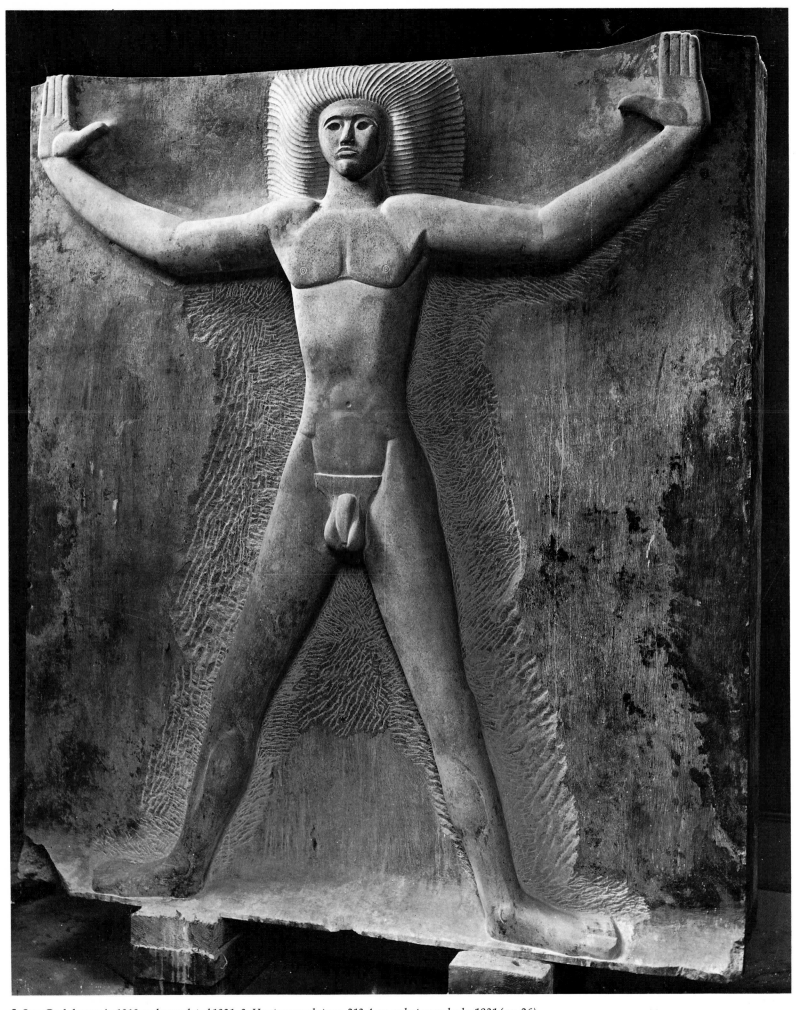

6 Sun God, *begun in 1910 and completed 1931–3, Hoptonwood stone, 213.4 cm.; photographed c.1931 (no. 26)*

7 *(opposite)* Sunflower, *c.1912–13, San Stefano stone, 61cm. (no. 42)*

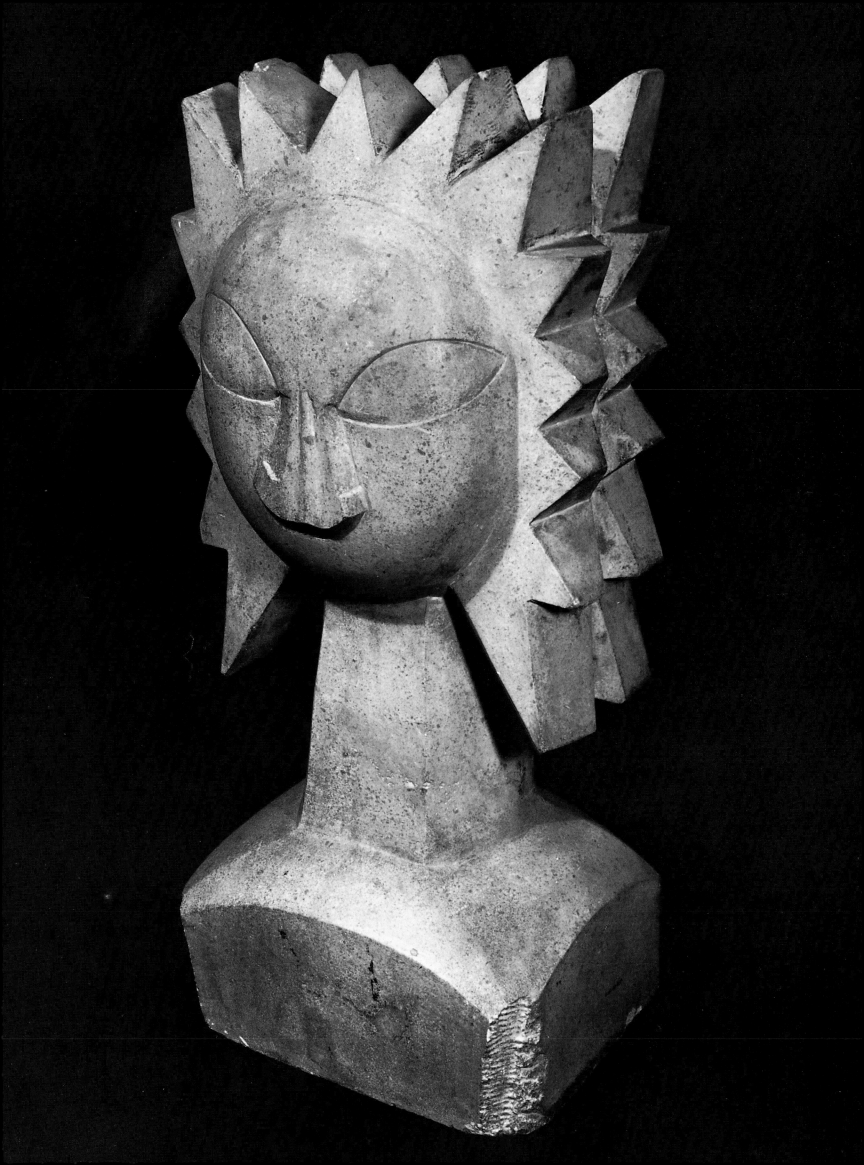

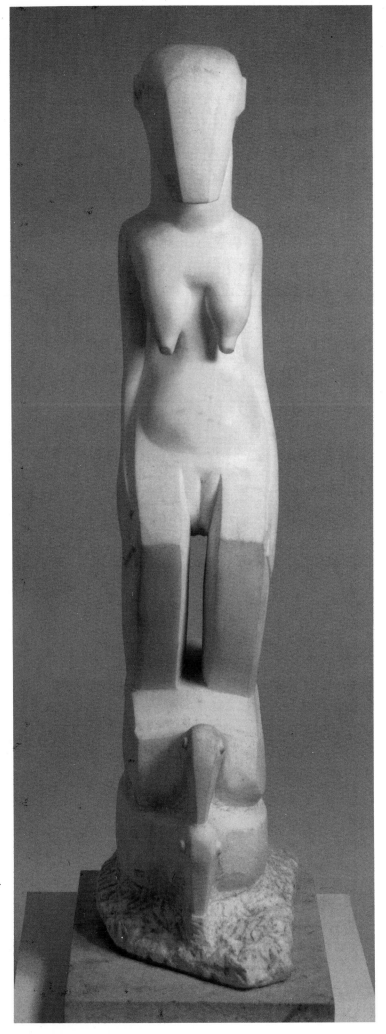 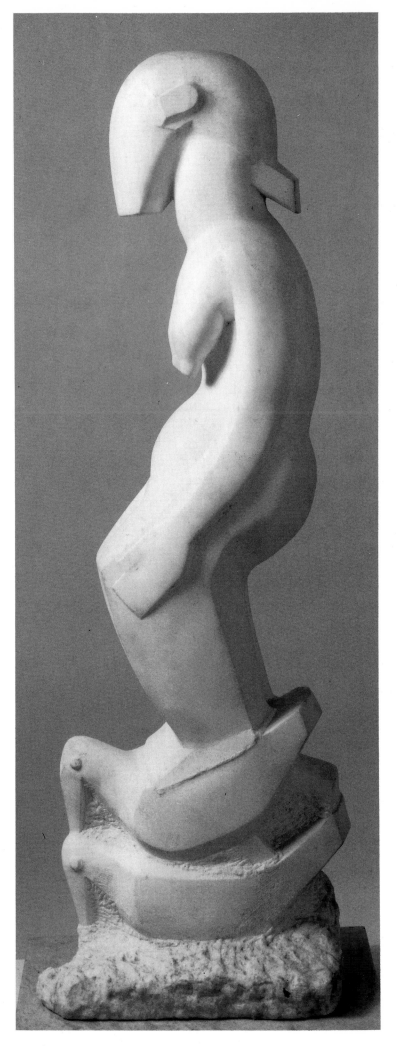

8 Venus—first version *(two views), 1913, marble, 123.2cm. (no. 49)*

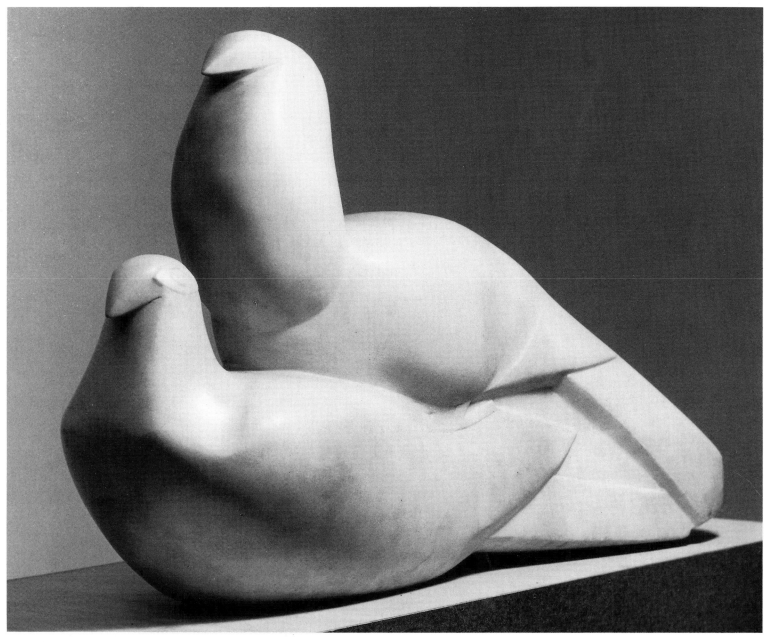

9 Doves—second version, *1913, marble, 47 cm. (no. 50)*

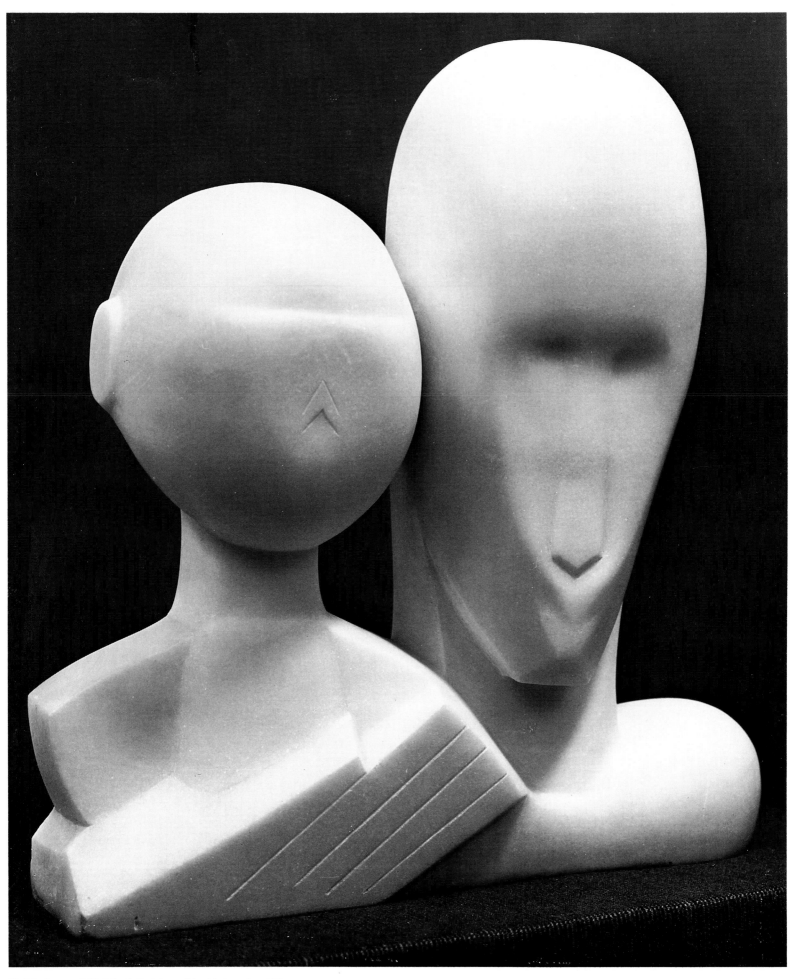

10 Mother and Child, *1913–14, marble, 43.1cm. (no. 52)*

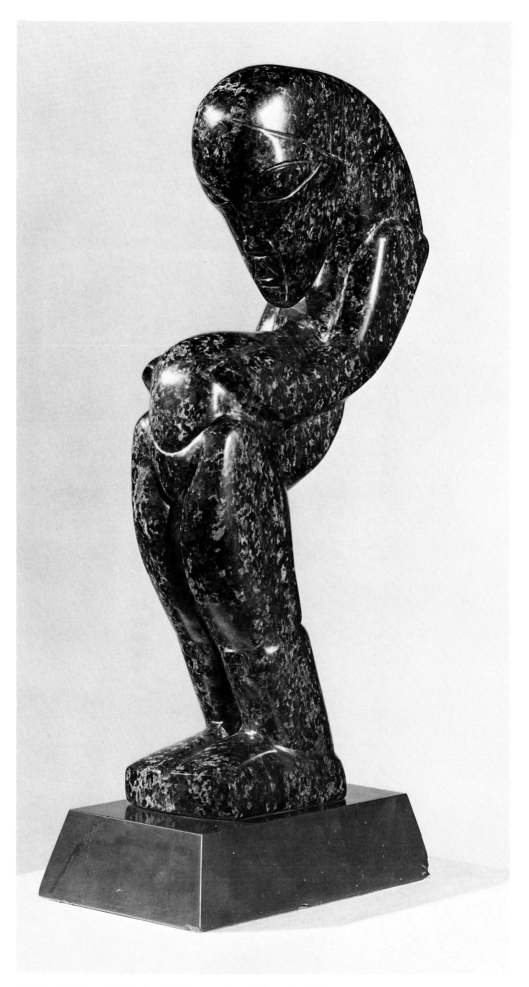

11 Female Figure in Flenite, *1913, serpentine, 45.7 cm. (no. 45)*

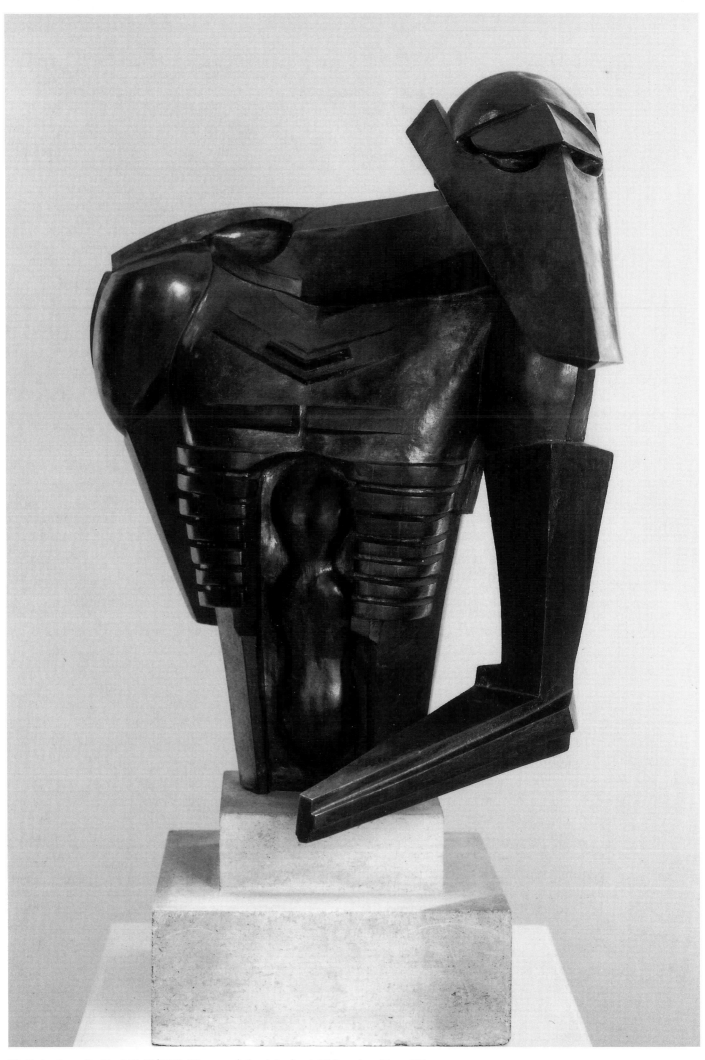

12 Torso from the Rock Drill, *1913–15, gunmetal, original cast, 70.8cm. (no. 54, cast 1)*

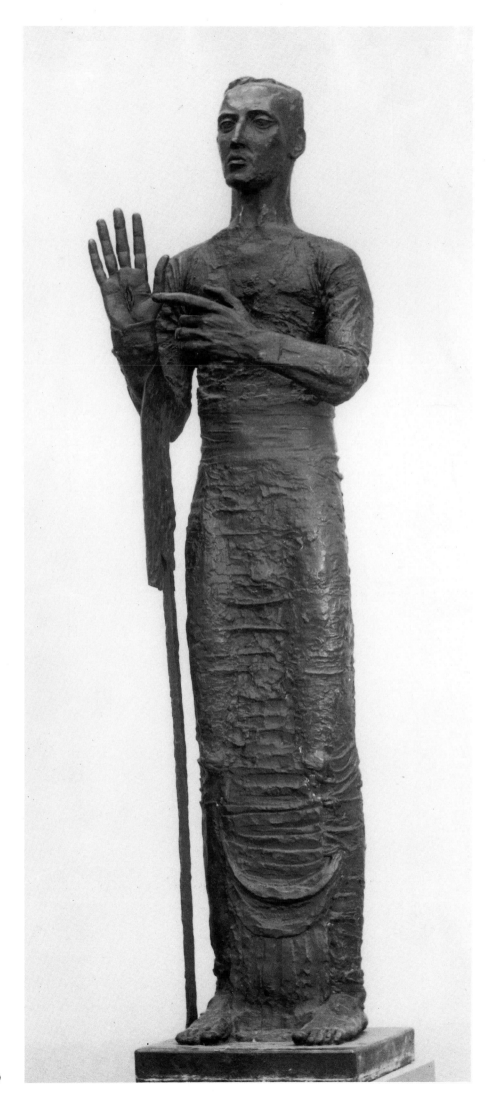

13 Risen Christ, *1917–19, bronze, 218.5 cm. (no. 97)*

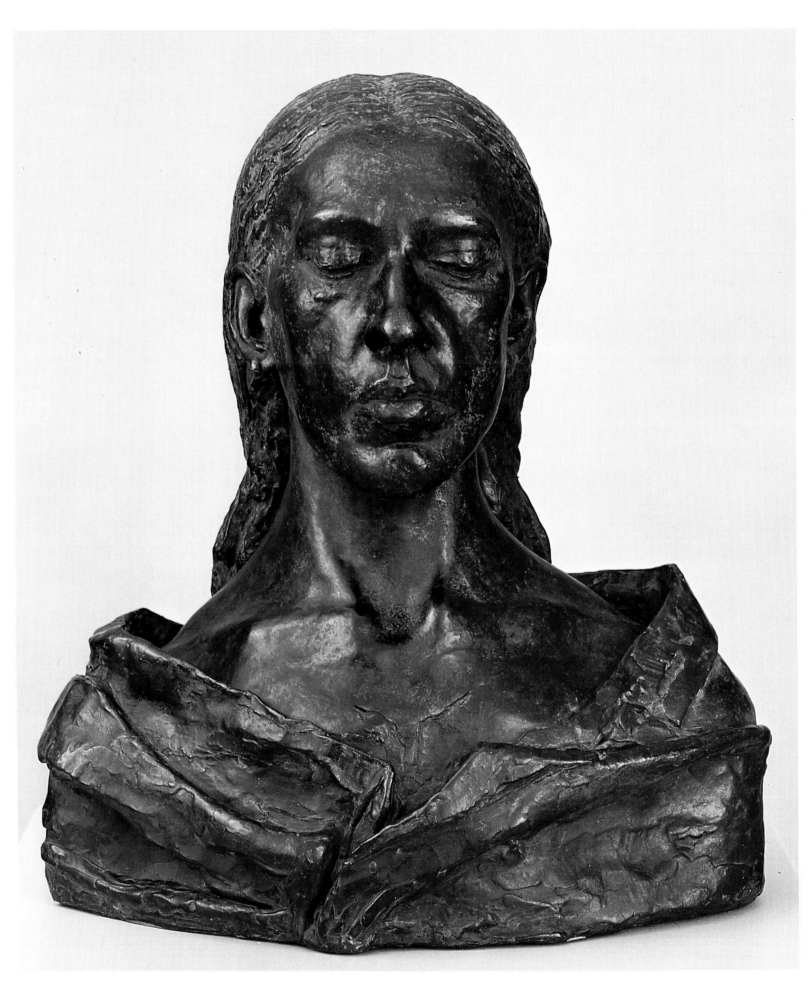

14 Bust of Nan, *1909, bronze, 44cm. (no. 17, cast 1)*

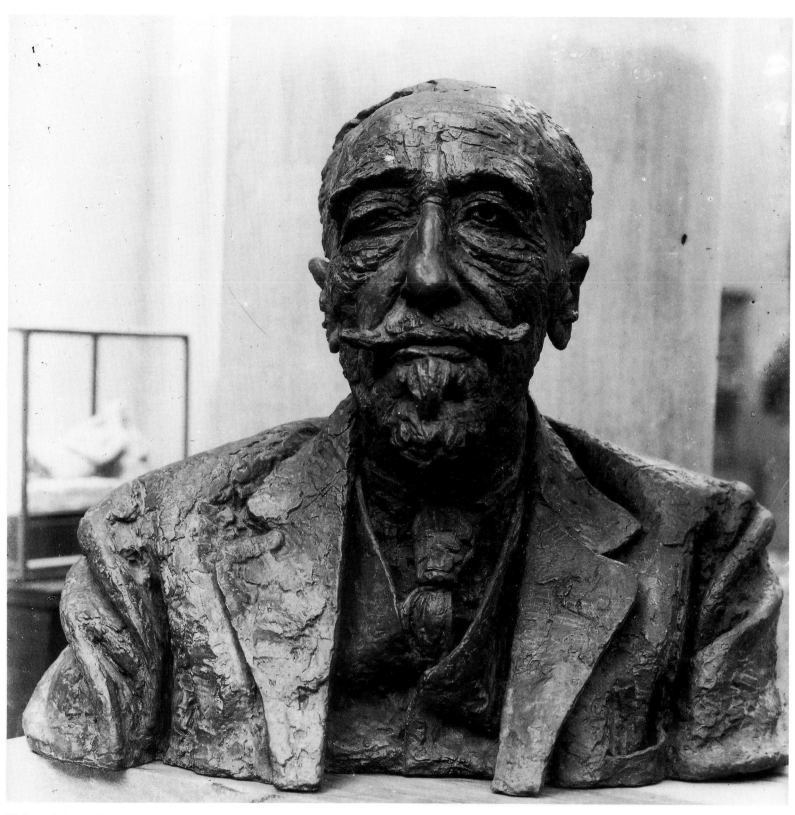

15 Joseph Conrad, *1924, bronze, 48.2cm. (no. 148, cast 2 or 3)*

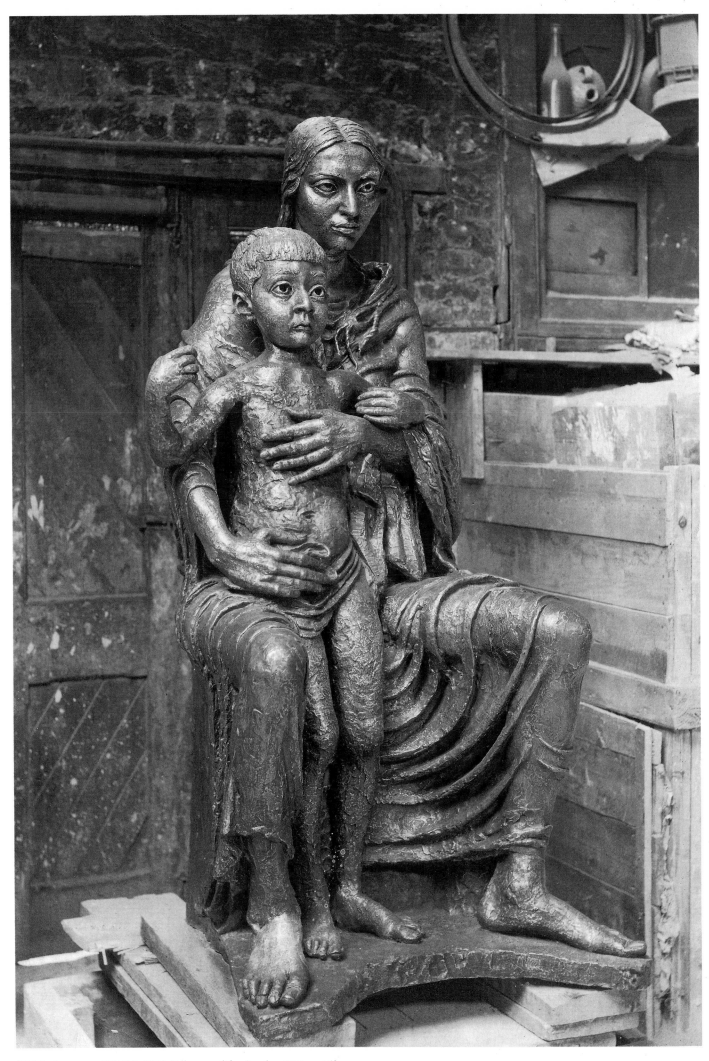

16 Madonna and Child, *1926–7, bronze, life-size, (no. 175, cast 1)*

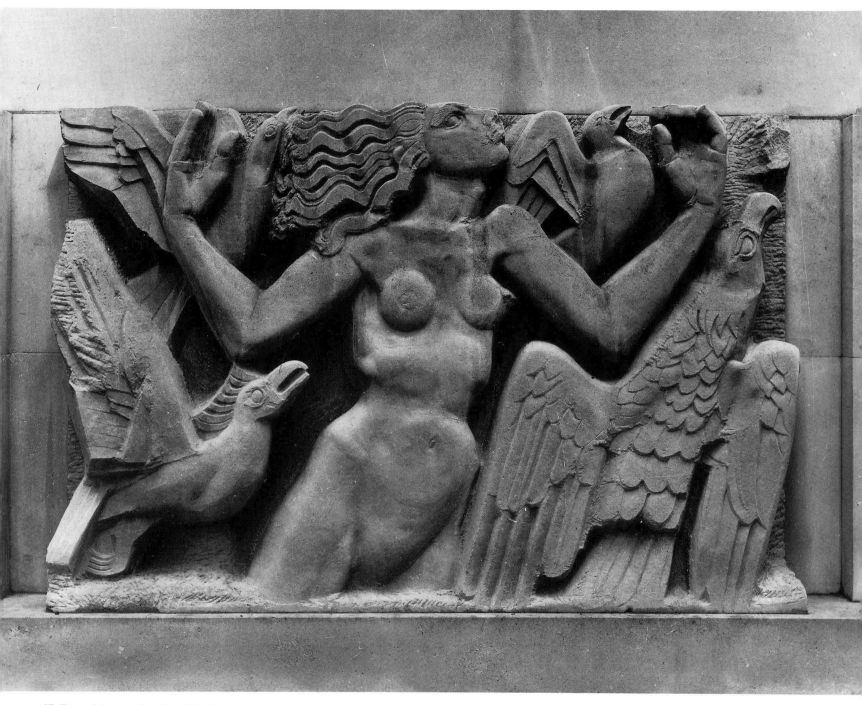

17 Rima, Memorial to W. H. Hudson, *1923–5, Portland stone (no. 147)*

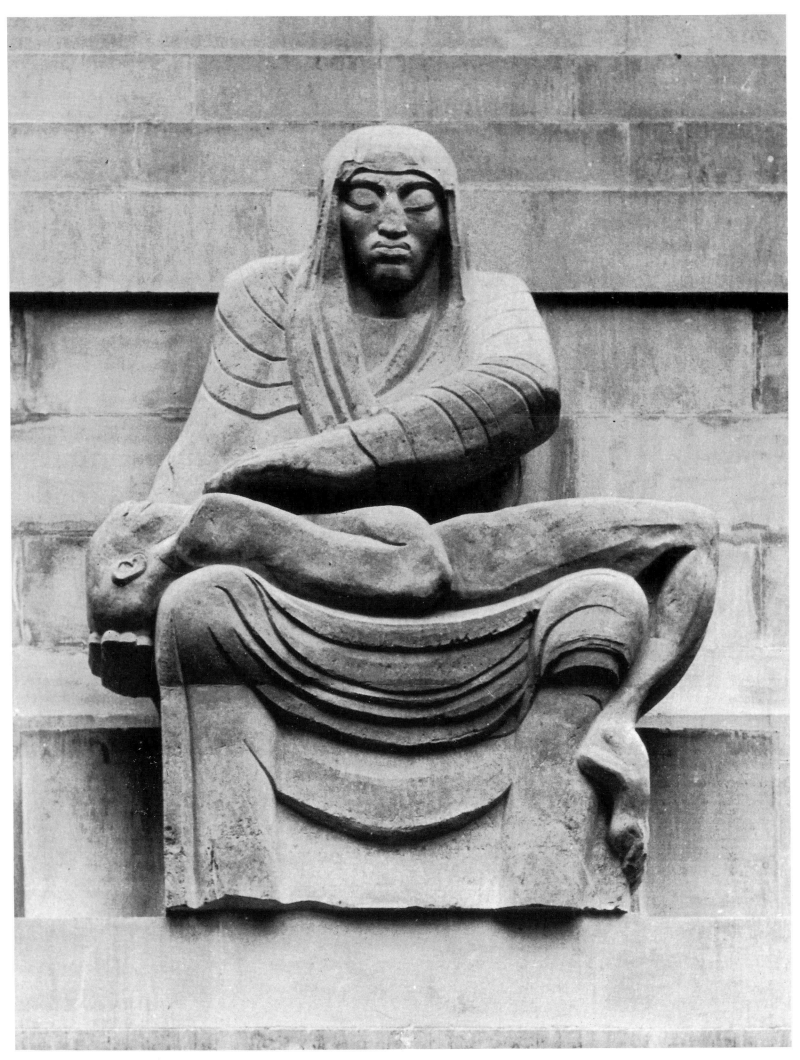

18 Night, *1928–9, Portland stone (no. 189)*

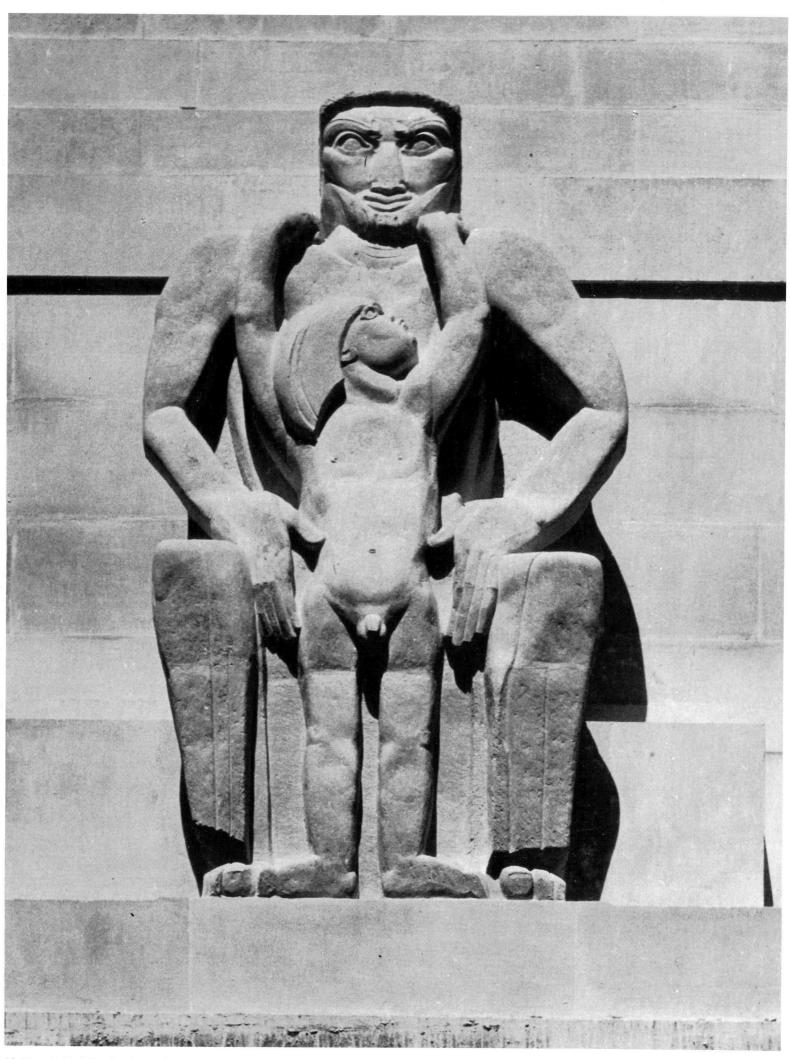

19 Day, *1928–9, Portland stone (no. 189)*

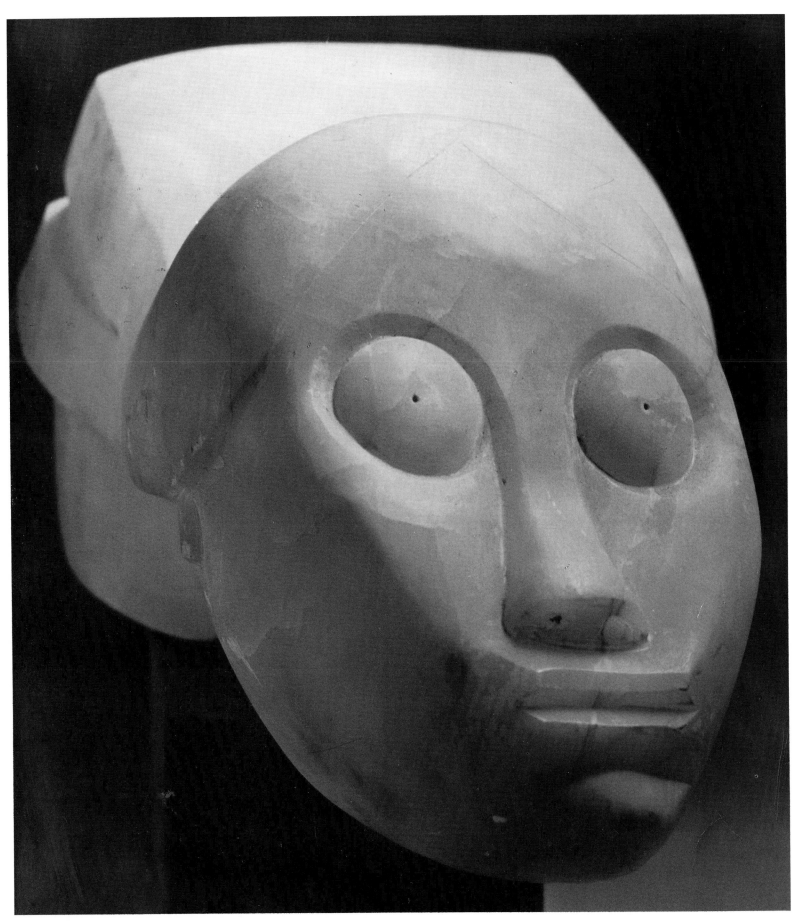

20 Chimera *1932, alabaster, 10cm. (no. 224)*

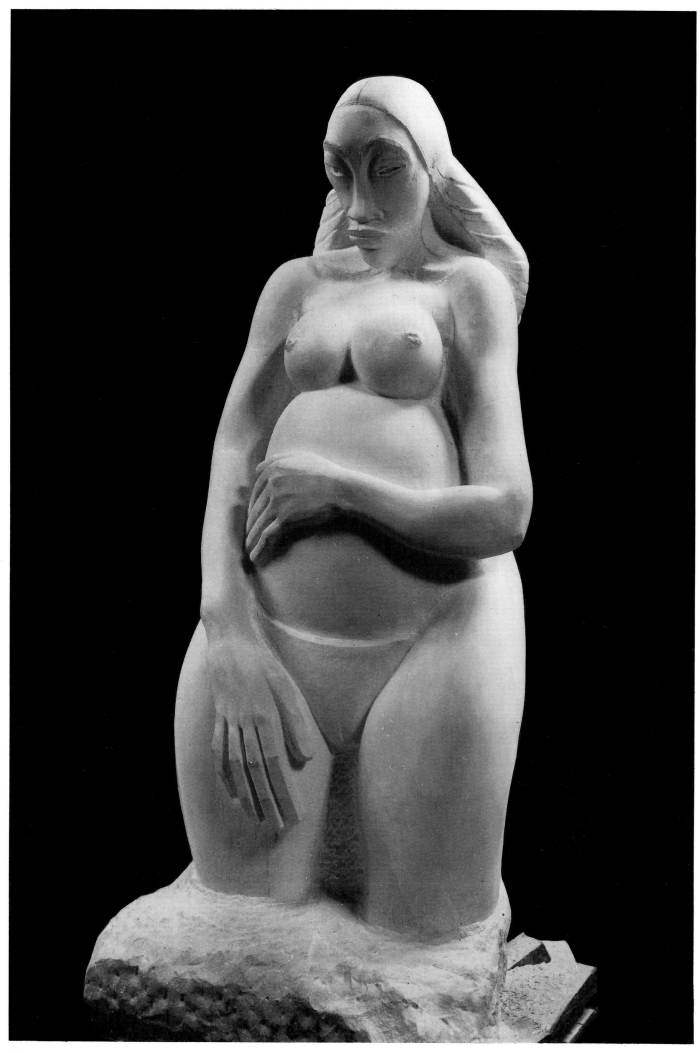

21 Genesis, *1929–30, marble, 158.1cm. (no. 194)*

22 Elemental, *1932, alabaster, 81cm. (no. 225)*

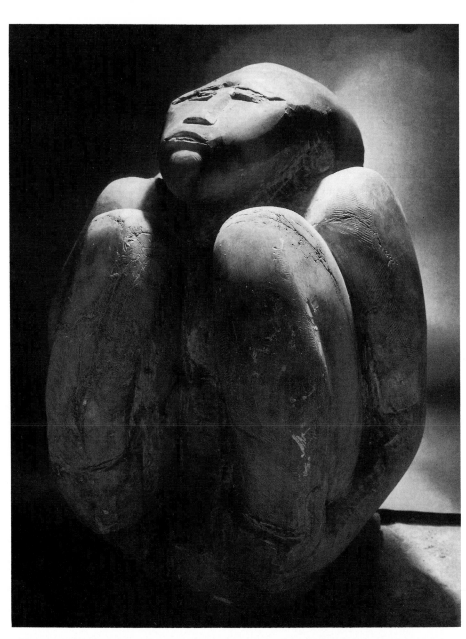

23 Woman Possessed, *1932, Hoptonwood stone, 107cm.*
(no. 226)

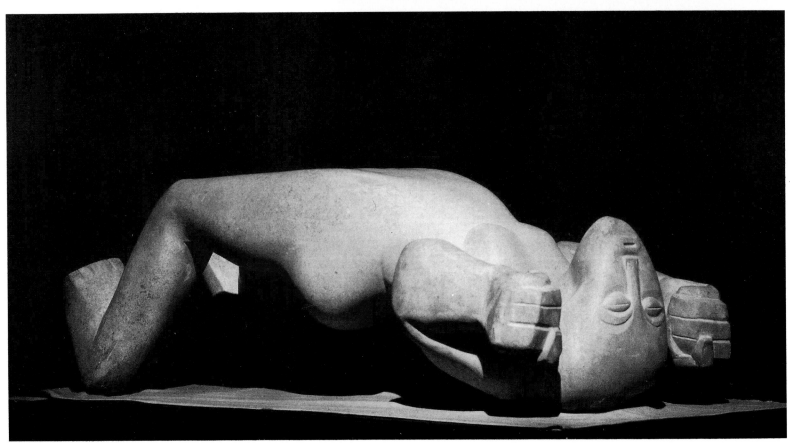

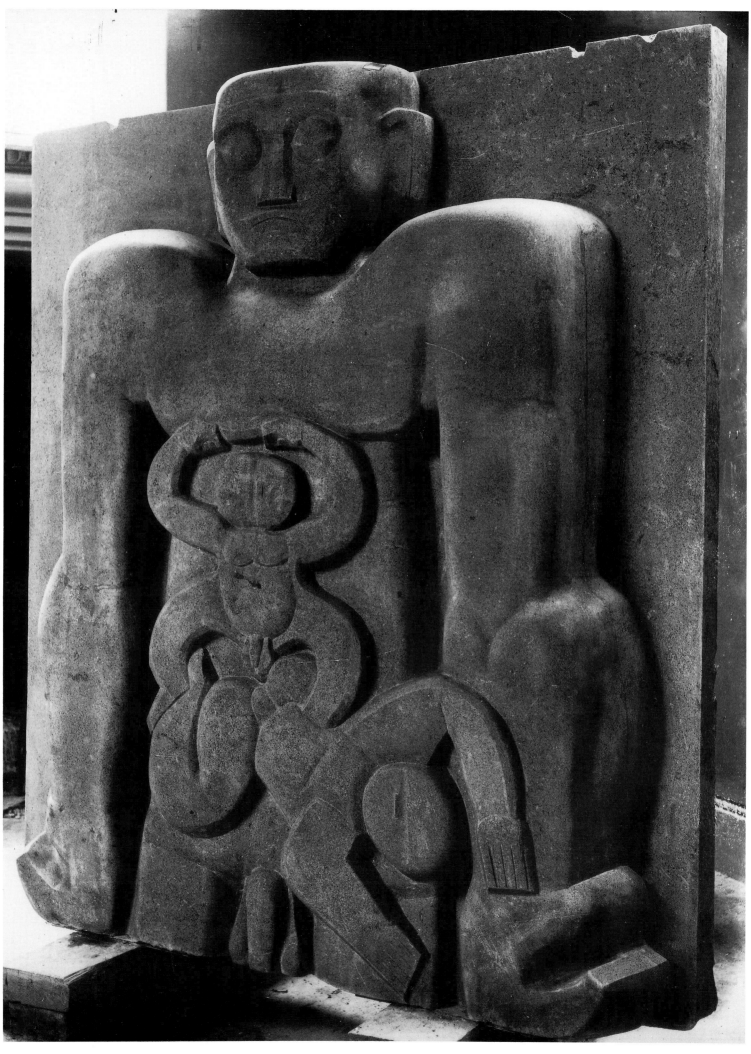

24 Primeval Gods, *1931–3, Hoptonwood stone, 213.4cm. (no. 218)*

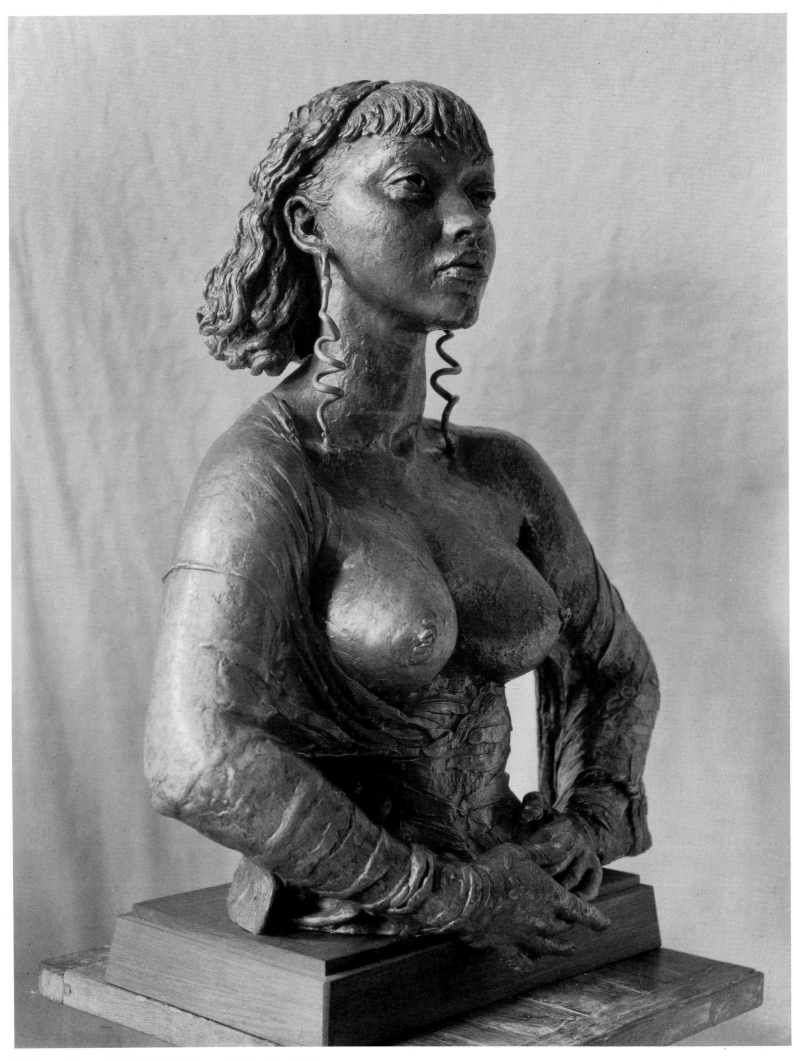

25 Second Portrait of Isobel, *1932, bronze, 70.6cm. (no. 232)*

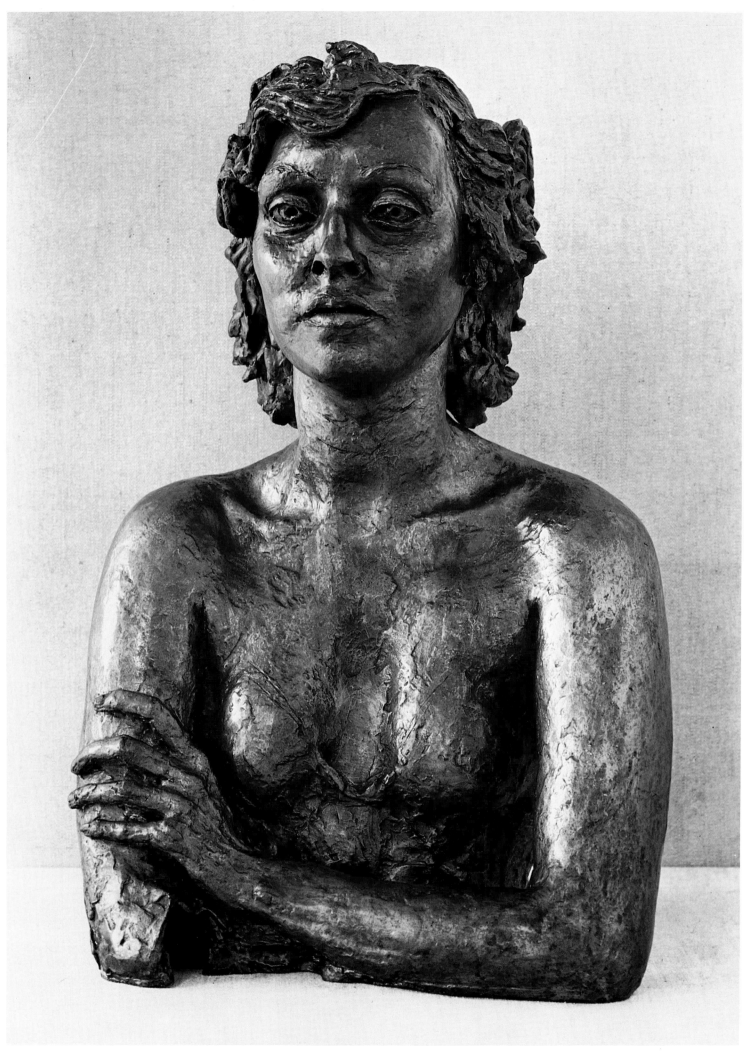

26 Third Portrait of Oriel Ross, *1931, bronze, 66cm. (no. 210, cast 1)*

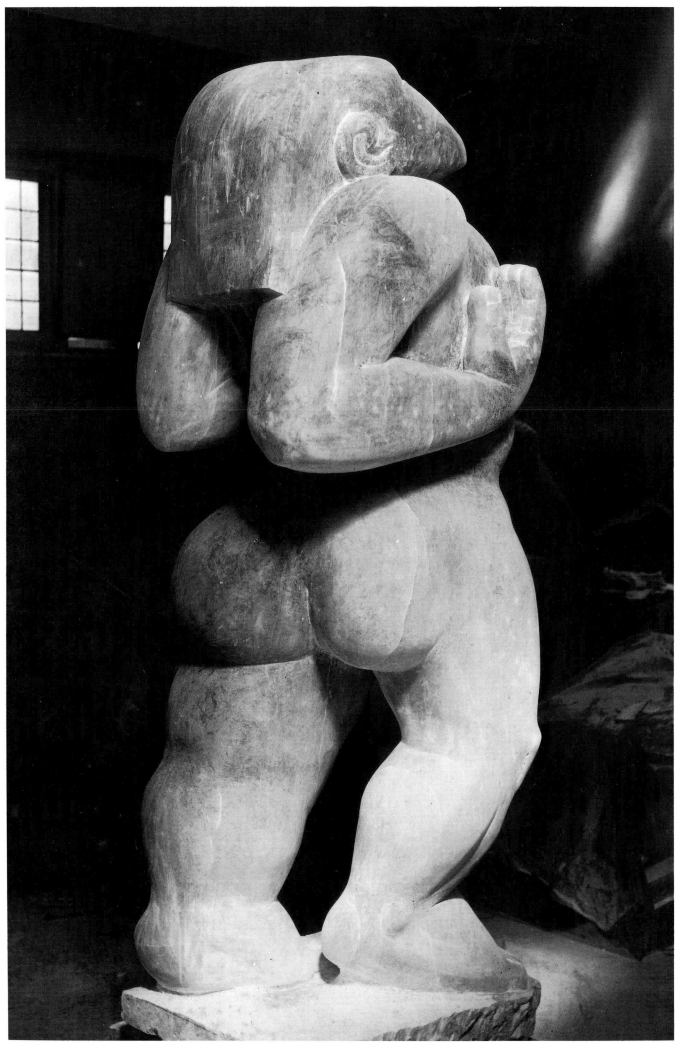

27 Adam *(before polishing), 1938, alabaster, 218.5cm. (no. 288)*

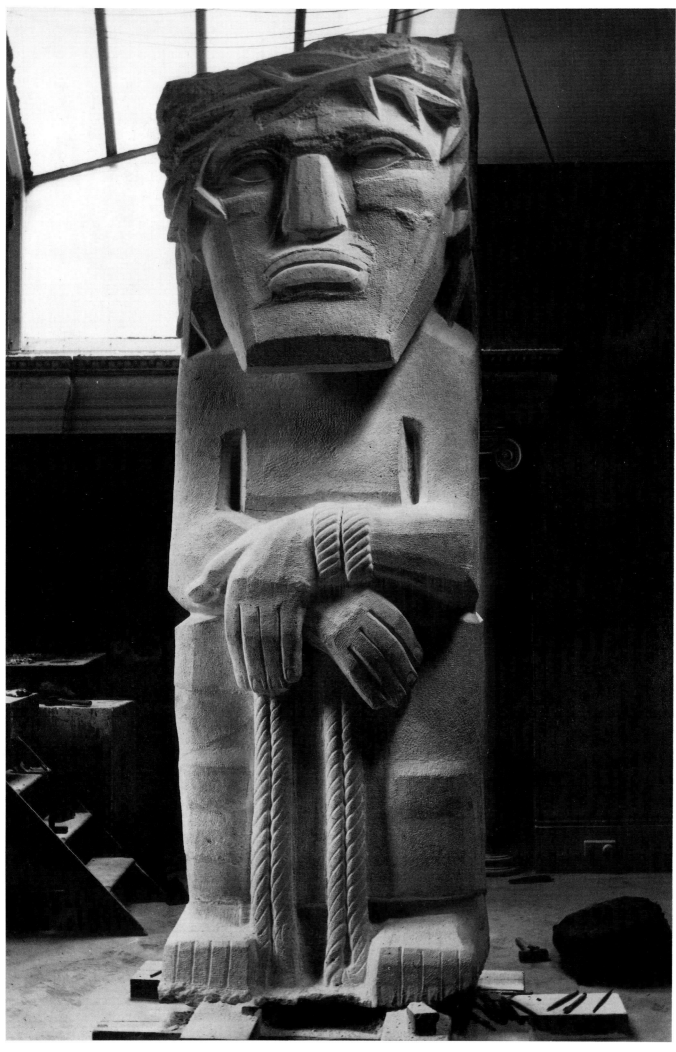

28 Behold the Man, *1934–5, Subiaco stone, c.300cm. (no. 246)*

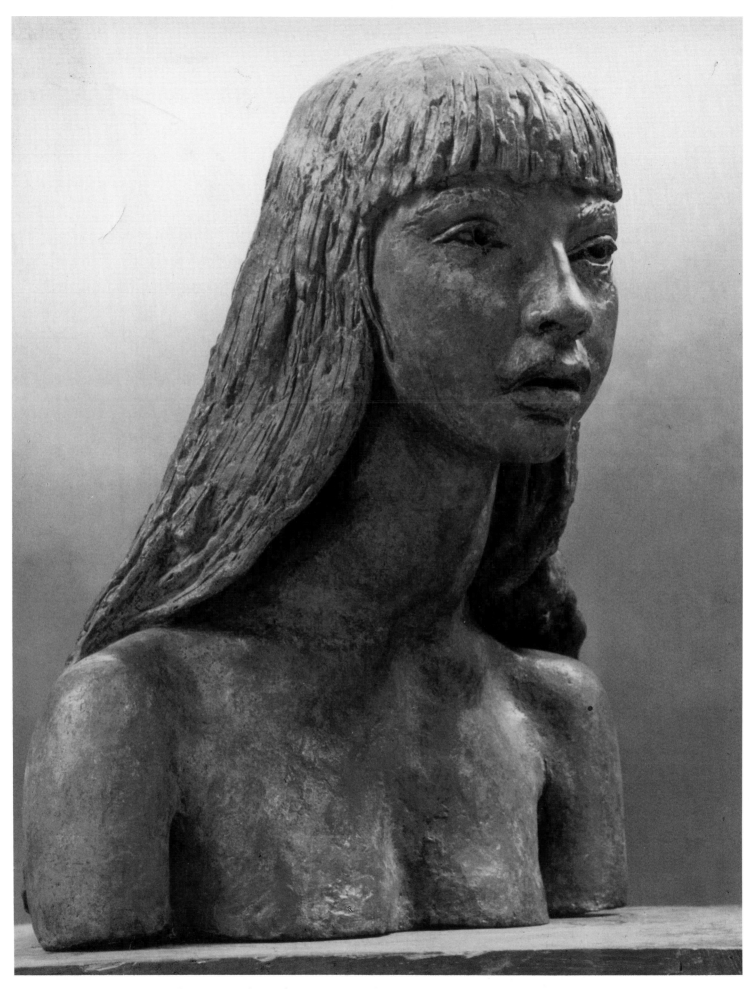

29 First Portrait of Esther, *1944, bronze, 47 cm. (no. 355)*

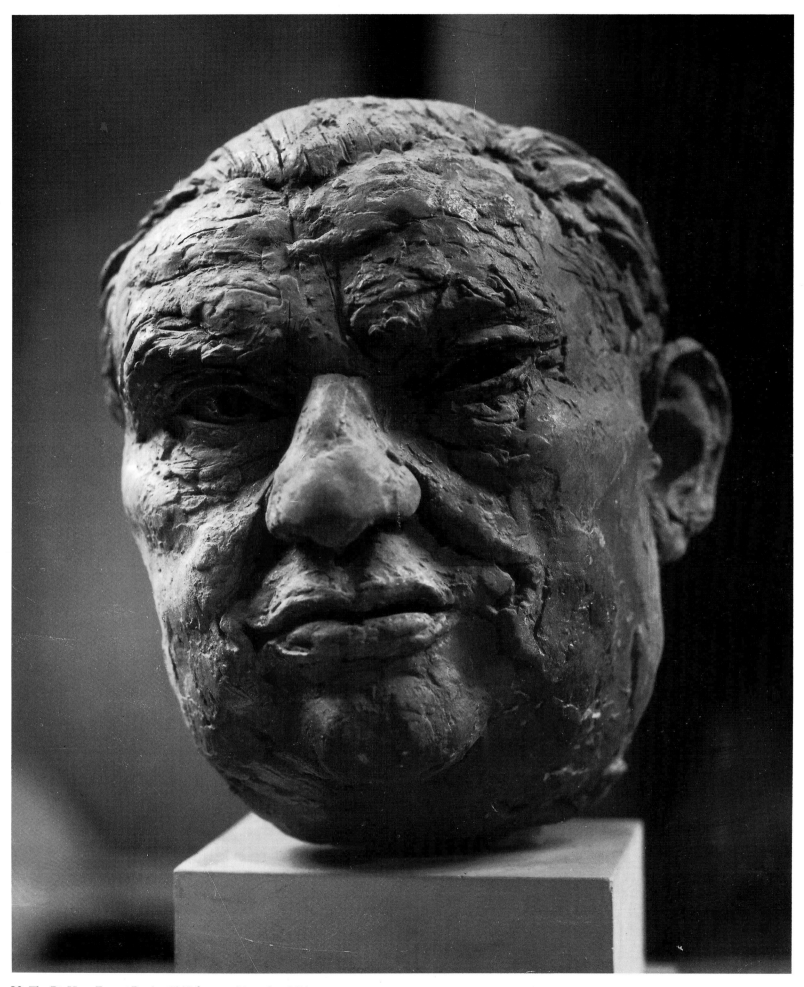

30 The Rt. Hon. Ernest Bevin, *1945, bronze, 26cm. (no. 363)*

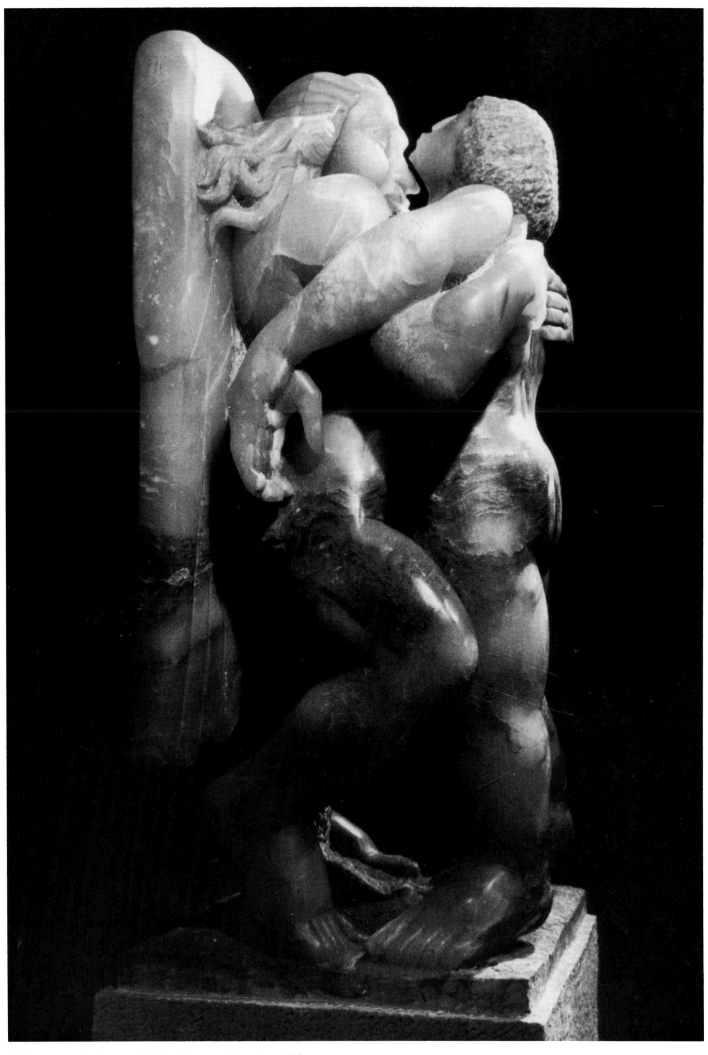

31 Jacob and the Angel, *1940–1, alabaster, 213cm. (no. 312)*

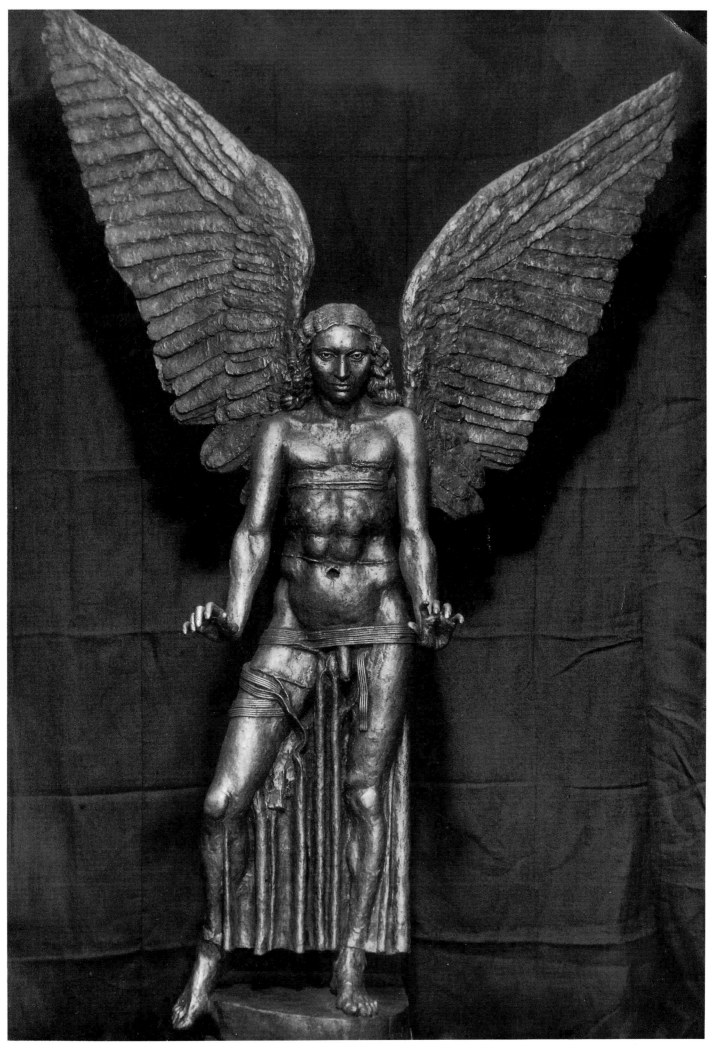

32 Lucifer, *1944–5, bronze, 315cm. (no. 362)*

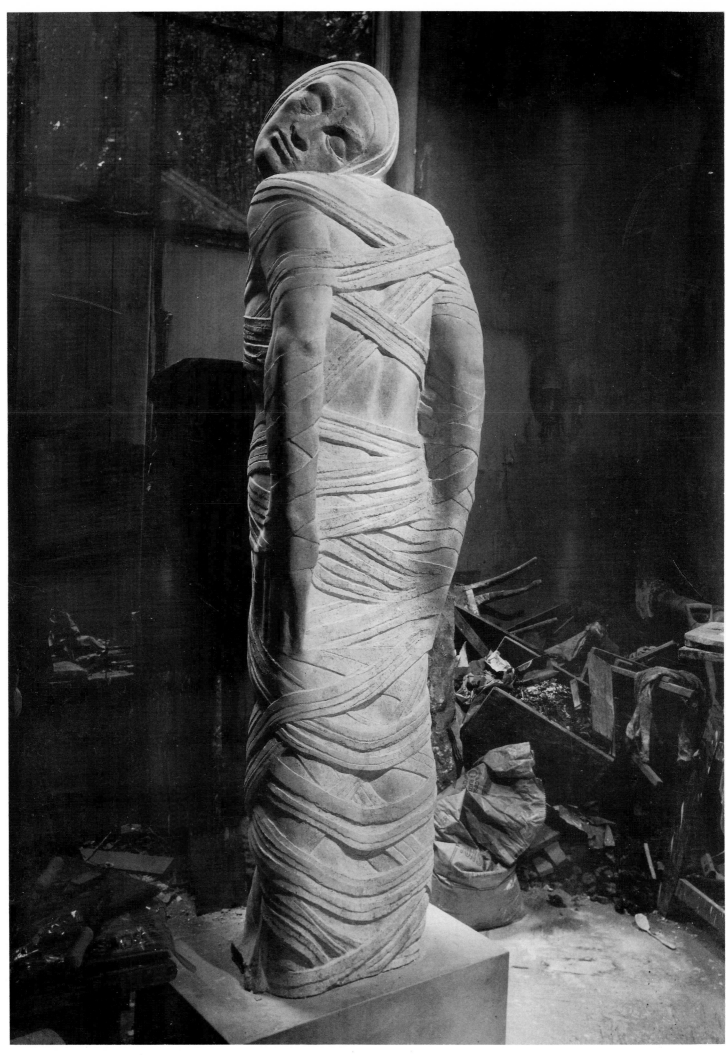

33 Lazarus, *1947–8, Hoptonwood stone, 254cm. (no. 391)*

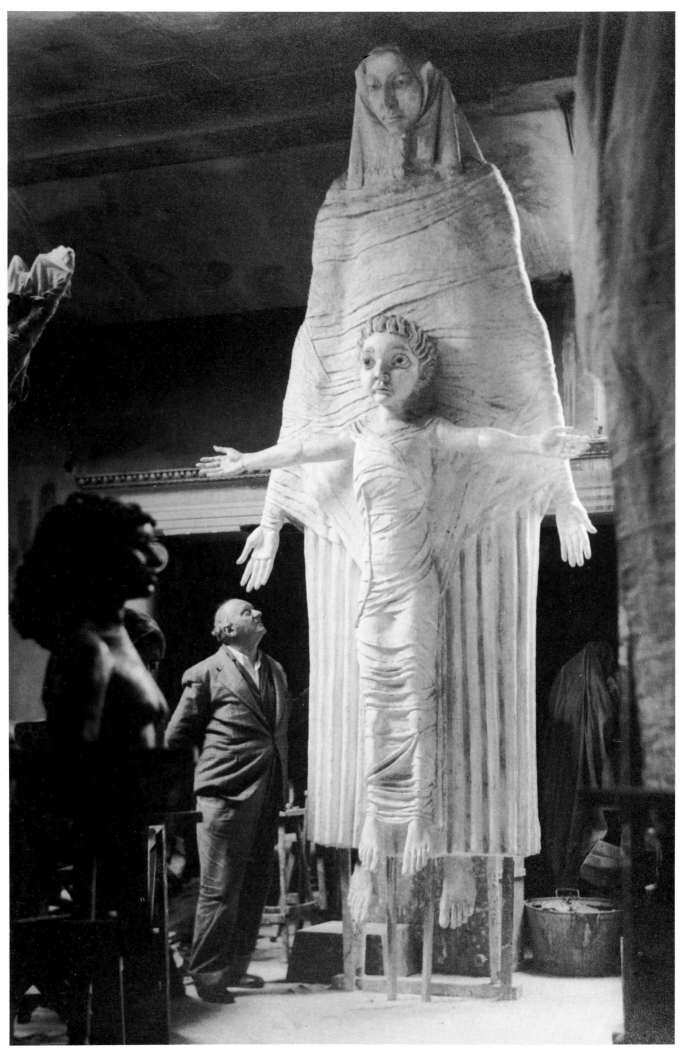

34 Madonna and Child *with the sculptor, 1950, plaster, c.390cm. (no. 438)*

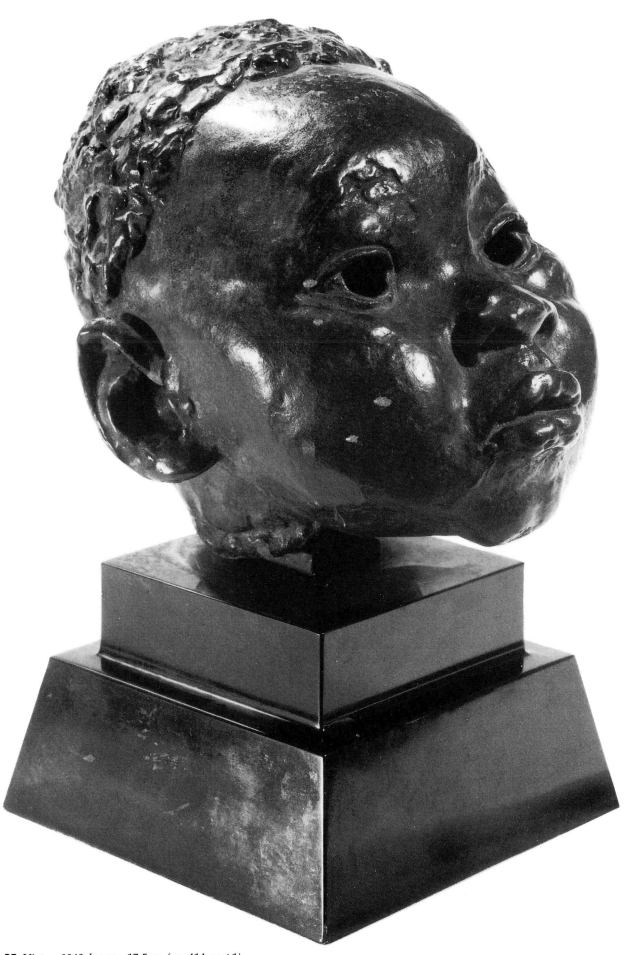

35 Victor, *1949, bronze, 17.5cm. (no. 414, cast 1)*

36 Ralph Vaughan Williams, *1949, bronze, 39.5cm. (no. 416)*

37 Bracha Zefira, *1949, bronze (no. 415)*

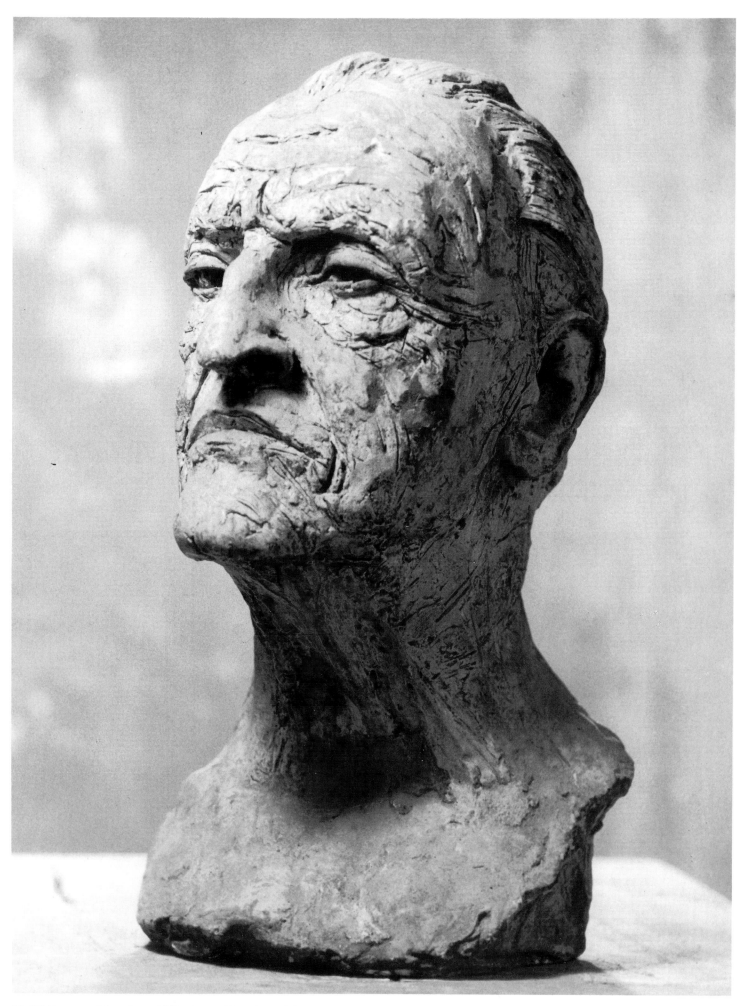

38 W. Somerset Maugham, *1951, plaster, 39cm. (no. 445)*

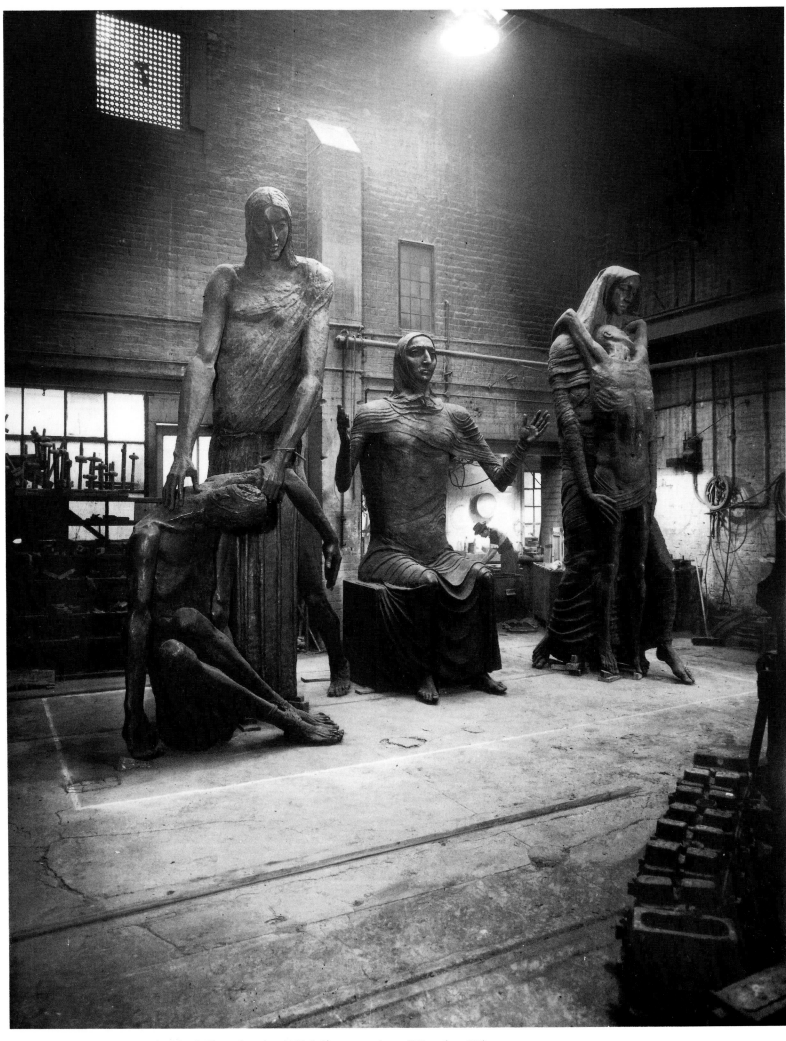

39 Social Consciousness *in the Morris Singer foundry, 1951–3, bronze, maximum 371cm. (no. 451)*

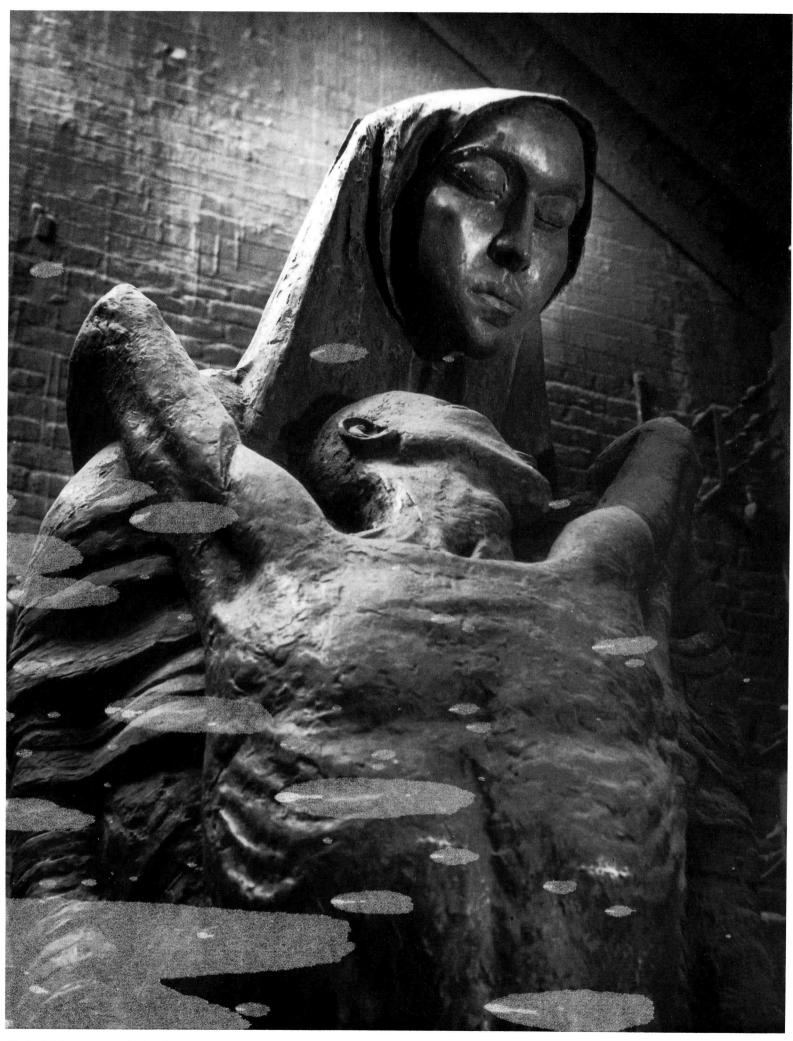

40 Social Consciousness (*detail*)

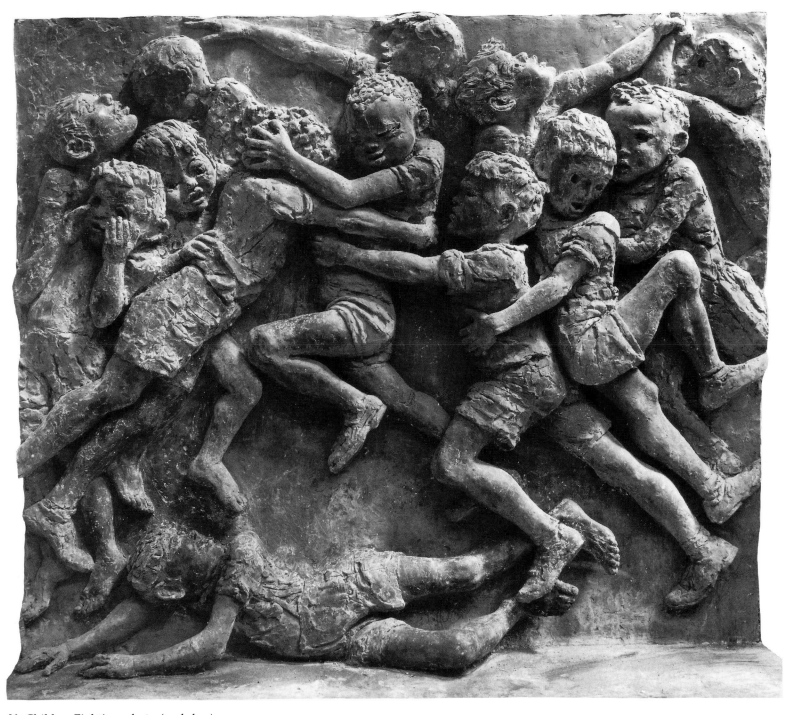

41 Children Fighting, *plaster (see below)*

42 *(opposite) Lewis's Store, Liverpool, c.1956, with* Liverpool Resurgent, *1954–5, bronze (no. 476), and* Children Fighting, Baby in a Pram *and* Children Playing, *1955–6, cement fondu, 101 × 183cm. each panel (no. 478)*

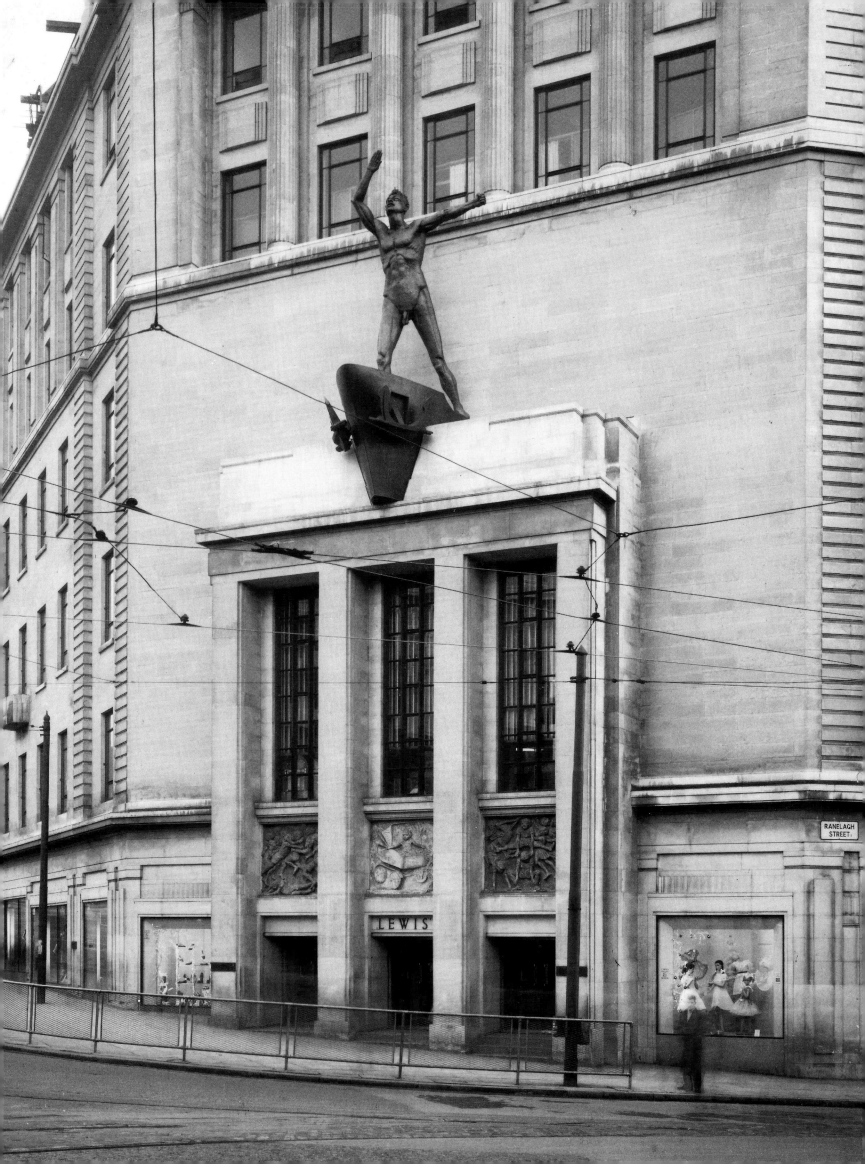

43 Jan Christian Smuts, *Parliament Square, London; 1953–5, bronze, over life-size (no. 483)*

44 Christ in Majesty, *Llandaff Cathedral, Wales; 1954–5, aluminium, c.430cm. (no. 475)*

45 Trades Union Congress War Memorial, *Congress House, London; 1956–7, Roman stone (no. 490)*

46 *Congress House under construction (1956), with Epstein standing by his block of Roman stone*

47 The Bowater House Group, *Knightsbridge, London; 1958–9, bronze (no. 522)*

48 St. Michael and the Devil, *Coventry Cathedral; 1956–8, bronze (no. 503).*

49 *Epstein's studio during the mid-1950s*

CATALOGUE

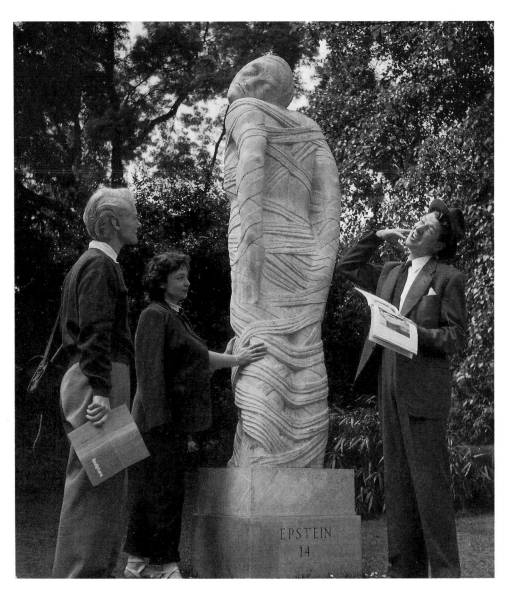

Lazarus in Battersea Park, 1951

The Catalogue of Epstein's Sculpture

[1] Haskell, appendix 2, incorporates a Catalogue of Works from 1907 to 1931 'as accurate as the memory of the sculptor will allow'. This is broadly followed by Black, pp. 227–43. Buckle, pp. 424–30, seems to rely less on Haskell than on the Leicester Galleries catalogues and information from Lady Epstein, who collaborated closely on the preparation of the book but whose knowledge of the chronology of Epstein's early work was not first hand.

[2] I have consulted the set of catalogues formerly belonging to the Leicester Galleries and now in the possession of Christopher Phillips, to whom I am indebted for his generous co-operation.

[3] For example, *Baby Asleep* (no. 3).

[4] I am grateful to Beth Lipkin for access to information on the dispersal of the Epstein plasters and the subsequent destruction of the remaining plasters in 1982.

Introduction

There are excellent reasons why no real catalogue of Epstein's sculpture has previously been attempted.[1]

Unlike Eric Gill, whose work can be minutely documented through his diaries, Epstein appears to have kept no systematic records of any kind. Thus dating of his sculpture usually depended upon the memory of either the sculptor or his widow. The exhibitions held at regular intervals during Epstein's life may provide a *terminus ante quem* for newly exhibited work. More rarely documentary evidence about a sitting dates a portrait precisely. Epstein also seems to have relied upon his memory for the number of casts taken from any one piece, so there are few records of how many casts were made, when, by which caster, for which dealer or buyer. Given the volume of work produced, the result is chaotic. However, it is possible to detect a pattern in Epstein's working method.

From 1920 to 1953 Epstein exhibited his recent work at roughly two-yearly intervals, sometimes more frequently, at the Leicester Galleries and elsewhere (see Exhibitions, pp. 232–4). It was his normal practice when exhibiting a piece for the first time to agree a maximum number of casts with the Leicester Galleries, his main dealers from 1917 until his death in 1959. Single, three, four or six casts were quite usual, ten or twelve very rare, but in any case the projected edition size was a very informal affair, hand-written into a few copies of the Leicester Galleries catalogue.[2]

Since it was unusual for the complete edition to be sold during its first exhibition, casts were often taken over a period of years by different casters and with varying patination, according to the sculptor's or the client's preference.[3] Often the originally stated edition was never sold out. Conversely a small edition was, on occasion, expanded freely if the demand was overwhelming; the portrait of Albert Einstein (no. 234) was first exhibited at Tooth's in 1933 with an edition of three specified. All three sold at once, two casts entering public collections within a year. More casts appear in the 1940s and still more in the 1950s. During the 1940s and 1950s Epstein was also selling bronzes in the USA, largely through the

agency of his brother, Irving Epstein; there is no means of establishing whether these casts were included in the reckoning of the English editions or whether they were treated as entirely separate from the English sales.

After the sculptor's death a huge number of original plasters remained in the studio at Hyde Park Gate and in store at the Pantechnicon. Casts were taken on behalf of the Epstein Estate both of sculptures whose 'editions' were incomplete and of hitherto uncast works. The last major batch of such casts were sold by the Leicester Galleries in 1968, but other sculptures, cast with Lady Epstein's permission, were sold both in the UK and the USA; some exhibitions and sales from the Brook Street Gallery, London, Dalzell Hatfield Galleries, Los Angeles, Weintraub Gallery, New York, Gaerlick's Gallery and Graphic Art Associates, Detroit, and in a series of department stores owned by the May's Company from 1960 to 1967 reflect this activity. Casts sold by several of these galleries include hands and arms separated from individual portraits; these disparate fragments have defeated the efforts of the author and they have therefore been omitted from the catalogue The dearth of proper records would have made it difficult if not impossible to know in many cases how many of a given edition had in fact been cast already. Lady Epstein's close personal knowledge of the studio dated only from the late 1940s and many records—letters, casters' accounts, etc.— were undoubtedly lost after Mrs Epstein's death in 1947.

Between 1965 and 1971 some 200 plasters were presented by Lady Epstein to museums and other public institutions throughout the world, all gifts stipulating that no further casts were to be taken. The majority are now in the Israel Museum, Jerusalem, and the Museum of Art at the kibbutz, Ein Harod. Some seventy plasters remained with the Epstein Estate at Lady Epstein's death in 1979. These were destroyed in 1982.[4]

The variability of Epstein's working practice, which owed more to the exigencies of his finances and the law of supply and demand than to the convention that bronze editions should not exceed ten or twelve, has given rise to controversy since his death. In 1971, a report by the *Sunday Times* Insight Team, entitled 'The Case of the

Multiplying Epsteins', revealed that at least sixteen casts of the famous portrait of Churchill (no. 371) existed, although several museums and private purchasers understood their cast to be one of ten.[5] The ensuing crisis of confidence about the size of Epstein's editions and the difficulty of assessing the relative rarity of a given sculpture has lingered on ever since. As has been shown, this problem, which Lady Epstein's continued casting after 1959 served to exacerbate, was largely the result of the sculptor's own practice.

It can be argued that this controversy is merely a matter of prices and has nothing to do with an assessment of Epstein the sculptor. However, it qualifies the validity of any 'catalogue raisonné' since unnumbered casts cannot be distinguished one from another unless they can be shown to have an unbroken provenance or to have been in institutional ownership. Users of this catalogue must therefore be cautioned that the number of casts listed is not definitive; gaps in provenance may well mean that some casts of, say, *Winston Churchill* or *Albert Einstein* may inadvertently appear more than once; on the other hand there are also casts in private collections, and probably in a few public collections, of which the author is unaware. Nevertheless this catalogue, necessarily incomplete as it is, also demonstrates that fears about the quantity of Epstein casts have been greatly exaggerated; only a handful of portraits appear to have been cast in large numbers. Of these the vast majority of casts were probably taken during the sculptor's lifetime and with his knowledge.

For the collector of Epstein's work the ultimate criterion must remain the quality of the cast and patination, though a knowledge of the provenance of the sculpture is obviously desirable.

Foundries

Epstein made use of a number of casters during his career—Hébrard, Furini and Parlanti during the early years, Cassandri and Gattai, who worked for Gaskin, later Gaskin himself and the Morris Singer Foundry—but, as with other aspects of his working life, very few records appear to survive and few sculptures are marked with the foundry stamp or name.[6]

The *Baby Asleep* (no. 3) and the *First Portrait of Euphemia Lamb* (no. 13) were both cast by Hébrard. The *Risen Christ* (no. 97) was cast by Parlanti, who also cast many of the 1920s portraits. After 1945, Gaskin's, then based in the King's Road, did most of the small-scale casting and they were also responsible for *Youth Advancing* (no. 423), *Jan*

Christian Smuts (no. 483), and for the lead *Madonna and Child* for Cavendish Square (no. 438).

Though the records kept by Gaskin's are almost non-existent, valuable insight into the sculptor's working practice can be gleaned from an undated, hand-written sheet listing the work carried out for Epstein by Gaskin from June to October inclusive. Since Epstein had a show at the Leicester Galleries in May–June 1944 and most of the sculpture cast was first exhibited there, the list can most plausibly be dated to that year. They comprise six casts of *Leda* (probably the Fifth Portrait), four of *Jackie* (Third Portrait), four maquettes for *Night*, single casts of a 'Chinese Girl' (probably *Chia Pi*), *Lord Portal*, *Walker*, *Juanita* and *Dr Whittaker*, as well as either one or two casts of a bust of *Deirdre*. A number of stepped stone and wooden bases were also supplied, the total account amounting to £240. The head of *Lord Portal* dates from 1942, when Dr Whittaker also sat. *Chia Pi* had been exhibited in 1942 and a portrait of *Alexander Walker* had been completed in 1934, which suggests that this may have been a later cast for a member of the Walker family, or even a different portrait altogether. The rest were first exhibited in 1944. The five months' work carried out by Gaskin illustrates a characteristically complex pattern of activity—casting to fulfil orders taken at the sculptor's most recent show, casts from work exhibited at earlier shows and even additional casts of commissioned portraits at the request of the sitter's family.

Patination varies not only amongst casts of an edition but also from work at the beginning and end of Epstein's career. Most of Epstein's early sculpture is dark brown or black but there are exceptions: *Marie Rankin* (no. 29) has an unusual blue-green patina, while in some casts of *Iris Tree* (no. 60) and *Romilly John* (no. 8) the carapace of hair is burnished gold. A darkish green patina becomes common during the 1920s and 1930s while golden and lighter green patinas can be found in work of the 1930s but become most common after 1945.

Signatures

At no time in his life did Epstein consistently sign his work. Scarcely any work from before 1920 is inscribed; the *Second Portrait of Mrs Epstein* (no. 70) has 'JE' on the back of the earrings; some casts of the *Marchesa Casati* (no. 95) are inscribed 'Epstein'. Inscriptions become more common in the 1920s and 1930s, usually taking the form of 'Epstein', in upper and lower case or upper case, placed on the lowest part of the back to left or right. There are one or two instances of his sign-

[5] *The Sunday Times,* 23.2.71.

[6] I am indebted to the late Bill Olds and to David McFall, who worked as waste moulders for Epstein during the 1940s and the early 1950s, for information on casters, as well as to Michael Gaskin.

ing monogrammatically 'Ep' in works of established provenance, e.g. *Elizabeth Scott-Ellis* (no. 59). In those portraits where some casts are inscribed while others are not, it would appear that those which are unsigned postdate the artist's death, but there may be exceptions to this rule. It has not been possible to examine many of the sculptures listed in the catalogue and full information has not always been available from owners even when they have been traced.

Notes on Entries

Title Some works are known under several names, e.g. *First Portrait of Dolores* or *La Bohemienne* (no. 131). Alternative titles are given in parentheses and cross-references included in the index. There are many different portraits of some sitters, such as Peggy Jean and Kathleen; these are numbered according to the practice established by Haskell, Black and Buckle, with special descriptions or alternative titles given in parentheses, e.g. *Fourth Portrait of Leda (with coxcomb)* (no. 311). Information on these and any other Epstein portraits not included or fully detailed in the catalogue would be welcomed by the author.

Date Sculptures are listed in year order. However, since the chronology of Epstein's sculpture remains relatively vague, the order in which sculptures are listed within a year does not necessarily indicate the order of execution within that year.

Sculptures for which no date can be established are placed at the end of the catalogue. Those works, like the *Sun God Relief* (no. 26), which were worked on with interruptions over many years, are listed under the year when work was begun. Where works were carried out over a two or three year period, e.g. *Risen Christ*, it has not proved possible to adopt a consistent practice except to place the work in question close to stylistically and thematically related pieces carried out over the same period.

Where the dates given by Haskell and Buckle conflict, greater reliance has in general been placed upon Haskell, who knew both Epstein and Mrs Epstein well, and who was writing thirty years earlier.

Size All dimensions are given in centimetres. Measuring irregular, three-dimensional objects is inherently difficult. Measurements supplied by owners of different casts of the same sculpture varied by as much as a centimetre, even where the casts were known to be of about the same age. Height is given exclusive of base unless one was cast with the sculpture, e.g. *Burial of Abel* (no. 291).

Inscription Since Epstein's practice was far from uniform (see above) location of signature has not been given.

Exhibition The first recorded exhibition is listed since this often provides a *terminus ante quem* where no other evidence of dating exists. Details of subsequent exhibitions are only included where the exhibition was of special importance— e.g. the Armory Show, New York—or where it yielded additional information about the size of the edition, etc. An importance source of such information was the Leicester Galleries exhibition of 1968, when casts owned by the Epstein Estate were finally dispersed. The edition size is described in the form 'up to 6' or '3 of 6', referring to the maximum number of casts and the number available.

Where no exhibition title is given, this indicates an Epstein one-man show, full details of which can be found under Exhibitions, see p. 232.

Provenance Wherever possible the provenance of each sculpture is traced back to its sale from the sculptor, his widow or his dealers, the earliest recorded casts being listed first. As has already been emphasized, the number given to a cast does not imply that the cast itself carries that number, since Epstein's bronzes were not cast in numbered editions. Inevitably, therefore, there are many incomplete ownership and sale records, so that some casts may inadvertently appear twice, while others of which the author is unaware are omitted.

Current whereabouts or the last recorded location of any given cast are indicated as follows:

Sotheby's 10.6.61(123); J. Smith = bought by J. Smith at Sotheby's in 1961

J. Smith, 1961 = bought by J. Smith in 1961 and still in his possession

J. Smith (1961) = last recorded as belonging to J. Smith in 1961

J. Smith (Edinburgh 1961) = last recorded as belonging to J. Smith when lent to Epstein Memorial Exhibition, Edinburgh, 1961

The names of institutional owners given in a shortened form are explained in the list of abbreviations on p. 118.

Literature Full details of works cited can be found in the Bibliography, see p. 229.

Abbreviations

AAA = Allied Artists' Association, London
ACGB = Arts Council of Great Britain
AG = Art Gallery
AI = Art Institute
AM = Art Museum
ARL = Alex, Reid & Lefevre, London (dealers)
CAG = City Art Gallery
CAS = Contemporary Art Society, London
Christie's = Christie's, London (auctioneers)
Christie's = Christie's South Kensington
 (auctioneers)
CMAG = City Museum and Art Gallery
Coll. = Collection
D = depth
FAS = Fine Art Society, London
FPAA *see* Bibliography: Unpublished Sources
GA = Gallery of Art
Gal. = Gallery
H = height
Holden *see* Bibliography: Unpublished Sources
Hornstein *see* Bibliography: Unpublished
 Sources
HRC *see* Bibliography: Unpublished Sources
IA = Institute of Art(s)
IFA = Institute of Fine Arts
ill. = illustrated
IWM = Imperial War Museum
L = length
LA = Los Angeles
Laib = Paul Laib, negatives c/o Courtauld
 Institute, London
Leicester Gal. = Leicester Galleries, London;
 Epstein's main dealers from 1917

MA = Museum of Art
MAA = Museum of African Art
MAG = Museum and Art Gallery
MAS = Midland Area Service
MFA = Museum of Fine Art(s)
MOMA = Museum of Modern Art
NAG = National Art Gallery
NG = National Gallery
NGA = National Gallery of Art
NMM = National Maritime Museum
NMW = National Museum of Wales
NPG = National Portrait Gallery
NPS = National Portrait Society, London
NY = New York
NY, AAA, 1927 = American Art Association Inc.,
 New York, The John Quinn Collection:
 Paintings and Sculptures of the Moderns, 9–11
 February 1927
NY, PB = Parke Bernet, New York (auctioneers,
 before 1964)
NY, SPB = Sotheby Parke Bernet, New York
 (auctioneers, after 1964)
Phillips' = Phillips', London (auctioneers)
P. Coll. = Private Collection
RIBA = Royal Institute of British Architects
RSPB *see* Bibliography: Unpublished Sources
SF = San Francisco
SNGMA = Scottish National Gallery of Modern
 Art
SNPG = Scottish National Portrait Gallery
Sotheby's = Sotheby's, London (auctioneers)
Tate = Tate Gallery, London
V & A = Victoria and Albert Museum, London
w = width
Wild = Hans Wild, negatives c/o L. Brooman

1 Temple of Love

1902–4
plaster?

Provenance: destroyed prior to Epstein's departure for England

Literature: Epstein 1940, pp. 28–9; Epstein 1955, p. 17; Buckle and Lady Epstein, pp. 16–17; Buckle, p. 18

2 Sun Worshippers
(Temple of the Sun)

1902–4
plaster?

Provenance: destroyed prior to Epstein's departure for England

Literature: Epstein 1940, pp. 28–9; Epstein 1955, p. 17; Buckle and Lady Epstein, pp. 16–17; Buckle, p. 18

The Group incorporated sun-worshippers which in retrospect seemed to the sculptor akin to some 'early Egyptian figures'.

3 Baby Asleep

1902–4?
bronze, H *c*.12.0

Inscription: *Epstein*

Exhibitions: Twenty-One Gal. 1913–14, no. 4?; Leicester Gal. 238, 1917, no. 20 *Babe's Head* (up to 12)

Plasters: (H 12.0) **1** Jerusalem, Israel Museum, 1966
2 Epstein Estate

Provenance: 1 HM Queen Alexandra (van Dieren); whereabouts unknown
2 (cast by Hébrard) Mrs D. U. McGregor Phillips; Mrs M. Mlada; Leeds CAG, 1968
3 (cast by Hébrard) Sir D. Y. Cameron; Edinburgh, NG Scotland, 1945; Edinburgh, MOMA, 1966
4 (cast by Hébrard) Mrs E. M. Crosskey, 1920s; Sotheby's, 10.6.81 (141); H. F. Astor
5 (cast by Hébrard) London, Zwemmer's, *c*.1932; Sir R. Sainsbury; University of East Anglia
6 (cast by Hébrard) London, A. Kohnmann, *c*.1917; family descent; Bruton Gal., 1983; P. Coll.
7 (no marks) J. Epstein, 1923; C. Rutherston; Manchester CAG, 1925
8 (monogram) Lord H. de Walden, *c*.1915; family descent
9 Maj.-Gen. Sir E. Spears; Christie's 12.7.74 (316); Leicester Gal.

10 M. Smith; Mrs J. Profumo
11 (cast by Hébrard) Mrs M. Bone; P. Coll.
12 F. P. M. Schiller; Bristol CAG, 1946—stolen 1963
13 (signed) Melbourne, NG Victoria, 1947
14 (cast to replace stolen one) Lady Epstein; Bristol CAG
15 Sotheby's 15.12.71 (68); Leicester Gal.?
16 Leicester Gal.; Christie's 5.3.76 (33); FAS
17 (cast by Hébrard) William Ware Gal.; Christie's 1.3.68 (59); London, Agnew's; P. Coll.
18 J. Norbury; Christie's 14.7.67 (135)
19 D. Blois; Sotheby's 1.11.67 (153) = Christie's 1.3.68 (60)
20 J. Epstein, *c*.1954; Dr I. Epstein; Dr M. Evans
21 G. R. Halkett (Leicester Gal., 1917)
22 Sotheby's 19.11.80 (258); N. J. Ebsworth
23 J. Epstein; P. Coll.; Sotheby's 18.4.84 (223); Y. Solomon

Literature: van Dieren, pl. XIX; Haskell, p. 166 (dates 1907); Black, no. 5, pl. 68 (dates 1907); Buckle, p. 19, pl. 10 (dates 1902–4)

The *Babe's Head* exhibited at the Twenty-One Gal., no. 4, is there dated 1907, so it is possible that Buckle is mistaken in suggesting that these pre-date the sculptor's arrival in London.

4 Baby Awake

1902–4?
bronze, H 12.7

Plaster: (H 14.0) Israel, Ein Harod, 1965

Provenance: 1 E. P. Schinman
2 W. E. Rothman; Princeton University AG, 1966
3 Sir Robert Mayer, 1950s
4 Lady Cochrane; Christie's 14.12.66 (1); P. Coll.
5 Leicester Gal., 1971; P. Coll.
VERSION WITH PART OF SHOULDER, H 18.5:
6 Walsall, Garman-Ryan Coll., 1972
7 L. Goodman; Sotheby's 22.7.64 (38); P. Coll.

Literature: Buckle, pp. 18–19, pls. 11–12 (dates 1902–4); Schinman, p. 93, ill.

Cast at unspecified later date.

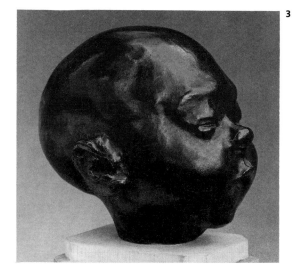

3

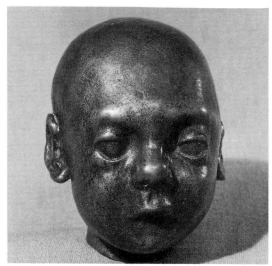

4

6 (drawing)

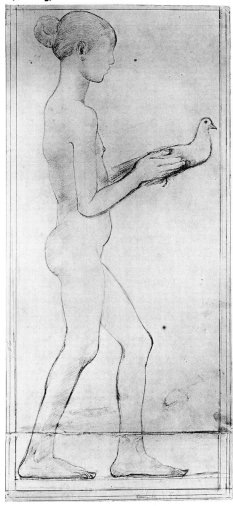

5

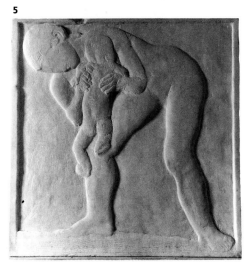

7 (1)

8 (4)

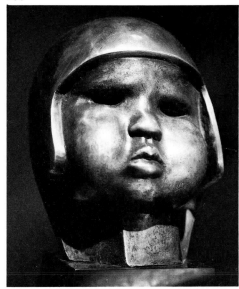

5 Mother and Child
1905–7
marble relief, 35.5 × 35.5
Exhibition: Tate 1961, no. 4
Provenance: Epstein Estate
Literature: Buckle, p. 21, pl. 14
Related drawing, P. Coll., Buckle, pl. 15.

6 Girl with a Dove
1906–7
clay, life-size
Provenance: destroyed by sculptor
Literature: Edinburgh 1961, catalogue, no.
11; Buckle, p. 24, pl. 19 (drawing); Buckle
and Lady Epstein, p. 14, pl. 12
Charles Holden was persuaded to commission Epstein to undertake the BMA Strand commission (no. 9) by seeing this figure in his studio early in 1907. The drawing is in the possession of Walsall, Garman-Ryan Coll.

7 Italian Peasant Woman with a Shawl
1907
bronze
Exhibition: NPS 1916, no. 36 *Old Woman*
Provenance: 1 J. Quinn, 1916; NY, Scott &
Fowles, 1924; whereabouts unknown
Literature: van Dieren, pl. xLvii (Quinn);
Black, no. 3, pl. 94; Buckle, p. 23, pl. 37;
Reid, pp. 259, 616

8 Romilly John
1907
bronze, H 20.3
Exhibitions: Twenty-One Gal. 1913–14,
nos. 9 and 3 (double entry); Leicester Gal.
238, 1917, no. 17 (up to 6)
Plaster: (H 23.0) Jerusalem, Israel Museum,
1966

Provenance: 1 A. John; whereabouts unknown
2 J. Quinn, 1914; NY, Scott & Fowles,
1924; whereabouts unknown
3 A. Kohnmann, *c.*1917; family descent;
London, Bruton Gal.; P. Coll.
4 J. Epstein; L. C. G. Clarke; Cambridge,
Fitzwilliam Museum, 1941
5 Rotterdam, Boymans-van-Beuningen
Museum
6 Sotheby's 8.7.70 (50); Leicester Gal.;
P. Coll.
7 Lady Tredegar (1973)
8 E. P. Schinman; whereabouts unknown
9 Leicester Gal.; Ottawa, NG Canada,
1955
Literature: van Dieren, pl. xiv (*Head of a
Boy*); Black, no. 2, pl. 87; Buckle, pp. 22–3,
pls. 16–17; Reid, p. 191; Schinman, p. 94,
ill.

9 British Medical Association Building, Strand and Agar Street, London (plates 1–3)
Spring 1907–June 1908
Portland stone, H 210–15
The programme comprises eighteen over life-size figures carved in niches on either side of the windows on the second storey. Reading from right to left, from the Strand to Agar Street:
1 Primal Energy. Male nude, frontal. His left arm is outstretched across his body 'as if pressing its way through mists and vapours', while into his cupped right hand he blows 'the breath of life into an atom'.
2 Matter. Bearded man 'of rude and primitive aspect', frontal, draped from hips. He holds before him a block on whose surface is incised an unborn foetus. Foetus frag-

9 a Agar Street façade, 1908

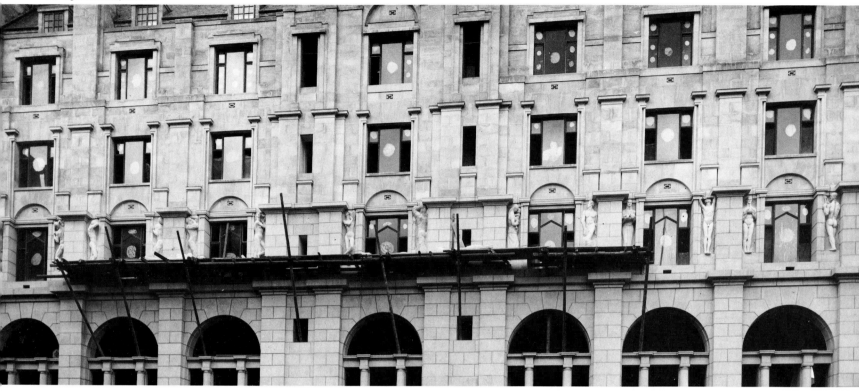

9 b Strand façade, 1908

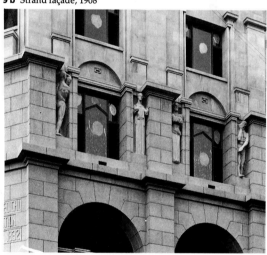

9.16 state in 1985

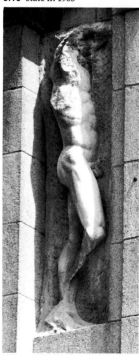

ment, coll. of Mrs. W. G. Richmond.

3 Hygieia, goddess of medicine and health. Woman, frontal, wearing peplos. She holds a cup and a serpent, the latter being the symbol of her father, Aesculapius, god of medicine.

4 Chemical Research. Male nude, three-quarter back view, head turned to the right, holds a retort before his face.

5 Academic Research. Male nude, three-quarter back view, the reverse of 4, holds a scroll before his face. Head fragment, badly weathered, Ottawa, NG Canada.

6 Mentality. Male nude, frontal. He holds in both hands a winged skull. Head sold at Sotheby's 15.4.64 (97); London, Brook Street Gal.; whereabouts unknown.

7 Youth. Male nude, frontal, both arms raised and folded across his brow.

8 New-Born. Old woman with plaited hair, frontal, draped from waist. She holds out on a cloth a new-born child. Woman's head, Girls' School, Bulawayo (Edinburgh 1961). Baby, Ottawa, NG Canada. Plaster cast of whole group taken 1937, Jerusalem, Israel Museum.

9 Man. Male nude, left leg and right arm advanced, turns to left to face 10.

10 Maternity. Pregnant woman, draped from hips, stands in profile facing 9. Her head is bent over the young child she enfolds in her arms. Original plaster (1907), Melbourne, NG Victoria. Plaster cast taken 1937, Jerusalem, Israel Museum.

11 Youth. Male nude, three-quarter back view, facing 12. Left leg back, left arm raised to clasp the back of his head.

12 Dancing girl. Female nude, frontal. She stands on her right leg with the left raised and bent across it; her head is tossed back

and to the right, and she pushes back her hair over her left shoulder with both hands.

13 Dancing girl. As 12, turned 45 degrees so that her head faces outwards and her body faces 12.

14 Dancing youth. Male nude faces 13. Similar pose to 13, but stands on left leg with right leg forward.

15 Dancing man. More heavily built male nude, faces 16. The left leg is bent and the left arm raised.

16 Dancing youth. Male nude, profile, faces 15. The right leg is bent and right arm raised.

17 Dancing youth. Male nude, profile, faces 18. Left leg is bent to touch shoulder, right arms raised overhead. Plaster cast taken 1937, Melbourne, NG Victoria.

18 Dancing youth. Male nude, profile, faces 17. Left leg bent, left arm back, right arm raised overhead.

Drawings: *Hygieia*, Birmingham MAG (Buckle and Lady Epstein, pl. 14); *Maternity*, whereabouts unknown (Buckle and Lady Epstein, pl. 15), Walsall, Garman–Ryan Coll. (Buckle and Lady Epstein, pl. 13), whereabouts unknown (Buckle and Lady Epstein, pl. 32); *Mentality*, whereabouts unknown (Buckle, pl. 16)

Literature: 'An Old Maid with a Spyglass', *British Medical Journal*, 27.6.1908; J. Epstein, 'The Artist's Description of his Work', *British Medical Journal*, 4.7.1908; *The Builder*, 4.7.1908, p. 8; J. Epstein, 'The Scribe and the Sculptor', *British Medical Journal*, 11.7.1908; *Academy Architecture*, 34, 1908, p. 29; *Architectural Review*, 24, 1908, pp. 2–3; *The Burlington Magazine*, 13, 1908, p. 191; *The Builder's Journal*, 29, 1908,

9.4 (plaster)

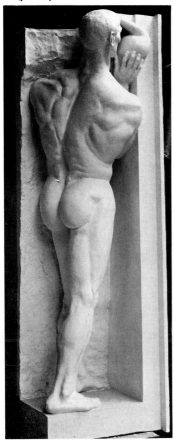

9.2 (plaster)

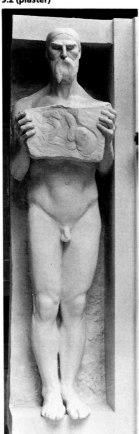

9.12 (plaster)

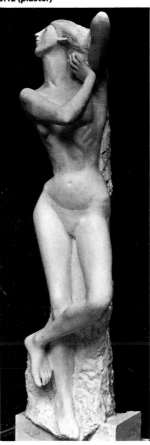

9.17 plaster cast taken from carving, 1937

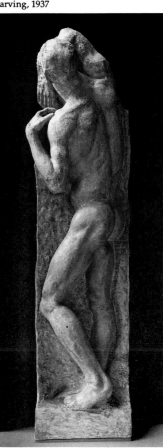

p. 1; Haskell, pp. 16–18; Epstein 1940, pp. 33–55, 259–75; Black, pp. 6, 19, nos. 1, 6, pls. 1, 32; P. Vaughan, *Doctors' Commons*, 1959, pp. 165–8; Buckle, pp. 24–37, pls. 19–50 (gives the order of figures in reverse, beginning in Agar Street); B. Harrison, 'Singing the Body Electric with Charles Holden', *Architectural Review*, 158, 1975, pp. 349–5; J. R. Heron, 'Bold Statues on the BMA Building', *British Medical Journal*, 281, 1980, pp. 1710–17; Cork 1985, chap. 1.

In April 1906, Percy Adams had been commissioned to design the new headquarters of the British Medical Association at the junction of Agar Street and the Strand. It was to replace the handsome but much smaller building designed by S. C. Cockerell in 1832 which, together with parts of some adjacent buildings, had formed the BMA's offices and library. The design was essentially that of Adams' assistant, Charles Holden, who became his partner in 1907. The building was in some respects traditional: the treatment of the ground and first-floor windows combined elements common to Belcher and Joass's Mappin & Webb building in Oxford Street, 1906–8, with deference to the classical elegance of Cockerell's building. The bold, vertical thrust of the pilasters, which are the main element fusing the granite lower storeys with the more abrupt and sculptural handling of masses in Portland stone above, also refers back to Cockerell's design (plate 1). Holden incorporated a frieze of eighteen over life-size

figures flanking the second storey windows, some 40 feet above the ground. The sculpted frieze provided the main focus, an emphasis heightened by the white Portland stone of the sculpture being set against the grey Cornish granite: 'I conceived the idea that the series of white sculptured figures on each side of the windows, set in a framework of dark granite, would serve to weave the two materials together like white stitching joining a dark to a light material.' (Holden at opening of Bolton AG Epstein exhibition, 15.10.1954.)

Epstein prepared a small model, incorporating symbolic figures of man, woman and Aesculapius, god of healing, for the BMA committee, but these figures were superseded as he worked on the full-scale models. There was a brief crisis when someone at the BMA suggested that famous medical men would be a more appropriate theme for the sculptures; though this proposal was quickly scotched it is possible that the final scheme, interspersing traditional symbolic figures with nudes representing the ages of man and woman, was a compromise between the conservative medical establishment and Holden and Epstein's desire for a bolder, humanistic theme (Cork 1985, pp. 17–18, 33). The six traditionally symbolic figures are restricted to the Strand and the first bay of the Agar Street façade, while the remaining twelve embody the ages of man and woman.

The framework constructed for the full-size plaster models Epstein prepared shows how

aware he was of their intended position on the building and the comparatively cramped space available to articulate the figures. Although he drew on his experience of working from Michelangelo casts in Paris, notably in some of the exaggerated musculature, the plasters are far less Michelangelesque than the preliminary models. Seen close up, the bodies are treated more broadly and realistically; the features, with the marked exception of the old woman's, are simplified and stylized, the necks elongated, to allow for proportional distortion when viewed from ground level.

Two of the plaster figures were never used on the building—a bountifully nude *Nature* (no. 10) and a bearded man carrying a child in his arms, probably intended to embody Fatherhood (no. 11). While the former was omitted at Holden's insistence, the latter appears to have been rejected by Epstein himself.

The modelled figures were probably virtually complete by December when the *British Medical Journal* published a report on the new offices, describing the sculptural programme:

…symbolic figures nearly 7 feet high placed in recesses above the first floor windows. The figures will represent medicine and its allied sciences, chemistry, anatomy, hygiene, medical research and experiment, and there will be a series

9.8 stone fragment, after 1937

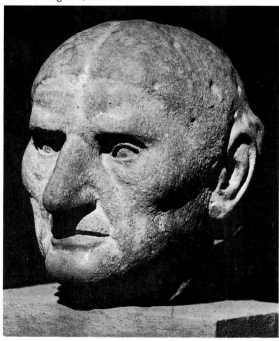

9.6 stone fragment, after 1937

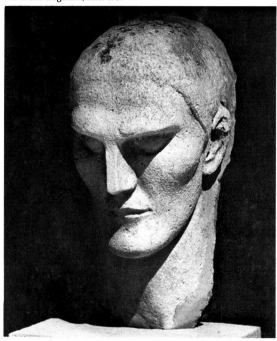

of figures telling the evolutional scheme of man's development from primitive inchoate form to the highest perfection of manhood and womanhood. ('The British Medical Association: The New Offices', *British Medical Journal*, 7.12. 1907, pp. 1161–4.)

Each figure was modelled in clay before being cast in plaster, as they appear in the studio photographs. Then, transferred to the scaffolding, his assistants roughed out each figure from a single Portland stone block, using pointing devices to transfer the design from plaster to stone before Epstein completed them. Subsequently Epstein gave the impression that he had carved the work direct; no assistants are mentioned in his autobiography, and in his letter to the *Observer* (5.5.1935) he stressed that 'they were actually carved *in situ*' (Black, p. 6; Edinburgh 1961, catalogue, room 2; Buckle, p. 26). In reality he was assisted by a firm of architectural carvers, John Daymond of Westminster Bridge Road. According to a fellow sculptor, Alec Mola, who knew Epstein before the First World War:

...about 1912 or 13 I asked him if he had really carved...the Strand statues...and he admitted that he had only 'touched them up' in the stone—and that they were carved by a firm John Daynond [*sic*] in Westminster Bridge Road—and he justified this by saying that he had only

eighteen months to do fourteen figures [*sic*] each about 8 feet high.' (A. Mola to J. Stern, 25.10.1942(?), reproduced by courtesy of R. Buckle.)

The sculptures were almost complete in June 1908 when the removal of some of the scaffolding prompted a public outcry. The BMA buildings committee (24.6.1908), fortified by an editorial in *The Times* (24.6.1908), and later by a report from Sir Charles Holroyd, Director of the nearby National Gallery (1.7.1908), resisted attempts to get them removed or altered.

After the BMA moved from the premises in 1924, the building was used for offices and the Strand News Theatre until it was taken over, in 1935, by the High Commission for Southern Rhodesia. An attempt was made to get the 'inappropriate' sculptures removed from the building but they were saved after a press campaign. Two years later, however, during the removal of bunting placed on the building for the coronation of George VI, a fragment fell, slightly injuring a passer-by. The High Commissioner then decided that the sculptures must be removed for safety reasons, since many of the figures showed signs of deterioration. Further press protests and suggestions that the rotten stonework should be replaced were disregarded, while Epstein himself was allowed neither to join the inspection nor to oversee the making of plaster casts. Holden and the President of the Royal Academy supervised the selection of all dam-

aged and dangerous portions which were subsequently cut away. The building, now the Embassy of Zimbabwe, has recently been cleaned (*c*.1982), so that the ruined fragments of the cycle are more clearly visible.

Much ink has been spilt in recriminations over the deterioration of the stone. The sculptor, who had noted that when rain fell water dripped directly on to the statues, blamed the chemical pollution emanating from the lead plates which protected the cornice overhead. Holden, however, recalled Epstein's insistence upon carving each of the figures from a single Portland block, which had to be laid contrary to its bed position, rather than the three Portland blocks the architect would have preferred. Epstein thought this argument might hold true though he disclaimed responsibility for placing the stone. (Epstein 1940, p. 52; Holden, Memoir, 5.3.1958.)

The bed position of the stone may well have been a contributory cause but the explanation may lie in Holden's original plan for the building. The recesses allowed for the sculptures are shallow and the cornice above breaks back sharply from the adjacent pilasters above the sculptures; they would have afforded some protection to sculpture in high relief but not to nearly free-standing figures such as Epstein's. The tragedy of the sculptures' eventual fate may thus lie partly in Holden's failure to extend the cornice to protect the sculpture and partly in Epstein's inexperience in using stone in an outdoor site.

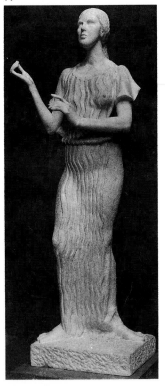

14

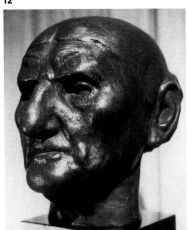

12

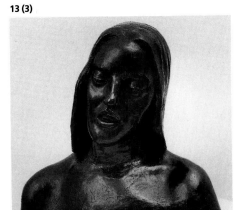

13 (3)

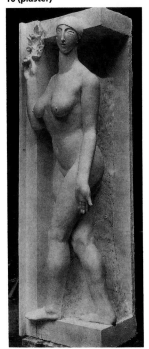

10 (plaster)

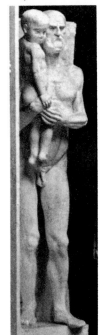

11 (plaster)

10 Nature
1907–8

plaster, H *c*.213

Provenance: destroyed after rejection by architects

Literature: Epstein 1940, p. 34; Buckle, p. 27, pl. 30

Commissioned. Nude based on Gertrude Williams (see no. 31), intended for BMA Building.

11 Man holding a Child
1907–8

plaster, H *c*.213

Provenance: destroyed

Literature: Epstein 1955, pp. 30–1, ill.; Cork 1985, pp. 21–2, pl. 23

Figure for BMA Building, apparently rejected on the sculptor's initiative.

12 Italian Peasant Woman
1907–8

bronze, H 33.7

Exhibition: NPS 1916, no. 36

Plaster: NY, Syracuse University, 1966

Provenance: **1** Sotheby's 28.3.62 (150)

 2 (H 29.2) E. P. Schinman; whereabouts unknown

Literature: Buckle, p. 23, pl. 18; Schinman, p. 38, ill.

The head is clearly related to *New Born* (8) on the BMA Building. Probably cast from the weathered stone head after its removal from the building.

13 First Portrait of Euphemia Lamb (bust)
1908

bronze, H 37.0

Inscription: *Epstein*; stamped, *cire perdu A. A. Hébrard*

Exhibitions: NY, Armory Show, 1913 (lent by J. Quinn); CAS 1913, no. 161; Twenty-One Gal. 1913–14, no. 6 (dated 1908)

Plaster: (H 37.0) Jerusalem, Israel Museum, 1966

Provenance: **1** J. Quinn, 1913; NY, Scott & Fowles, 1924

 2 London, Goupil Gal.; CAS; Tate, 1917

 3 C. & L. Handley-Read; Birmingham MAG, 1973

 4 E. P. Schinman; whereabouts unknown

 5 Mrs J. Pamelee; Washington, Corcoran AG, 1941

 6 J. Stanhope; E. Littler; Eisenberg-Robbins; Washington, MAA, 1973

 7 Mrs E. Cookson; Sotheby's 13.12.67 (84), ill.; FAS

 8 Mrs G. Solomon; Israel, Ein Harod, 1950s

Literature: Epstein 1940, p. 56; Buckle, pp. 52–3, pl. 75 (dates 1911); Schinman, pp. 40–1, ill.

Often wrongly called *Second Portrait*. When exhibited at the Leicester Gal. in 1917 Epstein envisaged up to six casts.

14 Fountain Figure (Euphemia Lamb)
1908–10

marble, H 134.5, base 39.4 × 39.4

Exhibitions: London, Whitechapel AG, English Art, 1910, no. 415 *Garden Statue* (lent by Lady O. Morrell); NPS 1911, no. 60 (plaster); Edinburgh 1961, no. 20, ill.

Provenance: Lady O. Morrell; A. Clifton; Mrs A. Clifton; A. McAlpine; Geneva, Musée d'Art Moderne, 1968

Literature: Hind, p. 6, ill.; Haskell, p. 168, ill.; Black, p. 227, no. 11; Epstein 1940, p. 56; Buckle, p. 50, pls. 72–3

Commissioned by Lady Ottoline Morrell in 1908 (HRC, Epstein to patron, 22.10.1908). 'One of a group symbolizing reincarnation.

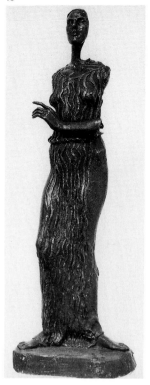

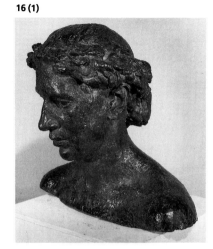

16 (1)

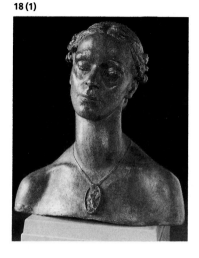

18 (1)

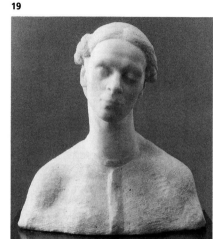

19

From the living water of life she rises, fragments of her former existence still clinging to her, but on her face is the light of a new cycle of life.' (Hind, following a visit to Epstein's studio, 1911.)

15 Euphemia Lamb (Fountain Figure)
1908–10
bronze, H 111.8
Exhibitions: Leicester Gal. 1191, 1960, no. 5 *Fountain Figure*, 1911 (1 of 3); Leicester Gal. 1968 (2 of 6)
Provenance: 1 (cast after 1959, with head) L. Goodman; Christie's 22.6.62 (94)
2 (no head) Epstein Estate; London, Anthony d'Offay Gal., 1980; P. Coll.
Literature: Haskell, p. 168 (uncast); Epstein 1940, p. 56; Buckle, p. 50, pl. 72

16 English Girl
1909
bronze
Exhibition: Leicester Gal. 365, 1924, no. 10 (up to 6)
Provenance: 1 A. Gradon; E. Littler; Eisenberg-Robbins; Washington, MAA, 1973
Literature: Black, no. 10, pl. 78 (but this shows *Noneen*, no. 106); Buckle, p. 39, pl. 53
Buckle identifies the subject as Gertrude Williams, see *Gertrude* (no. 31).

17 Bust of Nan (Condron) (plate 14)
1909
bronze, H 44.0
Exhibition: Leicester Gal. 238, 1917, no. 8 (up to 6)
Plaster: (H 45.0) Israel, Ein Harod, 1965
Provenance: 1 Leicester Gal.; Tate, 1922
VERSION WITH UNDRAPED SHOULDERS AND NO EARRINGS:

2 Eumorfopoulos Coll. (van Dieren); whereabouts unknown
3 Leicester Gal.; Queensland AG, 1956
Literature: van Dieren, pls. XXI (draped, with earrings), XLIX (undraped); Wellington, p. 15, pl. 3 (draped); Epstein 1940, p. 56; Epstein 1955, ill.; Buckle, p. 42, pls. 58–60 (including related drawing); Chamot, *et al.* 1964, I, p. 165
Related drawings, Birmingham MAG and Walsall, Garman-Ryan Coll.

18 Mrs Ambrose McEvoy
1909–10
bronze, H 41.5
Exhibitions: Leicester Gal. 238, 1917, no. 4 (up to 6); Ferargil Gal. 1927, no. 13; Leicester Gal. 1191, 1960, no. 3 (1 of 6)
Plaster: (H 46.0) Israel, Ein Harod, 1965
Provenance: 1 J. Epstein, *c.*1949; Mrs A. Bazell; Tate, 1953
2 J. Gibbins; Sotheby's 24.11.32; Mrs J. B. Priestley; Melbourne, NG Victoria, 1933
3 Leeds CAG, 1942
4 (cast 1953) Mrs A. Bazell
Literature: van Dieren, pl. XXIV; Wellington, pl. 1 (dates 1908); Haskell, p. 167 (dates 1910); Black, no. 15, pl. 74; Buckle, pp. 40–1, pls. 55–6 (dates 1909); Chamot *et al.*, 1964, I, p. 170
Mary Spencer Edwards (1871–1941), wife of Ambrose McEvoy, one of Epstein's first supporters in England.

19 Mrs Ambrose McEvoy
1909
marble, H 48.0
Exhibition: AAA 1910, no. 1200
Provenance: Johannesburg AG, 1910
Literature: Buckle, pp. 40–1, pl. 57 (dates 1909); Chamot *et al.*, 1964, I, p. 170
Marble immediately post-dates bronze.

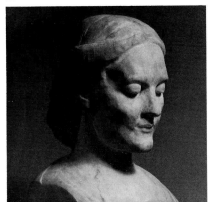

22

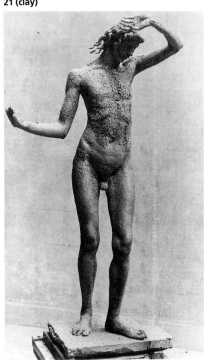

21 (clay)

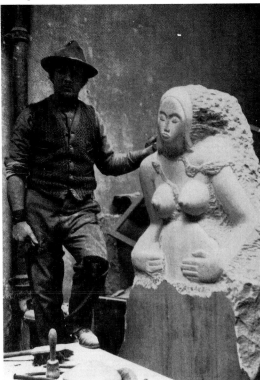

23 a Epstein at work, *c*.1910

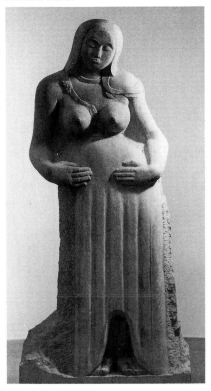

23 b state in 1961

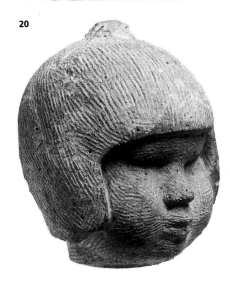

20

20 Rom—first version
1909–10?
limestone, H 22.5
Provenance: Epstein Estate
Unfinished. Developed from *Romilly John* (no. 8).

21 Narcissus
1909–10
clay, or wax (C. Holden), near life-size
Provenance: destroyed by sculptor
Literature: Buckle, p. 50, pl. 71 (from photo in V & A)
Related to the *Fountain Figure* (no. 14), probably a study for the *Tomb of Oscar Wilde* (no. 40).

22 Mrs Emily Chadbourne
1910
alabaster, H 45.7
Exhibition: NPS 1911, no. 171
Provenance: Epstein Estate, 1961; E. P. Schinman; whereabouts unknown
Literature: Hind, p. 66; Haskell, p. 167; Black, p. 228, no. 13; Buckle, p. 40, pl. 54; Schinman, p. 87, ill.
Commission. Mrs Chadbourne, a wealthy American collector, was a friend of the Knewstubs, Augustus John and Roger Fry.

23 Maternity (plate 5)
1910
Hoptonwood stone, H 206
Exhibitions: AAA 1912, no. 1179 (unfin-

ished); Edinburgh 1961, no. 15
Provenance: Lady Epstein, 1961; London, Brook Street Gal.; B. Rose; SF, SPB 23.6.80 (272), ill.; SF, P. Coll.; SF, Harcourt Gal.; Leeds CAG, 1983
Literature: van Dieren, p. 27, pl. VI (unfinished); Haskell, p. 166; Black, no. 7, pl. 93 (unfinished, dates 1908); Buckle, pp. 42–9, pls. 61–8 (finished and unfinished states, dates 1909); Buckle and Lady Epstein, pls. 18, 19; R. Cork, *NA-CF Fund Review*, 1984, pp. 137–8
Completed in the 1920s. Related drawing, Leeds CAG (hands).

24 Lady Gregory
1910
bronze, H 38.0
Exhibition: NPS 1917, no. 53
Provenance: 1 H. Lane; Dublin, Hugh Lane Municipal Gal. of Modern Art
2 Leicester Gal.; Leeds CAG, 1942
Literature: van Dieren, p. 53, pl. XL; Haskell, p. 167; Black, no. 14, pl. 95; Epstein 1940, pp. 56–7; Epstein 1955, pp. 42–3; Buckle, p. 57, pl. 81; Lady Gregory, *Hugh Lane*, 1973, pp. 83, 266
Commissioned by Hugh Lane.

25 Rom—second version
1910
stone, H 87.5
Inscription: ROM, by Eric Gill
Exhibitions: AAA 1910, no. 1198; NPS

24 (2)

25

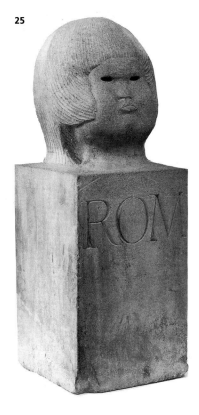

26 state *c*.1910

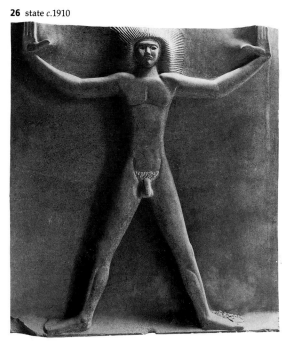

27

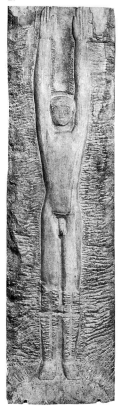

28

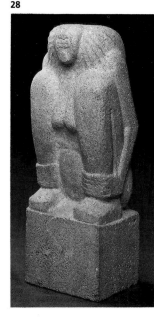

Provenance: J. Epstein; H. D. Harben; family descent; H. Pound; Cardiff, NMW, 1979

Literature: Hind, pp. 66–7, ill.; Wilson 1977, pp. 352–4

This head, like the contemporary *Romily John* (sic) by Eric Gill, was developed from Epstein's bronze portrait (no. 8). Hind stated, on the basis of a visit to Epstein's studio after the NPS exhibition, that it was 'one of the flanking figures of a group apotheosising Man and Woman, around a central shrine, that the sculptor destines in his dreams for a great temple.' When he saw the head on exhibition he commented:

> Emerging from a cube of stone I saw the big head of a chubby child, not the child of the present or of the past, but the Eternal Child that has crowed and capered from Egypt and Assyria to the present moment. The treatment is severe yet humorous, essentials only, and the symbol of the flat roguish features is in harmony with the symbolic treatment of the hair.

26 Sun God Relief (plate 6)

1910

Hoptonwood stone, H 213.4, W 198, D 35.5

Exhibition: Leicester Gal. 553, 1933, no. 23 *Primeval Gods*

Provenance: J. Epstein; S. Ryan, 1950; NY, Metropolitan Museum (presented by

Lady Epstein and Sally Ryan in memory of the sculptor), 1970

Literature: van Dieren, pl. II (detail); Haskell, p. 190; Powell, p. 36, ill.; Black, no. 160, pls. 38, 39, 54; Buckle, p. 203, pls. 310–11

Begun 1910, continued deepening relief of *Sun God* and produced *Primeval Gods* during 1931–3 (see no. 218).

27 Sun-Worshipper

1910?

stone relief, H 190 × 54.0

Provenance: Lady Epstein; London, Royal Borough of Kensington and Chelsea (Chenil Gal.)

Unfinished. Related to *Sun God* (no. 26) and to Epstein's ideas on a temple project with Eric Gill (see page 21). It may also contain echoes of *Temple of the Sun* (no. 2).

28 Sun Goddess, Crouching

1910?

limestone, H 37.5

Exhibitions: Birmingham MAG 1980, no. 7, ill.; London, Whitechapel AG, British Sculpture in the Twentieth Century, I, 1981, no. 36

Provenance: J. Epstein; A. F. Thompson; Nottingham Castle Museum, 1974

Usually called *Sun God*, but the presence of breasts and vulva indicate that the subject is female. Closely connected with the Egyptian interests of the 1910–12 period, cf. *Sun God Relief* (no. 26), *Tomb of Oscar Wilde* (no. 40).

31

30

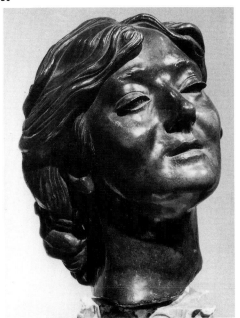

29 (2)

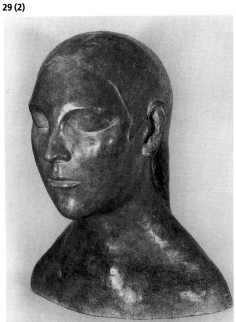

32

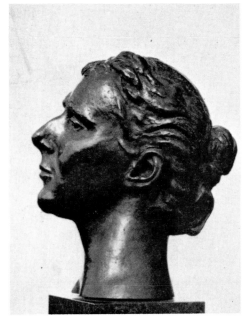

29 Marie Rankin (Irish Girl)
1910–11

bronze, H 29.0

Exhibitions: Twenty-One Gal. 1913–14, no. 7 *Head of a Girl*, 1908?; Leicester Gal. 1387, 1971, no. 18 *Irish Girl*

Provenance: 1 J. Quinn, 1916; NY, Scott & Fowles, 1924; NY, AAA 1927, no. 698 = cast 3?

2 Lady Epstein; B. Lipkin

3 Rogers Estate; NY, PB 19.1.55 (44); P. Coll.

Literature: Haskell, p. 168 (dates 1911); Buckle, p. 54, pl. 78

According to Haskell, an earlier version of 1907 did not survive. Clearly related to *Maternity* (no. 23).

30 Mrs Marjorie Clifton
1911

bronze, H 28.0 (plaster)

Exhibitions: Leicester Gal., Fame and Promise, 966, 1951, no. 190; Edinburgh 1961, no. 26

Plaster: (H 28.0) Israel, Ein Harod, 1965

Provenance: 1 Leicester Gal., 1951; Mrs Turton; P. Coll.

2 Sotheby's 6.4.60 (82); P. Coll.

Literature: Black, p. 228, no. 19; Buckle, p. 57, pl. 79

Commission. The subject's husband, Arthur Clifton, ran the Carfax Galleries. According to Leicester Gal., 1951, a unique cast.

31 Gertrude (The Bather)
1911

bronze, H 94.0

Exhibitions: Ferargil Gal. 1927, no. 33; Leicester Gal. 553, 1933, no. 21 *Nude (half-*

length), 1910; Leicester Gal. 1191, 1960, no. 4 *Gertrude*, 1911; Leicester Gal. 1968 (5 of 6)

Provenance: 1 Washington, Hecht Co., 1965

2 Sir E. Hayward; Hayward Bequest, Carrick Hill

Literature: Haskell, p. 168 (uncast); Epstein 1940, p. 56; Black, p. 240, no. 189 (dates plaster 1910, casting 1932); Buckle, p. 54, pl. 76

32 Mrs Francis Dodd
1911

bronze

Provenance: 1 Sitter (1940)

Literature: Black, p. 228 no. 20; Buckle, p. 57, pl. 80

Commission. Francis Dodd, the painter, was one of Epstein's early friends in England. Etching of Epstein by Dodd (Hull University AG).

33 Second Portrait of Euphemia Lamb (half-length)
1911

bronze, H 58.0

Exhibition: NPS 1914, no. 86

Plaster: NY, Museum of the City, 1971 (soft bow)

Provenance: 1 Eumorfopoulos Coll. (1932)

2 M. Bone; P. Coll.

3 R. Bevan; A. d'Offay, 1977

4 Leicester Gal. 1387, 1971, no. 17

Literature: van Dieren, pl. XVII (Eumorfopoulos); Haskell, p. 168; Black, no. 21, pl. 82; Epstein 1940, p. 56; Buckle, p. 52, pl. 74 (plaster, square bow, calls *First Portrait*)

33 (3)

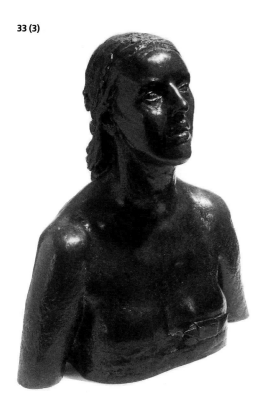

34

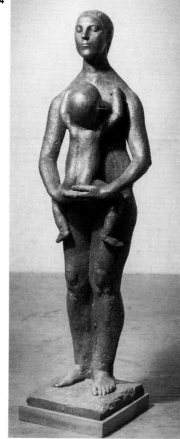

35 (1)

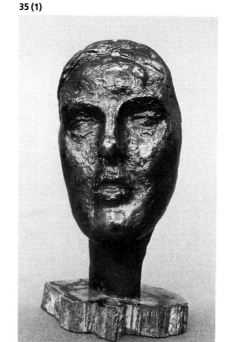

Casts 1 and 2 show a geometrically angular bow on the dress, while that in cast 3 is much more naturalistic.

34 Mother and Child, Standing
1911
bronze, H 167.6
Exhibition: London, Battersea Park, Sculpture in the Open Air, 1960, no. 19, ill.
Plaster: Sir E. and Lady Hayward, pre-1959; Lady Epstein; Israel, Ein Harod
Provenance: 1 Sir E. Hayward; Sotheby's 17.7.68 (109), ill.
2 Sir E. Hayward; Hayward Bequest, Carrick Hill
3 W. Bowmore (1972)
Literature: Buckle, p. 54, pl. 77
Head of mother is *Marie Rankin* (see no. 29), while child is *Romilly John* (see no. 8).

35 Euphemia Lamb (mask)
1911?
bronze, dark patina
Provenance: 1 Lady Epstein; A. F. Thompson; N. J. Ebsworth, 1983

36 Nan (The Dreamer)
1911
bronze, H 28.0
Exhibitions: AAA 1910, no. 1199 *The Dreamer* (nude study); FAS 1911
Plasters: 1 J. Epstein; K. Garman, 1921—stolen; Sotheby's 26.4.72 (75)—damaged; FAS; E. Astaire; FAS, 1975; NY, J. Solomon; W. M. Milliken; Cleveland MA
2 Israel, Ein Harod, 1965
Provenance: 1 Twenty-One Gal., 1914; Mr

& Mrs F. Rinder; Cambridge, Fitzwilliam Museum, 1937
2 CAS; Bradford CAG, 1929
3 I. MacNicol; Christie's 19.7.68 (115); FAS; C. Handley-Read; Birmingham MAG, 1973
4 Walsall, Garman-Ryan Coll., 1972
5 W. A. Evill (Edinburgh 1961)
6 Lady Tredegar
7 A. Lady; Sotheby's 16.12.64 (109); E. Littler; Eisenberg-Robbins; Washington, MAA, 1973
8 Lady Cochrane; Sotheby's 14.12.66 (2); Leicester Gal.
9 Sotheby's 12.12.68 (17A)
Literature: Haskell, p. 167; Black, p. 228, no. 16; Epstein 1940, p. 56; Epstein 1955, p. 42; Buckle, pp. 58–9, pls. 83, 86

37 Nan (The Dreamer)—head and shoulders
1911
bronze, H 14.0
Provenance: 1 F. Rawnsley; Bradford CAG, 1918
2 Detroit IFA, 1921
3 V. Leigh; Dr N. Harvey; Christie's, 19.7.68 (116); FAS; Mrs M. Black
4 Sotheby's 22.4.70 (331); V. Arwas
VERSION WHICH APPEARS TO DIFFER FROM THESE, BASED ON PLASTICINE HEAD EXHIBITED EDINBURGH, 1961 (EX-CAT.), CAST BY LADY EPSTEIN 1962:
5 Miss E. M. J. Pleister; Zoe Hadwen Bequest, Cambridge, Fitzwilliam Museum, 1982
Literature: Haskell, p. 168 (*Nan—head and neck*)
See no. 36.

36

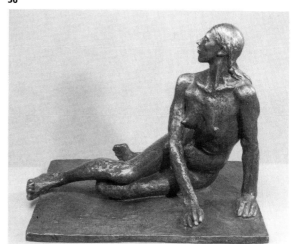

37 (2)

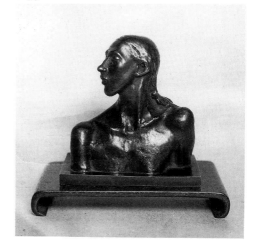

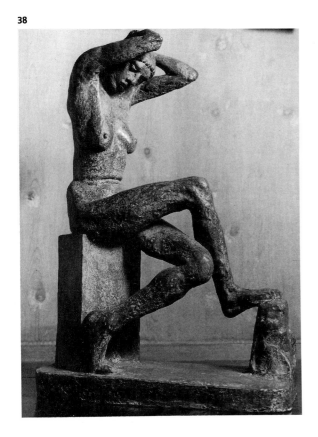

38

38 Nan Seated

1911

bronze, H 50.0

Exhibition: Leicester Gal. 238, 1917, no. 1 *Nan—study* (up to 6)

Plaster: (H 51.0) Israel, Ein Harod, 1965

Provenance: 1 J. Quinn, pre-1916; Quinn Estate, 1924–7; NY, AAA 1927, no. 709; NY, MOMA

2 J. Epstein; H. Wild; P. J. Dyer

3 A. Clifton, pre-1925; Christie's 10.5.74 (193); London, Postan

4 E. P. Schinman; whereabouts unknown

5 M. K. B. Hill, pre-1961; Christie's, 4.3. 77 (68)

6 P. Phillips (Leicester Gal.); Sydney, Artarmon Gal.; D. R. Sheumack

7 S. Box; Sotheby's 1.11.67 (158); P. Arnold

Literature: Haskell, p. 167; Black, p. 228, no. 17; Epstein 1940, p. 56; Buckle, pp. 58–9, pls. 84–5; Ede, pp. 206–7; Schinman, p. 39, ill.

39 Two columns, The Cabaret Theatre Club, 9 Heddon Street, London

1912

carved and painted plaster over pre-existing iron columns

Literature: Epstein 1940, p. 134; Epstein 1955, p. 113; Cork 1982, pp. 56–68; Cork 1985, chap. 2, esp. pp. 92–6, citing contemporary recollections

Part of a decorative ensemble to which Gill, Lewis, Gore and Ginner also contributed, in the nightclub run by Frieda Strindberg, the Austrian ex-wife of the dramatist. It opened on 26 June 1912. Fragmentary descriptions of figures with the heads of hawks, cats and camels, painted scarlet, suggest an Egyptian flavour appropriate to a club also known as The Cave of the Golden Calf. There is nothing to indicate the degree of sexual content suggested by Cork on the basis of drawings, such as *Totem*, c.1913 (Tate), which have only a superficial similarity with the column decoration described.

The club went into liquidation in early 1914 and Epstein's decorations, which were almost certainly not removable, were probably destroyed.

40 The Tomb of Oscar Wilde, Père Lachaise Cemetery, Paris (plate 4)

1909–12

Hoptonwood stone

Inscription: OSCAR WILDE, by Eric Gill; dedication, verso, by Joseph Cribb

Drawings: S. Wilson; London, Anthony d'Offay Gal.; Walsall, Garman-Ryan Coll.

Literature: *The New Age* (Supplement), 6.6.1912, ill.; van Dieren, p. 27, pl. I; Wellington, pp. 15–16; Haskell, p. 169; Powell, ill.; Black, pp. 7–8, pl. 3; Epstein 1940, pp. 65–9, 276–85, ill.; Epstein 1955, pp. 51–5, 250–6, ill.; Buckle, pp. 60–3, pls. 87–90

Commissioned through Robert Ross, the literary executor of Wilde's estate, on behalf of an anonymous lady—in fact Mrs James Carew —who donated £2,000 for the monument on condition that Epstein was the sculptor.

The commission came as a complete surprise; it was announced by Robert Ross on 1 December 1908, at a dinner to celebrate the winding up of Wilde's estate and before Epstein himself had been informed (Ross, pp. 152–7; Epstein 1940, p. 65).

Wilde's admirers 'would have liked a Greek youth standing by a broken column, or some scene from his works such as the Young King, which was suggested many times' (Haskell, p. 19). Indeed, one of Epstein's preparatory drawings (S. Wilson) shows just such a figure, and the figure he began to model was, according to Charles Holden (whom Epstein asked to design a plinth when the model was nearing completion), 'a fine figure over life-size —in wax I believe—with something of the spirit of Havard Thomas's *Lycidas* about it' (Holden, notes on Sculpture; *Lycidas*, 1902–8, Tate, illustrated in Farr, pl. 25a). It can almost certainly be identified with *Narcissus* (no. 21), which does possess a certain kinship with Havard Thomas's bronze; it may not be purely coincidental that Havard Thomas proposed Epstein unsuccessfully for membership of the Royal Society of British Sculptors at about this time (Epstein 1940, pp. 57–8). Only a few days after he had approached Holden, however, Epstein asked him to stop work on the plinth because he had another idea he was developing (Holden, Memoir, 3.12.1940). Since Gill's Diary records two hours' work on an inscription for Oscar Wilde

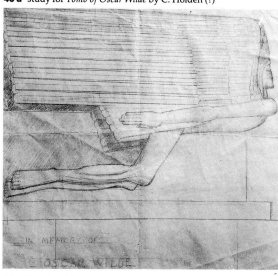

on 21 and 29 July 1910, this may indicate when the first version was abandoned.

For the new monument, Epstein visited the Hoptonwood quarries in Derbyshire and selected a huge block, which weighed 20 tons and was originally intended to be cut up for wall-facings (Epstein 1940, p. 65).

Possibly the block he chose prompted the design, rather than vice versa, since before reaching the solution closely based on the Khorsabad gates in the British Museum (fig. 9), he tried out a more overtly symbolist interpretation of the same Assyrian source (Anthony d'Offay Gal., illustrated in Wilkinson, no. 74). Though partially squared for transfer this drawing shows numerous areas of uncertainty and is quite impractical as a design for sculpture. Its Egyptian exoticism, seen through a veil of *fin-de-siècle* decadence, was largely swept away in the rigorous final design, possibly drawn by Charles Holden while designing the plinth (see 40 a).

The carving took about nine to ten months to complete. Holden refers to the nine months the carving took, while Epstein, writing to the American collector, John Quinn, refers to '10 months of hard labor'. Work on the new block was well advanced by autumn 1911, when Quinn visited Epstein's studio and was impressed with the work (Epstein to Quinn, 12.8.1914; Reid, pp. 129–30, 191).

Gill's design for the inscription was finally carved on to the plinth *in situ* by his assistant, Joseph Cribb, in September 1912 (Gill 1964, p. 35, no. 255). The crisp linear carving of the wings also strongly suggests Gill's participation, and he was observed working on the wings by at least one visitor to the studio:

> I went in 1913 [*sic*] to see it in his studio in Chelsea…with P. G. Mairet and there we saw the work nearly done—but it was Eric Gill who was hard at work on those beautiful Assyrian wings!…the trouble over the genitalia—again I am sure carved by Gill—was largely due to the peculiarly elaborate and almost decorative treatment he gave them, while the rest of the figure is summarized and simple. (A. Mola to J. Stern, 25.10.1942(?), reproduced by courtesy of R. Buckle.)

This last comment is impossible to assess since early photographs carefully darken this area of the sculpture while subsequent vandalism has obliterated the details.

At the beginning of June 1912, the sculpture was exhibited in the studio, before being crated and shipped. A dispute broke out even before its arrival when the French customs demanded payment of duty on the import of the stone and even a protest letter organized by Lytton Strachey and signed by George Bernard Shaw, H. G. Wells, John Lavery, Leon Bakst and Ross himself, was of no avail. When Epstein arrived in July to oversee the masons installing the work in the cemetery and to put the finishing touches to the stone, a more serious dispute arose. The cemetery authorities considered the work indecent, prevented Epstein and the masons from working on it and covered it with a tarpaulin. A gendarme was stationed nearby to prevent surreptitious attempts by the sculptor and others to unveil it.

For three or four months Epstein shuttled to and fro between London and Paris trying to rally support amongst French artists, gallery curators and literary figures. On 3 August, Epstein wrote from Paris, thanking Robert Ross for writing to Jacques Blanche about the remission of customs duties, and begging him to intercede with G. M. Solomon, for whom Epstein was due to carve two lions for Pretoria, South Africa, and who was getting impatient at the delay (Ross, pp. 230–1). On 14 September, Epstein wrote from Chelsea to H. P. Roché, appealing for help and announcing that he would be in Paris from the following Sunday:

> The conservateur of the cemetery objects to the work as it stands as immoral and wishes me to modify it. It is not an immoral work and I cannot modify it without destroying it or rendering it ridiculous. I wish to bring this matter to the attention of all artists and writers who value the freedom of their conceptions and who might wish to protest against the tyranny of petty officials. Can you help me in this matter?

Having seen the tomb, Roché sent the names of several interested friends, for which Epstein wrote to thank him on the 28th (HRC, Epstein to H. P. Roché). *Comoedia* came out with a satirical protest by Georges Bazile, and

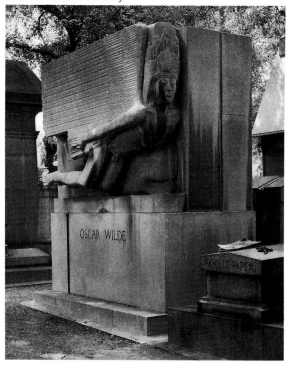

40 b Epstein with carving, 1912

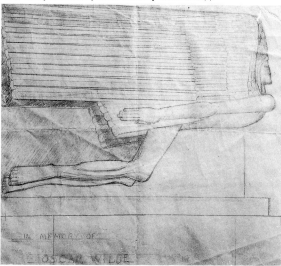

40 c Père Lachaise Cemetery

41

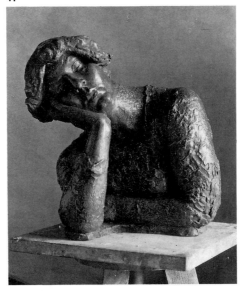

43

a group of artists, including Brancusi, regularly accompanied Epstein on forays to Père Lachaise to protest at the concealed sculpture and its gendarme (Hamnett, p. 45; Epstein 1940, pp. 276–85).

To Gaudier-Brzeska Epstein gave a humorous account of his forays to the cemetery:

> When he arrived 'les worki' [genitals] were plastered over; then the Prefect of the Seine had the whole monument covered with straw as being altogether indecent. Epstein took off the straw and plaster, leaving Wilde with his 'Couilles de taureau' which hung down a good half metre, and thanks to the petition of some artists he got the better of the authorities. (Gaudier to Sophie Brzeska, 25.11.1912, translation from Cole, p. 25.)

In fact this was over-optimistic. The sculpture was eventually unveiled in August 1914, the angel's genitals covered by a bronze figleaf, much to the sculptor's disgust. Removed during the war, the plaque was subsequently presented to Epstein one evening at the Café Royal (Epstein 1940, p. 68).

41 First Portrait of Mrs Jacob Epstein
1912
bronze
Provenance: 1 whereabouts unknown
Literature: Haskell, p. 169 (dates 1912); Epstein 1940, p. 116 (dates 1912); Buckle, p. 20, pl. 13 (dates 1905)

42 Sunflower (plate 7)
1912–13
San Stefano stone, H 61.0
Exhibitions: Edinburgh 1961, no. 42; Lon-

don, Whitechapel AG, British Sculpture in the Twentieth Century, I, 1981, no. 35
Provenance: Epstein Estate; E. P. Schinman; A. d'Offay; Melbourne, NG Victoria, 1983
Literature: Haskell, p. 167 (dates 1910); Buckle, p. 49, pl. 69; Schinman, p. 88, ill.; Cork 1976, pp. 115–16; Wilkinson, no. 73 (dates c.1910); A. G. Wilkinson in Rubin (ed.), p. 430 (dates 1912–13)

Possibly originally intended as a garden piece, since it is labelled *Garden Statue* in T. E. Hulme's photograph (Hull University). Redated on grounds of style to after Epstein's visit to Paris in 1912.

43 Birth
1913?
stone, H 30.6, W 26.6, D 10.2
Exhibitions: Tate 1961, no. 9; London, Hayward Gal., Vorticism and its Allies, 1974, no. 221; London, Whitechapel AG, British Sculpture in the Twentieth Century, I, 1981, no. 41
Provenance: Epstein Estate; E. P. Schinman; A. d'Offay; Toronto, AG Ontario, 1983
Literature: Buckle, p. 68, pls. 97–8; Schinman, p. 90, ill.; Cork 1976, pp. 460–1, ill.

44 Flenite Relief
1913
serpentine, H 30.5, W 28.0, D 9.0
Exhibitions: London Group, 1915, no. 94?; Leicester Gal. 553, 1933, no. 20 or 24; Edinburgh 1961, no. 48
Provenance: T. E. Hulme; J. Epstein; Mrs G. E. Rogers?; Epstein Estate; E. P. Schin-

44 a

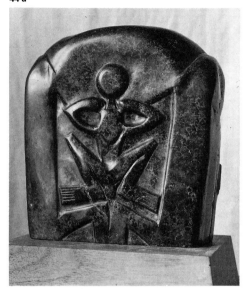

44 b

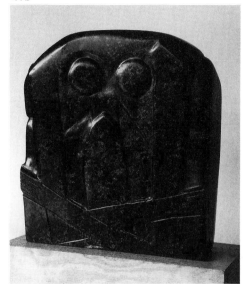

45 back view

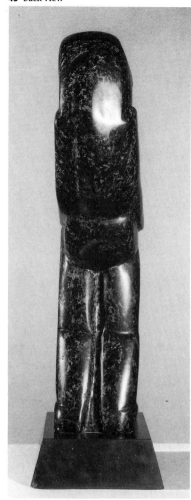

man; B. Dannenberg; V. Steele Scott; SF, Butterfield's 3.5.81 (22), ill.; Dr M. Evans
Literature: van Dieren, pl. vii; Black, pl. 51; Buckle, pp. 68–9, pls. 97–8; Schinman, p. 90, ill.; Cork 1976, pp. 119–20
Cork sees it as a technical experiment, least ambitious of flenite carvings. One side is clearly dependent upon Brancusi's *The Kiss* (fig. 11).

45 Female Figure in Flenite (plate 11)
1913
serpentine, H 45.7
Exhibitions: AAA 1913, no. 1204; Twenty-One Gal. 1913–14, no. 1 or 2?; Leicester Gal. 543, 1933, no. 20 or 24
Provenance: T. E. Hulme; J. Epstein; Mrs G. E. Rogers, 1933?; Epstein Estate; E. P. Schinman, 1963; NY, Danenberg-Roman Gal.; A. d'Offay, 1971; Tate, 1971
Literature: T. E. Hulme in *The New Age*, 25.12.1913; Epstein 1940, p. 64; Black, no. 30 (but illustrating *Figure in Flenite*); Buckle, pp. 69–70, pls. 100–1; Schinman, p. 90, ill; ACGB 1974, no. 96; Cork 1976, pp. 119–21, ill; Tate, *Report*, 1972–4, pp. 130–1

This version probably preceded *Figure in Flenite* (no. 46), as it is firmly identified as the sculpture exhibited at the AAA in July 1913 by a visitor's sketch in the catalogue (Tate, cited by Cork 1976, p. 121). Both nos. 45 and 46 were exhibited at the Twenty-One Gal., judging from Hulme's unpublished draft for his review for *The New Age* in which he wrote:

Take the smaller 'Carving in flenite', which seems to me the best thing he has

done so far…The archaic elements it contains are in no way imitative. What has been taken from African and Polynesian work is the inevitable and permanent way of getting certain effects. (Tate, Archive, 8135.35.)

46 Figure in Flenite
1913
serpentine, H 60.9
Exhibitions: Twenty-One Gal. 1913–14, no. 1 or 2; London Group, 1915, no. 94?
Provenance: J. Quinn; NY, Scott & Fowles, 1924; Quinn Estate, 1924–7; NY, AAA 1927, no. 710; E. P. Schinman; Minneapolis IA
Literature: T. E. Hulme in *The New Age*, 25.12.1913; E. Pound, 'The New Sculpture', *The Egoist*, 16.2.1914; van Dieren, pl. xi; Haskell, p. 169; Black, pl. 50; Epstein 1940, p. 64; Epstein 1955, p. 49; Buckle, pp. 69–70, pl. 99; Cork 1976, pp. 119–20, ill.
The later of the two flenite figures (see no. 45).

47 Bird Pluming Itself
1913
stone
Exhibition: London Group, 1914, no. 489
Provenance: whereabouts unknown
Literature: E. Pound, 'Exhibition at the Goupil Gallery', *The Egoist*, 16.3.1914; T. E. Hulme in *The New Age*, 26.3.1914, pp. 661–2; Buckle, p. 78; Cork 1976, p. 125
'A cloud bent back on itself—not a woolly cloud but one of those clouds that are blown smooth by the wind. It is gracious and aeriel.' (Pound.)

46

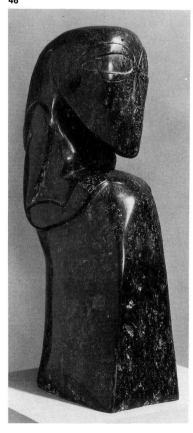

51

53 a (drawing)

53 b Epstein's studio, *c*.1913

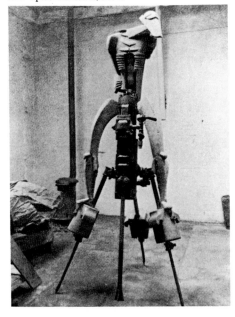

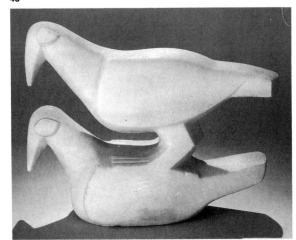

48

48 Doves—first version

1913

marble, H 35.0, L 49.5, W 18.4

Exhibitions: AAA 1913, no. 1205?; Twenty-One Gal. 1913–14, no. 5?; London, Whitechapel AG, British Sculpture in the Twentieth Century, I, 1981, no. 38

Provenance: Mrs E. Steyn; Sir R. Sainsbury; Sotheby's 15.4.64 (98), ill.; J. H. Hirshhorn; Washington, Hirshhorn Museum, 1966

Literature: Black, p. 229, no. 33 (dates 1914, calls *Second Group of Birds*); Epstein 1940, p. 64; Buckle, p. 78, pls. 119–20 (dates 1914–15, calls *First Marble Doves*); R. Cork in ACGB 1974, no. 97 (dates *c*.1913, calls *First Group*); Cork 1976, pp. 122–3

Possibly a trial for *Venus—first version* (no. 49).

49 Venus—first version (plate 8)

1913

marble, H 123.2

Provenance: A. & J. Wurtzburger; Janal Foundation; Baltimore MA, 1966

Literature: Epstein 1940, p. 64; Epstein 1955, p. 49; Buckle, p. 70, pls. 102, 104; Cork 1976, pp. 454–6, ill.

50 Doves—second version (plate 9)

1913

Parian marble, H 47.0, L 72.0, W 30.0

Exhibitions: London, Doré Gal., Post-Impressionist & Futurist, 1913; Twenty-One Gal. 1913–14, no. 5?; London Group, 1914

Provenance: J. Alford; NY, PB 10.2.44 (107), ill.; J. Epstein; B. Rose; Jerusalem, Israel Museum

Literature: van Dieren, pl. IX; Wellington, pl. 5; Black, no. 27, pl. 100 (dates 1913, calls *First Group*); Epstein 1940, p. 62; Buckle, pp. 78–9, pls. 121–2 (calls *Third Group*); Cork 1976, pp. 122–4, ill.

Identifiable as the group shown at the Doré Gal. in October 1913 from a *Daily Mirror* photograph (Tate, Nevinson cuttings, no. l).

The Twenty-One Gal. show opened in December 1913, so the same piece could well have been shown.

51 Cursed be the Day Wherein I was Born

1913–14

plaster and wood, painted red, H 115.5

Exhibition: London Group, 1915, no. 92

Provenance: J. Quinn; NY, AAA 1927, no. 721; whereabouts unknown, probably destroyed

Literature: van Dieren, pp. 14–15, 17, pl. V; Haskell, p. 169; Powell, p. 35, ill.; Black, no. 28, pl. 99 (as bronze); Buckle, p. 73, pl. 108; Cork 1976, pp. 462–3, ill.

52 Mother and Child (plate 10)

1913–14

marble, H 43.1, W 43.1

Exhibitions: London Group, 1915, no. 93; NY, Sculptor's Gal., 1922

Provenance: J. Quinn, 1916; Quinn Estate, 1924–7; NY, AAA 1927, no. 704; W. C. Findlay, 1928–38; A. Conger-Goodyear; NY, MOMA, 1938

Literature: van Dieren, pp. 30–1, 47, 93, pl. X; Haskell, p. 170; Epstein 1940, p. 64; Buckle, p. 73, pl. 107; Cork 1976, pp. 454–6, ill.; Zilczer 1978, no. 24, ill.

53 Rock Drill

1913–15

ready-made drill, plaster, H 205

Exhibition: London Group, 1915, no. 91

Provenance: dismantled by sculptor, 1915; reconstruction by K. Cook and A. Christopher for Hayward Gal., Vorticism and its Allies, 1974, no. 244, now Birmingham MAG, 1982

Literature: van Dieren, pp. 34, 44, 47, 50; *Daily Graphic*, 5.3.1915; Haskell, p. 45; Powell, p. 7; Epstein 1940, pp. 70–84, ill.; Black, p. 229, no. 32; Epstein 1955, pp. 56–68; Buckle, pp. 66–8, pl. 94; Anthony d'Offay Gal. 1973, catalogue; ACGB 1974, no. 244; Cork 1976, pp. 466–79, ill.

54 (2) back view

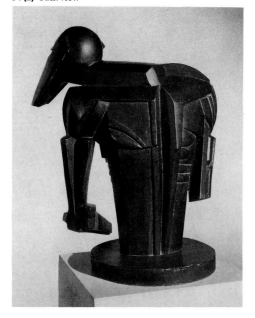

55

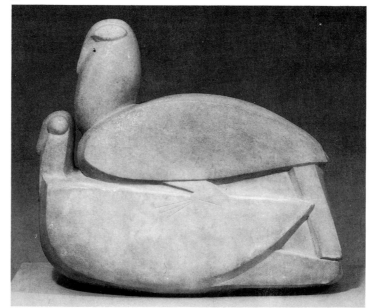

56

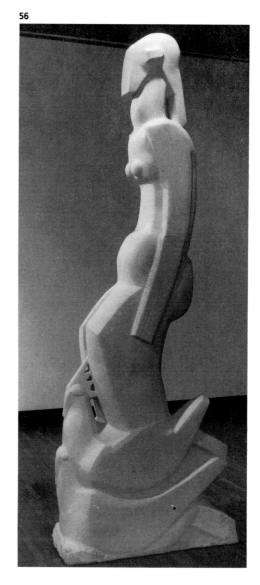

When originally exhibited, it was mounted on a stepped triangular plinth. Epstein claimed he thought of attaching a motor to make the piece kinetic.

By late in 1913, the sculpture appears to have been well on the way to completion. Many years later Bomberg recalled visiting Epstein, accompanied by either Lewis or Roberts, in a garage in Lamb's Conduit Street where he was 'finishing the large white plaster "Rock Drill"' (unsent letter, Bomberg to Roberts, 1957, cited in Cork 1976, p. 467). Gaudier-Brzeska and Pound also saw the work during 1913, Pound holding forth until Gaudier snapped, 'Shut up, you understand nothing!' (Epstein 1940, p. 70). Thus, by implication, the acquisition of the drill and the dozen or so preparatory drawings also date from that year. Epstein had shown drawings for *Rock Drill*, both in the Cubist Room at Brighton, and in his show at the Twenty-One Gal.; another was reproduced in the Christmas edition of *The New Age*. At least two of the drawings are signed and dated 1913 (Anthony d'Offay Gal. 1973, catalogue, nos. 8, 13, ill.). See no. 54.

54 Torso from the Rock Drill (plate 12)
1913–15
gunmetal or bronze, H 70.8
Exhibition: London Group, 1916, no. 100
Plaster: (H 67.0) Jerusalem, Israel Museum, 1966
Provenance: 1 (gunmetal) J. Epstein; Ottawa, NG Canada, 1956

THREE CASTS IN BRONZE MADE 1960–2:

2 Lady Epstein; Tate, 1960
3 Auckland AG, 1961
4 NY, MOMA, 1962

Literature: van Dieren, pp. 33, 44, 47, 50, pl. XIII; Wellington, pp. 17–18, pl. 4; Black, no. 32, pls. 40–1 (dates 1913); Buckle, pp. 66–8, pls. 95–6; Chamot *et al.* 1964, I, pp. 170–1; Cork 1976, pp. 478–81, ill.

Van Dieren claims Epstein intended to cast the figure on a larger scale and place it on a base, the shape and proportions of which were to complete the realization of the sculptural idea. See no. 53.

55 Doves—third version
1914–15
marble, H 64.8, L 78.8, W 31.8
Exhibitions: NY, AAA 1927, no. 712; London, Whitechapel AG, British Sculpture in the Twentieth Century, I, 1981, no. 39
Provenance: J. Quinn, 1915; Quinn Estate, 1925–7; NY, AAA 1927, no. 712, ill.; NY, E. Weyhe; S. J. Lamon; Christie's 4.12.73 (109), ill.; Tate, 1973
Literature: Black, p. 229, no. 34 (dates 1915, calls *Third Group of Birds*); Epstein 1955, pp. 45–6; Buckle, p. 78 (calls *Second Group*); ACGB 1974, no. 98 (calls *Second Group*); Tate, *Report*, 1972–4, pp. 131–3; Cork 1976, pp. 123–4, ill. (calls *Second Group*); Zilczer 1978, p. 40, note 15

Zilczer cites the Pound–Quinn–Epstein correspondence. Pound to Quinn, 8.3.1914, urges him to buy the pair 'stuck together'. Quinn to Epstein, 12.4.1914, requests a marble replica of the *Two Doves*. Epstein willing (Epstein to Quinn, 1.5.1914), carving completed in 1915 and Epstein thought it superior to the first (Epstein to Quinn, 24.11.1915).

56 Venus—second version
1914–16?
marble, H 244
Exhibition: Leicester Gal. 238, 1917, no. 15
Provenance: J. Quinn; NY, AAA 1927, no. 723, ill.; Chite Coll.; New Haven, Yale University AG
Literature: van Dieren, pl. VII; Wellington, pp. 19–20, pl. 6; Black, no. 50, pl. 9; Epstein 1940, p. 64; Buckle, p. 70, pls. 103, 105; Cork 1976, pp. 456–61, ill.

On 25 June 1916 Mrs Epstein wired John Quinn for help in preventing Epstein's call-up, mentioning 'Sungod, Venus, Man, Woman, Maternity and the Rock Drill' as unfinished (Reid, pp. 258–9).

59 (plaster)

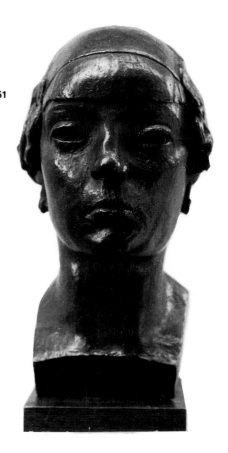

60

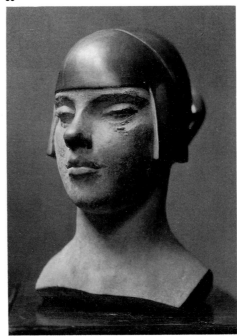

61

58 (1)

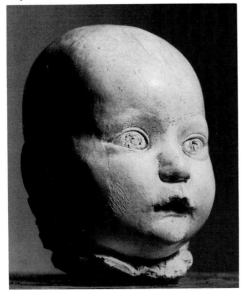

57

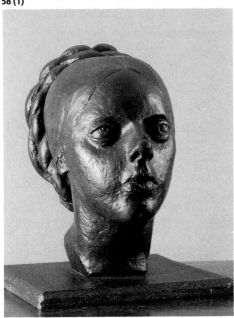

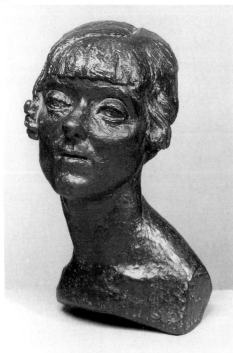

57 Marie Beerbohm
1915
bronze, H 36.9
Exhibition: Leicester Gal. 238, 1917, no. 2 (up to 6)
Provenance: 1 Sotheby's 13.12.67 (85); P. Coll.
Literature: Haskell, p. 171; Black, p. 230, no. 41; Buckle, p. 74, pl. 111

58 Hilda Hamblay
1915
bronze, black patina, H 29.0
Exhibition: Leicester Gal. 238, 1917, no. 18 (up to 6)
Plaster: (H 27.0) Israel, Ein Harod, 1965
Provenance: 1 Lady Epstein; B. Lipkin
2 whereabouts unknown (illustrated by Buckle)
Literature: Haskell, p. 171 (dates 1915); Black, p. 230, no. 40 (dates 1915); Buckle, p. 39, pl. 52 (dates 1909).

59 Elizabeth Scott-Ellis
1915
bronze, H 15.0
Exhibition: NPS 1916, no. 38
Plaster: NY, Museum of the City, 1971
Provenance: 1 Lord & Lady Howard de Walden; P. Coll.
Literature: van Dieren, pl. XLVI; Haskell, p. 174 (dates 1917); Buckle, p. 90, pl. 136
Portrait of their daughter, commissioned by Lord & Lady Howard de Walden, 1915.

60 Iris Beerbohm Tree
1915
bronze, H 68.6

Exhibitions: NPS 1916, no. 87; Leicester Gal. 238, 1917, no. 14 (up to 6)
Provenance: 1 J. Quinn, 1916; NY, Scott & Fowles, 1924; NY, AAA 1927, no. 703, ill.; NY, PB 26.3.46 (41); P. Coll.; Granville, Ohio, Denison University, 1949
2 Leicester Gal., 1938
Literature: van Dieren, pl. XXXVI (Quinn); Haskell, p. 171; Black, no. 39, pl. 88; Buckle, p. 74, pl. 109 (dates 1914–15)
Quinn–Epstein correspondence records a dispute over the number of casts, as Quinn claimed a prior agreement with Epstein for only two casts (Reid, pp. 258–61, 299).

61 Marcelle
1915?
bronze, H 45.4
Exhibition: Leicester Gal. 238, 1917, no. 5 (up to 6)
Provenance: 1 Coleman Coll. (1932) = cast 2?
2 Mr & Mrs S. Zacks; Toronto, AG Ontario, 1970
Literature: van Dieren, pp. 53–4, pl. XXIX (Coleman Coll.); Haskell, p. 177 (dates 1920); Black, pl. 85 (dates 1920); Buckle, p. 75, pl. 114 (dates 1914–15)
French waitress at Café Royal.

62 Countess of Drogheda
1915
bronze
Exhibition: NPS 1917, no. 54
Plaster: destroyed 1982
Provenance: 1 J. Quinn, 1917; Quinn Estate, 1924–7; NY, AAA 1927, no. 708; P. J. Goodhart; H. L. Goodhart; Bryn Mawr

62 (1)

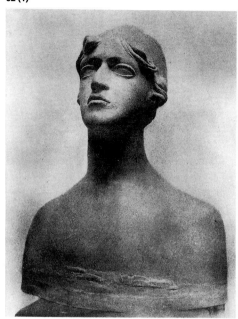

63 (4)

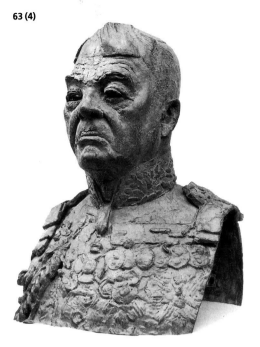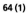

64 (1)

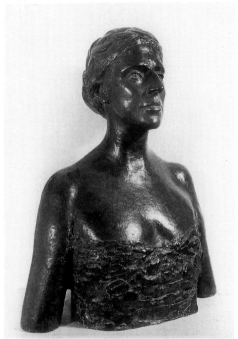

65 (1)

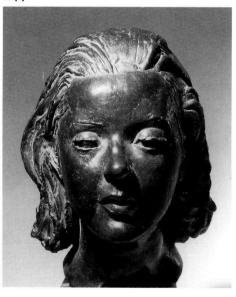

College, 1948; whereabouts unknown
Literature: van Dieren, pl. xxxii; Haskell, p. 171; Black, no. 37, pl. 67; Buckle, pp. 74–5, pl. 112
Commissioned by sitter but disliked by sitter's husband.

63 Admiral Lord Fisher of Kilverstone, OM

1915
bronze, H 62.0
Exhibitions: Leicester Gal. 238, 1917, no. 6; NPS 1917, no. 47
Plasters: 1 (with arms) London, NMM, 1966
2 (without arms) Jerusalem, Israel Museum, 1966
Provenance: VERSION WITH ARMS:
1 Duke of Hamilton
2 Lord & Lady Clifford
3 E. P. Schinman; whereabouts unknown
VERSION WITHOUT ARMS:
4 M. Bone; London, IWM
5 J. Quinn; NY, Scott & Fowles; Ottawa, NG Canada, 1924
Literature: van Dieren, p. 47, pl. xxxiv; Wellington, p. 21, pl. 7; Haskell, p. 171 (dates 1915); Epstein 1940, pp. 105–6; Black, no. 35, pl. 6 (no arms); Epstein 1955, pp. 87–8, ill.; Buckle, pp. 76–7, pls. 116–7 (no arms, dates 1914–15); Schinman, p. 44, ill.
Commissioned for the Duchess of Hamilton who was also urged by Fisher to get her own portrait done. See no. 64.

64 Nina, Fifteenth Duchess of Hamilton

1915

bronze, H 64.8
Exhibition: NPS 1917, no. 52
Plaster: destroyed 1982
Provenance: 1 Duke of Hamilton
2 J. Quinn, 1917; Quinn Estate, 1924–7; NY, AAA 1927, no. 713, ill.; NY, Stevenson Scott, 1933; Toledo MA, 1937; NY, PB 28.3.46 (99A); P. Tretchakov; J. H. Hirshhorn; Washington, Hirshhorn Museum, 1972
Literature: van Dieren, pl. xvii; Haskell, p. 171; Black, no. 36, pl. 66; Buckle, p. 77, pl. 118
Commissioned. Lord Fisher wrote to encourage the Duchess to commission a portrait. See no. 63.

65 First Portrait of Lillian Shelley

1915
bronze, H 32.5
Exhibitions: NPS 1916, no. 37; Leicester Gal. 238, 1917, no. 22 (up to 6)
Plaster: destroyed 1982
Provenance: 1 S. Schiff; Sir E. Beddington-Behrens; Christie's 9.6.78 (104); NY, Christie's 8.11.79 (64), called *Dorelia*
2 J. Quinn, 1917; NY, Scott & Fowles, 1924; Montreal MFA, 1924
3 O. Brown (1961)
Literature: Epstein 1955, pp. 113–4, ill.; Buckle, p. 80, pl. 123 (dates 1918); Reid, pp. 299, 616–7
Commissioned by a member of the Sassoon family. The subject was a singer and dancer at the Cave of the Golden Calf. When Quinn bought his cast in 1915/16 he thought the agreed cast limit was four and complained to Epstein about Leicester Gal. 1917 limit of six.

68 (3)

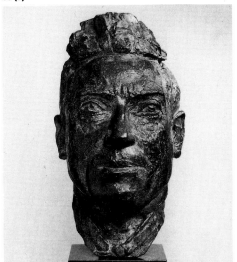

69 (plaster)

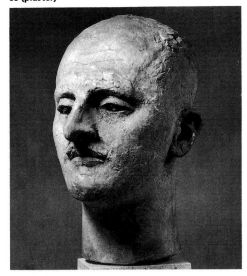

67 Epstein at work

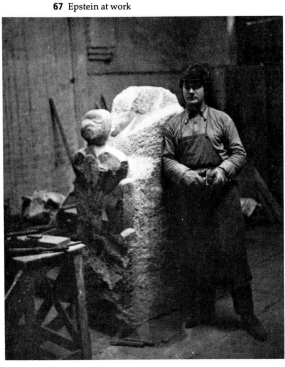

66 (1)

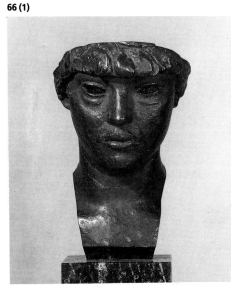

66 Billie Gordon (mask)

1915

bronze, H 30.0

Exhibitions: Leicester Gal. 238, 1917, no. 3 (up to 6); NPS 1918, no. 48 *Billie (bronze mask)*

Plaster: portrait with mobcap uncast (Buckle, pl. 110)

Provenance: 1 Mrs A. C. Hardy; Ottawa, NG Canada, 1948

Literature: Buckle, p. 75, pls. 110–11 (dates 1914–15)

'Red-head who frequented the Café Royal' (Buckle).

67 Mother and Child

1915–17

granite, over life-size

Exhibition: Leicester Gal. 238, 1917, no. 23

Provenance: J. Quinn, 1917; L. Epstein—destroyed 1923?

Literature: Haskell, p. 172 (dates 1917); Buckle, pp. 72–3, pl. 106; Cork 1976, pp. 122, 305, note 77; Reid, pp. 299, 373, 397, 607; Zilczer 1978, pp. 40–1

The sculpture stems from the drawings and reliefs on the theme of birth (e.g. nos. 43, 44), but it is not known when Epstein began or abandoned it. He appears to have placed the huge child in front of the mother, rather like a Romanesque Madonna and Child. The appearance of the piece, which was allegedly dropped in the Hudson on Epstein's instructions after Quinn received it in mistake for the marble *Mother and Child* (no. 52), is unknown except for a studio photograph which shows only the outline of the child, very similar to that on the *Flenite Relief* (no. 44). However, J. B. Manson remarked that the title was misleading since the 'solid, expressive mass—this granite "Mother" – holding up its offspring in a pride of achievement', possessed the strength of a life-force (*The New Age*, 1.3.1917, pp. 425–6). Bernard van Dieren commented on how 'the huge child, which seems to grow while one looks at it, conveys

with extreme clearness the underlying idea of the young generations making slaves of their mothers...one can admire the two heads between the sloping triangles of the shoulders, and the finely modelled contours of the child's limbs' (*The New Age*, 7.3.1917, pp. 451–53).

68 William Henry Davies

1916?

bronze, H 31.0

Exhibitions: Leicester Gal. 238, 1917, no. 25 (up to 6); Leicester Gal., New Year, 465–6, 1942, no. 149

Provenance: 1 Hon. E. Morgan (Lord Tredegar); Newport MAG, 1917

2 Mrs W. H. Davies; Leicester Gal.; London, NPG, 1953

3 Sotheby's 21.11.62 (178); Leicester Gal., 1966; P. Coll.

Literature: van Dieren, pl. XXXII; W. H. Davies, *Later Days*, 1925, pp. 157–8; Haskell, p. 172; Black, no. 45, pl. 77; Buckle, p. 80, pl. 124

Epstein invited Davies to sit at their first meeting, at Harold Munro's Poetry Bookshop, and probably therefore earlier than 1916.

69 T. E. Hulme

1916

bronze, H 32.0 (plaster)

Exhibitions: Leicester Gal. 246, 1917, no. 4; NY, Sculptor's Gal., 1922 (lent by Quinn); Leicester Gal., Summer, 680, 1938, no. 184

Plaster: (H 32.0) Jerusalem, Israel Museum, 1966

Provenance: 1 Sitter; J. Epstein; J. Quinn; NY, Scott & Fowles, 1924; NY, AAA 1927, no. 695

2 Mrs Kibblewhite; A. Dukes; P. Coll.

Literature: van Dieren, pl. XXXI; Haskell, p. 171 (dates 1915); Black, no. 38, pl. 73; Epstein 1955, pp. 59–68; Buckle, pp. 75–6, pl. 115 (dates 1914–15); Jones, p. 141

70 (1) 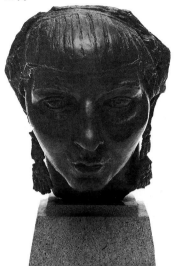 71 (1) 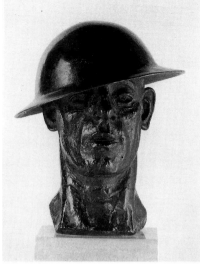 72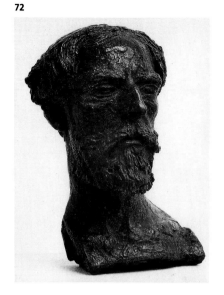

Philosopher and close friend of the sculptor, Hulme was writing a book on Epstein which is thought to have been lost with him when he was killed in France on 27 September 1917. Sittings took place from spring to autumn 1916 when Hulme was on leave. The same sculpture with the addition of a French helmet, was exhibited under the title *Officer* (Leicester Gal. 246, 1917, no. 10). A photograph was in the possession of Hulme's friend, Kate Lechmere (information courtesy of Professor S. Hynes).

70 Second Portrait of Mrs Jacob Epstein (mask with earrings)

1916
bronze, H 21.5
Inscription: *JE* on verso of both earrings
Exhibitions: Leicester Gal. 246, 1917, no. 2; NPS 1918, no. 47 *Bronze Mask?*; Ferargil Gal. 1927, no. 3 or 40
Plaster: (H 14.0) Israel, Ein Harod, 1965
Provenance: 1 Leicester Gal., 1922; C. Rutherston; Manchester CAG, 1925
2 J. Quinn, 1918; Quinn Estate, 1924–6; A. Conger Goodyear, 1926; Buffalo, Albright-Knox AG, 1953
3 Speiser; NY, PB 26.1.44 (107); P. Coll.
4 (no earrings) Epstein Estate; Mrs P. J. Lewis, 1959
5 Auckland CAG
6 Mrs E. Hersheim; Sotheby's 20.6.62 (46); A. Tooth
7 (no earrings) E. P. Schinman; whereabouts unknown
8 Dowager Duchess of Marlborough; Christie's 17.11.78 (111), ill.; FAS
9 Christie's 6.11.81 (85)
Literature: van Dieren, pl. xv; Wellington, pl. 14; Haskell, p. 172; Epstein 1940, p. 116, ill.; Black, no. 42, pl. 7; Epstein 1955, p. 96, ill.; Buckle, p. 85, pl. 128; Schinman, p. 66, ill.
Epstein 1940, p. 116, states that two casts were purchased by Japanese.

71 The Tin Hat

1916
bronze, H 35.5
Exhibitions: Leicester Gal. 238, 1917, no. 7 (up to 6); London, Royal Academy, Nation's War Paintings, 1920, no. 679a
Plaster: (H 41.0) Israel, Ein Harod, 1965
Provenance: 1 M. Bone; London, IWM, 1919
2 J. Quinn, 1916; NY, Scott & Fowles; J. L. Brodie? (on loan to Brooklyn Museum, 1935–6); whereabouts unknown
3 Maj.-Gen. Sir E. Spears; Christie's 12.7.74 (314); FAS; LA, Feingarten Gal.
4 Mrs D. Samuel; Jerusalem, Israel Museum, 1972
Literature: van Dieren, pl. xxiii; Haskell, p. 172; Powell, p. 64, ill.; Black, no. 44, pl. 17; Buckle, p. 85, pl. 129
Commission. See *American Soldier* (no. 84).

72 Augustus John

1916
bronze, H 35.2
Exhibitions: Leicester Gal. 238, 1917, no. 16 (plaster, up to 6); Leicester Gal. 1191, 1960, no. 11
Plaster: Jerusalem, Israel Museum, 1966
Provenance: 1 Sitter
2 Lady Tredegar, 1917; Cardiff, NMW
3 J. Quinn, 1917; NY, Scott & Fowles, 1924
4 Lady Epstein; London, Obelisk Gal.; Baron Buttner; Glasgow AG, 1965
5 London, Tooth's; London, NPG, 1962
6 E. P. Schinman; whereabouts unknown
7 D. Hughes; E. Littler; Eisenberg-Robbins; Washington, MAA, 1973
8 Lord Cottesloe (King's Lynn 1963)
9 Sotheby's 20.4.66 (77)
10 P. Coll.; Christie's 18.7.69 (163)
11 Sotheby's 3.11.82 (48)
Literature: van Dieren, pl. xli; Haskell, p. 171; Epstein 1940, pp. 107–8; Black, no. 47, pl. 76; Buckle, pp. 82–5, pl. 127; Schinman, p. 43, ill.

74 (1)

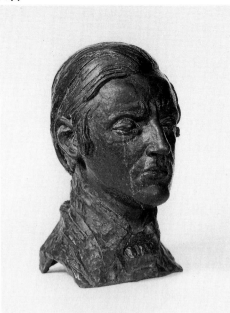

75 (2)

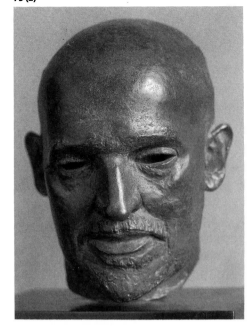

76 (2)

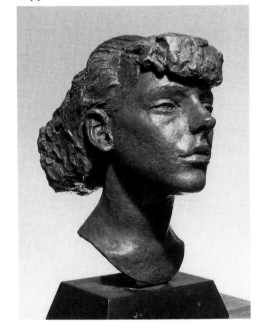

73 (2)

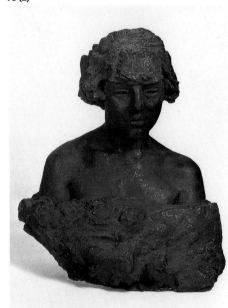

**73 First Portrait of Meum
(Mrs Lindsell-Stewart)—bust**
1916
bronze, H 55.0
Exhibition: Leicester Gal. 238, 1917, no. 26?
(up to 6)
Plaster: Ottawa, NG Canada, 1966
Provenance: 1 J. Quinn, 1917; Quinn
Estate, 1924–6; Buffalo, Albright-Knox
AG, 1926–43; NY, PB 4.10.43 (99); P. Coll.
2 Leicester Gal.; Manchester CAG, 1923
Literature: van Dieren, pl. xxxv; Haskell,
p. 172; Black, p. 230, no. 43; Buckle, p. 87,
pl. 130

74 First Portrait of Bernard van Dieren
1916
bronze, H 33.0
Exhibition: Leicester Gal. 246, 1917, no. 5
Plaster: Hull University AG, 1965
Provenance: 1 J. Quinn; NY, Scott &
Fowles, 1924; NY, AAA 1927, no. 696; NY,
PB 26.2.46 (102); Stevenson Scott; Detroit
IFA, 1953
2 C. Gray (1917)
3 E. P. Schinman; City of Rotterdam
Literature: van Dieren, pl. xlv; Epstein
1940, pp. 96, 121; Black, no. 46, pl. 80;
Epstein 1955, pp. 78–9, 101; Buckle, p. 82,
pl. 125; Schinman, p. 42, ill.
Composer. Model for head of *Risen Christ*
(no. 97). Author of first book on Epstein's
work.

75 James Muirhead Bone
1916
bronze, H 26.5
Exhibition: Leicester Gal. 238, 1917, no. 24
(up to 6)
Plaster: (H 26.0) Jerusalem, Israel Museum,
1966
Provenance: 1 M. Bone; P. Coll.

2 J. Quinn, 1918; Quinn Estate, 1924; NY,
Scott & Fowles; Providence, Rhode Island
School of Art and Design MA, 1924
3 Dundee CAG, 1918
4 M. Paez-Vilano; NY, SPB 3.6.70 (90), ill.
Literature: van Dieren, pl. xlii; Haskell,
p. 172 (dates 1916); Black, no. 48, pl. 72;
Buckle, p. 82, pl. 126
Commission. The artist Bone was one of
Epstein's staunchest defenders.

76 Second Portrait of Meum (head)
1916
bronze, H 32.5
Exhibitions: Leicester Gal. 238, 1917, no. 11
(plaster, up to 6); NPS 1918, no. 49?
Plaster: (H 35.0) Israel, Ein Harod, 1965
Provenance: 1 J. Quinn, 1917; Quinn
Estate, 1924–7; NY, A. Conger-Goodyear;
Pittsfield, Mass., Berkshire Museum, 1960
2 A. Tooth (via Melbourne/Sydney,
1933); Sydney, AG NSW, 1933
3 Sotheby's 14.12.66 (35); P. Coll.
4 H. W. Lewis; E. Littler; Eisenberg-
Robbins; Washington, MAA, 1973
5 (signed) Sotheby's 10.11.76 (36); J.
Constable
6 (signed) Sir Robert Abdy; Mr & Mrs E.
M. M. Warburg—promised to Cambridge,
Fogg AG
Literature: Black, p. 231, no. 51 (dates
1917); Haskell, p. 173; Buckle, p. 87, pl. 131

77 Bronze Head
1916–17
bronze
Exhibition: Leicester Gal. 238, 1917, no. 21
(up to 6)
Provenance: no record
No recorded casts, unless it is to be iden-
tified with J. Epstein; A. F. Thompson;
Watford AG, 1981.

77?

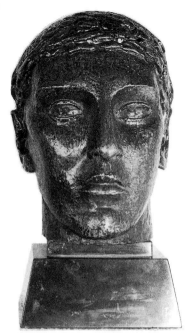

79

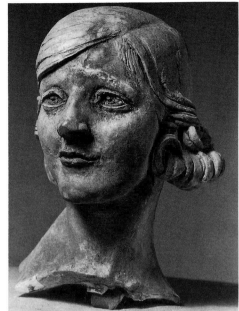

80

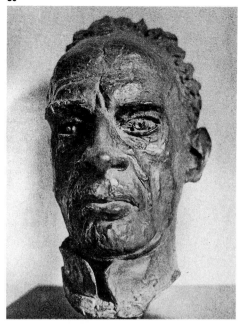

84 (3)

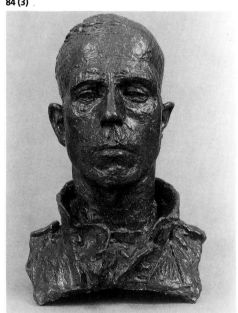

78 Study for a Monument
1916–17
plaster
Exhibition: Leicester Gal. 238, 1917, no. 12
Provenance: destroyed
Literature: B. van Dieren in *The New Age*,
7.3.1917, pp. 451–3
'These mud-besmirched, heavily packed
men, deliberately and slowly moving for-
ward, driven by an implacable desire to
perform an almost superhuman task...the
balance of the composition, the rhythm of
the figures and the unsurpassable force of
line...' (van Dieren).

79 Doris Keane
1917
bronze
Exhibition: Leicester Gal. 246, 1917, no. 1
Provenance: 1 Sitter
Literature: Haskell, p. 173; Black, p. 231,
no. 54; Buckle, p. 88, pl. l32
Commission. Star of *Romance*, a long-
running wartime show.

80 Josef Holbrooke
1917
bronze
Exhibition: Leicester Gal. 246, 1917, no. 3
Provenance: 1 Sitter (1920)
Literature: van Dieren, p. 53, pl. XLIII;
Haskell, p. 174; Black, no. 60, pl. 81;
Buckle, p. 90, pl. 135
Commission. Composer.

81 Harlay Matthews
1917
plaster?
Provenance: no record
Literature: Haskell, p. 174 (plaster); Black,
p. 231, no. 62 (plaster); Buckle, p. 425
Uncast in 1931 (Haskell).

82 Sir Francis Newbolt, KC
1917
bronze?
Provenance: no record
Literature: Haskell, p. 174; Epstein 1940, p.
112?; Black, p. 231, no. 57; Buckle, p. 425
Commission. If this is the portrait referred
to by the sculptor in his autobiography, it
may never have been completed.

83 Mrs Andrews
1917
bronze
Provenance: 1 Sitter (1942)
Literature: Haskell, p. 174; Black, p. 231,
no. 55; Buckle, p. 425
Commission.

84 American Soldier
(Augustus Franklin Kopf)
1917
bronze, H 39.9
Exhibitions: NPS 1919, no. 229a (plaster);
Leicester Gal. 291, 1920, no. 11 (up to 6)
Provenance: 1 J. Epstein; J. Quinn, 1920;
NY, Scott & Fowles, 1924; NY, Metro-
politan Museum, 1924
2 C. Mutter; Sotheby's 15.4.64 (99)
3 R. L. Joseph; Washington, NG, 1960
4 Trenton, NJ, M. Robling Coll.
5 P. Coll., 1933
VERSION WITH BRITISH HELMET:
6 London, IWM
7 E. P. Schinman = cast 8?
8 P. Coll.; NY, Graham Gal., 1985
Literature: van Dieren, pl. xxv; Haskell,
p. 173; M. L. de Muñoz Marín, 'The typi-
cal American Soldier lives in Puerto Rico',
The University of Puerto Rico Bulletin, 1937,
pp. 188–91; Black, no. 56, pl. 8; Buckle, p.
90, pl. 138; Schinman, p. 67, ill.
According to Muñoz, executed in Sep-
tember. See also *The Tin Hat* (no. 68).

86 (1)

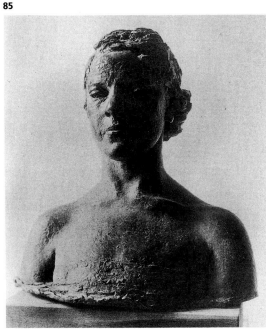

85

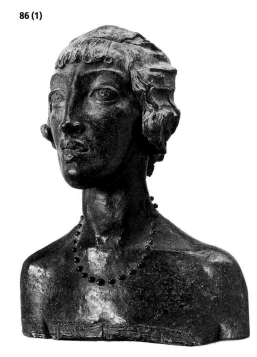

87

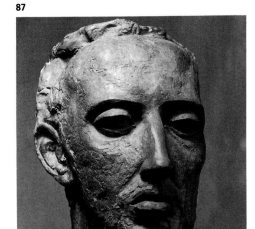

88

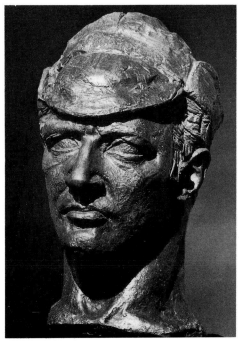

85 Marguerite Nielka

1916–17

bronze

Exhibition: Leicester Gal. 291, 1920, no. 8
Provenance: 1 Sitter (1920)
Literature: van Dieren, pl. xxvi; Haskell, p. 173; Black, p. 231, no. 53
Commission. Swedish singer.

86 Gladys Deacon

1917

bronze, H 50.0

Exhibitions: Leicester Gal. 291, 1920, no. 7 *Portrait of a Lady* (up to 6); Ferargil Gal. 1927, no. 8; Leicester Gal. 1191, 1960, no. 12 (dated 1918, 1 of 3)
Plaster: (H 69.0) Jerusalem, Israel Museum, 1966
Provenance: 1 A. F. Thompson; Sotheby's 17.3.76 (51); V. Arwas
Literature: van Dieren, pl. xLIV (*Bust of a Lady*); Wellington, p. 24, pl. 13; Haskell, p. 174; Black, p. 231, no. 58; Buckle, p. 88, pl. 134
Commissioned by the sitter, an American, later Ninth Duchess of Marlborough (see no. 142).

87 Second Portrait of Bernard van Dieren (mask)

1917

bronze, H 34.3

Plaster: (H 36.0) Israel, Ein Harod, 1965
Provenance: 1 Sotheby's 22.7.64 (64), ill.; P. Coll.

Literature: Epstein 1940, p. 96; Epstein 1955, pp. 78–9, 101; Buckle, p. 99, pl. 152

88 Self-Portrait in a Storm Cap

1917

bronze, H 50.8

Exhibition: Leicester Gal. 752, 1942, no. 4 (dated 1916)
Plaster: (H 51.0) Jerusalem, Israel Museum, 1966
Provenance: 1 Leicester Gal.; Preston, Harris AG, 1942
 2 Epstein Estate; London, NPG, 1959
 3 A. Margulies
 4 E. P. Schinman; whereabouts unknown
 5 Detroit, Graphic Art Assoc., 1968, no. 1
Literature: Haskell, p. 174 (dates plaster 1917); Black, p. 231, no. 61; Buckle, p. 65, pl. 91 (dates 1912); Schinman, p. 40, ill.
Cast after 1931 (Haskell).

89 Third Portrait of Meum (mask)

1918

bronze, H 28.0

Exhibitions: NPS 1919, no. 1026 (wax study); Leicester Gal. 291, 1920, no. 12 (up to 6); Ferargil Gal. 1927, no. 5
Plaster: Israel, Ein Harod, 1965
Provenance: 1 G. F. Porter; Chicago AI, 1922
 2 H. Halle; NY, PB 17.3.61 (37); E. J. Arnold; LA, SPB 5.2.74 (59)
 3 Sir E. Spears; Christie's 12.7.74 (315); V. Arwas
 4 A. Haskell; FAS

89

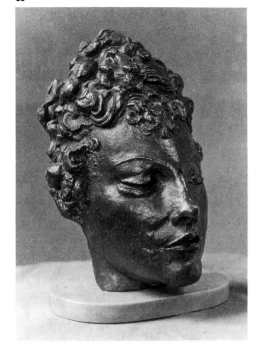

90 (1)

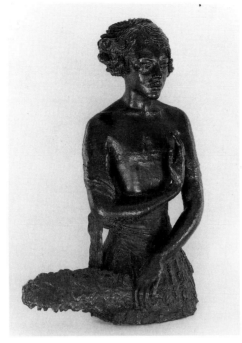

91

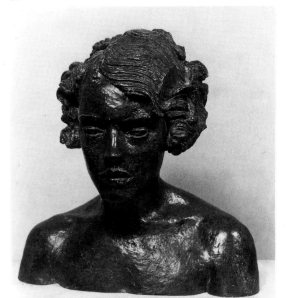

92

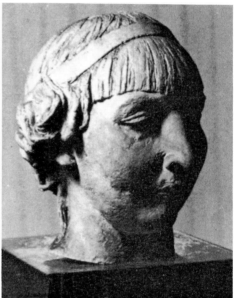

93

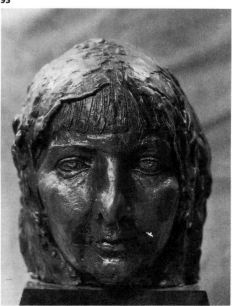

5 E. P. Schinman; NY, SPB 19.5.78 (351), ill.; Dr M. Evans

6 M. Reach; Sotheby's 17.7.68 (120); P. Coll.

7 E. Littler; Eisenberg-Robbins; Washington, MAA, 1973

8 Christie's 12.3.82 (140), ill.; London, Whitford & Hughes, 1984

Literature: van Dieren, pl. XLVIII; Wellington, p. 23, pl. 12; Haskell, p. 175; Epstein 1940, p. 105; Black, no. 64, pl. 92; Epstein 1955, p. 86, ill.; Buckle, p. 94, pl. 145; Schinman, p. 68, ill.

90 Fourth Portrait of Meum (with fan)

1916–18

bronze, H 87.6

Exhibition: Leicester Gal. 291, 1920, ex-cat. (up to 3)

Provenance: **1** Mrs A. Sutro, 1925 = Leicester Gal.?; W. Burrell; Glasgow, Burrell Collection, 1948

Literature: van Dieren, p. 52, pl. XXXVIII; Wellington, pp. 23–4, pls. 10–11; Black, no. 66, pls. 52–3; Buckle, p. 94, pl. 146

It may have been this portrait of Meum which Ashley Gibson observed in the making during a wartime leave: '…and while Mrs Epstein gravely sat and stitched, the sweet silhouette of Miss M, enthroned where the light made cunning play with the folds of her green velvet, wavered nebulously. Epstein was quietly busy with his clay. His movements had the stealthy, quick precision of a tiger's.' (Gibson, pp. 150–1.)

91 Fourth Portrait of Meum (version of)

1918

bronze, H 42.0

Plaster: Cleveland MA, 1975

Provenance: **1** Walsall, Garman-Ryan Coll., 1972

2 London, Hamilton Gal.; ACGB, 1966

See no. 90.

92 Third Portrait of Mrs Jacob Epstein (with ribbon)

1918

bronze, H 36.8

Exhibition: Leicester Gal. 1968 (bust, 2 of 6)

Plaster: destroyed 1982

Provenance: **1** LA, Dalzell Hatfield Gal.; V. Steele Scott; SF, Butterfield's, 3.5.81 (249), ill.

VERSION WITH HEAD ONLY, H 25.7:

2 NY, W. Irving Gal.; NY, Marlborough Gal.; NY, SPB 18.10.79 (60), ill.

Literature: Haskell, p. 176 (plaster); Black, p. 232, no. 73 (dates plaster 1919); Buckle, p. 92, pl. 140 (head, calls *Third Portrait*)

Cast after 1931 (Haskell).

93 Fourth Portrait of Mrs Jacob Epstein (with a scarf)

1918–19?

bronze, H 26.3 (head only)

Provenance: no record

Literature: Black, p. 232, no. 73 (dates plaster 1919 after *Fifth Portrait*); Buckle, p. 92, pl. 141

99 (1)

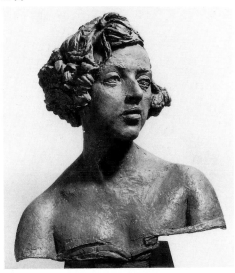

95 (3)

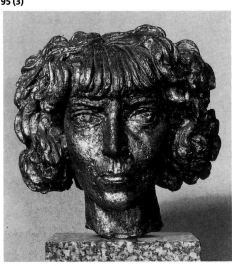

94

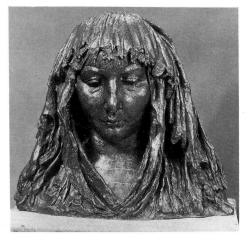

94 Fifth Portrait of Mrs Jacob Epstein (in a mantilla)
1918
bronze, H 38.0
Exhibition: Leicester Gal. 291, 1920, no. 3 (up to 3)
Plaster: (H 38.0) Jerusalem, Israel Museum, 1966
Provenance: 1 Northern Art Collections Fund; Newcastle-upon-Tyne, Laing AG, 1934
2 Leicester Gal.; NY, Scott & Fowles, pre-1940; NY, PB 28.3.46 (6), ill.; D. Montagu; London, Tooth's; D. L. Kreeger, 1962
3 Sir Alec Martin, 1952; Lady Martin (1961)
4 A. C. J. Wall; Christie's 30.10.70 (216), ill.; Leicester Gal.; Prof. E. Shils (1971)
6 Mrs J. S. Hill; Sotheby's 1.5.68 (64); P. Coll.
7 E. P. Schinman; whereabouts unknown
Literature: van Dieren, pl. XVI; Wellington, p. 25, pl. 15; Haskell, p. 175 (dates 1918); Epstein 1940, pp. 116–7, ill.; Black, no. 63, pl. 97 (dates both 1917–20 and 1918); Epstein 1955, p. 97; Buckle, pp. 92–3, pls. 142–4; Schinman, p. 73, ill.

95 Marchesa Casati
1918?
bronze, H 29.3
Inscription: *Epstein*
Exhibition: Ferargil Gal. 1927, no. 4
Plaster: (H 29.0) Israel, Ein Harod, 1965
Provenance: 1 NY, Ferargil Gal., 1927; D. W. Prall; Oberlin, Allen Memorial Museum, 1950
2 J. Gibbins; Sotheby's 24.11.32; Cecil Leitch & Levin
3 Mrs A. Lieberman; NY, PB 10.2.44 (91), ill.; Mrs W. M. Elkins; Philadelphia MA, 1950
4 K. Graham (Da Vinci Gal.), 1953; E. K. Cole; Southend-on-Sea, Beecroft AG
5 Lady Moorea Wyatt (Edinburgh 1961)
6 C. A. Jackson; London, Da Vinci Gal.; Dr R. Gainsborough, 1948; London, P. Coll., 1965
7 NY, PB 17.1.45 (186), ill.; NY, Knoedler
8 Mrs. A. Crossley; Sotheby's 14.12.66 (34)
Literature: Haskell, p. 175; Epstein 1940, pp. 104–5; Black, p. 232, no. 65; Epstein 1955, p. 86, ill.; Buckle, p. 96, pl. 147

96 Cecil Gray (bust)
1918–19
plaster
Exhibition: NPS 1919, no. 105a (plaster)
Provenance: no record
Literature: Haskell, p. 177 (dates 1920); Black, p. 233, no. 81 (plaster, dates 1920); Buckle, p. 425 (dates 1918, believes destroyed); Gray, pp. 206–7
Uncast in 1931 (Haskell). The sculptor visited Italy with Cecil Gray in 1919 after demobilization. According to Gray it was 'not one of his best works...too heroic in conception'.

97 Risen Christ (plate 13)
1917–19
bronze, H 218.5
Inscription: caster's mark of Parlanti, London
Exhibition: Leicester Gal. 291, 1920, no. 1
Provenance: 1 Leicester Gal.; A. Cherry-Garrard; Mrs G. Matthias; Edinburgh, SNGMA, 1969
VERSION WITH HANDS ONLY H 31.0:
2 Walsall, Garman-Ryan Coll.
3 Sotheby's 19.7.69 (101); London, Agnew's; P. Coll.
Literature: van Dieren, pp. 30, 63–7, pls. III, IV; Wellington, pp. 22–3, pls. 8, 9; Haskell, p. 175; Powell, pp. 102–8; Epstein 1940, pp. 119–27, Appendix, ill.; Black, no. 68, pls. 10, 98; Epstein 1955, pp. 99–106, 257–62, ill.; Buckle, pp. 99–101, pls. 151–5
Begun as a portrait study of the sick Bernard van Dieren during 1917, the head was rapidly developed into an over life-size standing figure:

Watching his head, so spiritual and worn with suffering, I thought I would like to make a mask of him. I hurried home and returned with clay and made a mask which I immediately recognized as the Christ head, with its short beard, its pitying accusing eyes, and the lofty and broad brow, denoting great intellectual strength...I saw the whole figure of my 'Christ' in the mask. With haste I began to add the torso and the arms and hand with the accusing finger...so far the work was a bust. I then set up this bust with an armature for the body. I established the length of the whole figure down to the feet. The statue rose swathed in clothes.

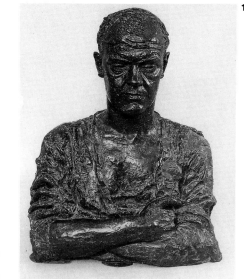

100 (1)

A pillar firmly set on the two naked feet...
I was interrupted on this work for...a
whole year. When I resumed work on it, it
was only to finish the feet...I had Kramer,
the artist, and Cecil Gray, the musician,
pose for the unfinished parts. (Epstein
1940, p. 122.)

Shortly before Epstein's enlistment in Sep-
tember 1917, he wrote to van Dieren from 23
Guildford Street: 'I have put up the torso of
the figure with hands in position but cannot
get much further without a model' (HRC,
Epstein to van Dieren). Gray subsequently
recalled his alarm at being brusquely com-
manded to remove his socks and shoes so
that Epstein could inspect his feet (Gray,
pp. 206–7).

98 First Portrait of Peggy Jean (at 3 months)

1918
bronze, H 26.7
Inscription: *Epstein*
Exhibition: Leicester Gal. 291, 1920, nos.
13–16 *Four Studies of a Babe*
Provenance: 1 M. Gallati; Christie's 18.7.
69 (168); London, Agnew's
Literature: van Dieren, pl. xx; Haskell, p.
175 (plaster); Epstein 1940, pp. 203–4 (on
all *Peggy Jean* studies); Black, no. 67, pl. 86
(*Peggy Jean at 3 months*); Buckle, p. 103
Epstein's first daughter, born October 1918.
Cast after 1931 (Haskell).

99 Clare Sheridan (bust)

1918–19
bronze, H 57.0
Exhibition: NPS 1919, no. 105c
Provenance: 1 Sitter; R. M. Frewen;
Sotheby's 19.7.67 (65); NY, W. Irving Gal.;
NY, SPB 27.5.71 (68), ill.; P. Coll.
VERSION WITH HEAD (?) ONLY, H 46.5:
2 LA, SPB 25.2.74
Literature: Haskell, p. 174; Black, p. 231,
no. 56; Sheridan, p. 123; Buckle, p. 90,
pl. 137
Commissioned after Armistice according to
sitter.

100 Sergeant David Ferguson Hunter, VC

1918–19
bronze, H 59.7
Exhibition: London, Royal Academy,

Nation's War Paintings, 1920, no. 85a
Plaster: destroyed 1982
Provenance: 1 M. Bone; London, IWM,
1919
Literature: van Dieren, pl. I; Haskell, p. 176
(dates 1919); Black, no. 69, pl. 90 (dates
1919); Buckle, p. 91, pl. 139 (dates 1918)
Commissioned.

101 Gabrielle Soene

1918–19
bronze, H 55.0 (plaster)
Exhibitions: Leicester Gal. 291, 1920, no. 4
(up to 3); Leicester Gal. 1191, 1960, no. 15
(2 of 6)
Plaster: (H 55.0) Jerusalem, Israel Museum,
1966
Provenance: 1 J. Quinn, 1920; NY, Scott &
Fowles, 1924; Stevenson Scott; Chicago
AI, 1933
Literature: van Dieren, pl. xxx; Haskell,
p. 177 (dates 1920); Buckle, p. 102, pl. 156
Belgian, former model of Modigliani.

102 Eve Dervich (Dervish)

1919
bronze, H 40.0
Exhibitions: Leicester Gal. 365, 1924, no. 3
Eve Dervish (up to 6); Cooling Gal. 1931/2,
no. 11?; Leicester Gal. 1968 (6, sold out)
Plaster: destroyed 1982
Provenance: 1 R. D. Elliott; Medura Art
Center, c.1925
2 Epstein Estate
3 J. Pilkington; Mrs B. Heys; Sotheby's
16.3.77 (75); FAS; P. Coll.
Literature: Haskell, p. 182; Black, p. 235,
no. 111; Buckle, p. 102, pl. 158

103 Hélène

1919
bronze, H 53.4
Exhibition: Leicester Gal. 291, 1920, no. 10
(up to 3)
Provenance: 1 (signed) A. E. Anderson;
Cambridge, Fitzwilliam Museum, 1931
2 (signed) E. le Bas; family descent;
Christie's 13.3.81 (98)
3 E. P. Schinman; whereabouts unknown
4 S. Box; Sotheby's 1.11.67 (157)
Literature: van Dieren, pl. xxviii; Wel-
lington, p. 25, pl. 16; Haskell, p. 176;
Powell, ill.; Buckle, p. 102, pl. 157; Schin-
man, p. 69, ill.
Wife of W. Yellin, musician.

101

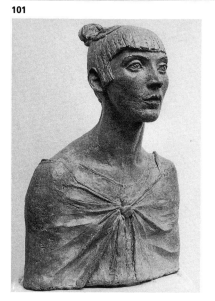

102 (2)

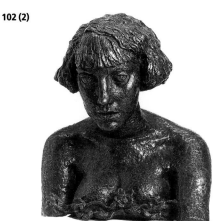

103 (1)

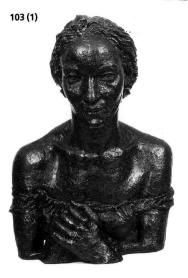

106 (1)

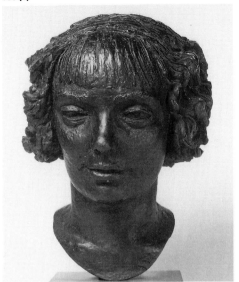

105 (1)

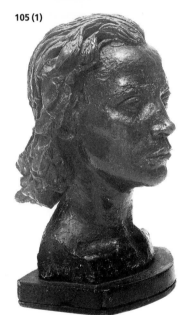

·104

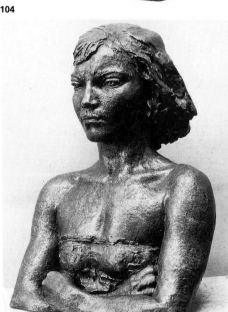

107

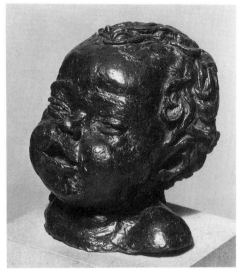

109 (1)

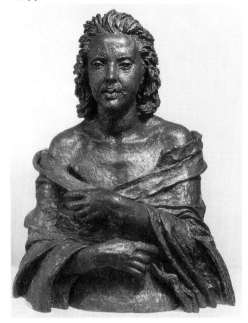

104 Betty May (bust)
1919

bronze, H 50.5

Inscription: *Epstein*

Exhibition: Leicester Gal. 291, 1920, no. 6 (up to 3)

Plaster: (H 54.0) Israel, Ein Harod, 1965

Provenance: 1 Mrs M. Cohen; Sotheby's 8.7.70 (97), ill.; P. Coll.
2 Sotheby's 12.3.75 (45); P. Coll.

Literature: van Dieren, pl. XXXIX; Haskell, p. 177 (dates 1920); Black, p. 233, no. 78 (dates 1920); Buckle, pp. 96–9, pl. 149

105 Betty May (head)
1919

bronze, H 31.8

Exhibition: Leicester Gal. 291, 1920, ex-cat. (up to 6)

Plaster: NY, Museum of the City, 1971

Provenance: 1 Leicester Gal., 1922; C. Rutherston; Manchester CAG, 1925

Literature: Haskell, p. 178 (dates 1921); Black, p. 233, no. 87 (dates 1921); Buckle, pp. 96–9, pl. 150

106 Noneen (Head of a Girl)
1919

bronze, H 33.0

Exhibition: Leicester Gal. 291, 1920, no. 9? *Head of a Girl* (up to 6)

Provenance: 1 T. Balston; Oxford, Ashmolean Museum, 1968

Literature: van Dieren, pl. XXII (*Head of a Girl*); Haskell, p. 176 (dates 1919); Black, no. 71, p. 232 (*Nareen*, dates 1919); Buckle, p. 102, pl. 158, (*Head of a Girl*, dates 1918)

107 Second Portrait of Peggy Jean (at 1 year)
1919

plaster

Provenance: no record

Literature: Haskell, p. 176 (plaster); Black, p. 232, no. 74; Buckle, p. 103

Cast, if at all, after 1931 (Haskell).

108 Third Portrait of Peggy Jean (smiling, at 14 months)
1919

bronze, H 22.8

Exhibition: Leicester Gal. 291, 1920, nos. 13–16 *Four Studies of a Babe*

Provenance: 1 L. Goodman; Sotheby's 22.7.64 (39); London, Roland, Browse & Delbanco; NY, SPB 12.11.65 (78), ill.; P. Coll.

Literature: Haskell, p. 176 (plaster); Black, p. 232, no. 72; Buckle, p. 103

109 Second Portrait of Lillian Shelley (bust)
1920

bronze, H 70.2

Inscription: EPSTEIN. TO LADY SACKVILLE 1920 (cast 1)

Exhibitions: Leicester Gal. 291, 1920, no. 5 (up to 2); Leicester Gal. 1968 (1 of 6)

Provenance: 1 (no bangle) W. Burrell; Glasgow, Burrell Coll., 1924

Literature: van Dieren, pp. 53–4, pl. XXXVII (bangle on left wrist); Haskell, p. 177; Powell, p. 116, ill.; Buckle, p. 96, pl. 148 (no bangle)

110 Fourth Portrait of Peggy Jean (asleep)
1920

bronze, H 26.0

Inscription: *Epstein* (on some casts)

Exhibitions: Leicester Gal. 291, 1920, nos.

111

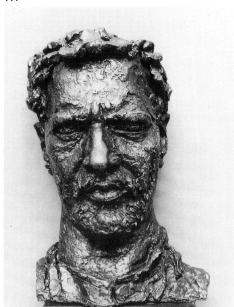

110 (13)

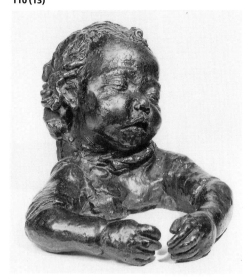

112 (1)

114 (2)

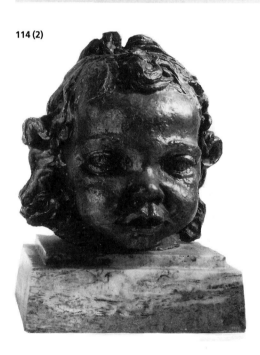

13–16 *Studies of a Babe* (up to 12); Leicester Gal. 365, 1924, no. 22 (up to 6); Ferargil Gal. 1927, no. 1

Plaster: (H 26.0) Jerusalem, Israel Museum, 1966

Provenance: 1 Sir H. Walpole, by 1925; Leicester Gal., 1945 = cast 3?
2 Sir L. Bagrit (MAS 1962–3)
3 E. P. Schinman; whereabouts unknown
4 Leicester Gal.; Wakefield AG, 1955
5 R. Jackson; Bolton AG, 1957
6 Sotheby's 21.11.62 (179); Leicester Gal.
7 L. Goodman; Sotheby's 22.7.64 (40); Leicester Gal.
8 Sotheby's 14.7.65 (84); P. Coll.
9 Sir E. Hayward; Hayward Bequest, Carrick Hill
10 Sydney, D. Jones Gal.; Lady Fairfax
11 Sotheby's 5.3.80 (119); Mrs A. Hull-Grundy; Doncaster Museums, 1981
12 (signed) Christie's 11.6.82 (86); Dr R. E. Pahl
13 P. Coll.; Phillips' 20.6.83 (76), ill.

Literature: Wellington, p. 25, pl. 17; Epstein 1940, p. 203, ill.; Black, p. 232, no. 76; Epstein 1955, ill.; Buckle, p. 103, pl. 160; Schinman, p. 72, ill.

111 Self-Portrait with a Beard
1920
bronze, H 38.1

Exhibition: Leicester Gal. 415, 1926, ill. (up to 3)

Plaster: (H 39.0) Israel, Ein Harod, 1965

Provenance: 1 J. Epstein; A. F. Thompson; Nottingham Castle Museum, 1960
2 Lady Epstein; Hull University AG, 1963
3 L. Goodman; NY, PB 11.10.61 (88), ill.; Mrs S. S. Theil; LA, County MA, 1965
4 E. Swann; Sotheby's 26.11.69 (166)

5 NY, Weintraub Gal.; C. M. Lewis; NY, SPB 6.6.74 (48), ill.; P. Coll.; Sotheby's 13.11.85 (143), ill.
6 E. P. Schinman; NY, SPB 16.3.78 (52), ill.; Mrs T. Hanley
7 P. Coll.; Christie's 22.6.62 (96); NY, P. Coll.

Literature: Haskell, p. 176; Black, p. 232, no. 75; Buckle, p. 104, pls. 164–7; Schinman, p. 70, ill.

112 Study of a Cat
1920?
bronze, H 17.0, L 30.0

Exhibition: Leicester Gal. 1968 (1 of 6)

Plaster: B. Lipkin

Provenance: 1 Walsall, Garman-Ryan Coll., 1973
2 Lady Epstein; P. Coll.

Literature: Buckle, p. 363

113 A. E. Newton
1920?
bronze, H 39.5

Inscription: *Epstein*

Provenance: 1 S. Box; Sotheby's 3.4.63 (89); Sotheby's 4.12.63 (109)

114 Fifth Portrait of Peggy Jean (head, at 2 years)
1920
bronze, H 23.0

Provenance: 1 Christie's 24.4.64 (201)
2 Lady Cochrane; Sotheby's 14.12.66 (3); P. Coll.
3 Sotheby's 23.4.69 (144); J. Nevill
4 K. McKenna; NY, SPB 17.7.80 (26), ill.
5 Sotheby's 14.11.84 (97), ill.

Literature: Buckle, p. 103, pl. 161 (mounted with *Sixth Portrait* as *The Putti*, see no. 116).

116

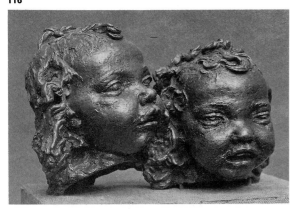

115 (1)

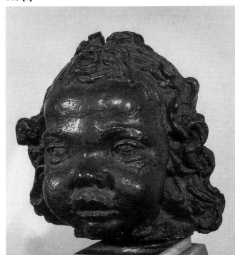

117

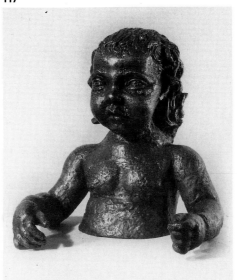

118 (3)

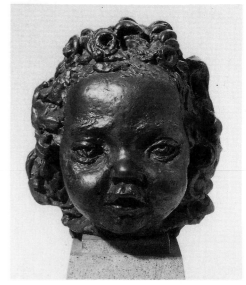

115 Sixth Portrait of Peggy Jean
1920
bronze, H 21.0
Provenance: 1 R. Austin; E. Littler; Eisenberg-Robbins; Washington, MAA, 1973
Literature: Buckle, p. 103, pl. 161 (mounted with *Fifth Portrait* as *The Putti*, see no. 116).

116 The Putti (Fifth and Sixth Portraits of Peggy Jean)
1920
bronze, H 22.8
Inscription: *JE* (on some casts)
Exhibition: Leicester Gal. 508, 1931, no. 1
Provenance: 1 (signed) A. C. J. Wall; Christie's 30.10.70 (217)
2 NY, W. Irving Gal.; London, Marlborough Gal.; NY, SPB 18.10.79 (62), ill.
3 Christie's 10.6.83 (199), ill.
Literature: Haskell, p. 179; Black, no. 88, pl. 11; Buckle, p. 103, pl. 161

117 Seventh Portrait of Peggy Jean (pouting, bust with hands)
1920–21
bronze, H 37.0
Exhibition: Ferargil Gal. 1927, no. 17 *Peggy Jean with arms?*
Provenance: 1 P. Naviasky; Bradford MAG, 1948
2 D. Hughes; E. Littler; Eisenberg-Robbins; Washington, MAA, 1973
Literature: Haskell, p. 179; Black, p. 233, no. 89; Buckle, p. 103, pls. 162–3

118 Eighth Portrait of Peggy Jean (with curly hair, at 2 years 4 months)
1921
bronze, H 26.5
Exhibition: Ferargil Gal. 1927, no. 34
Provenance: 1 L. Goodman; NY, SPB 20.2.64 (61), ill.; P. Coll.

2 London, Kaplan Gal., 1960; P. Coll.; Sotheby's 11.3.81 (293)
3 Sotheby's 11.11.81 (330)
4 P. Coll.; Christie's 9.3.84 (103), ill.
Literature: Haskell, p. 179; Black, p. 233, no. 90; Buckle, p. 425
Identified by comparison with E. O. Hoppé photograph, Leicester CAG.

119 Jacob Kramer
1921
bronze, H 64.0
Exhibitions: London, Whitechapel AG, Works by Jewish Artists, 1923 (lent by CAS); Ferargil Gal. 1927, no. 20
Plaster: (H 66.0) Israel, Ein Harod, 1965
Provenance: 1 J. Epstein; CAS, 1921; Tate, 1923
2 J. Epstein; Leeds CAG, 1931
3 LA, Skirball Museum
4 E. P. Schinman; whereabouts unknown
5 E. Littler; Eisenberg-Robbins; Washington, MAA, 1973
Literature: Wellington, p. 26, pl. 22; Haskell, p. 178; Powell, p. 117, ill.; Epstein 1940, p. 113, ill.; Black, no. 84, pl. 12; Epstein 1955, p. 94; Buckle, p. 110, pls. 173–4; Schinman, p. 71, ill.
Leeds artist. Intended as a model for St. John which, with *Weeping Woman* (no. 126), would form the figures in a Crucifixion group.

120 First Portrait of Miriam Plichte (bust)
1921
bronze, H 39.0 (plaster)
Exhibition: Leicester Gal. 365, 1924, no. 14 (up to 6)
Plaster: (H 39.0) Epstein Estate; Prof. & Mrs W. Godley
Provenance: 1 (cast by Gaskin) P. Coll.
2 (cast in France) P. Coll.
Literature: Haskell, p. 178, ill.; Black, p.

119 (2)

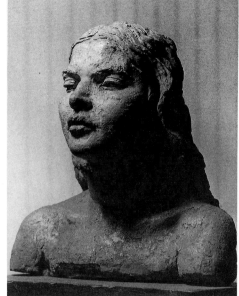

120 (plaster)

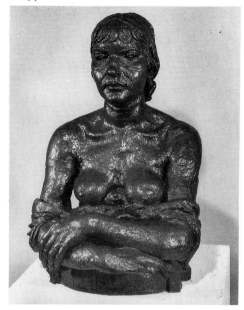

121 (5)

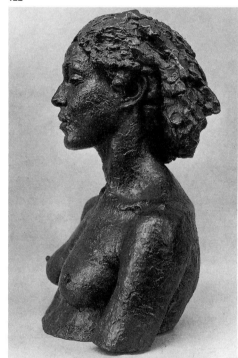

122

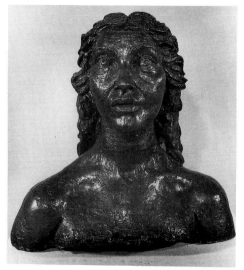

123 (8)

233, no. 86 (head); Buckle, p. 106, pl. 168
Russian girl. (Casting information courtesy of Mrs K. Godley.)

121 Second Portrait of Miriam Plichte (bust with arms)

1921
bronze, H 61.5
Exhibitions: Leicester Gal. 365, 1924, no. 16 (up to 3); Leicester Gal. 1968 (2 of 6)
Plaster: destroyed 1982
Provenance: 1 A. C. J. Wall; Christie's 3.10.70 (219), ill.
2 Lady Epstein; Detroit IFA, 1967
3 (signed) Mrs V. Shima; Montreal MFA, 1960
4 E. P. Schinman; whereabouts unknown
5 Paris, Mme M. Baur; E. Littler; Eisenberg-Robbins; Washington, MAA, 1973
6 Sotheby's 16.6.76 (88B)
7 Christie's 2.3.79 (18); V. Arwas
VERSION WITH HEAD ONLY, H 30.5:
8 Sotheby's 24.7.85 (467), ill.; P. Coll.
Literature: Haskell, p. 178; Powell, p. 117, ill.; Black, p. 233, no. 85; Buckle, p. 106, pl. 169; Schinman, p. 45, ill.

122 Girl from Senegal (Madeleine Bechet)

1921
bronze, H 55.9
Exhibitions: Leicester Gal. 365, 1924, no. 13; Ferargil Gal. 1927, no. 27; Venice 1930, no. 52 (cast 4)
Provenance: 1 A. E. Anderson; Manchester, Whitworth AG, 1930
2 NY, Ferargil Gal., 1927; S. H. Knox; Buffalo, Albright-Knox AG, 1927
3 Mrs R. Pulitzer, pre-1930; Cambridge, Mass., Fogg AG, 1957
4 F. Archdale, c.1940; J. F. Archdale
5 A. C. J. Wall; Christie's 30.10.70 (218); Leicester Gal.

6 Mrs C. Green; E. Littler; Eisenberg-Robbins; Washington, MAA, 1973
7 N. A. Rockefeller; NY, SPB 23.6.82 (64), ill.
8 FAS, 1977; Sydney, Artarmon Gal.
Literature: *Vanity Fair*, 7, 1923, p. 54, ill.; Wellington, p. 26, pl. 19; Haskell, p. 178; Epstein 1940, pp. 110; Black, no. 82, pls. 13–14; Epstein 1955, p. 91; Buckle, pp. 199, 425, pl. 172

123 First Portrait of Kathleen

1921
bronze, H 47.0
Exhibition: Leicester Gal. 365, 1924, no. 27 (up to 3)
Plaster: Phoenix AM, 1966
Provenance: 1 Leicester Gal., 1924; CAS; Tate, 1952
2 C. Rutherston, 1925; Manchester CAG, 1925
3 Sotheby's 4.11.59 (79)
4 L. Goodman; NY, PB 16.3.60 (48); W. Wyler
5 Sotheby's 22.7.64 (41)
6 J. Cowles; Cambridge, Mass., Fogg AG, 1961
7 E. P. Schinman; NY, SPB 16.12.77 (65), ill.; Mrs T. Hanley
8 Auction, Cranbourn Court; E. Littler; Eisenberg-Robbins; Washington, MAA, 1973
9 Walsall, Garman-Ryan Coll., 1973
10 NY, Christie's 21.10.80 (39), ill.
11 (signed) M. Reach; Sotheby's 10.6.81 (143), ill.
12 LA, Dalzell Hatfield Gal.; V. Steele Scott; SF, Butterfield's 3.5.81 (182), ill.
Literature: Wellington, pl. 20; Haskell, p. 178; Black, no. 83, pl. 59E; Epstein 1955, ill.; Buckle, p. 109, pl. 171; Schinman, p. 74, ill.

Begun the day after their first meeting during August.

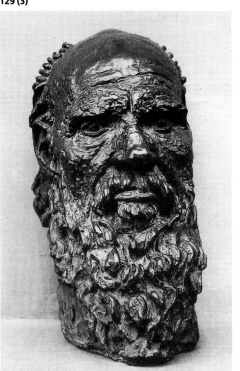

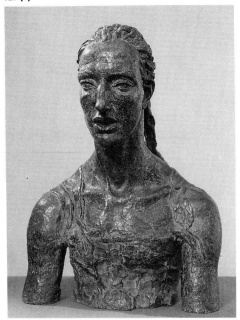

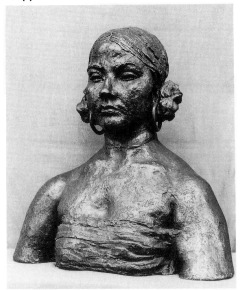

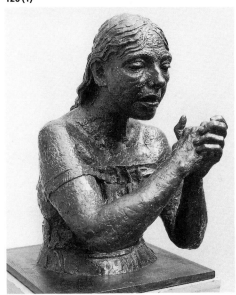

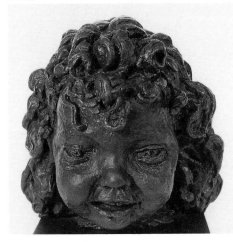

124 Ninth Portrait of Peggy Jean (laughing, at 2 years 9 months)
1921

bronze, H 23.0

Exhibitions: Leicester Gal. 365, 1924, no. 24 (up to 6); Ferargil Gal. 1927, no. 24

Plaster: (H 21.0) Jerusalem, Israel Museum, 1966

Provenance: 1 J. Gibbins; Sotheby's 24.11.32

2 Leeds CAG, 1942

3 Fulford Bequest, Oxford, Ashmolean Museum, 1945

4 M. Smith; Mrs M. Keene; Sotheby's 22.7.64 (71); P. Coll.

5 I. A. Myers; Memphis, Brooks MA, 1960

6 NY, PB 13.12.61 (39); P. Coll.

7 C. D. B. Hawksley; Christie's 10.3.61 (14) = Christie's 23.3.62 (104)

8 E. P. Schinman; whereabouts unknown

9 Christie's 3.6.69 (88)

10 NY, SPB 26.2.70 (42), ill.

11 Sydney, D. Jones Gal.; Lady Fairfax

12 Montreal, Dominion Gal.; NY, Christie's 17.2.82 (24)

13 P. Coll.; Sotheby's 13.11.85 (284), ill.

Literature: Haskell, p. 179; Black, p. 233, no. 91; Buckle, p. 107, pl. 170; Schinman, p. 46, ill.

According to Lady Epstein there was an edition of twelve.

125 Tenth Portrait of Peggy Jean (sad)
1921

bronze

Exhibition: Leicester Gal. 365, 1924, no. 26 *Peggy Jean Grave* (up to 6)

Literature: Black, p. 234, no. 92; Buckle, p. 425

126 The Weeping Woman
1922

bronze, H 59.9

Exhibitions: Leicester Gal. 365, 1924, no. 4 (up to 3); Ferargil Gal. 1927, no. 21

Provenance: 1 J. Epstein; Leicester CAG, 1923

2 May Co.; Cleveland MA, 1966

3 J. Stanhope; E. Littler, 1965; Eisenberg-Robbins; Washington, MAA, 1973

Literature: Wellington, p. 26, pl. 21; Haskell, p. 179; Powell, p. 133, ill.; Epstein 1940, ill. opp. p. 240; Black, no. 93, pl. 15; Buckle, p. 110, pl. 175

Cleveland MA records suggest an edition of six.

127 Selina
1922

bronze, H 56.0

Exhibitions: Leicester Gal. 365, 1924, no. 23 (up to 3); Ferargil Gal. 1927, no. 30

Provenance: 1 A. Lewisohn; Brooklyn Museum, 1928

Literature: Wellington, p. 25, pls. 23–4; Haskell, p. 180; Black, no. 94, pls. 16, 48, 49; Buckle, p. 113, pl. 178

128 Fedora Roselli
1922

bronze, H 52.1

Exhibitions: Leicester Gal. 365, 1924, no. 20 (up to 3); Leicester Gal. 1968 ('edition complete')

Plaster: destroyed 1982

Provenance: 1 A. C. J. Wall; Christie's 30.10.70 (220), ill.; Leicester Gal.; Christie's 5.3.76 (34); FAS

2 Mrs M. C. Hannaway; Sotheby's 14.7.65 (79); P. Coll.

Literature: Haskell, p. 180 (dates 1923); Black, p. 234, no. 96; Buckle, p. 113, pl. 177

Singer in *Chu Chin Chow*.

130
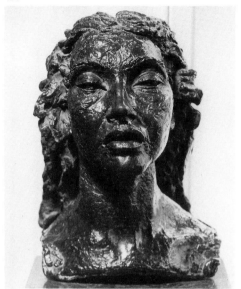

131
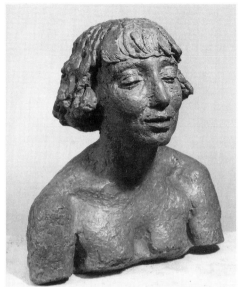

132
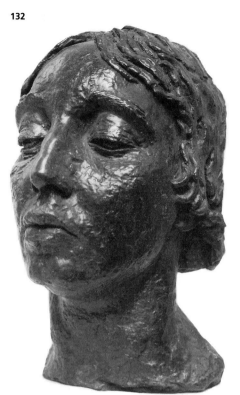

133
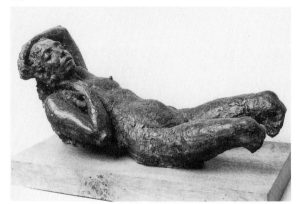

129 Old Smith
1922
bronze, H 36.8
Provenance: 1 London, Tooth's 4.3.59; J. H. Hirshhorn; Washington, Hirshhorn Museum, 1966
2 L. Goodman; Sotheby's 22.7.64 (43); P. Coll.
3 A. C. J. Wall; Christie's 30.10.70 (221); London, Agnew's; P. Coll.
Literature: Haskell, p. 180; Epstein 1940, p. 112; Black, p. 234, no. 97; Epstein 1955, p. 93; Buckle, p. 113, pl. 179

130 Second Portrait of Kathleen
1922
bronze, H 39.0
Inscription: *Epstein*
Exhibition: Leicester Gal. 365, 1924, no. 9 (up to 6)
Plaster: (H 40.0) Israel, Ein Harod, 1965
Provenance: 1 J. Epstein, 1956; R. Haines; D. R. Sheumack
2 L. Goodman; NY, PB 14.1.59 (32), ill.
3 Wing Co.; Sotheby's 15.12.65 (104); J. Scott-Taggart; Sotheby's 9.7.69 (105); P. Coll.
4 Sotheby's 22.11.72 (83); Mrs R. Simon
5 Auction, Cranbourn Court; E. Littler; Eisenberg-Robbins; Washington, MAA, 1973
Literature: Buckle, p. 113, pl. 176

131 First Portrait of Dolores (La Bohemienne)
1922
bronze, H 46.5
Inscription: *Epstein*
Exhibition: Leicester Gal. 508, 1931, no. 11 *Bohemienne*

Provenance: 1 Lady Cochrane; Sotheby's 14.12.66 (4)
2 L. Goodman; Sotheby's 22.7.64 (42); London, Brook Street Gal.
3 Sotheby's 3.11.82 (74)
VERSION WITH HEAD ONLY, H 32.9:
4 T. W. Spurr; Vancouver AG, 1931
5 (signed *Epstein 3*) H. Bliss; Cambridge, Fitzwilliam Museum, 1945
6 Sotheby's 22.11.72 (82)
Literature: Haskell, p. 180; Epstein 1940, pp. 108–9; Epstein 1955, p. 90; Buckle, pp. 114–15, pls. 180, 185 (bust)
Head cast 1931, bust probably cast much later.

132 Second Portrait of Dolores
1922
bronze, H 30.0
Exhibition: Leicester Gal. 365, 1924, no. 1 *Head of Dolores* (up to 6)
Provenance: 1 J. Epstein; A. F. Thompson; N. J. Ebsworth
Literature: Haskell, p. 181 (dates 1923); Epstein 1940, pp. 108–9; Epstein 1955, p. 90; Buckle, pp. 115–16, pls. 181, 186

133 Dolores (reclining study)
1923
bronze, L 69.0
Exhibition: Leicester Gal. 365, 1924, no. 12 (up to 3)
Plaster: (H 29.0, L 65.0) Israel, Ein Harod, 1965
Provenance: 1 J. Epstein, *c.*1926; P. Coll.
2 Mrs A. E. Laskin; Jerusalem, Israel Museum, 1979
Literature: Haskell, p. 182; Black, p. 235, no. 107; Buckle, p. 115, pl. 182

136

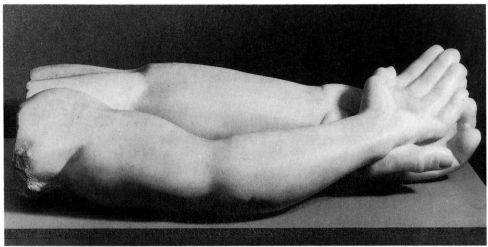

137 (2)

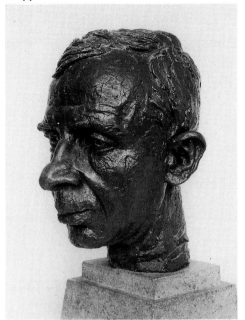

135

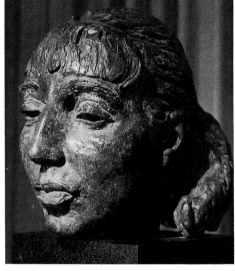

134 (2)

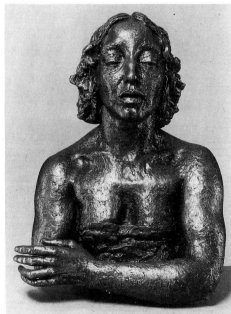

134 Third Portrait of Dolores (bust with crossed arms)

1923

bronze, H 57.2

Exhibition: Leicester Gal. 365, 1924, no. 8, ill. (up to 3)

Provenance: 1 (with earrings) A. Margulies

2 Leicester Gal., c.1938/9; J. Archdale; P. Coll.

3 Lady Epstein; R. Jackson; Ms S. G. Stote (1964)

4 D. Hughes; E. Littler; Eisenberg-Robbins; Washington, MAA, 1973

5 Sotheby's 17.7.68 (108)

6 (with earrings) Lady Epstein; R. Jackson; M. Siwek; S. Gorelick

7 Sotheby's 2.11.83 (105), ill.; J. Doubleday

8 A. Welker (Edinburgh 1961)

9 J. Epstein; Dr I. Epstein, 1940s; Dr M. Evans

Literature: Wellington, pls. 25–6; Haskell, p. 181; Powell, ill.; Epstein 1940, pp. 108–9; Black, no. 106, pls. 64–5; Epstein 1955, p. 90, ill.; Buckle, pp. 116–18, pls. 183–4, 187

According to Lady Epstein (1965) there was an edition of ten casts. Earrings which appear in the earliest casts were lost for many years, found by Lady Epstein after 1959 and reused in later casts.

135 Fourth Portrait of Dolores (head)

1923

bronze, H 24.0

Exhibition: Leicester Gal. 365, 1924, no. 19

Plaster: (H 31.0) Israel, Ein Harod, 1965

Provenance: 1 Mrs E. M. Crosskey, 1925; Sotheby's 10.6.81 (140); Black-Nadeau Ltd.

2 Leicester Gal., 1924; C. Rutherston; Manchester CAG, 1925

3 J. Gibbins; Sotheby's 24.11.32; H. Walpole

4 E. P. Schinman; NY, SPB 16.12.77 (66), ill.; P. Coll.

5 H. H. Jonas; NY, SPB 22.5.75 (579), ill.

Literature: Wellington, pls. 27, 28; Haskell, p. 181; Epstein 1940, pp. 108–9; Black, no. 103, pls. 17–18; Buckle, pp. 118–21, pls. 188–90; Schinman, p. 6, ill.; Epstein 1955, p. 90; Buckle, p. 118, pls. 188–90

136 Marble Arms

1923

marble, L 94.0

Exhibitions: Leicester Gal. 365, 1924, no. 21; Edinburgh 1961, no. 84

Provenance: Mrs A. Crossley; Sotheby's 22.7.64 (73); London, Hecht, 1965; H. Kaye

Literature: Wellington, pl. 34; Haskell, p. 180; Black, no. 98, pl. 55; Buckle, pp. 122–3, pl. 191

Based on the arm of Kathleen resting in that of the sculptor. Ironically, in March 1948, Epstein agreed to Peggy Jean's suggestion that it should be used as a memorial to Mrs Epstein, with an inscription to be carved by Epstein's assistant, David McFall (Epstein to P. Hornstein, 6.3.1948). This was never carried out.

137 Dr Adolph S. Oko

1923

bronze, H 31.5

Exhibition: Leicester Gal. 365, 1924, no. 2 (up to 3)

Plaster: Israel, Ein Harod, 1965

Provenance: 1 Mrs Chester Beatty (pre-1931)

2 J. Epstein, 1957; Mrs G. Oko; Plymouth CAG, 1965

Literature: Haskell, p. 182; Buckle, pp. 127–8, pl. 199

Friend of Epstein from 1898.

140

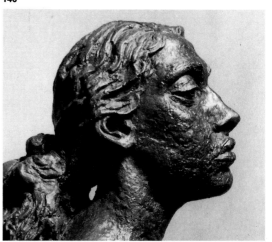

141 (plaster) state *c*.1960

142 (1)

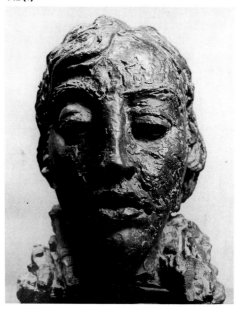

138 (1)

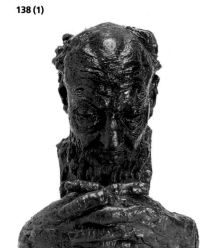

139 (4)

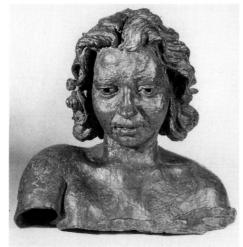

138 Old Pinager
1923

bronze, H 41.5

Exhibition: Leicester Gal. 365, 1924, no. 7, ill. (up to 6)

Plaster: (H 44.0) Israel, Ein Harod, 1965

Provenance: 1 Aberdeen CAG, 1924

2 NY, PB 11.5.60; NY, El Dieff; Austin, HRC, 1960

3 London, Tooth's; H. Hartford; NY, SPB 11.3.71 (29), ill.

4 L. Goodman; Sotheby's 22.7.64 (449)

VERSION WITH HANDS ONLY:

5 Epstein Estate

Literature: Wellington, pl. 32; Haskell, p. 181; Powell, p. 92, ill.; Epstein 1940, pp. 112–3; Black, no. 105, pl. 61; Epstein 1955, p. 93; Buckle, p. 127, pl. 197

Old matchseller asked to model by Epstein.

139 Eileen Proudfoot
1923

bronze, H 43.0

Exhibitions: Leicester Gal. 365, 1924, no. 5 *Eileen* (up to 3); Leicester Gal. 1968 (4 of 6)

Provenance: 1 A. C. J. Wall; Christie's 30.10.70 (222); Leicester Gal.

2 J. F. Archdale, 1930s; P. Coll.

3 Mrs P. Harris; Sotheby's 16.3.77 (74)

4 Leicester Gal., 1971; Sydney, Artarmon Gal.

Literature: Wellington, pl. 18; Haskell, p. 181; Black, no. 102, pl. 58; Buckle, p. 127, pl. 198

South African art student.

140 Ferosa Rastoumji
1923

bronze

Exhibition: Leicester Gal. 365, 1924, no. 15 (up to 6)

Plaster: amalgamated with torso for *Angel*

of the Annunciation (post 1959)

Provenance: 1 R. E. Smith (1948–54)

2 LA, Dalzell Hatfield Gal.; V. Steele Scott; SF, Butterfield's 3.5.81 (197), ill.

Literature: Wellington, p. 28, pls. 29–30; Haskell, p. 181; Black, no. 104, pl. 33; Buckle, p. 128, pls. 200–1

Parsee pianist. See *Angel of the Annunciation* (no. 141).

141 Angel of the Annunciation
1923

bronze, H 158

Plaster: Israel, Ein Harod, 1965

Provenance: 1 Lady Epstein; Otterloo, Rijksmuseum Kröller-Müller, 1961

2 E. P. Schinman; whereabouts unknown

Literature: Buckle, p. 128, pl. 201; Schinman, p. 37, ill.

Unfinished. From studio photographs taken after Epstein's death it is evident that the head, based on the portrait of Ferosa Rastoumji (no. 140), was added to the torso after 1959. It may be related to the abortive Bush House project (no. 155).

142 Second Portrait of Gladys, Duchess of Marlborough (sketch)
1923

bronze, H 30.5

Exhibitions: Leicester Gal. 365, 1924, no. 11 study; Ferargil Gal. 1927, no. 16

Plaster: destroyed 1982

Provenance: 1 J. Epstein; A. F. Thompson; Leicester Gal.; Sotheby's 17.7.76 (52); F. Foster; P. Coll.

Literature: Haskell, p. 181; Black, p. 234, no. 101; Buckle, p. 125, pls. 192–3

Commissioned. Formerly Gladys Deacon (see no. 86). Begun during a stay at Blenheim. Unfinished.

143

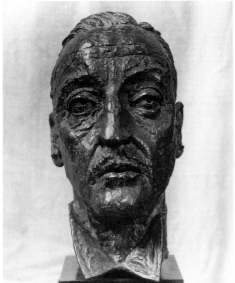

144 (1)

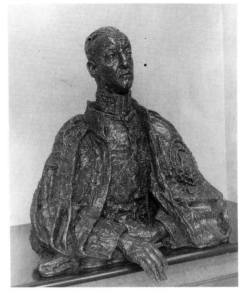

145

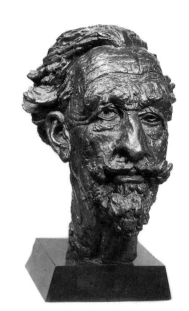

143 Study for Portrait of
the Duke of Marlborough

1923

bronze, H 40.0 (plaster)

Exhibitions: Leicester Gal. 365, 1924, no. 6;
Ferargil Gal. 1927, no. 9

Plaster: (H 40.0) Jerusalem, Israel Museum,
1966

Provenance: 1 J. Epstein, 1925; where-
abouts unknown

Literature: Wellington, pl. 33; Black, p. 234,
no. 100; Buckle, p. 125, pl. 194

Commission. Study executed at Blenheim.
Sittings discontinued after disagreement
with the Duke, who wanted a nude bust in
the Chantrey manner, or perhaps after the
style of the bust by Rodin. See no. 144.

144 The Ninth Duke of Marlborough

1923–5

bronze, H 104.2

Plasters: 1 (head only, H 40.0) Jerusalem,
Israel Museum, 1966
2 (hands) Israel, Ein Harod, 1965

Provenance: 1 Blenheim, Duke of Marl-
borough

Literature: Haskell, p. 181–3; Epstein 1940,
pp. 113–6, ill.; Black, no. 117, pl. 21; Ep-
stein 1955, pp. 94–6; Buckle, p. 138, pl. 211

Commissioned. Begun in 1923 but sittings
interrupted after a disagreement about
dress. The Duke wanted a nude bust but
Epstein favoured modern dress (see no.
143). Completed in 1925 with Garter robes.

145 R. B. Cunninghame Graham

1923

bronze, H 35.0

Exhibitions: Leicester Gal. 365, 1924, no. 25,
ill. (up to 6); Ferargil Gal. 1927, no. 10

Plaster: destroyed 1982

Provenance: 1 C. Rutherston; Manchester
CAG, 1925
2 Aberdeen CAG, 1924

3 Toronto, AG Ontario, 1928
4 J. Epstein; A. C. J. Wall; Christie's,
30.10.70 (223); Glasgow AG, 1970
5 Edinburgh, NPG, 1938
6 (cast 1940) S. Samuels; Sotheby's
16.3.77 (71); FAS; Sydney, D. Jones Gal.
7 Lady Epstein; London, NPG, 1961
8 I. & B. Karp; Christie's 17.10.80 (59);
FAS
9 Mrs Spafford (Bolton AG 1954)

Literature: Wellington, pl. 31; Haskell, p.
180; Powell, p. 27; Epstein 1940, pp. 106–7,
ill.; Black, no. 99, pl. 60; Epstein 1955, pp.
88–9, 107–10, ill.; Buckle, p. 125, pls. 195–6

Scottish traveller and writer.

146 Maquette for Memorial
to W. H. Hudson

1922–3

bronze, H 32.5, W 44.0

Plaster: (H 32.0) Israel, Ein Harod, 1965

Provenance: 1 L. Goodman; Sotheby's
22.7.64 (45); NY, El Dieff; Austin, HRC,
1965
2 Christie's 27.10.72 (180); P. Coll.;
Sotheby's 17.3.76 (59); P. Coll.

Literature: Minute Book of the Hudson
Memorial Committee, letters and press
cuttings held by the RSPB; Buckle, pp.
134–6, pl. 207 (plaster)

Muirhead Bone approached Epstein in De-
cember 1922, on behalf of the W. H. Hudson
Memorial Committee of which he was a
member, asking him to submit a design with
a view to its installation as part of a bird pool
and fountain. 'The memorial is to take the
form of a Fountain, upon which Mr Hudson
would be portrayed, and designed so as to
serve as a drinking and bathing place for
Birds, to be erected in some accessible open
space in or near London.' One of the Royal
Parks, where Hudson had been instrumental
in introducing bird sanctuaries, was, from the
first, considered a suitable site, and Hyde

Park was chosen by agreement between the
Committee and Sir Lionel Earle of the Office
of Works (13.12.1922). Lionel Pearson of
Adams, Holden & Pearson was asked to
design the whole setting. He met Epstein on
10 January 1923 and they agreed on the use of
Portland stone.

The clay model Epstein prepared 'took the
form of a recumbent figure fashioned as far as
possible as a likeness of W. H. Hudson, in an
attitude of watching the birds drinking and
bathing in the runnels, channels and pools
of water hewn from the stone below the fig-
ure.' The figure was abandoned after Bone
was informed by Earle, on 1 February, that no
form of portraiture was admissable in the
Royal Parks.

147 Memorial to W. H. Hudson (Rima),
Hyde Park, London (plate 17)

1923–5

Portland stone, relief area 116 × 183

Inscription: *MDCCCXLI* (left), *MCMXXII*
(right), by Eric Gill

Literature: Minute Book of the Hudson
Memorial Committee, letters and press
cuttings held by the RSPB; Haskell, p. 183;
Powell, pp. 81–2, ill.; Epstein 1940, pp.
128–32, 294–302; Black, p. 12, no. 116, pl. 20;
Epstein 1955, pp. 107–11, 263–9, ill.; Buckle,
pp. 134–6, pls. 209–10

Commissioned by the W. H. Hudson Mem-
orial Committee. Adams, Holden & Pearson
architects.

The revised conception of the figure as 'an
imaginative figure of nature' was decided at a
site meeting between Epstein, Cunninghame
Graham, Muirhead Bone, Lionel Pearson and
a representative of the Office of Works, on 13
February 1923. The week before this, how-
ever, Bone had written to the Committee
chairman, Cunninghame Graham, informing
him of the rejection of the portrait maquette
(no. 146) and suggesting Rima as the subject

146 (1)

for the bas-relief: 'I confess I am as anxious as ever to get something really strikingly imaginative and beautiful from Epstein, and I want to know what you think of the idea of the relief on the stone representing the wonderful woman spirit in *Green Mansions*?' (Leeds CAG, Henry Moore Sculpture Study Centre, Bone to Graham, 2.2.1923). He added, over-optimistically as it turned out, that 'perhaps we might agree on an image of *her* where we could never have agreed on an image of *him*.' Three days later he was able to tell the Committee secretary, Mrs Lemon, that he and Graham had already discussed Rima for the revised design (RSPB, Bone to Lemon, 5.2.1923).

Epstein was formally commissioned on 15 February: 'in all probability you would, in a setting of trees and birds, in some way portray Rima' (RSPB, Committee to Epstein, 15.2. 1923). A contract was drawn up in April after the Committee had seen a miniature clay model (lost) of 'Rima with an indication of birds in flight above her head and of a tree from which her figure is springing' (Committee minutes, reporting a studio visit on 22 March). Possibly this was the design shown to the Office of Works in June, though one of the preparatory drawings by Adams, Holden & Pearson (RIBA) shows Rima reclining, her right arm raised in a gesture of greeting or release to the birds overhead, with a stylized tree in the background. At all events the design got a frosty reception from the Office of Works:

The Committee...could not recommend permission being given for the stone as designed. They feel that the sculptured stone would evoke wide and bitter controversy, and that even the setting leaves much to be desired. They fully recognise Mr Epstein's genius, but they do not consider that his present design is either worthy of his talent or of the site upon

which it is intended to place it. (RSPB, Earle to Committee, 26.6.1923.)

The next day Graham was writing to Earle to see if there was any way they could salvage the scheme by getting Epstein to modify the figure, 'the neck less long, the arms shorter, the face prettier', but to no avail. Faced with this response several members of the Committee began to get cold feet about Epstein's employment which had been persuasively sponsored by Graham and Bone from the beginning, against the wishes of influential men such as Sir George Frampton and John Galsworthy who had been present at the inaugural meeting of the Committee. Lutyens's name was put forward. However, Cunninghame Graham obtained the Committee's and Epstein's agreement to submit a revised design, and arranged a meeting between himself, Earle, Pearson and Epstein on 16 July.

Now Epstein, working in seclusion at Loughton, produced a whole series of preparatory drawings, eighty-six of which survive in a handsome drawing album which was circulated amongst the members of the Committee that autumn. The album and a letter (Lemon to Bone, 16.11.1923) mentioning the circulation of the sketchbook are at Leeds CAG, Henry Moore Sculpture Study Centre.

The final design was submitted and accepted in February 1924, but even now there were some reservations from the Office of Works about the depth of the relief and the scale of the figure. Epstein's sketch model (lost) was exhibited at the Architecture Club in Grosvenor House without ill effect. Muirhead Bone, a brilliant topographical draughtsman, produced a cunning bird's eye view of the impression the finished memorial should make, and had it published with an appeal for funds (*The Times* and *Manchester Guardian*, 21.3.1924, and *Country Life*, 22.3.1924). Bone's drawing camouflages

neither the nudity nor the boldly simplified rendering of the figure and birds, but the subtlety of his technique and the small scale of the drawing enabled him to minimize its angularity.

By May the stone, about 2 metres wide, had arrived at Epstein's shed in Loughton, which he had enlarged and lined with felt to enable him to spend the next seven months 'working through the winter, solitary, surrounded by silent and often fog-laden forest' (Epstein 1940, p. 128). On 29 April 1925 he was able to report the carving virtually complete. Gill was commissioned to carve the inscription on the stone and around the pool. Finally on 19 May 1925 the Memorial was unveiled by the Prime Minister, Stanley Baldwin.

A strong campaign for the removal of the work followed. The sculpture was daubed in green paint on 25 November 1925, after a campaign amounting to incitement in the *Morning Post*, which also published (18.11.1925) a letter petitioning for the removal of the work from the Park and signed by, amongst others, the President of the Royal Academy, Sir Frank Dicksee, Alfred Munnings, Sir Philip Burne-Jones, Sir Arthur Conan Doyle and Hilaire Belloc. Bone produced equally heavy literary and artistic artillery to defend it in a letter to *The Times* (23.11.1925), signed by George Bernard Shaw, Sibyl Thorndike, Hugh Walpole, Frank Dobson, Eric Kennington and many more. The *Manchester Guardian*, where Stephen Bone worked, published an Editorial in Epstein's defence the same day. A letter from Bone to Viscount Peel, Commissioner of Works, on 29 November, clinched the matter in Epstein's favour. Not only was Bone able to show that the Committee had acted correctly and in full consultation with the Office of Works throughout, but that the publication of Bone's drawing, showing the final design for the sculpture, had preceded the collection of most of the subscriptions for the memorial so that the public had not been misled.

150 (1)

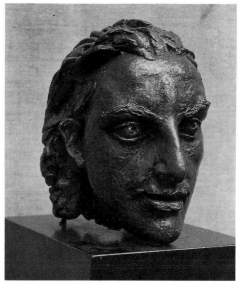

151 (1)

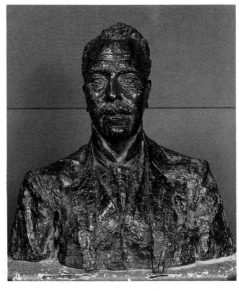

152

149 (painted plaster)

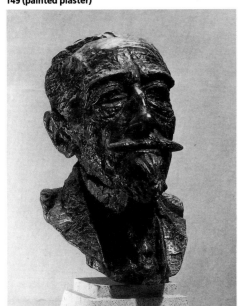

148 Joseph Conrad (bust) (plate 15)
1924
bronze, H 48.2
Exhibition: Leicester Gal. 553, 1933, no. 2
Plaster: (H 51.0) Israel, Ein Harod, 1965
Provenance: 1 J. Epstein; P. Coll., *c.*1926
 2 M. Bone; Manchester CAG, 1925
 3 J. Epstein; M. Bone; P. Coll.
 4 J. Epstein; Birmingham MAG, 1926
 5 W. B. Leeds; NY, SPB 5.4.67 (69), ill.;
 B. G. Cantor (on loan to NY, Jewish
 Museum)
 6 Morton Day; P. Coll.; NY, SPB 26.2 70
 (58), ill.; P. Coll.
Literature: Wellington, p. 27, pl. 35; Powell,
p. 67; Epstein 1940, p. 42, ill.; Black, no.
109, pl. 19; Epstein 1955, pp. 73–7, ill.;
Buckle, pp. 130–1, pls. 202–3
Commissioned but not purchased by Polish
Government (cast 1).

149 Joseph Conrad (head)
1924
bronze, H 43.3
Inscription: *Epstein*
Provenance: 1 Leicester Gal.; NY, Knoed-
ler; J. H. Hirshhorn; Washington, Hirsh-
horn Museum, 1966
 2 Leicester Gal.; London, NPG, 1960
 3 C. Jackson; Stoke-on-Trent MAG, 1959
 4 T. E. Hanley; Austin, HRC, 1959
 5 NY, Graham & Sons, 1958; T. E.
 Hanley; Philadelphia MA, 1959
 6 L. Goodman; Sotheby's 22.7.64 (46);
 Leicester Gal.
 7 E. P. Schinman; NY, SPB 16.12.77 (67),
 ill.; P. Coll.
 8 NY, El Dieff; Ithaca, Cornell University,
 W. S. Hall Coll., 1962
 9 NY, Berry-Hill Gal.; H. Hartford; NY,

SPB 11.3.71 (24), ill.; P. Coll.
Literature: Schinman, p. 47, ill.

150 Jacob Epstein of Baltimore
1924
bronze, H 52.7
Inscription: *Epstein*
Provenance: 1 Sitter; Baltimore MA, 1951
Literature: Haskell, p. 183; Black, p. 235,
no. 114; Buckle, p. 426
Commissioned. Industrialist, collector and
major benefactor of Baltimore MA.

151 David Erskine of Linlathen
1924
bronze, H 58.5
Provenance: 1 Linlathen Library
 2 Miss Amy Erskine; Dundee CAG, 1923
Literature: Haskell, p. 183; Black, p. 235
no. 115; Buckle, p. 426
Commissioned.

152 The Seraph (Marie Collins)
1924
bronze, H 28.0
Exhibition: Leicester Gal. 415, 1926, no. 6
(up to 6)
Plaster: Brunswick, Maine, Bowdoin Col-
lege, 1969
Provenance: 1 Sotheby's 13.12.61 (161)
 2 Miss S. C. Simon (Bolton AG 1954)
 3 Lady Mayer, 1961
 4 P. Coll.; Christie's 13.11.64 (12), ill.
 5 S. Box; Sotheby's 16.12.64 (115); E.
 Littler; Eisenberg-Robbins; Washington,
 MAA, 1973
 6 A. C. J. Wall; Christie's 30.10.70 (224);
 Christie's 12.11.82 (57)
Literature: Haskell, p. 182, ill.; Black, p.
235, no. 112; Buckle, p. 132, pl. 206

155 (plaster)

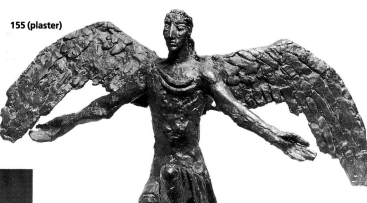

153 (plaster)

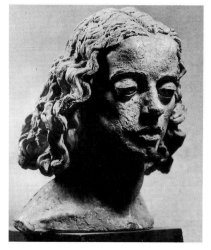

154

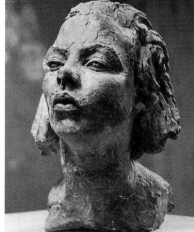

156 (1)

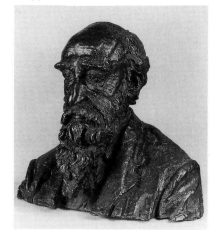

157

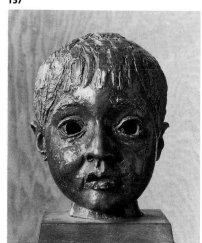

158

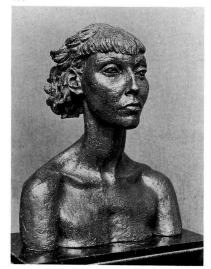

Portrait used in Llandaff *Christ in Majesty* (no. 476).

153 Elsa Lanchester
1924
bronze, H 47.3
Exhibitions: Leicester Gal. 365, 1924, no. 17 (up to 6); Leicester Gal. 1968 (2 of 6)
Plaster: destroyed 1982
Provenance: 1 A. Haskell; FAS, 1974; Venezuela, P. Coll.
2 Sotheby's, 14.12.60 (101); I. Fox; NY, PB 11.4.62 (80) ill.
Literature: Haskell, p. 182, ill.; Powell, ill.; Black, p. 235, no. 110; Buckle, p. 132, pl. 204
Commission. Actress, later wife of Charles Laughton.

154 Sheila
1924
bronze, H 35.6
Exhibition: Leicester Gal. 365, 1924, no. 18 (up to 6)
Provenance: 1 formerly LA (Buckle)
2 E. P. Schinman; whereabouts unknown
Literature: Haskell, p. 183; Buckle, p. 132, pl. 205; Schinman, p. 47, ill.

155 Kneeling Angel
1924
plaster, H 45.0, w 74.0
Provenance: Church of Wales; P. Coll.
Commissioned in 1924 as a maquette for the Aldwych entrance of Bush House, London.

156 Professor Samuel Alexander
1924
bronze
Exhibition: Leicester Gal. 415, 1926, ill. (up to 2)

Provenance: 1 M. Oyved; London, Ben Uri Gal.
2 Manchester University
Literature: Haskell, p. 184; Black, p. 236, no. 122; Buckle, pp. 142–3, pl. 217
Commission. Professor of Philosophy, Manchester University (1893–1924).

157 First Portrait of Enver (head)
1925
bronze
Exhibitions: Leicester Gal. 415, 1926, no. 8, ill. (up to 6); Ferargil Gal. 1927, no. 23
Provenance: two casts sold 1926
Literature: Haskell, p. 183; Buckle, p. 141, pl. 214
Son of Sunita, model for Christ in *Madonna and Child* (no. 175). This portrait is not readily identified because of its similarity to the *Christ Child*'s head (no. 176), often found on its own.

158 First Portrait of Oriel Ross (bust)
1925
bronze, H 55.5
Exhibitions: Leicester Gal. 415, 1926, no. 12, ill. (up to 6); Ferargil Gal. 1927, no. 18
Plaster: Plainfield, Vermont, Goddard College, 1966
Provenance: 1 J. Gibbins; Sotheby's 24.11.32; H. Walpole or H. Lees Jeffrey
2 A. F. Graham Watson; Leicester Gal., 1967
3 A. C. J. Wall; Christie's 30.10.70 (225); A. d'Offay; FAS; P. Coll.
4 Sotheby's 22.11.72 (84); P. Coll.
5 Miss M. Crichton; E. Littler; Eisenberg-Robbins,; Washington, MAA, 1973
Literature: Buckle, p. 139, pl. 212
Actress, later Lady Paulett.

161 (3)

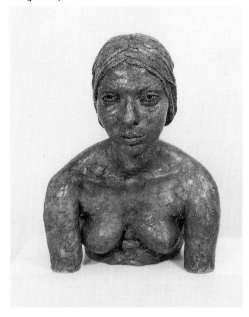

162 (2)

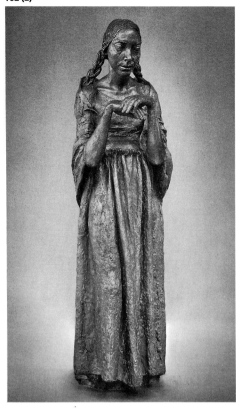

163 (plaster)

160

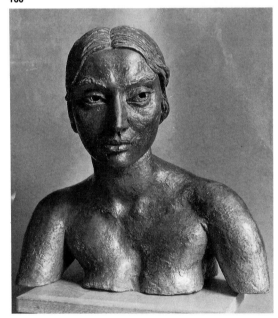

159

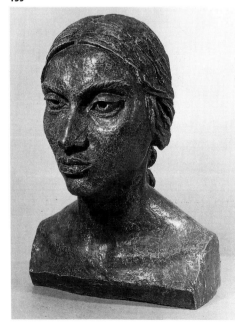

159 First Portrait of Sunita
1925
bronze, H 48.9
Exhibition: Leicester Gal. 415, 1926, no. 2 (up to 3)
Provenance: 1 Manukin Corp.; Christie's 11.5.73 (107a)
Literature: Haskell, p. 184; Black, p. 235, no. 119; Buckle, p. 141

160 Second Portrait of Sunita (bust)
1925
bronze, H 57.0
Exhibition: Leicester Gal. 415, 1926, no. 11, ill. (up to 3)
Provenance: 1 C. Rutherston; Manchester CAG, 1925
2 I. W. Brown; E. Littler, 1965; Eisenberg-Robbins; Washington, MAA, 1973
Literature: Haskell, p. 184; Powell, ill. opp. p. 3; Black, p. 235, no. 120; Buckle, pp. 140–2, 182, pl. 213

161 Sibyl Thorndyke
1925
bronze, H 48.0
Exhibition: Edinburgh 1961, no. 198
Provenance: 1 Sir Lewis & Lady Casson; J. Casson, 1970
2 Sir B. Albery; London, Garrick Club, 1960
3 H. H. Edmunds; R. T. Clough; Doncaster MAG, 1959
Literature: Haskell, p. 184, ill.; Powell, pp. 43–4; Black, p. 236, no. 121; Buckle, p. 142, pl. 216
Commission. Sculpted during Sibyl Thorndyke's appearance in Shaw's *St. Joan*.

162 Visitation
1926
bronze, H 165
Exhibition: Leicester Gal. 415, 1926, no. 7 (study)
Plaster: Jerusalem, Israel Museum, 1966
Provenance: 1 Leicester Gal.; CAS; Tate, 1927
2 (cast 1941) S. Samuels; Sotheby's 16.3.77 (66), ill.; M. Lewis
3 J. Epstein, 1955; J. H. Hirshhorn; Washington, Hirshhorn Museum, 1966
4 J. Epstein, 1955; A. & J. Wurtzburger; Baltimore MA, 1966
5 W. J. Keswick
6 J. Epstein; Queensland AG, 1958
7 Israel, Jerusalem Museum, Billy Rose Coll., 1966
8 Caracas, Museo de Bellas Artes
Literature: Haskell, pp. 63, 72, 184, ill.; Powell, pp. 117–18, ill.; Epstein 1940, pp. 133–9, ill.; Black, no. 123, pl. 24; Epstein 1955, p. 112, ill.; Buckle, pp. 145, 153, 174, pls. 220–2

163 Anita (Miriam Patel)
1926
bronze, H 53.3
Exhibition: Leicester Gal. 415, 1926, no. 4 (up to 3)
Plaster: Buffalo, Albright-Knox AG, 1966
Provenance: 1 F. H. Lowe (1948)
2 Christie's 19.10.79 (45), ill.; P. Coll.
Literature: Haskell, p. 186; Powell, p. 53, ill.; Black, p. 236, no. 134; Buckle, p. 150, pl. 228
Sunita's sister who lived in Epstein's house was the model for many drawings c.1926–8.

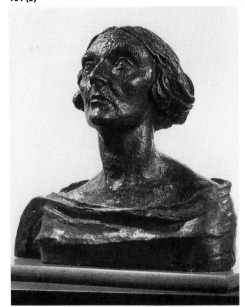

164

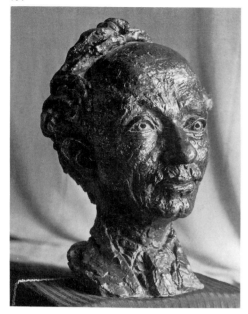

165 (1)

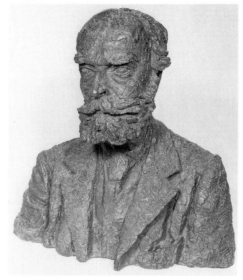

166

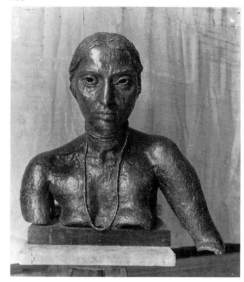

164 Moshe Oyved (Edward Good)
1926

bronze, H 41.0 (plaster)

Exhibition: Leicester Gal. 415, 1926, no. 9 (up to 3)

Plaster: (H 41.0) destroyed 1982

Provenance: 1 Sitter; Jerusalem, Israel Museum, 1937

2 Sitter; London, Ben Uri Gal.

Literature: Haskell, p. 185; Epstein 1940, pp. 110–11; Black, no. 130, pl. 22; Buckle, p. 231, pl. 230

Commission. Friend of sculptor, Jewish poet, proprietor of 'Cameo Corner'. Account of sittings in *Gems and Life* (1927). Epstein illustrated his *Book of Affinity* (1933).

165 Charles Prestwich Scott
1926

bronze, H 58.0

Exhibition: Leicester Gal. 415, 1926, no. 13 (up to 3)

Provenance: 1 Manchester CAG, 1926

Literature: Haskell, p. 185; Black, p. 236, no. 128; Buckle, p. 143, pl. 218

Presented by subscribers in commemoration of the sitter's eightieth birthday and of his fifty-five years editorship of the *Manchester Guardian*.

166 Third Portrait of Sunita
(bust with necklace)
1926

bronze, H 58.3

Exhibitions: Leicester Gal. 415, 1926, no. 14 (up to 3); Ferargil Gal. 1927, no. 14

Plaster: Jerusalem, Israel Museum, 1966

Provenance: 1 A. Haskell; FAS, 1974; Sydney, Artarmon Gal.; Lady Fairfax

2 Sotheby's 4.11.59 (76), called *A Burmese Girl*

3 P. Coll.; NY, PB 18.5.60 (43), ill.; P. Coll.

4 Texas, P. Coll.; NY, Knoedler; NY, PB 13.12.61 (32), ill.; A. Quinn

5 L. Goodman; Sotheby's 22.7.64 (47); M. Wickham-Boynton

6 Auction, Cranbourn Court; E. Littler, 1964; Eisenberg-Robbins; Washington, MAA, 1973

Literature: Black, p. 236, no. 124; Buckle, p. 146, pl. 223

167 Eleventh Portrait of Peggy Jean
(long hair, at 7 years 6 months)
1926

bronze

Exhibition: Leicester Gal. 415, 1926, no. 10 (plaster—version with crown, up to 6)

Provenance: no record

Literature: Haskell, p. 185; Black, no. 132, pl. 236; Buckle, p. 149, pl. 227

A photograph (Hulton M 88899), taken at the Leicester Gal., shows version with Peggy Jean wearing a toy crown.

168 Second Portrait of Oriel Ross
(head)
1926

bronze, H 40.6

Exhibition: Ferargil Gal. 1927, no. 2

Provenance: 1 A. E. Anderson; Manchester, Whitworth AG, 1929

2 J. Gibbins; Sotheby's 24.11.32; H. Walpole or H. Lees Jeffrey

3 A. C. J. Wall; Christie's 30.10.70 (226)

4 Mrs D. Bannerman; Sotheby's 9.12.70 (60)

Literature: Buckle, p. 151, pl. 231

167 (plaster)

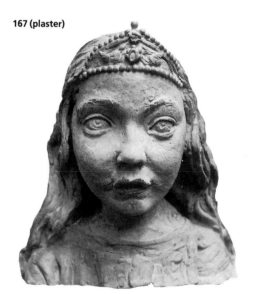

168

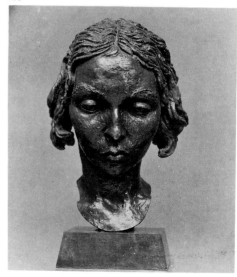

170

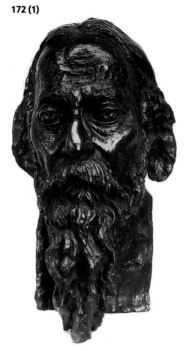

172 (1)

173 (1)

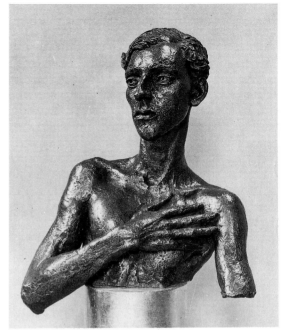

169 (1)

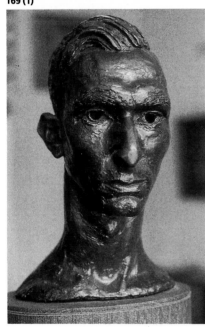

169 James K. Feibleman
1926
bronze, H 40.0
Plaster: destroyed 1982
Provenance: 1 Sitter
Literature: Haskell, p. 186; Black, p. 236, no. 133; Buckle, p. 151, pl. 229
Commission. American philosopher and aesthetician.

**170 First Portrait of
J. Ramsay Macdonald**
1926
bronze, H 47.0
Inscription: *JE* in monogram
Exhibition: Ferargil Gal. 1927, no. 6
Plaster: Aberdeen CAG, 1966
Provenance: 1 J. Epstein; Glasgow CAG, 1927
2 NY, Scott & Fowles; Washington, Corcoran AG, 1929
Literature: Haskell, p. 185; Powell, p. 117, ill.; Black, no. 126, pl. 23; Buckle, pp. 148–9, pl. 226
Commission. Became first British Labour Prime Minister in 1924.

171 Bust of Mlle Mijinska
1926
bronze
Provenance: no record
Literature: Haskell, p. 185; Black, p. 236, no. 129 (*Nijinska*); Buckle, p. 426
Commission. Black describes the bust with hair parted centre and chignon.

172 Rabindranath Tagore
1926
bronze, H 50.8
Inscription: *Epstein*
Exhibitions: Ruskin Gal. 1927, no. 1; Ferargil Gal. 1927, no. 19; Leicester Gal.

1191, 1960, no. 22 (6 of 8)
Plaster: (H 55.0) Israel, Ein Harod, 1965
Provenance: 1 H. Vincent; Birmingham MAG, 1928
2 C. A. Jackson; P. Coll., 1951
3 Dr Saint (Bolton AG 1954)
4 FAS; Coventry, Herbert AG, 1961
5 Melbourne, NG Victoria, 1948
6 London, Estorick Gal.; Mrs C. Abrahams-Curiel, 1956
7 L. Goodman; NY, PB 9.11.59 (38), ill.; P. Coll.
8 T. S. Barlow; Sotheby's 12.7.61 (93); London, Tooth's; H. Hartford; NY, SPB 11.3.71 (22), ill.; P. Coll.
9 Sotheby's 28.3.62 (151)
10 E. P. Schinman; whereabouts unknown
11 Sir Barnett & Lady Stross; Stoke-on-Trent MAG, 1967
12 Mrs N. Eddy; LA, County MA, 1968
13 Walsall, Garman-Ryan Coll., 1973
14 E. Swann; Sotheby's 26.11.69 (167); J. Merton; Christie's 8.6.79 (195), ill.
15 A. C. J. Wall; Christie's 30.10.70 (227); J. Solomon
16 Sotheby's 3.11.82 (75); HM Government
Literature: Haskell, p. 185; Powell, ill.; Epstein 1940, pp. 111–12; Black, p. 236, no. 125; Epstein 1955, p. 92, ill; Buckle, pp. 146–8, pls. 224–5; Schinman, p. 37, ill.
Some casts, e.g. 10, have a wider shoulder base than others, e.g. 1.

173 The Hon. Stephen Tennant
1926
bronze, H 73.5
Plaster: destroyed 1982
Provenance: 1 Sitter; Sotheby's 15.12.71 (61)
Literature: Haskell, p. 185, ill.; Black, p. 236, no. 127; Buckle, p. 143, pl. 219

174 (1)

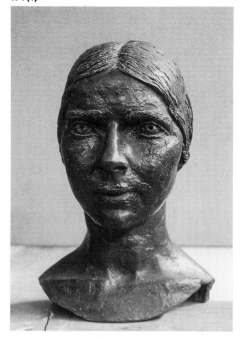

176 (4)

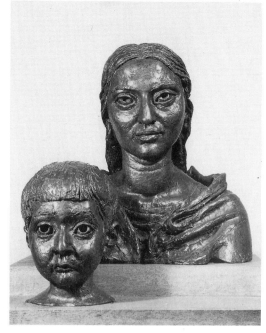

177

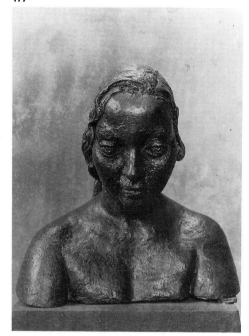

178

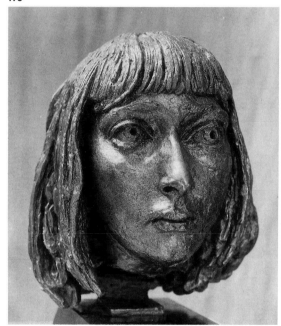

174 Pearl Oko
1926
bronze, H 36.0
Plaster: Israel, Ein Harod, 1965
Provenance: 1 Jerusalem, Israel Museum
Literature: Haskell, p. 185 (dates 1926); Black, p. 236, no. 131 (dates 1926); Buckle, p. 153, pl. 234 (dates 1927)

175 Madonna and Child (plate 16)
1926–7
bronze, life-size
Plaster: Jerusalem, Israel Museum, 1966
Exhibitions: Ferargil Gal. 1927, no. 44; London, Knoedler Gal., 1929; Leicester Gal. 553, 1933, no. 13
Provenance: 1 J. Epstein (lent to Brooklyn Museum); Miss S. Ryan; NY, Church, Riverside Drive (exterior)
Literature: Haskell, p. 186, ill.; Powell, pp. 109–14, ill.; Epstein 1940, pp. 145–6, ill.; Black, no. 135, pls. 26–7, 84; Epstein 1955, p. 123, ill.; Buckle, pp. 154–8, pls. 237–40
Sunita and her son Enver were the models (see nos. 157, 159, 160). A head and shoulder version of the pair was also produced (see no. 176).

176 Madonna and Child (Sunita and Enver)—heads only
1926–7
bronze, H 48.2 (mother), 29.2 (child)
Exhibitions: Ferargil Gal. 1927, no. 11 *Enver—second study*; Godfrey Phillips Gal. 1928, no. 83 *Head of Christ Child*
Plaster: (*Madonna*, H 48.3) Toronto, AG Ontario, 1967
Provenance: 1 Walsall, Garman-Ryan Coll., 1973
2 E. P. Schinman; whereabouts unknown
3 S. Box; Sotheby's 1.11.67 (154)
4 (= cast 2 or 3?) V. Steele Scott; NY, SPB 21.2.85 (82)

VERSION WITH MADONNA ONLY:
5 Mr & Mrs B. Walker; Detroit IFA, 1963
VERSION WITH CHILD ONLY, H 29.2:
6 H. Halle; NY, SPB 17.3.61 (39), ill.; E. J. Arnold; LA, SPB 5.2.74 (126) = cast 7?
7 NY, Christie's 11.81; Dr M. Evans
Literature: Black, p. 236, no. 136 (*Enver*); Buckle, pp. 154–8, pls. 237–40; Schinman, p. 65, ill.

177 Daisy Dunn
1927
bronze, H 47.0
Plaster: destroyed 1982
Exhibitions: Ferargil Gal. 1927, no. 29; Windermere 1943
Provenance: 1 Dr D. S. Greig (1948)
2 E. P. Schinman; whereabouts unknown
3 Sotheby's 21.11.62 (181); London, Shrubsole
4 P. Coll.; Christie's 9.11.84 (129), ill.
Literature: Haskell, p. 186 (states second version with long hair also cast); Black, p. 136, no. 137; Buckle, p. 153, pl. 235; Schinman, p. 33, ill.
Member of cast of Florence Mills' Blackbirds Revue, London, 1925. According to Lady Epstein in 1968 the edition was complete.

178 Little Eileen
1927
bronze, H 35.7?
Exhibition: Ruskin Gal. 1927, no. 5 *Eileen*
Provenance: 1 J. Gibbins; Sotheby's 24.11.32; H. Walpole; Sydney, D. Jones Gal.; Dr N. Behan, 1950
2 L. Goodman; NY, PB 6.5.59 (45), ill., called *Young French Girl*
3 Sotheby's 9.7.69 (102); London, Agnew's; P. Coll.
Literature: Haskell, p. 186; Buckle, p. 173, pl. 262 (dates 1930)
Childhood friend of Peggy Jean.

180

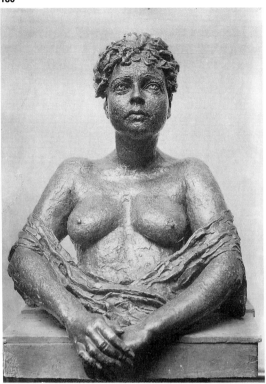

179 (2)

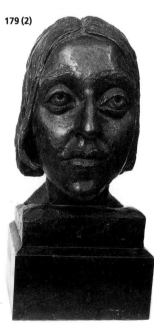

181 (plaster)

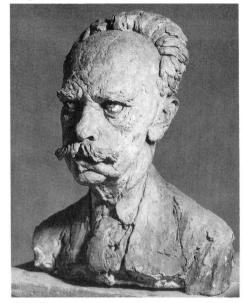

182 (2)

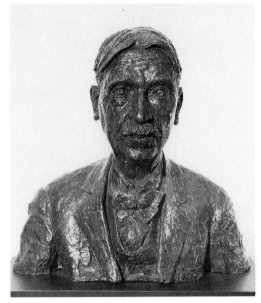

179 Virginia Jay

1927

bronze, H 26.7

Provenance: 1 A. Haskell; whereabouts unknown = cast 2?

2 Sotheby's 1.11.67 (170) = cast 3?

3 London, Mayor Gal.; Christie's 12.11.82 (54), called *Head of a Girl*

Literature: Black, p. 236, no. 138; Buckle, p. 426.

180 Zeda (Pasha)

1927

bronze, H 68.5

Exhibitions: Ferargil Gal. 1927, no. 36; Leicester Gal. 508, 1931, no. 9 *Zeda*

Provenance: 1 Bolton CAG, 1961

VERSION WITH HEAD ONLY, H 36.8:

2 Miss M. C. Walker; Toronto, AG Ontario, 1952

Literature: Haskell, p. 187; Buckle, p. 152, pl. 233

Turkish model.

181 Professor Franz Boas

1927

bronze

Exhibition: Leicester Gal. 662, 1937, no. 3

Plaster: Ithaca, Cornell University, 1966

Provenance: 1 whereabouts unknown

2 (cast post 1959) Sitter's family

Literature: Haskell, p. 187; Epstein 1940, pp. 153–4; Black, no. 140, pl. 30; Epstein 1955, pp. 131, 159; Buckle, p. 158, pl. 241

Commission. Anthropologist. Sculpted in the USA during the four months Epstein spent there for his show at the Ferargil Gallery, New York, in late 1927 and early 1928.

182 Professor John Dewey

1927

bronze, H 55.9

Exhibition: Cooling Gal. 1931/2, no. 1

Plaster: Plainfield, Vermont, Goddard College, 1966

Provenance: 1 NY, Columbia University, 1927

2 Sitter's family; Washington, NPG, 1981

Literature: Haskell, p. 186; Epstein 1940, pp. 153–4, ill.; Epstein 1955, p. 131; Buckle, p. 158, pl. 242

Commissioned by students and friends, 1925. Sculpted during Epstein's visit to the USA (see no. 181).

183 Paul Robeson

1928

bronze, H 33.0

Inscription: *Epstein*

Exhibitions: Godfrey Phillips Gal. 1928, no. 80; Zwemmer's 1939, no. 6

Plaster: (H 33.0) Jerusalem, Israel Museum, 1966

Provenance: 1 (unsigned) J. Epstein; P. Coll., *c.*1928

2 (unsigned) F. M. van Vechten, 1928; NY, MOMA, 1965

3 P. Coll.; London, Roland, Browse & Delbanco; Washington, NPG, 1975

4 (signed) J. Epstein; Lincoln, Usher Gal., 1953

5 Leslie de Sarum; Sotheby's 14.12.55 (76); York CAG, 1955

6 H. Walpole (1945)

7 E. P. Schinman; whereabouts unknown

8 A. Margulies (from early 1950s or earlier); S. E. Kesten, 1965

9 J. Epstein, 1950s; Dr I. Epstein; Dr M. Evans

183 (5) a

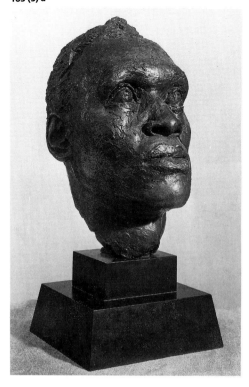

183 (5) b

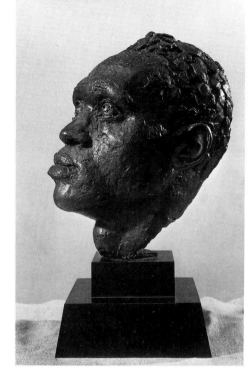

184

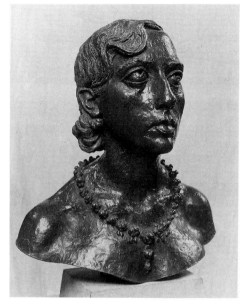

10 Sotheby's 16.12.64 (114); E. Littler; Eisenberg-Robbins; Washington, MAA, 1973
11 Christie's 4.11.66 (39)
12 Mrs J. Hart (Edinburgh 1961)
13 V. Feather (MAS 1961–2)
14 (signed) Christie's 11.6.82 (90)
15 (signed) Christie's 4.3.83 (262)
16 S. Burton; Sotheby's (Christian Action) 27.11.62 (10)
17 Lady Beddington-Behrens; Sotheby's 21.11.62 (175)
18 NY, Berry Hill Gal.; H. Hartford; NY, SPB 3.11.71 (26); P. Coll.
19 F. V. Lloyd; NY, SPB 13.5.77 (681), ill.
Literature: Haskell, p. 187, ill.; Epstein 1940, pp. 153–4, ill.; Black, no. 145, pl. 25; Epstein 1955, pp. 128–31, ill.; Buckle, p. 160, pl. 243
Singer. Sculpted during Epstein's visit to the USA (see no. 181).

184 First Portrait of Mrs Betty Joel (with necklace)
1928
bronze, H 39.4
Exhibitions: Godfrey Phillips Gal. 1928, no. 79 *Betty Joel*; Leicester Gal. 600, 1935, no. 20 *Betty Joel*
Provenance: 1 C. Jackson; Bolton AG, 1960
2 Dunedin AG
Literature: Haskell, p. 188 (dates 1929); Black, p. 237, no. 147 (*Head*, dates 1929); Buckle, p. 184

185 Mrs Godfrey Phillips
1928
bronze, H 46.0
Exhibitions: Godfrey Phillips Gal. 1928, no. 77; Zwemmer's 1939, no. 3; Leicester

Gal. 1968 (1 of 6)
Plaster: Des Moines Art Center, 1973
Provenance: 1 Phillips'; A. E. Anderson; Tate, 1928
2 Sitter; family descent
3 D. U. Radcliffe; Bradford CAG, 1967
4 Mrs S. A. Clarke; Christie's 22.6.62 (95); NY, P. Coll.
5 E. P. Schinman; whereabouts unknown
Literature: Haskell, p. 187, ill. opp. p. 108 (*A Portrait*); Buckle, p. 163, pl. 248 (plaster without stand-up collar); Chamot *et al.* 1964, I, p. 167; Schinman, p. 34, ill.
Commission. Mrs Phillips (Dorothy Jacobs) was the wife of an art dealer at whose gallery in St. James's Epstein exhibited seventy-five figure studies and eight sculptures in 1928. The drawings were published in 1929 with a foreword by H. Wellington.

186 Twelfth Portrait of Peggy Jean (The Sick Child)
1928
bronze, H 36.8
Exhibition: Godfrey Phillips Gal. 1928, no. 76
Plaster: (H 36.0) Jerusalem, Israel Museum, 1966
Provenance: 1 J. Epstein; A. Haskell, c.1930
2 A. E. Anderson; Manchester, Whitworth AG, 1929
3 L. Goodman; Sotheby's 22.7.64 (48); P. Coll.
4 E. P. Schinman; NY, SPB 21.10.77 (337a); Dr M. Evans
5 Sotheby's 7.6.78 (96)
Literature: Haskell, pp. 187, ill.; Epstein 1940, ill.; Buckle, pp. 160–2, pls. 244–6; Schinman, p. 51, ill.

185 (1)

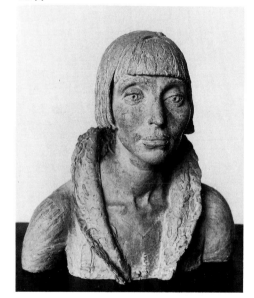

186

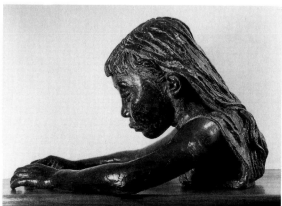

187

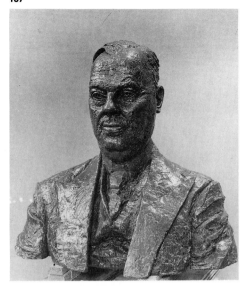

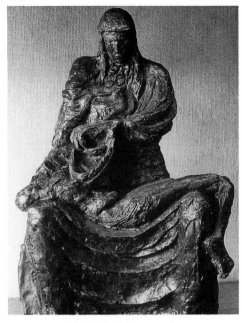

187 Lord Rothermere

1928

bronze

Exhibition: Leicester Gal. 508, 1931, no. 15
Plaster: destroyed 1982
Provenance: 1 Sitter; whereabouts un-known
Literature: Haskell, p. 187; Epstein 1940, pp. 97–8; Black, p. 237, no. 142; Epstein, 1955, pp. 79–80; Buckle, p. 163, pl. 247
Commission. Newspaper magnate and proprietor of *Daily Mail*.

188 Maquette for Night

1928

bronze, H 35.5

Exhibitions: Leicester Gal. 794, 1944, no. 7; Leicester Gal. 1191, 1960, no. 25 (3rd of 6)
Plaster: (H 36.0) Israel, Ein Harod, 1965
Provenance: 1 Lord & Lady Strauss
 2 J. Epstein; H. Wild; P. Dyer
 3 Dame Myra Hess
 4 Sotheby's 22.6.77 (77)
Literature: Epstein 1940, p. 158; Buckle, p. 164, pls. 249 (drawing), 252
Originally associated with a project for a Pietà; related drawings, Leeds CAG, Birmingham MAG.

189 Night and Day, London Underground Electric Railways, 55 Broadway, London (plates 18, 19)

1928–9

Portland stone, carved from blocks
c.275 × 275 × 100

Drawings: Leeds CAG, Henry Moore Sculpture Study Centre; Birmingham MAG; P. Coll.
Literature: Haskell, pp. 43–58, ill.; Powell, pp. 84–5, *passim*, ill.; Epstein 1940, pp. 159–61, 303–7, ill.; Black, pp. 19–20, no. 146, pl. 32; Epstein 1955, pp. 136–8, 270–3; Buckle, pp. 163–9, pls. 253, 255, 257; Cork 1985, chap. 6
Commissioned by the board of the Underground Railway, Charles Holden architect.

Holden's design for the building was substantially complete before sculptors and the sites for their work were selected. Muirhead Bone's presentation drawing of the building, *c*.1926, indicates only winged symbols carved high on the cruciform towers, and an anonymous standing figure placed in a niche over the narrow northern façade (Cork 1985, p. 255, pl. 303). The reluctant Frank Pick had been persuaded to approve Epstein's employment by Holden who, having approached Epstein unofficially and asked him to make some models, brought Pick to the studio to see them (Holden, Memoir, 3.12.1940).

Epstein was to undertake the main figures sited above the entrances to the Underground Station on the north-western and eastern façades of the building early in 1928. At the same time Eric Gill, Henry Moore, Eric Aumonier, F. Rabinovitch, A. H. Gerrard and Allan Wyon were invited to carve relief panels of the Winds high on the towers, some 25 metres above the ground.

It was a condition that the figures were to be carved direct in the stone without the use of the pointer or any mechanical means of reproduction from a preliminary clay or plaster model, the objection to this being that the resulting sculpture is not as a rule the work of the artist's own hand, that it is usually dull and lifeless as a result of its translation from one medium for which the model is suitable to another medium for which it is unsuitable. It was preferred to preserve all the virility and adventure brought into play with every cut of the chisel, even at the expense of some accuracy of form (Holden to *Manchester Guardian*, 3.8.1929).

Epstein made full use of the favoured position given him, though at first, having been given a free choice of subject, he had some difficulty finding a satisfactory sculptural idea. As he told James Bone in an extensive interview: 'my first idea was in some way to

189 a Epstein at work on *Night*

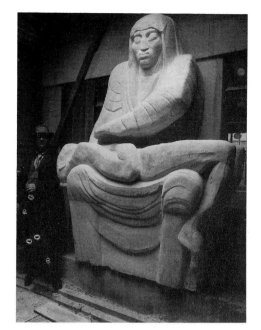

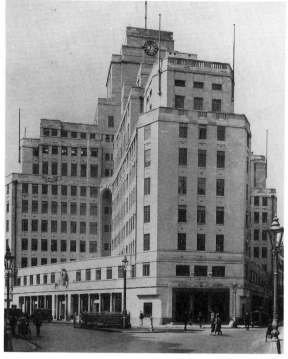

191 (1)

192

express traffic in the sculptures, the sense of the crowds passing out and in by day and night through the stations and the movements of the trains' ('Mr Epstein Replies', *Manchester Guardian*, 3.8.1929).

Even after he arrived on site Epstein's participation was kept secret for as long as possible in order to avoid adverse publicity and interference (Epstein 1940, p. 159). The newspapers only began to take note of the 'Gothic workshop' of sculptors working on the building in late January, reports becoming increasingly frequent in March. Epstein began working on *Day* when the curved Broadway front, on which it was placed, had reached parapet height, the rest of the building being only 'an open skeleton framework of steel'. By the time he started work on *Night*, however, the rest of the building was almost complete, so that he was better able to judge the effect of the sculpture in its setting (Holden to C. Barman, 19.8.1953).

Each carving comprised three Portland blocks, the joins posing a delicate problem because of slight variations in the colour and shelliness of the stone. The uncomfortable work on site took six months. Apart from the winter weather and the draughts, there were the hazards of the building materials being hoisted about overhead, and the insatiable curiosity of journalists who tried to get into the locked shed constructed primarily to safeguard the sculptor's privacy. A photograph published in *The Graphic* dwelt on the muffled and sinister-looking figure of Epstein locking up his shed!

Epstein nearly completed *Day* before starting and finishing *Night*, which progressed more quickly as a result of his experience with the other piece (*Manchester Guardian*, 3.8.1929). The scaffolding was removed from *Night* on 24 May, while Epstein went back to put the finishing touches to *Day*, which was revealed on 1 July. Public feeling, already running high, ran still higher after the appearance of *Day*. One member of the railway board offered to pay for suitable replace-

ments if Epstein's work could be hacked from the building, while others wanted them removed altogether. Though Pick himself did not like Epstein's figures, he backed Holden and even threatened to resign if the board voted for their removal. Some time after the sculptures were unveiled, the scaffolding around *Day* was re-erected so that Epstein, bowing with great reluctance to outside pressure, could shorten the child's penis (Barman, pp. 130–1).

190 David Cohen
1929
bronze
Provenance: 1 Sitter; whereabouts unknown
Literature: Haskell, p. 188; Black, p. 237, no. 149 (dates 1929); Buckle, p. 426 (dates 1928)
Commission. Friend of James K. Feibleman (no. 169).

191 Sir William Dingwall Mitchell Cotts
1929
bronze, H 58.0
Provenance: 1 Lady M. Cotts; Dumfries Museum, 1936
Literature: Buckle, p. 426 (dates 1931)
Commissioned by sitter. Owner of shipping company, Liberal MP for Inverness, Ross and Cromarty.

192 Tirrenia (Mrs Gerrard)
1929
bronze, H 52.7
Exhibition: Leicester Gal. 1968 (2 of 6)
Plaster: destroyed 1982
Provenance: 1 A. C. J. Wall; Christie's 30.10.70 (230); Leicester Gal.; Christie's 23.5.75 (122) = Christie's 14.11.75 (152)?
2 Mrs H. A. Bunzl; Christie's 2.6.81 (72), ill.
Literature: Haskell, p. 188 (dates 1929); Black, p. 237, no. 148 (dates 1929); Buckle, pp. 173–4, pls. 261–2 (dates 1930)

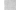

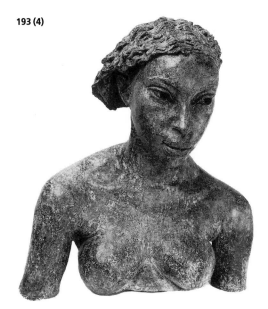

193 (4)

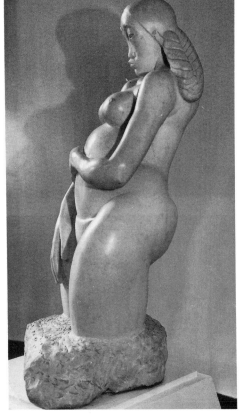

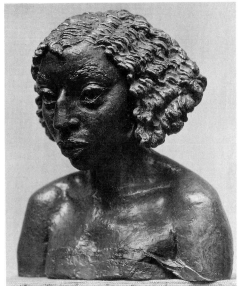

193 First Portrait of Lydia
1929–30

bronze, H 52.0

Inscription: *Epstein*

Exhibitions: Venice 1930, no. 48; Leicester Gal. 508, 1931, no. 7

Plaster: (H 54.0) Israel, Ein Harod, 1965

Provenance: 1 J. Gibbins; Sotheby's 24.11.32; Mrs J. B. Priestley

2 NY, Knoedler; NY, PB 11.10.61 (90), ill.; E. J. Arnold; NY, SPB 19.10.73 (121), ill.

3 P. Coll.; Christie's 23.3.62 (110), ill.

4 L. Goodman; Sotheby's 22.7.64 (49); M. Wickham-Boynton

5 P. Waxer; NY, SPB 24.10.74 (367), ill.

6 NY, O'Reilly; NY, SPB 27.2.76 (69), ill.

7 Sydney, D. Jones Gal.; P. Coll.

Literature: Haskell, p. 190 (dates 1930); Powell, ill.; Black, p. 238, no. 157; Buckle, p. 174, pl. 268

194 Genesis (plate 21)
1929–30

Seravezza marble, H 158.1

Exhibition: Leicester Gal. 508, 1931, no. 5

Provenance: Leicester Gal.; Mr & Mrs A. Bossom; M. Forbes; Sotheby's 26.3.58 (68); W. Cartmell; Lord Harewood and Sir J. Lyons, 1961; Granada Ltd., 1965 (on loan to Manchester, Whitworth AG)

Literature: Haskell, pp. 62–3, 73, 80–5, ill; Powell, pp. 45–60, ill; Epstein 1940, pp. 162–4, 308–18, ill; Black, pp. 20–1, 24, no. 159, pls. 9, 93; Epstein 1955, pp. 139–41, 274–81, ill; Buckle, pp. 174–81, pls. 269–72

Carved from a block of Seravezza marble bought in Paris (though exactly when this visit took place is not known). It was begun at Deerhurst, presumably during the latter part of 1929 after the completion of the Under-

ground sculptures, but subsequently moved to Hyde Park Gate (Epstein 1940, p. 163). Though the sculptor claimed that he worked on the figure with great certainty and without preliminary studies, there are a number of drawings of pregnant women clearly related to the development of the figure (Buckle and Lady Epstein, pl. 54, and two drawings, Birmingham MAG).

Epstein's own explanation of the figure is one of the most detailed he ever gave:

I felt the necessity for giving expression to the profoundly elemental in motherhood, the deep down instinctive female, without the trappings and charm of what is known as feminine; *My* feminine would be the eternal primeval feminine, the mother of the race. The figure from the base upward, beginning just under the knees, seems to rise from the earth itself. From that the broad thighs and buttocks ascend, a base solid and permanent for her who is to be the bearer of man. She feels within herself the child moving, her hand instinctively and soothingly placed where it can feel this enclosed new life so firmly bound within herself. The expression of the head is one of calm, mindless wonder. This boulder, massive yet delicate, with transparent shadows of the light marble, goes deep, deep down in human, half-animal consciousness. The forms are realistic, the treatment grave. There is a luminous air about it as if it partook of light and air. Complete in herself, now that there is that consummated within her, for which she was created. She is serene and majestic, an elemental force of nature. (Epstein 1940, p. 162.)

196 (1)

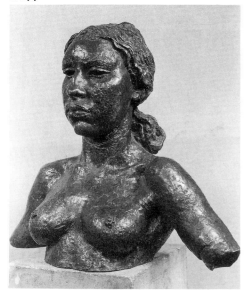

197

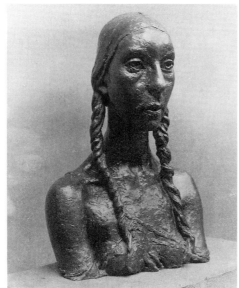

198 (2)

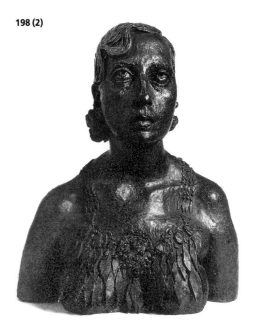

199

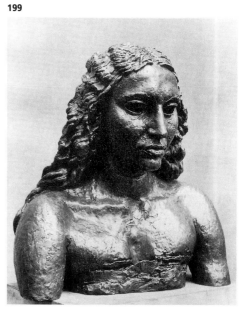

After its controversial exhibition at the Leicester Gal., Mr Bossom organized an extensive national tour the fees from which raised funds for charity. When it was subsequently bought by Mansfield Forbes and became part of the décor of Finella, Cambridge, it was satirized by David Low as part of his *Rake's Progress* cartoons. Later, under the ownership of W. Cartmell, it joined the sideshow of other controversial works by Epstein—*Consummatum Est* (no. 275), *Adam* (no. 288), *Jacob and the Angel* (no. 312) and one bronze nude—at Tussaud's in Blackpool.

195 May Goldie
1930

bronze

Exhibitions: Leicester Gal. 508, 1931, no. 6, ill.; Leicester Gal. 1968 (4 of 6)

Plaster: destroyed 1982

Provenance: 1 whereabouts unknown

Literature: Haskell, p. 189; Epstein 1940, ill. opp. p. 304; Buckle, p. 174, pl. 267

196 Betty (Esther)
1930

bronze

Exhibition: Leicester Gal. 508, 1931, no. 4, ill.

Provenance: 1 Leicester Gal.; H. Bliss; Tate, 1945

2 Sydney, D. Jones Gal.; W. Bowmore

Literature: Haskell, p. 190, ill.; Black, p. 238, no. 158; Buckle, p. 174, pl. 266

Nightclub singer.

197 Rebecca
1930

bronze, H 56.0

Inscription: *Epstein*

Exhibition: Leicester Gal. 508, 1931, no. 12

Plaster: destroyed 1982

Provenance: 1 Lady Entwhistle; Sotheby's 21.11.62 (177); P. Coll.; Sotheby's 13.11.85 (144), ill.

Literature: Haskell, p. 189; Black, no. 154, pl. 35; Buckle, p. 174, pl. 265

Half-black, half-Jewish nightclub singer.

198 Second Portrait of Joel (La Belle Juive)
1930

bronze, H 57.0

Exhibitions: Leicester Gal. 508, 1931, no. 10 *La Belle Juive*; Cooling Gal. 1931/2, no. 9

Provenance: 1 Adelaide, AG S. Australia, 1933

2 P. Coll.; Christie's SK 24.4.81 (22), ill. = Sotheby's 2.11.83 (104), ill.?

3 Christie's 7.3.86

Literature: Haskell, p. 188; Black, no. 150, pl. 34; Buckle, p. 184, pl. 279

199 Israfel (Sunita)
1930

bronze, H 53.3

Exhibition: Leicester Gal. 508, 1931, no. 2

Provenance: 1 (gilt) A. Margulies

2 J. Epstein; Liverpool, Walker AG, 1940

3 Dr W. Boyd; Sotheby's 13.12.67 (83); P. Coll.

4 Sydney, D. Jones Gal.; Mr & Mrs R. C. Crebbin, 1960s

Literature: Haskell, p. 189; Powell, p. 119, ill.; Epstein 1940, ill. opp. p. 246; Black, p. 237, no. 151; Buckle, p. 181, pl. 274

202

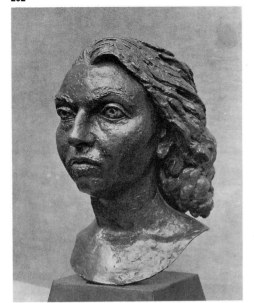

201

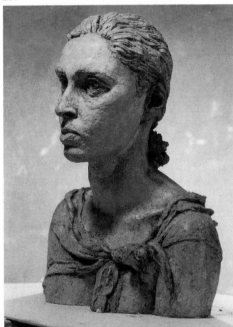

200

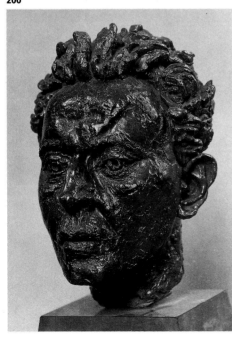

203 (2)

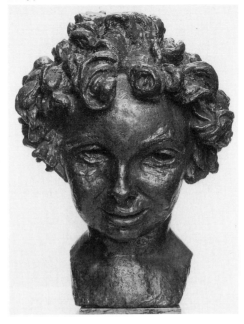

204

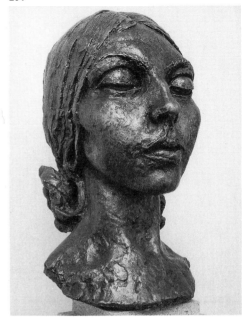

200 Hans Kindler
1930
bronze
Exhibitions: Leicester Gal. 508, 1931, no. 13, ill.; Cooling Gal. 1931/2, no. 12
Provenance: 1 Sitter; whereabouts unknown
Literature: Haskell, p. 189; Black, no. 152, pl. 36; Buckle, p. 171, pl. 258
Friend, cellist, brother-in-law to B. van Dieren (see no. 74).

201 Isobel Powys
1930
bronze, H 50.8
Exhibition: Leicester Gal. 508, 1931, no. 14, ill.
Provenance: 1 Sotheby's 3.4.63 (90) = Sotheby's 22.7.64 (69)?
2 whereabouts unknown
Literature: Haskell, p. 189; Black, p. 238, no. 153; Buckle, p. 172, pl. 259
Commissioned by family. Daughter of architect, T. C. Powys.

202 Germaine Bras
1930
bronze, H 40.0
Inscription: *Epstein*
Exhibitions: Leicester Gal. 508, 1931, no. 8; Cooling Gal. 1931/2, no. 8
Provenance: 1 E. P. Schinman; whereabouts unknown
2 (brown patina) A. C. J. Wall; Christie's 30.10.70 (229)
Literature: Buckle, p. 173, pl. 264; Schinman, p. 48, ill.

203 Joan Greenwood (child)
1931?
bronze, H 35.4

Inscription: *Epstein*
Exhibition: Leicester Gal. 508, 1931, no. 3
Plasters: 1 (H 38.1) Toronto, AG Ontario, 1967
2 Jerusalem, Israel Museum, 1966
Provenance: 1 H. Walpole; Leicester Gal., 1945
2 J. Epstein, 1948; Miss E. M. J. Pleister; Cambridge, Fitzwilliam Museum, 1982
3 A. Haskell; FAS; Sydney, D. Jones Gal.; P. Coll.
4 Lady Cochrane; Sotheby's 14.12.66 (5)
5 A. C. J. Wall; Christie's 30.10.70 (228); P. Coll.
6 Lord Derby (1942)
Literature: Haskell, p. 190 (dates 1931); Powell, ill. (dates 1930); Black, p. 238, no. 161; Buckle, p. 172, pl. 260 (dates 1930)
Childhood friend of Peggy Jean. According to Lady Epstein in 1970 eight were cast from an edition of ten.

204 Mary Blandford
1930–1
bronze, H 37.5
Exhibition: Leicester Gal. 1191, 1960, no. 26 *Mary*, 1930
Provenance: 1 J. Gibbins; Sotheby's 24.11.32 (120); Leicester CAG, 1932
2 E. P. Schinman; whereabouts unknown
3 (gilt patina) Christie's 22.2.80 (249), ill.
4 Sotheby's 14.12.66 (36)
5 London, Shrubsole; Christie's 15.7.69 (165)
6 Sotheby's 16.3.77 (67); FAS; Sydney, Artarmon Gal.
Literature: Haskell, p. 189 (dates plaster 1930); Powell, ill. (dates 1931); Black, p. 238, no. 156; Buckle, p. 187, pl. 284 (dates 1931); Schinman, p. 49, ill.

205

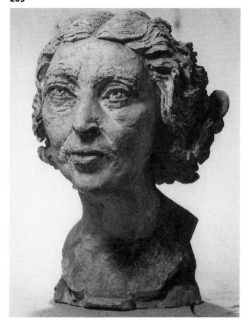

206

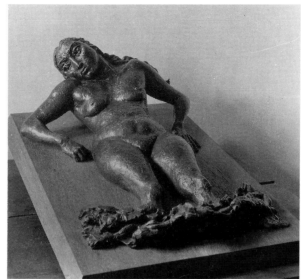

207

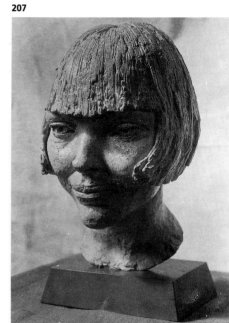

208 (plaster)

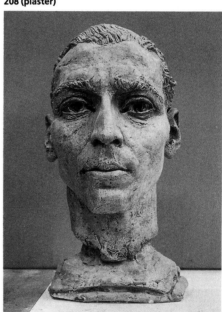

209 (1)

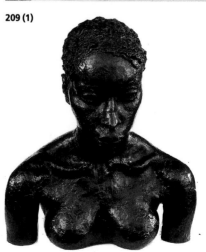

205 Mrs A. Chester Beatty
1931
bronze
Exhibition: Leicester Gal. 553, 1933, no. 16
Provenance: 1 Sitter (1933)
Literature: Black, p. 239, no. 171; Buckle, p. 184, pl. 277
Commissioned by sitter.

206 Sunita Reclining (Reclining Goddess)
1931
bronze, L 76.0
Exhibition: Leicester Gal. / ARL 1933, no. 27
Provenance: 1 E. P. Schinman; NY, SPB 16.3.78 (51), ill.; Mrs T. Hanley
HALF-LENGTH VERSION, L 35.0:
2 P. Coll.; Christie's 9.12.66 (87) = cast 3?
3 Sotheby's 22.4.70 (327); L. F. Dye
Literature: Haskell, p. 190; Buckle, p. 182, pl. 275; Schinman, p. 62, ill.

207 Ellen Jansen (Smiling Head)
1931
bronze, H 33.0
Exhibitions: Leicester Gal. 553, 1933, no. 27 *Smiling Head* (up to 6); Cooling Gal. 1931/2, no. 4
Provenance: 1 (green patina) H. Pearlman; NY, PB 7.5.52 (12), ill., called *Head of a Girl*; J. & E. Lowe Foundation; NY, SPB 26.2.70 (41), ill.; P. Coll.
2 Leicester Gal., 1933
Literature: Haskell, p. 191, ill.; Black, p. 238, nos. 163 (*E. Jansen*), 172 (*Smiling Head*); Buckle, p. 184, pl. 281
Commission. Married to theatrical producer, Maurice Browne.

208 Malcolm Bendon
1931
bronze, H 38.0 (plaster)
Exhibition: Leicester Gal. 553, 1933, no. 8
Plaster: (H 38.0) Jerusalem, Israel Museum, 1966
Provenance: 1 Mrs A. Bendon (1933)
Literature: Haskell, p. 191; Black, p. 238, no. 164; Buckle, p. 184, pl. 282
Commissioned by sitter's mother.

209 Second Portrait of Lydia
1931
bronze, H 48.2
Exhibition: Leicester Gal. 553, 1933, no. 15
Provenance: 1 R. E. Smith; Sotheby's 12.4.67 (79); Leicester Gal.
Literature: Haskell, p. 191; Black, p. 238, no. 157; Buckle, p. 183, pl. 276

210 Third Portrait of Oriel Ross (bust) (plate 26)
1931
bronze, H 66.0
Exhibition: Leicester Gal. 553, 1933, no. 5, ill. (up to 3)
Plaster: (H 67.0) Israel, Ein Harod, 1965
Provenance: 1 Leicester Gal., 1933; Mrs Chester Beatty; Cambridge, Fitzwilliam Museum, 1948
2 Leicester Gal.; E. M. M. Warburg; NY, MOMA, 1933
3 Aberdeen CAG, 1936
4 Lord Cohen of Birkenhead; Liverpool University, 1948
5 (cast 1949) J. Epstein; Palm Beach, Norton School of Art
Literature: Haskell, p. 191; Black, no. 166, pl. 40; Buckle, pp. 194–5, pls. 295, 298

213

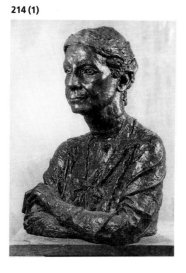
214 (1)

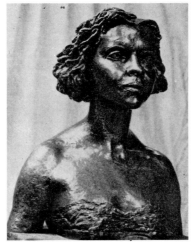
215

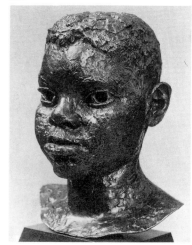
216

212 (1)

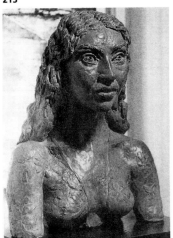

211 (2)

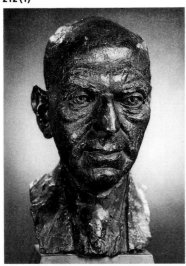

211 Mrs Sonia Heath
1931
bronze, H 57.0
Exhibition: Leicester Gal. 553, 1933, no. 17
Provenance: 1 Liverpool, Walker AG, 1933
2 Sir B. Stross; Keele University, c.1957
Literature: Haskell, p. 191; Buckle, p. 184, pl. 278
Commission. The cast at Keele is known as *Isobel Elsom* but is identical with that at Liverpool.

212 Dr William Cramer
1931
bronze, H 35.6
Exhibition: Leicester Gal. 553, 1933, no. 10 (dated 1932)
Plaster: destroyed 1982
Provenance: 1 Sitter; P. Coll.
Literature: Haskell, p. 191; Powell, p. 119, ill. (dates 1931); Buckle, p. 184, pl. 280
Commissioned by sitter. American cancer researcher.

213 Third Portrait of Kathleen
1931
bronze, H 53.4
Exhibition: Leicester Gal. 553, 1933, no. 12 (up to 6)
Provenance: 1 Mrs H. Snowman; Sotheby's 16.12.64 (112); E. Littler; Eisenberg-Robbins; Washington, MAA, 1973
2 E. C. Meadows; Christie's 24.4.64 (199); London, Wartski
3 P. Coll.

214 Professor Lucy Martin Donnelly
1931
bronze, H 55.9
Exhibition: Leicester Gal. 553, 1933, no. 3, ill.
Plaster: destroyed 1982
Provenance: 1 Countess E. Russell; Bryn Mawr College, 1948
Literature: Black, p. 239, no. 169; Buckle, pp. 186–7, pl. 283
Commissioned by Bryn Mawr. Professor of English, 1911–36.

215 Harriet Hoctor
1931
bronze, H 49.5
Provenance: 1 Sitter; NY, PB 2.5.56 (52), ill.
Literature: Black, p. 239, no. 183 (dates 1932); Buckle, p. 197, pl. 301
Commission. American dancer.

216 Paul Robeson Jun.
1931
bronze, H 42.0
Exhibitions: Leicester Gal. 704, 1939, no. 6; Famous Gal. 1940, no. 6; Leicester Gal. 1968 (edition complete)
Plaster: destroyed 1982
Provenance: 1 Leicester Gal.; Sheffield CAG, 1939
2 S. Box, Sotheby's 16.12.64 (116); E. Littler; Eisenberg-Robbins; Washington, MAA, 1973
Literature: Buckle, p. 187, pl. 286 (dates 1931)

Literature: Black, p. 239, no. 170; Epstein 1955, ill.; Buckle, p. 187, pl. 285

218 *Sun God* (no. 26), state in 1933

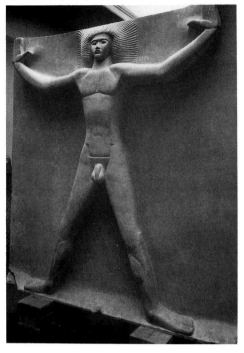

217 (1)

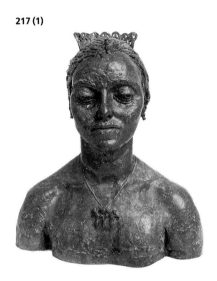

219

220

221

217 Mrs Sarah Oyved

1932

bronze, H 43.0

Exhibition: Leicester Gal. 553, 1933, no. 26 *Portrait of a Lady*

Plaster: destroyed 1982

Provenance: 1 M. Oyved; Jerusalem, Israel Museum, 1937

Literature: Black, p. 239, no. 181; Buckle, p. 231

Commission. Illustrated in unidentified cutting reviewing Leicester Gal. show (NY Public Library).

218 Primeval Gods (plate 24)

1931–3

Hoptonwood stone, H 213.4, W 198, D 35.5

Exhibition: Leicester Gal. 553, 1933, no. 23

Provenance: J. Epstein; S. Ryan; NY, Metropolitan Museum, 1970

Literature: Black, no. 160, pl. 38; Buckle, p. 203, pl. 310

Verso of *Sun God* (no. 26). Judging from surviving photographs this relief refers back to the incomplete lost *Mother and Child* (no. 67) as well as being similar stylistically to the London Underground carvings (no. 189).

219 Ahmed

1932

bronze, H 49.5

Exhibition: Leicester Gal. 553, 1933, no. 11 (up to 6)

Provenance: 1 Mrs Chester Beatty; Belfast, Ulster Museum, 1956

Literature: Black, p. 239, no. 178; Buckle, p.

197, pl. 300

Arab dancer.

220 Basil Burton

1932

bronze

Exhibition: Leicester Gal. 553, 1933, no. 1

Provenance: 1 Mrs P. Burton, 1933; whereabouts unknown

Literature: Black, p. 239, no. 175; Buckle, p. 204, pl. 314 (dates 1933)

Commission.

221 First Portrait of Isobel

1932

bronze, H 53.3

Exhibition: Leicester Gal. 553, 1933, no. 6 (head)

Plaster: (H 54.9) Melbourne, NG Victoria, 1971

Provenance: 1 J. Heritage Peters, pre-1938; Sotheby's 20.4.66 (119); London, Agnew's **2** Lady Epstein; LA, Dalzell Hatfield Gal.; Mr & Mrs Gardner; Des Moines Art Center, 1969 **3** LA, Dalzell Hatfield Gal.; V. Steele Scott; SF, Butterfield's 3.5.81 (247), ill. VERSION WITH HEAD ONLY, H 33.0: **4** J. Epstein; A. Haskell; FAS, 1980; M. J. Elliott **5** A. A. de Pass; Cape Town, South African NG, 1934 **6** M. Orman; NY, SPB 28.5.76 (531A), ill. **7** Sotheby's 14.7.82 (70); Dr Pahl

Literature: Black, p. 239, no. 176 (head); Buckle, p. 194, pl. 294 (bust)

Isobel Nicholas, artist, now Mrs I. Rawsthorne.

222

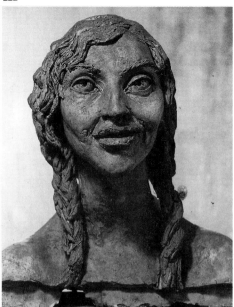

223

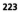
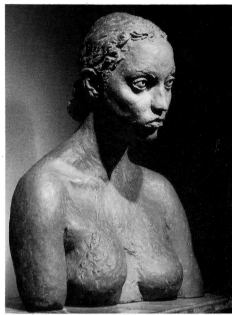

227 (plaster)

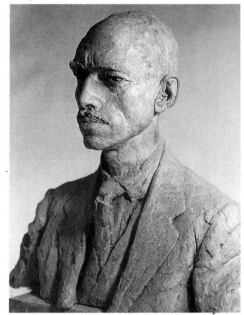

222 Fourth Portrait of Kathleen (laughing)
1932
bronze, H 38.5
' **Exhibition:** Leicester Gal. 553, 1933, no. 4 (up to 6)
Provenance: 1 Lady Cochrane; Sotheby's 14.12.66 (6); S. Ryan
2 London, Brook Street Gal.; NY, SPB 16.4.69 (52), ill.
3 Sotheby's 15.11.78 (190), ill.; Mrs A. Hull-Grundy; Maidstone MAG, 1978
VERSION WITH HEAD ONLY:
4 (gilt) Christie's 15.3.85 (134), ill.; I. J. Holland
Literature: Black, p. 239, no. 187; Buckle, p. 204, pl. 316

223 First Portrait of Louise
1932
bronze, H 50.8
Exhibitions: Leicester Gal. 553, 1933, no. 25; Leicester Gal., Summer, 608, 1935, no. 212 *Head*; Leicester Gal. 1968, version H 38.0 (2 of 10)
Plaster: (H 53.5) Caracas, Museo de Bellas Artes, 1966
Provenance: 1 J. Scaramanga, 1930s; P. Coll.
VERSION, H 38.0:
2 (gold patina) Amsterdam, Stedelijk Museum
3 Leicester Gal.; V. Steele Scott; SF, Butterfield's 3.5.81 (162), ill.
Literature: Black, p. 239, no. 180; Buckle, p. 197, pl. 299

224 Chimera (plate 20)
1932
alabaster, H 10.0, D 26.0
Exhibition: Leicester Gal. 553, 1932, no. 18
Provenance: Epstein Estate; E. P. Schinman; whereabouts unknown
Literature: Black, p. 239, no. 174; Buckle, p.

191, pls. 289–90; Schinman, p. 91, ill. Allegedly damaged by fire while in the Schinman Collection.

225 Elemental (plate 22)
1932
alabaster, H 81.0
Exhibitions: Edinburgh 1961, no. 86, ill.; Tate 1961, no. 35, ill.; Trenton, NJ, Schinman Coll. 1968, p. 13, ill.
Provenance: Epstein Estate; E. P. Schinman; A. d'Offay; London, P. Coll., 1981
Literature: Buckle, pp. 188–91, pls. 287–8; Schinman, p. 89, ill.
Not to be identified with Leicester Gal., 553, 1933, no. 19 *Elemental Figure*, which was *Woman Possessed* (no. 226).

226 Woman Possessed (Elemental Figure) (plate 23)
1932
Hoptonwood stone, L 107, W 43.2
Exhibitions: Leicester Gal. 553, 1933, no. 19 *Elemental Figure*; Edinburgh 1961, no. 87 *Woman Possessed*
Provenance: Epstein Estate; E. P. Schinman; A. d'Offay; Canberra, Australian NG, 1981
Literature: Black, p. 239, no. 173 (*Elemental Figure*); Schinman, pp. 92–3, ill.
A photograph in Hulton Picture Library confirms the identification of this piece in the Leicester Gal. show.

227 Arthur Villeneuve Nicholle .
1932
bronze
Exhibition: Leicester Gal. 553, 1933, no. 29
Provenance: 1 Sitter, 1963; whereabouts unknown
Literature: Black, p. 239, no. 182; Buckle, p. 199, pl. 305
Commission. Jersey landowner.

228

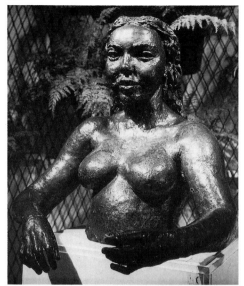

229

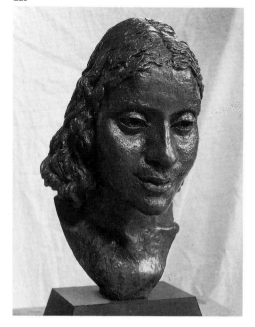

230

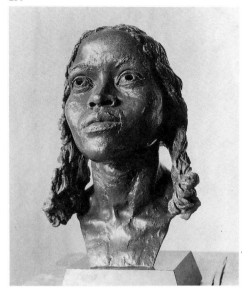

231 (1)

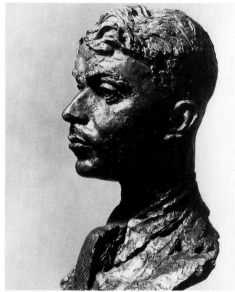

233

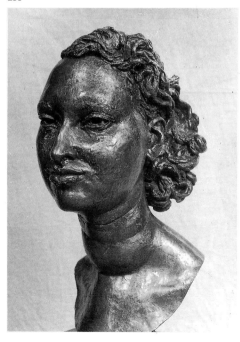

228 Fourteenth Portrait of Peggy Jean (Jeunesse)

1932

bronze, H 68.5

Inscription: *Epstein*

Exhibitions: Leicester Gal. 553, 1933, no. 7; Leicester Gal. 1968, without arms (2 of 6)

Plaster: destroyed 1982

Provenance: VERSION WITH ARMS:

1 Sir L. Bagrit (Edinburgh 1961)

VERSION WITHOUT ARMS, H 58.4:

2 1. NY, W. Irving Gal.; NY, S. Deutsch AG; NY, SPB 22.10.76 (336), ill.

3 NY, Salander Gal.; NY, SPB 21.10.77 (338), ill.

4 NY, Christie's 20.5.81 (458)

Literature: Black, p. 239, no. 177; Buckle, p. 198, pl. 303

229 Rose

1932?

bronze, H 37.5

Exhibitions: Leicester Gal. 600, 1935, no. 16; Leicester Gal. 1968 (2 of 6)

Plaster: destroyed 1982

Provenance: 1 Mrs L. Porter; Leeds CAG, 1950

2 W. Margulies

Literature: Black, p. 240, no. 190 (dates 1933); Buckle, p. 199, pl. 304

230 First Portrait of Roma of Barbados (head)

1932

bronze, H 35.5

Exhibition: Leicester Gal. 553, 1933, no. 14 (up to 6)

Provenance: 1 H. Bliss; Cambridge, Fitzwilliam Museum, 1945

2 J. Epstein, *c.*1957; NY, W. Irving Gal.

3 A. Haskell; FAS, 1975; Sydney, D. Jones Gal.; Mr & Mrs K. A. Wood

Literature: Black, p. 239, no. 179; Buckle, p. 197, pl. 302

231 Emlyn Williams

1932

bronze, H 47.0 (plaster)

Exhibition: Leicester Gal. 553, 1933, no. 28 (up to 3)

Plaster: (H 47.0) Jerusalem, Israel Museum, 1966

Provenance: 1 Sitter

Literature: Powell, ill. (dates 1932); Black, p. 239, no. 185 (dates 1932); Buckle, p. 212, pl. 326 (dates 1934); E. Williams, *Emlyn, An Early Autobiography 1927–1935*, 1973, pp. 238–41

Commissioned by Miss Cooke. Actor and dramatist.

232 Second Portrait of Isobel (bust) (plate 25)

1932

bronze, H 70.6

Exhibition: Leicester Gal. 553, 1933, no. 9, ill.

Plaster: NY, MOMA, 1966

Provenance: 1 Leicester Gal., 1933; J. W. Freshfield; Hull, Ferens AG, 1946

2 Sir H. Walpole; Leicester Gal., 1945

3 Leicester Gal.; E. Franklin (1946)

4 L. Lee (Edinburgh 1961)

5 Sotheby's 3.11.82 (47); P. Coll.

Literature: Epstein 1940, ill.; Black, p. 240, nos. 188, 203; Buckle, p. 209, pls. 321–2

Black states that the bust was modelled in 1932, but only the head cast then, the whole bust being cast in 1934.

233 Phyllis

1933

bronze

Exhibitions: Leicester Gal., Summer, 559, 1933, no. 121; Leicester Gal. 600, 1935, no. 15 (up to 6)

Provenance: no record

Literature: Buckle, p. 427 (dates 1932)

235

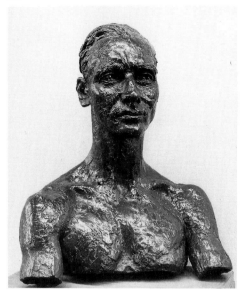

236

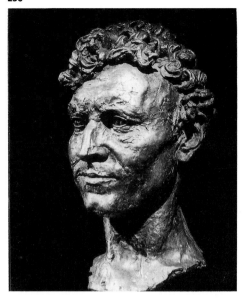

237 (1)

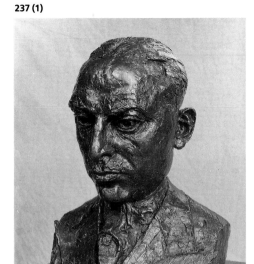

234 (13)

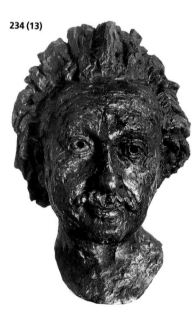

234 Albert Einstein
1933
bronze, H 44.5
Inscription: *Epstein*
Exhibition: Tooth's 1933 (up to 3)
Plaster: (H 45.0) Jerusalem, Israel Museum, 1966
Provenance: 1 London, Tooth's; Lady Jeans; Cambridge, Fitzwilliam Museum, 1933
2 London, Tooth's; Tate, 1934
3 Lord Simon of Glaisdale, 1936; Sotheby's 17.3.76 (50); P. Coll.
4 J. Watt; Edinburgh, NG Scotland, 1958, transferred to SNGMA, l960
5 Jackson; Huddersfield AG, 1951
6 Jackson; Bolton AG, *c*.1947
7 Leicester Gal., 1955; J. H. Hirshhorn; Washington, Hirshhorn Museum, 1961
8 London, Ben Uri Gal., *c*.1950; Mr & Mrs H. Livingstone
9 London, Obelisk Gal., 1955; P. Coll.
10 NY, Downtown Gal.; J. & E. Bates Cowles; Des Moines Art Center, 1957
11 London, Science Museum, 1952
12 Oxford, St. Catherine's College, 1955
13 Birmingham MAG, 1956
14 Lord Cohen of Birkenhead; Liverpool University, 1953
15 Mrs I. Yates; Christie's 30.10.70 (231); Princeton, University AG, 1970
16 Princeton, Institute for Advanced Study
17 S. Samuels, 1935 or 1941; Sotheby's 16.3.77 (68); Mrs R. H. Woodsend; Sotheby's 14.11.79 (172); Sutton Manor Arts Centre
18 J. J. Wallis (Ben Uri Gal. 1959)
19 London, Roland, Browse & Delbanco; Dr R. Einstein (1947)
20 Mrs Margulies; Christie's 1.3.68 (61); P. Coll.
21 Jackson, *c*.1952; P. Coll.; Sotheby's 19.11.80 (253)
22 Lord Marks of Broughton; Sotheby's

19.6.74 (120); P. Coll.; Sotheby's 25.3.83 (127)
23 P. Coll., early 1950s; Sotheby's 23.5.84 (124), ill.
24 H. Halle; NY, PB 17.3.61 (38), ill.; Schaffner
25 L. Goodman; Sotheby's 22.7.64 (50); P. Coll.
26 Sotheby's 14.12.66 (33); O. Hana
27 Mrs G. Rosenthal; Christie's 3.11.67 (73)
28 Oliphant; Sotheby's 26.11.69 (329); London, Wartski
29 E. Halpert; NY, SPB 16.5.73 (161), ill.
30 I. & B. Karp; Christie's 17.10.80 (58)
31 J. Epstein; F. Pleasants, 1954; Honolulu Academy of Fine Arts, 1963
32 P. Coll.
33 F. H. Lowe (Laing AG 1948)
34 Melbourne, NG Victoria, 1947
35 Sir E. Hayward; Hayward Bequest, Carrick Hill
Literature: Epstein 1940, pp. 94–6, ill.; Black, no. 91, pl. 62; Epstein 1955, pp. 77–8, ill.; Buckle, p. 206, pl. 320

235 John Gielgud
1933
bronze, H 40.0 (head)
Exhibition: Leicester Gal. 1968 (1 of 6)
Provenance: 1 (head only) J. Clark; E. Littler; Eisenberg-Robbins; Washington, MAA, 1973
Literature: Black, p. 139, no. 184 (bust, dates 1932); Buckle, p. 204, pl. 315
Commissioned by an admirer. Actor. Extant photos show versions with bust or head only.

236 Tiger King (Man of Aran)
1933
bronze, H 44.5
Inscription: *Epstein* (some casts)
Exhibition: Leicester Gal. 600, 1935, no. 14, ill.

238

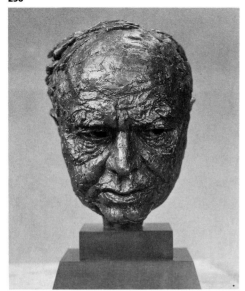

239 (1)

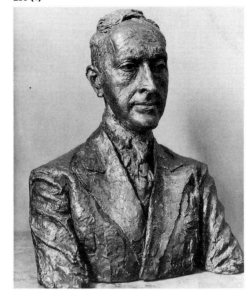

240

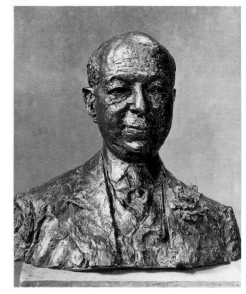

241 (1)

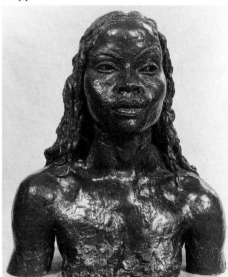

242 (1)

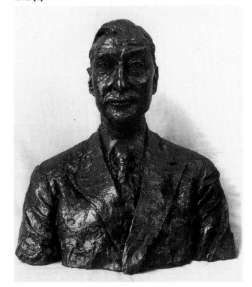

Plaster: Hull University, 1965
Provenance: 1 Leicester Gal., 1935; S. Samuels; Liverpool, Walker AG, 1956
2 J. Epstein; London, Tooth's; Sir J. Lyons, *c.*1959
3 London, Tooth's; P. Coll., 1960
4 (signed) Dublin, Hugh Lane Municipal Gal. of Modern Art, 1963
5 E. P. Schinman; whereabouts unknown
6 (signed) P. Coll.; NY, PB 16.3.60 (47), ill.
7 Sotheby's 10.11.76 (37); P. Coll.
8 S. Koehler; NY, SPB 18.3.82 (100), ill.
Literature: Black, p. 240, no. 201; Buckle, p. 200, pl. 309; Schinman, p. 64, ill.
Commissioned by Robert Flaherty (see no. 290). Tiger King was the protagonist in Flaherty's film, *Man of Aran.*

237 Michael Balcon
1933
bronze
Exhibition: Leicester Gal. 600, 1935, no. 5
Provenance: 1 Sitter; Lady Balcon
Literature: Black, p. 240, no. 200; Buckle, p. 212, pl. 325
Commissioned by Gaumont British. Film-producer.

238 Lord Beaverbrook
1933
bronze, H 26.0
Exhibition: Leicester Gal. 600, 1935, no. 4
Plaster: Israel, Ein Harod, 1965
Provenance: 1 Sitter, 1935; whereabouts unknown
2 I. Ostrer; Fredericton, New Brunswick, Beaverbrook AG, 1959
Literature: Epstein 1940, pp. 98–9; Black, p. 240, no. 196; Epstein 1955, p. 81; Buckle, p. 204, pl. 313
Commissioned by I. Ostrer (see no. 239).

239 Isidore Ostrer
1933
bronze

Exhibition: Leicester Gal. 600, 1935, no. 7
Provenance: 1 Sitter, 1935; whereabouts unknown
Literature: Buckle, p. 204, pl. 312
Commission. Canadian film magnate.

240 M. S. Myers
1933
bronze, H 43.2
Inscription: *Epstein*
Exhibition: Leicester Gal. 600, 1935, no. 6
Provenance: 1 Sotheby's 14.12.60 (100)
2 NY, Gaerlick's Gal.; NY, SPB 12.2.65 (72), ill.
3 Sotheby's 12.4.67 (84)
4 P. Coll.; Sotheby's 13.5.66 (83) = Sotheby's 1.5.68 (65); P. Coll.
5 Sotheby's 23.4.69 (94); P. Coll.
Literature: Black, p. 240, no. 198; Buckle, p. 216, pl. 331
Commissioned by sitter. Stockbroker. Buckle speaks of several casts being made for the sitter's friends.

241 Second Portrait of Roma of Barbados (bust)
1933
bronze, H 51.0
Exhibition: Leicester Gal. 600, 1935, no. 10 (up to 6)
Provenance: 1 J. Epstein, 1930s; C. Welker; C. Clifton-Welker; Sotheby's 7.6.78 (102); Schmidt & Bodner
Literature: Black, p. 240, no. 192; Buckle, p. 199, pl. 306

242 A. C. J. Wall
1933
bronze, H 57.1
Provenance: 1 Sitter; Christie's 12.11.82 (58); Dr V. Advani
Literature: Black, p. 240, no. 193
Commission. Important collector of Epstein's work. His collection was sold at Christie's between November 1970 and October 1976 and at one or two subsequent sales.

244 (1)

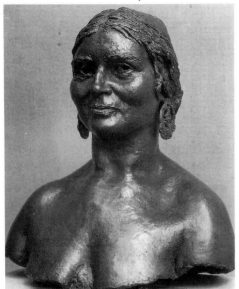

245

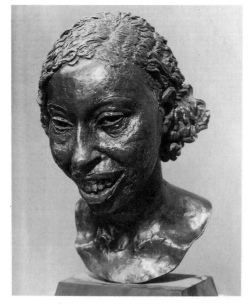

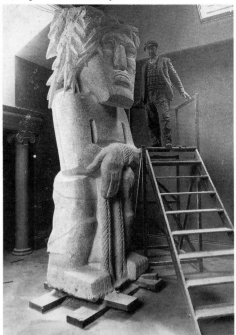

243

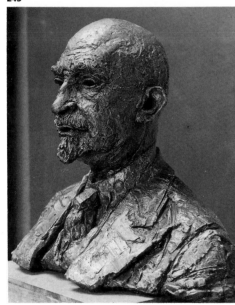

243 Chaim Weizmann

1933

bronze, H 47.0

Exhibition: Leicester Gal. 600, 1934, no. 3 (1 of 5 remaining)

Plaster: (H 45.0) Jerusalem, Israel Museum, 1966

Provenance: 1 Balfour Diamond Jubilee Trust

2 A. Margulies

3 E. P. Schinman; whereabouts unknown

4 Children of D. & B. Cohen; Glasgow Jewish Institute, 1948

5 Lady Epstein; Sir Jack Lyons, 1961

6 Lord Franks; Manchester University, Chemistry Dept.

7 (signed) Sotheby's 19.6.74 (121); P. Coll.; Sotheby's 13.11.85 (129), ill.

8 Christie's 2.3.79 (116), ill.

9 (signed) I. & B. Karp; Christie's 17.10.80 (57)

10 P. Coll.

11 L. Goodman; NY, PB 25.1.61 (42), ill.

12 H. Kaye; NY, PB 8.4.64 (53), ill.; P. Coll.; NY, Christie's 17.2.82 (107)

13 Dr M. Pearlman; NY, SPB 27.5.71 (67), ill.; B. G. Cantor

14 C. Kalman; NY, SPB 13.10.65 (46), ill.

15 (signed) Sotheby's 16.3.77 (69); Wolfson

16 (signed) Christie's 2.3.79 (116), ill.

17 Rehovot, Weizmann Institute of Science; Israel, Ein Harod

18 London, Grosvenor Gal.; Cahners Publishing Co.; H. Cahners; South Hadley, Mass., Mount Holyoke MA, 1979

19 Tel Aviv Museum

Literature: Powell, ill. (dates 1932); Black, p. 240, no. 199; Buckle, p. 206, pl. 319; Schinman, p. 63, ill.

244 Mrs Belle Cramer

1933

bronze, H 44.5

Exhibition: Leicester Gal. 600, 1935, no. 19 (up to 3)

Provenance: 1 Sitter; P. Coll.

2 NY, Christie's 17.2.82 (43), ill.

Literature: Epstein 1940, p. 172; Epstein 1955, p. 149; Buckle, p. 204, pl. 318

Artist, wife of Dr W. Cramer (see no. 212).

245 Third Portrait of Lydia (laughing)

1933–4

bronze, H 35.5 (head)

Exhibitions: Leicester Gal., Summer, 584, 1934, no. 122; Leicester Gal. 600, 1935, no. 12 (up to 6, 1 sold)

Provenance: 1 R. E. Smith (Laing AG 1948)

2 Mrs Nesbitt, (Auckland AG 1961)

VERSION WITH HEAD ONLY:

3 Mrs L. Porter; Leeds CAG, 1950

4 J. Pilkington; Bolton AG, 1976

5 Aberdeen University

6 Sydney, D. Jones Gal.; P. Coll. (1976)

Literature: Black, p. 240, no. 197 (head); Buckle, p. 214, pl. 328 (bust)

246 Behold the Man (Ecce Homo) (plate 28)

1934–5

Subiaco stone, H c.300

Exhibitions: Leicester Gal. 600, 1935, no. 1; London, Battersea Park, Sculpture in the Open Air, 1960, no. 18; Edinburgh 1961, no. 99, pl. 17 (detail)

Provenance: J. Epstein; Canon C. B. Mortlock, c.1959; Coventry Cathedral, ruins

Literature: Epstein 1940, pp. 168–75, ill.; Black, pp. 23–4, 241, pl. 96; Buckle, pp. 216–21, pls. 333–6

Epstein purchased the block of stone before he had any real idea what he was going to carve from it. When he did begin to work on it:

I found the toughest, most difficult piece of stone I had ever tackled. All the tools I

247 (plaster)

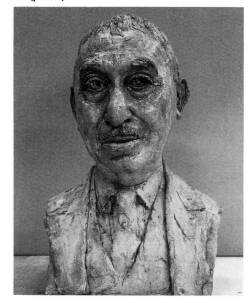

248 (1)

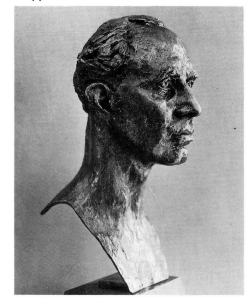

249

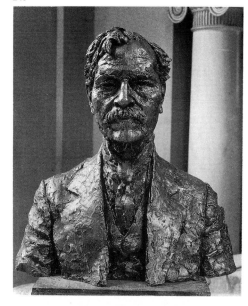

250

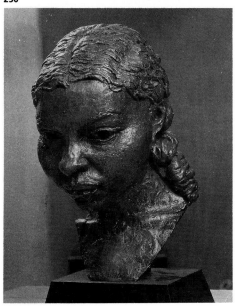

had broke on it, and it was.only after try-
ing out endless 'points'...with different
tool-makers that I finally hit upon a
'point' that resisted, and began to make
an impression on the stone...Because of
the hardness of the material I treated the
work in a large way, with a juxtaposition
of flat planes, always with a view to re-
taining an impression of the original
block...The plastic aim was always of
paramount importance and the 'preach-
ing' side, or rather the idea, the subject,
was so clear and simple to me, that, once
having decided on it, I gave myself up
wholly to a realisation of lines and
planes...

I exhibited this statue before it was
quite finished. I had worked at it at dif-
ferent periods whenever I could, and I
still have it in my studio and return to it
from time to time. (Epstein 1940, pp.
168–9.)

He was still working on it during the late
1940s, when there are several references to
his efforts to make time for it, while working
on the portraits of Prinz, Brodetsky and
Myers, in his letters to his daughter: 'In
between I am trying to finish *Behold the Man*, a
gigantic task' (Epstein to P. Hornstein, 14.6
and 6.7.1948).

247 Hiram Halle
1934
bronze, H 45.8
Exhibition: Leicester Gal. 600, 1935, no. 18
Plaster: (H 48.0) Jerusalem, Israel Museum,
1966
Provenance: 1 NY, W. Irving Gal.; I. M.
Atkins; NY, SPB 10.4.80 (125), ill.
Literature: Black, p. 240, no. 194 (dates
1933); Buckle, p. 216, pl. 332
Commission. American oil magnate and
collector of Epstein's work.

248 Benn Levy
1934
bronze
Provenance: 1 Sitter; whereabouts un-
known
Literature: Buckle, p. 224, pl. 342
Commission. Publisher.

249 Second Portrait of J. Ramsay Macdonald
1934
bronze, H 61.0
Exhibition: Leicester Gal. 662, 1937, no. 19
(up to 3)
Plaster: destroyed 1982
Provenance: 1 Leicester Gal.; London,
NPG, 1938
2 Sir A. Grant; Edinburgh, SNPG, 1938
3 Macdonald Estate; London, Agnew's;
Leicester CAG, 1984
Literature: Black, p. 240; no. 204, Buckle, p.
211, pl. 324
Commission. British Prime Minister. An
NPG memo of 1937 states that four casts
were taken.

250 Olive
1934
bronze, H 34.8
Exhibition: Leicester Gal. 600, 1935, no. 13,
ill. (up to 6, 1 sold)
Plaster: destroyed 1982
Provenance: 1 J. Epstein; A. F. Thompson;
Watford AG, 1981
2 Mrs T. S. Franklin (Ben Uri Gal. 1959)
3 E. P. Schinman; whereabouts unknown
4 Sotheby's 20.6.62 (162)
5 L. Goodman; Sotheby's 22.7.64 (51)
6 Sotheby's 22.4.70 (329); Leicester Gal.
7 B. Sewell; Christie's 12.7.74 (328); V.
Arwas
8 Sotheby's 16.11.77 (55)
9 (= cast 5?) Leicester Gal., 1968; P. Coll.
Literature: Buckle, p. 214, pl. 329; Schin-
man, p. 51, ill.

252 (4)

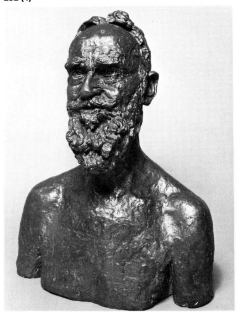

253 (16)

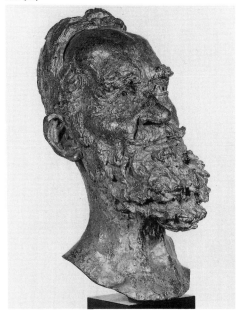

254 (1)

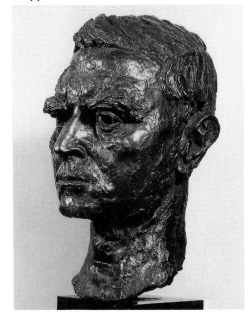

251

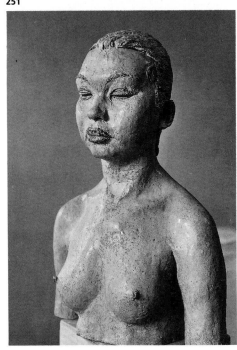

251 Rani Rama
1934

bronze, H 57.2

Exhibitions: Leicester Gal. 600, 1935, no. 17 (up to 6, 3 sold); Leicester Gal. 1968 (1 of 8)

Provenance: 1 (green patina) Leicester Gal., 1935; Mrs R. Samuels; Sotheby's 16.3.77 (70); V. Arwas

2 R. E. Smith, 1948; Sotheby's 12.4.67 (80)

3 H. Young; Christie's 11.5.73 (242)

4 Taubman; Christie's 11.6.76 (148)

5 (signed with initials and marked 6/6) LA, Dalzell Hatfield Gal.; V. Steele Scott; NY, Christie's 20.5.81 (451)

6 A. Welker (Edinburgh 1961)

7 (green patina) P. Coll.; Christie's 10.6.83 (200) ill.; P. Coll.

Literature: Buckle, pp. 214–15, pl. 330

252 First Portrait of George Bernard Shaw (bust)
1934

bronze, H 64.2

Inscription: *Epstein*

Exhibition: Leicester Gal. 600, 1935, no. 2 ill.

Plaster: (H 63.0) Jerusalem, Israel Museum, 1966

Provenance: 1 Sir H. Walpole; Leicester Gal., 1945; NY, El Dieff; Austin, HRC, 1964

2 E. P. Schinman; NY, SPB 21.10.77 (338A), ill.

3 Sir E. Hayward; Hayward Bequest, Carrick Hill

4 Lady Epstein, 1965; P. Coll.; Washington, NGA, 1982

5 Mr & Mrs C. Rosenblum; Pittsburg, Carnegie Institute, 1948

Literature: Epstein 1940, pp. 99–101, ill.; Black, no. 205, pl. 41; Buckle, pp. 210–11; Schinman, p. 50, ill.

253 Second Portrait of George Bernard Shaw (head)
1934

bronze, H 44–47.0

Inscription: *Epstein*

Provenance: 1 Leicester Gal.; Birmingham MAG, 1947

2 C. A. Jackson, Manchester; Bolton AG, 1947

3 A. Tooth; Ottawa, NG Canada, 1949

4 J. McNaughton; Glasgow CAG, 1961

5 A. Tooth; Bradford CAG, 1962

6 J. Epstein; A. Millwood; Bury CAG, 1973

7 (cast 1958) J. Epstein; London, NPG, 1958

8 V. Waddington, 1958; P. Coll.; Christie's 2.3.79 (117)

9 London, Roland, Browse & Delbanco, 1951; Queensland AG, 1954

10 Mr & Mrs L. Schachter (Edinburgh 1961)

11 A. Dickson-Wright; Sotheby's 19.7.68 (117)

12 C. J. Sawyer; NY, Metropolitan Museum, 1948

13 Sotheby's 12.11.58 (63)

14 Sotheby's 3.4.63 (91)

15 R. E. Smith; Sotheby's 15.4.64 (101)

16 NY, El Dieff; Austin, HRC, 1965

17 Toronto, Sotheby's 16.10.67 (83)

18 Mr & Mrs S. Kingsley; NY, SPB 16.4.69 (20), ill.; J. H. Schaffner; Cambridge, Mass., Fogg AG, 1972

19 Sotheby's 9.7.69 (60)

20 J. Epstein, 1950s; Dr I. Epstein; Dr M. Evans

21 P. Coll.; Christie's 3.11.67 (74)

22 J. M. Lawton; NY, SPB 15.10.69 (43A), ill.

23 NY, SPB 16.4.69

24 A. Tooth; H. Hartford; NY, SPB

255 (1)

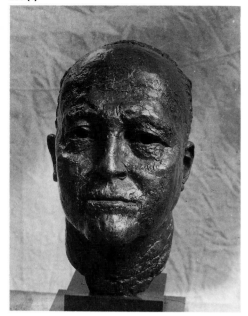

256 (1)

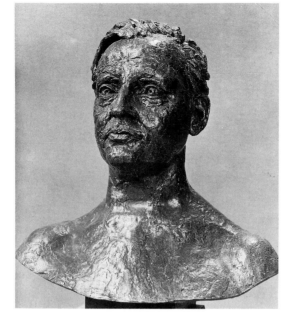

257

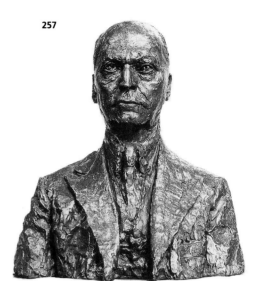

258 (1)

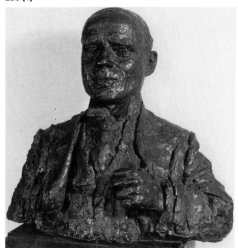

259 (plaster)

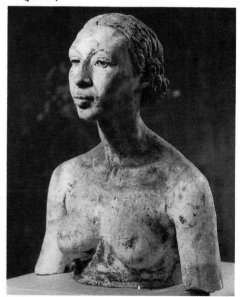

11.3.71 (21), ill.
25 NY, Christie's 21.10.80 (195)
Literature: Epstein 1940, pp. 99–101, ill.;
Epstein 1955, pp. 81–3, ill.; Buckle, pp.
210–11, pl. 323

254 Sir Alexander Walker
1934
bronze, H 36.0
Inscription: *Epstein*
Exhibition: Leicester Gal. 662, 1937, no. 2
Provenance: 1 John Walker & Sons
Literature: Buckle, p. 224, pl. 344
Commission. Head of family distillery
company.

255 Hugh Walpole
1934
bronze
Exhibitions: Leicester Gal. 600, 1934, no. 8;
Leicester Gal., Walpole Collection, 811,
1945, no. 141 (not for sale)
Plaster: University of Sussex, 1966
Provenance: 1 Sitter; Leicester Gal., 1945;
whereabouts unknown
Literature: Black, p. 240, no. 195 (dates
1933); Epstein 1940, p. 89; Buckle, p. 212,
pl. 326
Commission. Novelist, collector of Epstein's
work. His collection was dispersed after
exhibition at the Leicester Gal., 1945.

256 Third Portrait of Bernard
van Dieren (bust)
1934–5
bronze, H 46.5
Exhibition: Leicester Gal. 600, 1935, no. 9
(up to 6)
Plaster: destroyed 1982
Provenance: 1 Burnley, Towneley Hall
AG, pre-1939
Literature: Epstein 1940, p. 96; Black, p.

241, no. 207 (dates 1935); Buckle, p. 228, pl.
351 (dates 1936)
Completed shortly before the composer's
death.

257 William Henry Collins
1935
bronze, H 58.0
Provenance: 1 Middlesex Hospital, 1935
2 Lady Collins; London, Royal College of
Surgeons
Literature: Black, p. 241, no. 209; Buckle, p.
224, pl. 343
Commissioned by the Middlesex Hospital.
Chairman of Cerebos Salt and donor of X-
ray dept. to the hospital.

258 Sir Alec Martin
1935
bronze, H 55.9
Exhibition: Leicester Gal., Fame and
Promise, 604, 1935, no. 145
Provenance: 1 Sitter; Dublin, Sir Hugh
Lane Municipal Gal. of Modern Art, 1965
Literature: Black, p. 241, no. 208; Buckle,
p. 235
Chairman of Christie's.

259 Nianda (Neander)
1935
bronze, H 39.3?
Exhibition: Leicester Gal., Fame and
Promise, 604, 1935, no. 144 *Nianda*
Provenance: 1 J. R. McGregor; P. Coll.
2 S. Eckman; Sotheby's 10.11.67 (168)
VERSION WITH HEAD ONLY:
3 Sir E. Hayward; Hayward Bequest,
Carrick Hill
Literature: Black, p. 241, no. 210 (head);
Buckle, p. 204, pl. 317 (bust)
Model from Middle East, according to
Buckle.

260

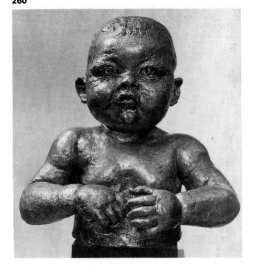

261 (4)

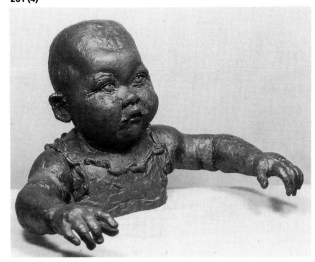

262 (plaster)

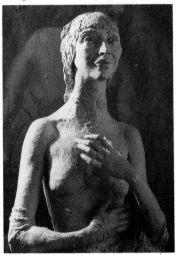

264

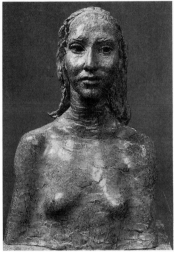

265 (2)

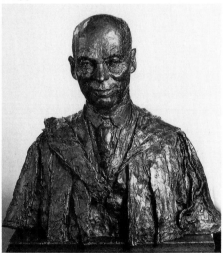

260 A Babe (Jackie)
1935
bronze
Exhibition: Leicester Gal. 704, 1939, no. 2
A Babe
Provenance: 1 whereabouts unknown
Not previously recorded, but identified from its evident kinship with the *First Portrait of Jackie* (no. 261) and from a photograph (Hulton M114418) of the Leicester Gal. exhibition.

261 First Portrait of Jackie (bust with arms)
1935
bronze, H 30.5
Exhibition: Leicester Gal. 704, 1939, no. 4
A Babe
Plaster: NY, Museum of the City, 1966
Provenance: 1 J. Epstein, 1950s; Dr I. Epstein; Dr M. Evans
2 Sotheby's 12.4.67 (151); London, Knoedler
3 R. E. Smith (1948)
4 Leicester Gal., 1970; NY, P. Coll.
Literature: Black, p. 241, no. 213; Buckle, p. 221, pl. 338

262 Fifth Portrait of Kathleen (half-length with hands)
1935

bronze, H 76.2
Exhibition: Leicester Gal. 662, 1937, no. 7 (last of 3)
Plaster: (H 79.0) Jerusalem, Israel Museum, 1966
Provenance: 1 Mrs E. Hulton; Leicester Gal.; Dr L. Ogilvie; Bristol MAG, 1975
2 NY, PB 26.10.60 (42), ill.
3 E. P. Schinman = cast 4?
4 NY, SPB 20.10.78 (38), ill.
Literature: Epstein 1940, ill.; Black, p. 241, no. 222 (dates 1936); Epstein 1955, p. 95, ill. (plaster); Buckle, p. 222, pls. 339–41; Schinman, p. 59, ill.

263 Deborah
1935
bronze
Provenance: no record
Literature: Black, p. 241, no. 212 (head) Buckle, p. 427
No description available.

264 Morna (Stewart)
1935
bronze, H 63.5
Inscription: *Epstein*
Exhibitions: Leicester Gal. 662, 1937, no. 4, ill.; Famous Gal. Ltd 1940, no. 3
Plaster: (H 64.0) Israel, Ein Harod, 1965
Provenance: 1 (signed) R. H. Spurr; I. & B.

Karp, 1947; Christie's 17.10.80 (61), ill.
2 (signed) J. Epstein; NY, P. Coll.; NY, PB 22.4.54 (35) ill.; A. Bianchi; NY, SPB 19.10.73 (123), ill.
3 Leicester Gal.; P. Coll., 1957
4 H. B. Dunn (Edinburgh 1961)
5 L. Goodman; NY, PB 26.4.61 (30), ill.; P. Coll.
6 J. D. Sutchell; NY, SPB 27.10.67 (5), ill.; P. Coll.
7 NY, SPB 18.12.81 (63), unsold
Literature: Black, p. 241, no. 220 (dates 1935); Buckle, p. 224, pl. 345 (dates 1936)
Commission. Author of play, *Traitor's Gate*.

265 Sir Frank Fletcher
1935
bronze, H 61.0
Inscription: *Epstein*
Exhibition: Leicester Gal. 662, 1937, no. 18
Provenance: 1 Sitter; whereabouts unknown
2 Godalming, Charterhouse
Literature: Black, p. 241, no. 216; Buckle, p. 230, pl. 353
Commissioned by Charterhouse in 1935. Fletcher was Headmaster of the school, 1911–35.

266 Mrs Adolph Oko
1935

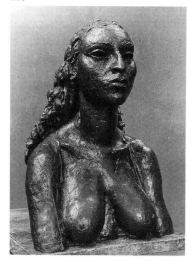

266 (1) 267 (2) 268

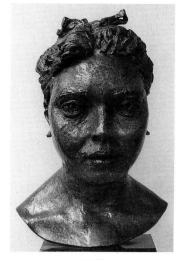

269 (4) 270 (plaster) 271 (1) 272 (1)

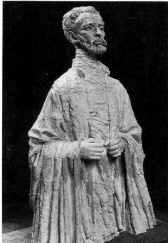

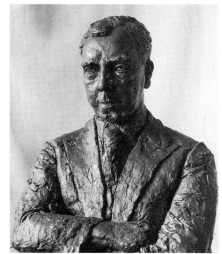

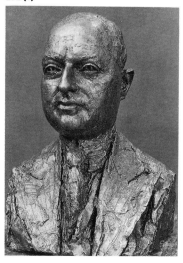

bronze
Provenance: 1 Sitter; whereabouts un-
known
Literature: Black, p. 241, no. 217; Buckle, p.
228, pl. 350
Commission.

267 Fifteenth Portrait of Peggy Jean
1935
bronze, H 55.6 (including base)
Exhibition: Leicester Gal. 662, 1937, no. 12
Provenance: 1 R. H. Spurr & Son; Oldham
AG, 1938
VERSION WITH HEAD ONLY, H 36.8:
2 Leicester Gal.; P. Coll.
Literature: Black, p. 241, no. 215 (*Eleventh
Portrait*); Buckle, p. 221, pl. 337
According to the archives of Oldham AG,
their cast was one of four. A photo of the
Leicester Gal. exhibition in the Hulton
Picture Library shows the version with head
only.

268 Shulamite Woman (Arab Girl)
1935
bronze, H 52.0
Exhibition: Leicester Gal. 662, 1937, no. 10
Arab Girl
Provenance: 1 J. Epstein; Honolulu Acad-
emy of Fine Arts, 1936, called *Shulamite
Woman*

2 J. Epstein; M. Oyved; London, Ben Uri
Gal.
VERSION WITH HEAD ONLY, H 38.0:
3 Sotheby's, 17.7.68 (107), ill., called *Arab
Girl*
Literature: S. Casson, *Sculpture of Today*,
1939, ill. p. 54 (bust); Black, p. 241, no. 211
(*Ethel Littman*, bust); Buckle, p. 427
Laib photographs indicate identical sculp-
ture under three titles.

269 Study for Emperor Haile Selassie
1936
bronze, H 35.0
Plasters: 1 (H 29.5) NY, Museum of the
City, 1971
2 (H 33.0) Israel, Ein Harod, 1965
Provenance: 1 Christie's 1.7.60 (129), ill.
2 T. S. Barlow; Sotheby's 17.7.61 (94)
3 NY, PB 21.3.62 (46), ill.
4 Lady Epstein; P. Coll.; Christie's
8.11.68 (151)
Literature: Buckle, p. 226, pl. 346

270 Emperor Haile Selassie
1936
bronze, H 121.8
Exhibitions: Tooth's 1936; Leicester Gal.
662, 1937, ex-cat.
Plaster: NY, MOMA, 1966
Provenance: 1 F. H. Lowe; Sotheby's

15.4.64 (100); P. Coll.; E. Littler, 1966;
Eisenberg-Robbins; Washington, MAA,
1973
2 E. P. Schinman; whereabouts unknown
Literature: Epstein 1940, pp. 101–2, ill.;
Black, p. 242, no. 225; Epstein 1955, pp.
83–4, ill.; Buckle, p. 226, pls. 347–8;
Schinman, p. 95, ill.
Commission.

271 J. B. Priestley
1936
bronze, H 76.2
Exhibition: Leicester Gal. 662, 1937, no. 16,
ill.
Provenance: 1 Sitter; NY, El Dieff; Austin,
HRC, 1965
Literature: Epstein 1940, p. 103; Black, no.
224, pl. 42; Buckle, p. 230, pl. 354
Commission. British writer. His wife was a
collector of Epstein's work.

272 Edward Goldstone
1937
bronze, H 47.0
Exhibition: Leicester Gal. 662, 1937, no. 22
Provenance: 1 Sotheby's 17.7.63 (9); J. A.
Gollin; NY, SPB 22.10.76 (339), ill.
Literature: Black, p. 241, no. 221 (dates
1936); Buckle, pp. 235, 427 (dates 1937)
Commission.

275

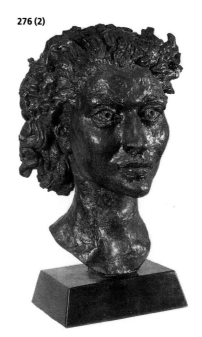

276 (2)

277

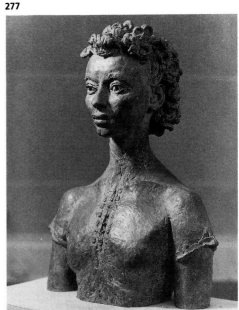

274

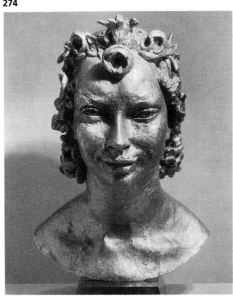

273 (1)

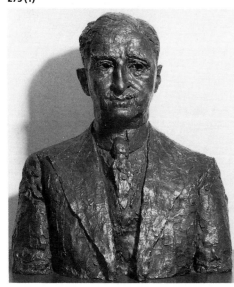

273 Robert Mayer
1936
bronze, H 57.0
Provenance: 1 Lady Mayer; Greater London Council (Royal Festival Hall), 1963
Literature: Black, p. 242, no. 223
Commission. Promoter of music education.

274 Tanya
1936
bronze, H 57.1 (plaster)
Exhibitions: Leicester Gal. 662, 1937, no. 8 *Tania*; Leicester Gal. 1968, head, H 38.1 (2 of 8)
Plaster: (H 57.1) Melbourne, NG Victoria, 1971
Provenance: 1 J. Scaramanga; P. Coll.
2 E. P. Schinman; whereabouts unknown
3 Rindler; NY, PB 16.5.62 (37), ill.; Arnet; NY, SPB 13.10.65 (48), ill.
4 NY, PB 11.12.63 (25), ill.
Literature: Black, p. 242, no. 229; Buckle, p. 237, pl. 360 (bust); Schinman, p. 61, ill. (head)

275 Consummatum Est
1936
alabaster, H 61.0, L 223.5, D 81.3
Exhibitions: Leicester Gal. 662, 1937, no. 11; Edinburgh 1961, no. 158
Provenance: W. Cartmell, c.1937; Earl of Harewood, 1961; E. P. Schinman; A. d'Offay; Edinburgh, SNGMA, 1981
Literature: Epstein 1940, pp. 176–87, Appendix, ill.; Black, pp. 24, 242, no. 231 (dates 1937); Epstein 1955, pp. 152–62; Buckle, pp. 232–3, pl. 355; Schinman, pp. 92–3, ill.

276 Elsa (Graves)
1936

bronze, H 36.0
Exhibition: Leicester Gal. 662, 1937, no. 23
Plaster: Buffalo, Albright-Knox AG, 1966
Provenance: 1 R. H. Spurr & Son, 1936; Stoke-on-Trent MAG, 1936
2 Leeds CAG, 1937
3 Lady Cochrane; Sotheby's 14.12.66 (7)
Literature: Epstein 1940, p. 378; Black, p. 241, no. 218 (dates 1935); Buckle, pp. 228–30, pl. 352 (dates 1936)
Epstein himself dated the work 1935.

277 Rosemary (Carver)
1936
bronze, H 60.0
Inscription: *Epstein*
Exhibitions: Leicester Gal. 662, 1937, no. 9, ill.; Famous Gal. 1940, no. 11 .
Provenance: 1 London, Tooth's, 1939; J. Archdale; P. Coll.
2 R. A. Peto; Christie's (Italian Art Rescue Fund) 14.7.67 (133); P. Coll.; Christie's 9.3.84 (105), ill.
Literature: Black, p. 242, no. 226 (*Rosemary Carver*); Buckle, p. 228, pl. 349
Commission. American actress.

278 Pola Givenchy (bust)
1937
bronze, H 54.5
Inscription: *Epstein*
Exhibition: Leicester Gal. 662, 1937, no. 20 *Pola*
Provenance: 1 Leicester Gal.; P. Coll.
2 Mrs O. Parker; Sotheby's 22.4.70 (326); B. Sandelson
3 Leicester Gal., 1930s; L. Fraser; Mrs C. Fraser
Literature: Epstein 1940, ill. opp. p. 316; Black, p. 242, no. 235; Buckle, p. 238, pl. 364

278

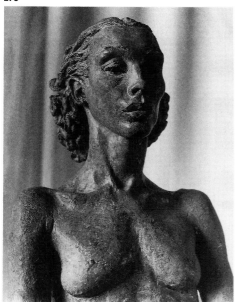

279

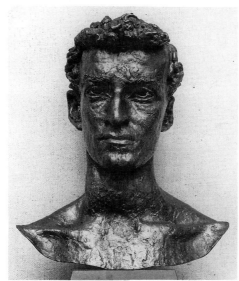

280

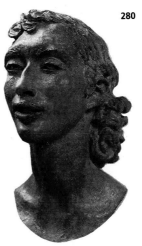

281

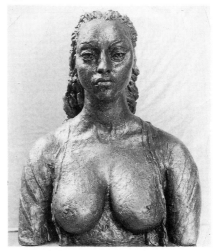

282 (plaster)

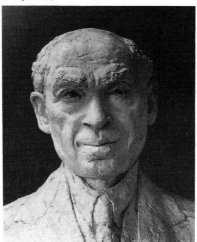

283

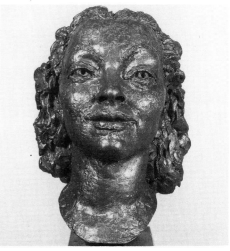

Polish model. See also *Study for Resurrection* (no. 317).

279 First Portrait of Norman Hornstein (The Young Communist)
1937
bronze, H 45.7
Inscription: *Epstein*
Exhibition: Leicester Gal. 662, 1937, no. 5
Provenance: 1 J. Epstein; J. Pilkington; P. Coll.; Bolton AG (loan)
2 Dame I. Cripps (1961)
3 NY, SPB 18.11.64 (41A)
4 P. Coll.; Christie's 18.7.69 (166); London, Agnew's
5 (gilt patina) Christie's 8.6.79 (194); FAS; Sydney, D. Jones Gal.; G. Broughan and J. Witschi
Literature: Black, p. 242, no. 237; Buckle, pp. 234–5, pls. 356–7
American of Russian-Jewish descent. In 1938 he married Peggy Jean, Epstein's eldest daughter.

280 Leona
1937
bronze, H 34.4
Exhibition: Leicester Gal. 662, 1937, no. 13
Provenance: 1 (green patina) Mrs R. Peto; Christie's 4.6.71 (103)
2 (gilt patina) Mrs R. Peto; Christie's 8.6.71 (79); Wolfson
3 (green patina) NY, Christie's, 8.11.79 (122)
Literature: Black, p. 242, no. 227 (dates 1936); Buckle, p. 237, pl. 359 (dates 1937)
Same model as *Nianda* (no. 259).

281 Second Portrait of Louise (Berenice)
1937

bronze, H 55.0
Exhibition: Leicester Gal. 662, 1937, no. 6 *Berenice* (up to 3)
Plaster: (H 58.0) Caracas, Museo de Bellas Artes, 1966
Provenance: 1 Sheffield CAG, 1942
2 E. P. Schinman; whereabouts unknown
Literature: Epstein 1940, ill.; Black, no. 236, pl. 43 (dates 1937); Buckle, p. 238, pl. 367 (dates 1938); Schinman, p. 60, ill.

282 David Morris
1937
bronze
Exhibition: Leicester Gal. 662, 1937, no. 21
Provenance: 1 Sitter, 1937; whereabouts unknown
Literature: Black, p. 242, no. 233; Buckle, p. 238, pl. 366
Commission. Jewish financier.

283 Pola Nerenska
1937
bronze, H 38.0
Exhibition: Leicester Gal. 662, 1937, no. 15 *Nerenska*, ill.
Plaster: (H 38.1) Melbourne, NG Victoria, 1971
Provenance: 1 S. Eckman; Sotheby's 11.10.67 (167)
2 (gold patina) Sotheby's 15.12.71 (69)
3 (green patina) Lady; Sotheby's 19.6.74 (115); Sotheby's 13.11.85 (309), ill.; P. Coll.
VERSION WITH HEAD ONLY, H 32.1:
4 I. L. Myers; Memphis, Brooks MA, 1961
5 J. Epstein; Mrs A. Wigglesworth; A. Oswald
Literature: Black, p. 242, no. 228 (dates 1936); Buckle, p. 238, pl. 365
Viennese dancer.

287

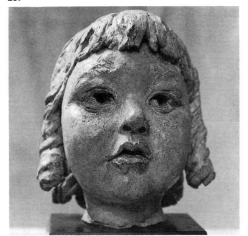

286 (plaster)

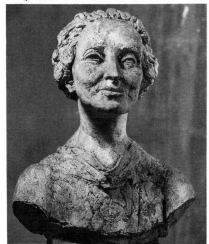

285

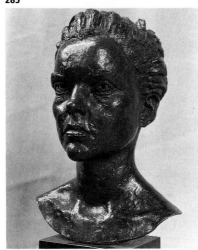

284

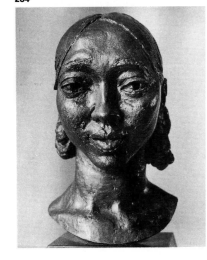

288

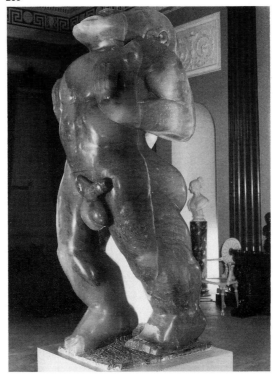

289

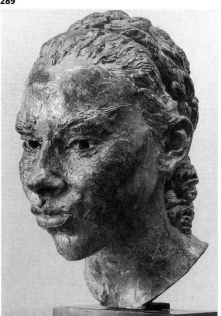

284 Rita Romilly
1937

bronze, H 33.0

Exhibitions: Leicester Gal. 662, 1937, no. 17; Leicester Gal. 1968, bust with hands (4 of 6)

Provenance: 1 (gold patina) NY, P. Coll.; NY, PB 11.2.53 (27), ill.

2 (brown-gold patina) NY, Christie's 4.11.82 (239), ill.

Literature: Black, p. 242, no. 232; Buckle, p. 237, pl. 361

Owner of night-club.

285 Sally Ryan
1937

bronze, H 39.0

Exhibition: Leicester Gal. 662, 1937, no. 1

Provenance: 1 Sitter; Walsall, Garman-Ryan Coll., 1973

2 London, Mayor Gal.; Hon. P. Samuel (1947)

Literature: Black, p. 242, no. 238; Buckle, pp. 235–6, pl. 358

American sculptor much influenced by Epstein. Also a collector of his work, notably *Madonna and Child* (no. 175). Co-donor of Walsall, Garman-Ryan Coll.

286 Countess Castle Stewart
1937

bronze

Plaster: Palm Beach AI

Provenance: 1 Sitter; whereabouts unknown

Literature: Buckle, p. 237, pl. 363

Commission. Daughter of S. R. Guggenheim.

287 Second Portrait of Jackie (with curls)
1937

bronze, H 24.9

Exhibitions: Leicester Gal. 704, 1939, no. 5 ill.; Leicester Gal. 1968 (2 of 6)

Provenance: 1 M. Orman; NY, SPB 22.10.76 (338), ill.; P. Coll.

Literature: Epstein 1940, ill. opp. p. 288; Buckle, p. 237, pl. 362

288 Adam (plate 27)
1938–9

alabaster, H 218.5, base 66.0 × 81.3

Exhibitions: Leicester Gal. 704, 1939, no. 1; Famous Gal. 1940, ill.

Provenance: J. Epstein; Stafford; W. Cartmell; Lord Harewood, 1961

Literature: Epstein 1940, pp. 195–201, Appendix, frontispiece ill.; Black, no. 244, pls. 44–6; Epstein 1955, pp. 170–5, 288–90; Buckle, pp. 244–7, pls. 376–7

Begun in 1938, interrupted, and then completed in a final two-month spurt early in 1939.

289 Ti-Yi
1938?

bronze, H 34.3

Exhibition: Leicester Gal. 704, 1939, no. 9

Provenance: 1 (signed) Leicester Gal.; NY, P. Coll.; NY, PB 11.2.53 (29); C. Gross

2 W. Randolph Hearst; LA, County MA, 1953; LA, SPB 9.11.77 (401)

3 E. P. Schinman; whereabouts unknown

Literature: Black, p. 241, no. 219 (dates 1935); Buckle, p. 242, pl. 372; Schinman, p. 104, ill.

Commission. Young opera singer.

290 Robert Flaherty
1938

bronze, H 31.7 (plaster)

Exhibitions: Leicester Gal. 704, 1939, no. 8;

290

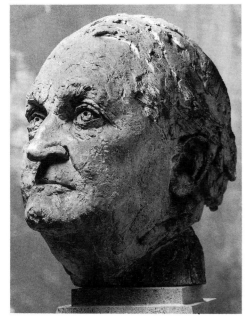

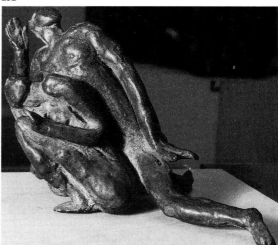

292

Leicester Gal. 1021, 1953, no. 2
Plaster: (H 31.7) NY, MOMA, 1966
Provenance: 1 Sitter; whereabouts unknown
Literature: Black, p. 243, no. 241 (dates 1938); Buckle, p. 200, pl. 307 (dates 1933)
Commissioned by sitter. Documentary film maker (see no. 236)

291 Burial of Abel
1938
bronze, green patina, H 23.3
Inscription: *Epstein* (on integral base)
Exhibition: Leicester Gal. 850, 1947, no. 9
Provenance: 1 J. Epstein; A. F. Thompson; Watford Museum, 1981
2 Birmingham auction, 1949; Dr T. J. Laszlo
3 NY, Christie's 17.2.82 (116), ill., wrongly called TUC maquette
Literature: Buckle, pp. 240–1, pl. 370

292 Adam and Eve
1938
bronze, H 11.5
Exhibition: Leicester Gal. 850, 1947, no. 11
Provenance: 1 J. Epstein; A. F. Thompson; Watford Museum, 1981
2 Sotheby's 12.7.61 (96) = cast 3?
3 Sotheby's 13.12.61 (163); S. Box; Sotheby's 1.11.67 (159)
4 Lady Cochrane; Sotheby's 14.12.66 (8); P. Coll.
Literature: Buckle, pp. 240–1, pl. 369
Related drawings, Birmingham MAG and A. Mathews.

293 Madame Ernest Ascher
1938
bronze

291 (1)

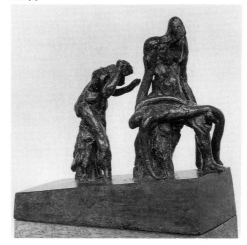

Provenance: 1 Sitter; whereabouts unknown
Literature: Black, p. 243, no. 240
Commission. No description available. Wife of Paris dealer specializing in tribal art.

294 Helen (or Ellen) Ballon
1938
bronze
Provenance: 1 Sitter; whereabouts unknown
Literature: Black, p. 243, no. 239; Buckle, p. 242, pl. 374
Commission. Friend of Sally Ryan (see no. 285).

295 Betty Cecil
1938
bronze, H 56.0
Exhibitions: Leicester Gal. 792, 1944, no. 21; Leicester Gal. 850, 1947, no. 3 *Betty*
Provenance: 1 Sir A. Maitland; Edinburgh, SNGMA, 1965
2 Mrs R. C. Weinberger; E. Littler; Eisenberg-Robbins; Washington, MAA, 1973
VERSION WITH HEAD ONLY, H 37.0:
2 Lady Epstein; London, Brook Street Gal.; Hammer Gal.; NY, SPB 15.2.68 (62), ill.
3 NY, W. Irving Gal.; Marlborough Gal.; NY, SPB 18.10.79 (61), ill.
Literature: Buckle, p. 242, pl. 371

296 Dave
1938
bronze
Provenance: 1 Sitter; whereabouts unknown
Literature: Buckle, p. 242, pl. 373
Black boxer.

294

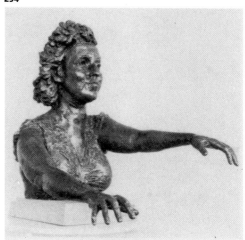

295 (1)

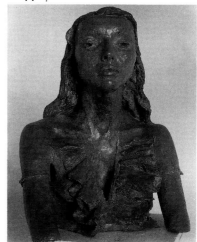

296

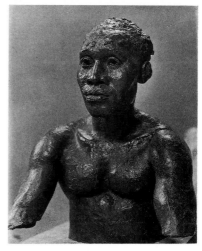

300 (plaster)

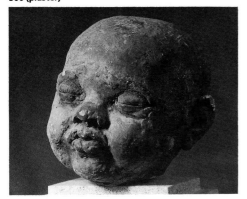

299

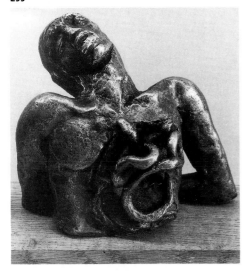

298

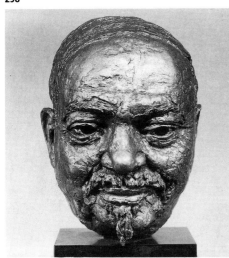

297 (plaster)

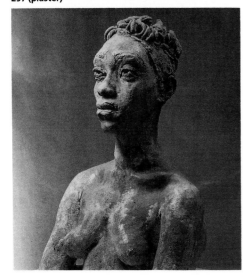

301

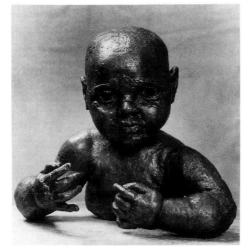

302

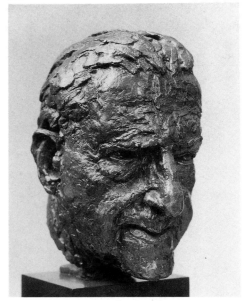

297 Marie Tracey

1938

bronze, H 54.6

Inscription: *Epstein*

Exhibition: Leicester Gal. 752, 1942, no. 6 *Marie*

Plaster: Plainfield, Vermont, Goddard College

Provenance: 1 Sir L. Bagrit; whereabouts unknown

2 R. Sainsbury; Sotheby's 14.12.60 (104); P. Coll.

3 D. Posnett; E. Littler, 1966; Eisenberg-Robbins; Washington, MAA, 1973

VERSION WITH HEAD AND SHOULDERS ONLY, H 41.6:

4 London, Zwemmer's, *c.*1946; Miss E. Watt

Literature: Buckle, p. 238, pl. 368

Model for wartime figure studies. Her daughter sat for *Piccaninny* (no. 310).

298 Ivan Maisky

1938

bronze, H 26.7

Exhibitions: Leicester Gal., Fame and Promise, 742, 1941, no. 141; Leicester Gal. 752, 1942, no. 3

Plaster: Jerusalem, Israel Museum, 1966

Provenance: 1 London, IWM, 1942

2 Greater London Council, County Hall

3 F. H. Lowe (pre-1948)

4 A. Wolmark (Ben Uri Gal. 1959)

5 Sotheby's 14.12.60 (103)

6 I. Fox; Christie's 10.3.61 (13)

Literature: Buckle, p. 243, pl. 375 (dates 1938)

Commissioned. Copyright remained with Epstein.

299 Le Serpent au Coeur (L'Homme aux Serpents)

1938–9

bronze, H 10.9

Exhibition: Weintraub Gal. 1960

Provenance: 1 J. Epstein; P. Coll.; Christie's 12.11.82 (55)

Related to Epstein's illustrations for Baudelaire's *Les Fleurs du mal*, commissioned by the Limited Editions Club of New York. Drawings exhibited December 1938 at A. Tooth & Sons, and October–November 1939 at Zwemmer's.

300 First Portrait of Leda (at 2 months)

1939

bronze

Provenance: no record

Literature: Buckle, p. 250, pl. 383

First daughter of Peggy Jean and Norman Hornstein.

301 Second Portrait of Leda (at 4 months)

1939

bronze

Exhibition: Leicester Gal. 730, 1940, no. 35

Provenance: 1 Mr & Mrs A. Abrahams; Sotheby's 27.6.79 (84), ill., called *Daphne*

Literature: Buckle, p. 250, pl. 387 (bust with truncated torso)

302 Rabbi Stephen Wise

1939

bronze, H 20.3

Exhibition: Leicester Gal. 704, 1939, no. 7

Provenance: 1 Sitter; NY, American Jewish Congress—stolen 24.12.79

2 Sotheby's, 12.11.75 (18)

Literature: Black, p. 243, no. 245; Buckle, p. 251, pl. 386

Commission. Rabbi of congregation in New York.

305

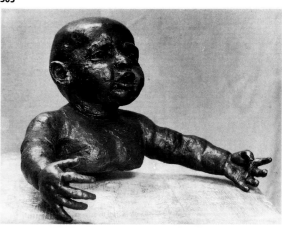

303 (1)

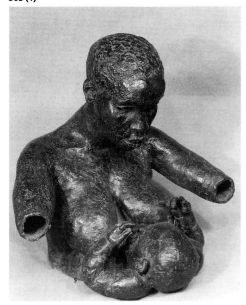

304 (plaster)

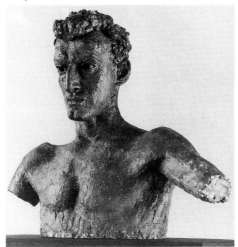

306 (plaster)

307 (2)

308 (1)

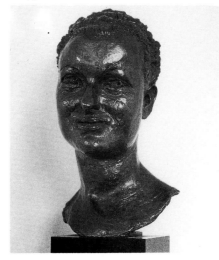

303 African Mother and Child
1939
bronze, H 52.3
Exhibitions: Leicester Gal. 931, 1950, no. 2;
Tate 1952, no. 45
Plaster: destroyed during sculptor's life-time
Provenance: 1 J. Sturgis Ingersoll; NY,
SPB 6.6.74 (43); Dr M. Evans
2 D. Ells (Ben Uri Gal. 1959)
Literature: Epstein 1955, ill. pp. 126–7
(dates 1940); Buckle, pp. 250–1, pl. 385
Mother was Namtanda Jaberwu who had
also posed pregnant for nude drawings.
Child was version of Leda at 4 months.
Intended as part of *Slave Hold* (no. 318).

304 Norman Hornstein the Second (Ishmael)
1939
bronze, H 45.5 (without arms)
Exhibitions: Leicester Gal. 752, 1942, no. 2
Ishmael; American-British Art Center
1942, no. 1 *Ishmael*
Plaster: (H 62.2) Toronto, NG Ontario, 1967
Provenance: 1 Sir Stafford Cripps
VERSION WITH NO ARMS:
2 Lady Epstein, 1960; Sitter
Literature: Buckle, p. 248, pl. 380 (bust)

305 Third Portrait of Leda (with outstretched arms)
1939
bronze, H 21.5
Exhibitions: Leicester Gal. 730, 1940, no. 34
(*at 7 months*); Leicester Gal. 752, 1942, no.
6 (*at 6 months*)
Plaster: (head only, H 13.0) Jerusalem, Israel
Museum, 1966
Provenance: 1 Glasgow, Connell's Gal.,
c.1941; P. Coll.; Glasgow MAG, 1978

2 J. Epstein; A. F. Thompson, 1947;
Nottingham Castle Museum
Literature: Black, p. 24, no. 24 (dates 1940);
Buckle, p. 237, pl. 388

306 Mrs Melinda Pearson
1939
bronze, H 41.0
Inscription: *Epstein*
Exhibitions: Leicester Gal. 752, 1942, no. 11;
Temple Newsam House 1942, no. 68
Plaster: destroyed 1982
Provenance: 1 J. Pilkington; Mrs B. Heys;
Sotheby's 16.3.77 (76)
Literature: Buckle, p. 251, pl. 384 (plaster)
Commission. Wife of Lionel Pearson,
architect and partner of Charles Holden (see
BMA Building, no. 9, and London
Underground Headquarters, no. 189).

307 Betty Peters
1939
bronze, H 68.5
Exhibition: Leicester Gal. 1191, 1960, no. 34
(3rd of 6)
Provenance: 1 Mrs H. Sonneborn, 1948
2 Leicester Gal., pre-1961; E. Littler;
Eisenberg-Robbins; Washington, MAA,
1973
3 Sotheby's 9.7.69 (104); London,
Agnew's
4 (light-green patina) NY, Christie's
17.2.82 (70), ill.
Literature: Buckle, p. 249, pl. 382

308 Lisa Sainsbury
1939
bronze, H 36.0
Provenance: 1 Sir Robert & Lady
Sainsbury

310

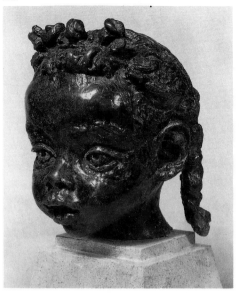

311

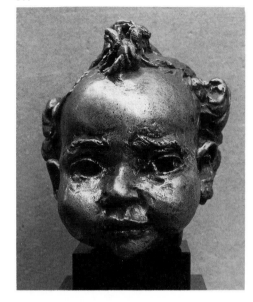

312 detail

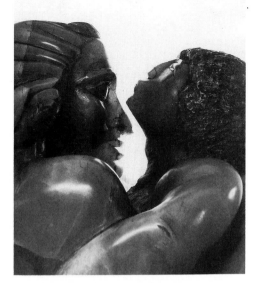

309

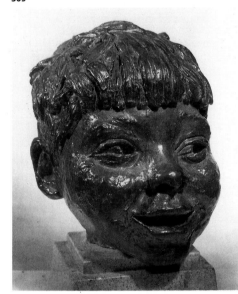

309 Third Portrait of Jackie (Ragamuffin)

1939

bronze, H 22.8

Exhibitions: Leicester Gal., Fame and Promise, 759, 1942, no. 144; Leicester Gal. 794, 1944, no. 17 *Ragamuffin*; Leicester Gal. 1968 (edition of 6 sold out)

Plaster: (H 23.0) Jerusalem, Israel Museum, 1966

Provenance: 1 R. H. Spurr & Son, 1947; I. & B. Karp; Christie's 17.10.80 (60)

2 Epstein Estate; Mrs P. J. Lewis, 1959

3 Sotheby's 1957; Leicester Gal.; P. Coll.

4 L. Goodman; NY, PB 25.1.61 (37)

5 Mrs S. Cohen; Sotheby's 17.3.65 (48); London, Piccadilly Gal.

6 Drs S. & B. Raxlen; NY, SPB 5.5.73 (78), ill.

7 Norfolk, Chrysler Museum, 1975

8 (signed) NY, Salander Gal.; NY, SPB 21.10.77 (337B), ill.; Dr M. Evans

9 Sotheby's 22.6.77 (72)

10 Sotheby's 16.11.77 (51)

11 NY, Christie's 13.4.83 (182), ill.

Literature: Black, no. 242 (*Fifth Portrait*, dates 1938); Buckle, p. 254, pl. 391 (dates 1940); Schinman, p. 107, ill.

Jackie was born in 1935. Black states the portrait was done when he was four.

310 Piccaninny

1940

bronze, H 22.3

Exhibitions: Leicester Gal. 730, 1940, no. 33? *African Girl*; Tate 1961, no. 52 (dated 1945)

Plaster: (H 27.0) Jerusalem, Israel Museum, 1966

Provenance: 1 J. Epstein, 1954/5; Dr M. Evans

2 Mrs R. H. Jackson (Bolton AG 1954)

3 London, Ionian Bank, 1964

4 Lady; Sotheby's 19.6.74 (116)

5 Drs S. & B. Raxten; NY, SPB 5.5.73 (77), ill., called *Head of a Girl*

6 Sotheby's 12.11.75 (15)

7 Christie's 17.11.78 (106); FAS; P. Coll.

8 NY, SPB 22.5.75 (578), ill.

Literature: Buckle, p. 254, pl. 390 (dates 1940)

Daughter of Marie Tracey (no. 297).

311 Fourth Portrait of Leda (with coxcomb)

1940

bronze, H 20.4

Inscription: *Epstein*

Exhibition: Leicester Gal. 752, 1942, no. 9 (*at 18 months*)

Plaster: (H 20.5) NY, MOMA, 1966

Provenance: 1 Leicester Gal., 1942; P. Coll.

2 (signed) J. Epstein, 1947; Dr M. Evans

3 Mrs P. J. Lewis, 1959

4 (signed) P. Coll.; Arundel, Armstrong-Davis Gal.; Portsmouth MAG, 1982

5 J. Pilkingon; Bolton AG, 1976

6 London, Obelisk Gal.; Mrs S. Wilding; P. Coll.; Sotheby's 7.6.78 (97); V. Arwas

7 Christie's 11.6.82 (91); J. Doubleday

8 P. Coll.; NY, PB 11.1.62 (76), ill.

9 Lady Cochrane; Sotheby's 14.12.66 (9)

10 Christie's 9.3.84 (104), ill.

Literature: Buckle, p. 252, pl. 389

312 Jacob and the Angel (plate 31)

1940–1

alabaster, H 213, base 109 × 117

Exhibition: Leicester Gal. 752, 1942, no. 1

Provenance: J. Epstein; W. Cartmell; S. Bernstein; Granada Ltd. (on loan to Liverpool University)

Literature: Black, p. 243, no. 247; Buckle, pp. 254–64, pls. 392–400

313 Burmese Girl

1941

bronze

314 (1)

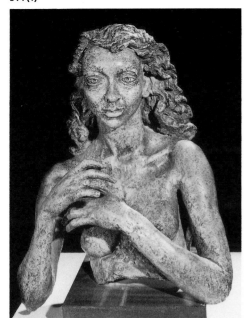

316

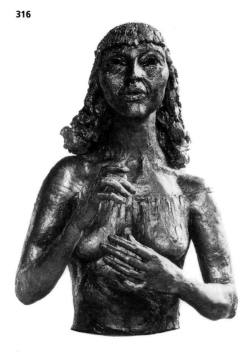

317

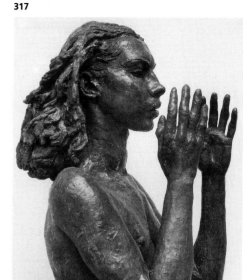

318 (1)

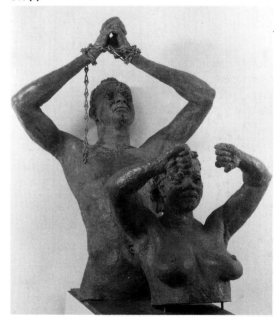

319

Exhibition: Leicester Gal. 752, 1942, no. 5
Provenance: no record
Possibly an alternative title for *Third Portrait of Sunita* (no. 166).

314 First Portrait of Deirdre (with arms)
1941
bronze, H 62.3
Plaster: (H 60.0) Jerusalem, Israel Museum, 1966
Provenance: 1 J. Epstein; Bolton AG, 1954
2 E. P. Schinman; whereabouts unknown
3 R. McGonigal; Sotheby's 22.7.64 (74); P. Coll.
4 International Business Machines; NY, PB 18.2.60 (118), ill.; P. Coll.
5 J. Epstein, 1959; Dr I. Epstein; Dr M. Evans
6 Sir E. Hayward; Hayward Bequest, Carrick Hill
Literature: Epstein 1955, ill. pp. 126–7; Buckle, p. 264, pls. 401–2; Schinman, p. 106, ill.

315 Grace
1941
bronze
Provenance: no record
Literature: Buckle, p. 428
No description available.

316 Sixth Portrait of Kathleen
1941
bronze, H 70.0
Plaster: NY, Jewish Museum, 1966
Provenance: 1 Mr & Mrs L. Factor; LA, County MA, 1964; LA, SPB, 9.11.77 (403)
2 E. P. Schinman; NY, SPB 19.5.78 (354), ill.;
3 E. Littler; Eisenberg-Robbins; Washington, MAA, 1973
4 L. Goodman; Sotheby's 22.7.64 (52)
5 W. G. Harris; F. Forsythe-Smythe; J. G.

Jacob; NY, SPB 12.12.68 (8), ill.
Literature: Buckle, p. 406, pl. 406; Schinman, p. 98, ill.
Half-length version of *Girl with Gardenias* (no. 336).

317 Study for Resurrection
1941
bronze, H 56.5
Exhibitions: Leicester Gal. 752, 1942, no. 12; Leicester Gal. 1191, 1960, no. 37
Plaster: (H 59.0) Israel, Ein Harod, 1965
Provenance: 1 Leicester Gal.; G. Black, 1942
2 M. H. Stonehill (Ben Uri Gal. 1959)
3 Dr Carew-Shaw (Edinburgh 1961)
4 E. P. Schinman; whereabouts unknown
Literature: Buckle, p. 272, pls. 410–11; Schinman, p. 99, ill.
Based on *Pola Givenchy* (no. 278).

318 Study for Slave Hold
1941
bronze, H 114.3
Exhibition: Leicester Gal. 752, 1942, no. 13
Provenance: 1 J. Epstein; Bolton AG, 1954
Literature: Buckle, p. 267, pls. 404–5
Related to *African Mother and Child* (no. 303).

319 Chia Pi
1941
bronze, H 61.0
Inscription: *Epstein*
Exhibitions: Leicester Gal. 764, 1942, no. 31 (up to 3); Leicester Gal., New Year, 1004, 1953, no. 154
Provenance: 1 J. Pilkington
2 Miss M. S. Davies; Cardiff, NMW, 1963
3 R. E. Smith, pre-1948; Sotheby's 14.7.71 (122)
4 Sotheby's 16.11.77 (53)
5 LA, Dalzell Hatfield Gal.; V. Steele Scott; SF, Butterfield's 3.5.81 (215), ill.
Literature: Buckle, p. 274, pl. 421 (dates 1942)

323 (1)

322 (1)

321

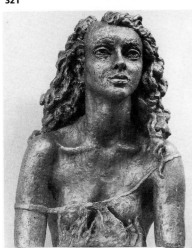

320 (1)

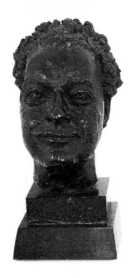

324 (1)

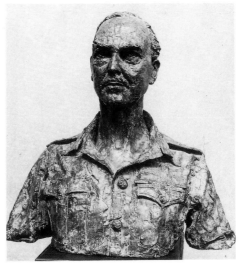

325

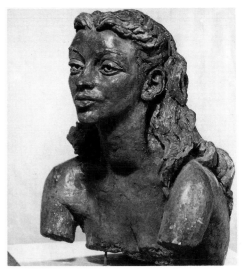

320 Robert Sainsbury
1942
bronze, H 30.5
Exhibitions: London Group, 1942; Leicester Gal. 794, 1944, no. 18
Provenance: 1 Sitter
Literature: Buckle, p. 272, pl. 414 (dates 1942)
Commission. Donor of Sainsbury Centre, University of East Anglia. Like Epstein, a collector of tribal art.

321 Second Portrait of Deirdre (in a slip)
1941–2
bronze, H 54.0
Inscription: *Epstein*
Exhibition: Leicester Gal. 794, 1944, no. 5
Plaster: (H 55.9) Melbourne, NG Victoria, 1971
Provenance: 1 Leicester Gal., 1946; Sir John & Lady Heathcote-Amory; National Trust (Knightshayes)
2 Lady Epstein; Plymouth CAG, 1960
3 Leicester Gal.; Beaverbrook AG, 1959
4 Ontario, Hamilton AG
5 L. Goodman; Christie's 22.6.62 (92)
6 Lady Cochrane; Sotheby's 14.12.66 (10)
7 LA, Dalzell Hatfield Gal.; V. Steele Scott; SF, Butterfield's 3.5.81 (79), ill.
Literature: Buckle, p. 267, pl. 403

322 The Countess of Berkeley
1942
bronze
Exhibition: Leicester Gal. 794, 1944, no. 14
Provenance: 1 Sitter
Literature: Buckle, p. 272, pl. 416
Commission. The sitter suggested the

subject of St. Francis for her villa overlooking Assisi (see no. 334).

323 George Black
1942
bronze, H 62.0
Inscription: *Epstein*
Exhibition: Leicester Gal. 794, 1944, no. 15
Plaster: destroyed 1982
Provenance: 1 Sitter
Literature: Buckle, p. 275, pls. 417–19
Commission. Opthalmologist.

324 Major-General Alan Cunningham
1942
bronze (cast by Gaskin), H 59.0
Provenance: 1 London, IWM
2 Sitter; family descent
Literature: Buckle, p. 276, pl. 424
Commissioned by War Artists' Advisory Committee. Existence of third cast suspected, but whereabouts unknown.

325 Third Portrait of Deirdre (leaning forward)
1942
bronze, H 41.0
Inscription: *Epstein*
Exhibition: Leicester Gal. 794, 1944, no. 19
Provenance: 1 C. A. Jackson; Liverpool, Lady Lever AG, 1948
2 (unsigned) Leicester Gal.; P. Coll., 1947
3 Mr & Mrs S. A. Searle; Winnipeg AG, 1960
4 E. P. Schinman; whereabouts unknown
5 Locke & England; Christie's 12.7.73 (137); Taubman; Christie's, 11.6.76 (147)
6 Lady Beddington-Behrens; Sotheby's

326

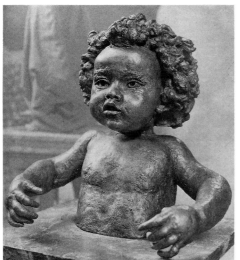

327 (1)

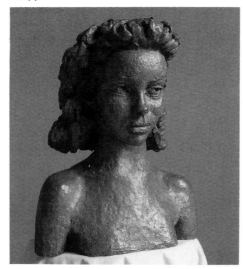

328 (plaster)

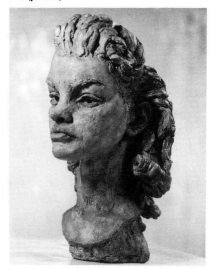

329 (plaster)

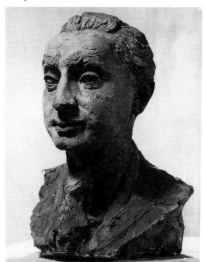

331 (1)

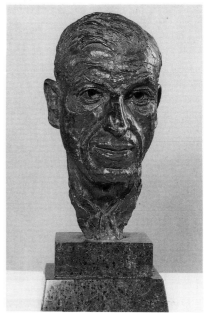

21.11.62 (176); London, Shrubsole
7 Sotheby's 27.6.79 (83)
8 Cork AG
Literature: Buckle, p. 275, pl. 423; Schinman, p. 96, ill.

326 Ian (Ossian)
1942
bronze, H 40.6
Exhibition: Leicester Gal. 794, 1944, no. 9
Ossian
Plaster: (H 23.6) Caracas, Museo de Bellas
Artes, 1966
Provenance: 1 Auckland CAG
VERSION WITH HEAD ONLY, H 23.7:
2 Mrs P. J. Lewis, 1959
3 L. Goodman; Sotheby's 22.7.64 (53); P.
Coll.; Christie's (Save the Children Fund)
3.6.69
4 E. P. Schinman; whereabouts unknown
5 Lady Epstein, c.1961; Dr. I. Epstein; J.
B. Lurie; NY, Jewish Museum, 1981
Literature: Epstein 1955, ill. p. 166; Buckle,
p. 275, pls. 422, 597 (bust with arms);
Schinman, p. 100, ill.
Ian Hornstein. See also no. 454.

327 Juanita Forbes
1942
bronze (cast by Gaskin), H 43.0
Inscription: *Epstein*
Exhibition: Leicester Gal. 794, 1944, no. 12
Provenance: 1 F. & H. Forbes; Sitter, 1975
2 R. E. Smith (Laing AG 1948)
3 Dr M. Solomons
4 Lady Cochrane; Sotheby's 14.12.66 (11)
5 Mrs C. Young; Sotheby's 12.4.67 (82)
Literature: Buckle, p. 272, pl. 413
Commissioned by F. Forbes.

328 Lalage Lewis
1942
bronze
Exhibition: Leicester Gal. 794, 1944, no. 4
Lalage
Provenance: 1 Sitter; whereabouts unknown
Literature: Buckle, p. 272, pl. 412
Commission. Actress.

329 Alexander Margulies
1942
bronze, H 41.9
Provenance: 1 Sitter
Literature: Buckle, p. 275, pl. 420
Commission.

330 Helen Patton
1942
bronze
Exhibition: Leicester Gal. 794, 1944, no. 6
Provenance: 1 Sitter; whereabouts unknown
Literature: Buckle, p. 428
Commission. No description available.
Daughter of General Patton.

331 Charles Portal, Viscount Hungerford
1942
bronze (cast by Anodic Foundry), H 45.1
Exhibition: Leicester Gal., Fame and
Promise, 816, 1945, no. 161
Plaster: destroyed 1982
Provenance: 1 London, IWM
Literature: Buckle, p. 278, pl. 427
Commissioned by the War Artists'
Advisory Committee. Chief of Air Staff,
1940–5.

335 (2)

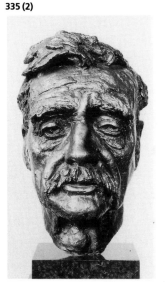

336 (1)

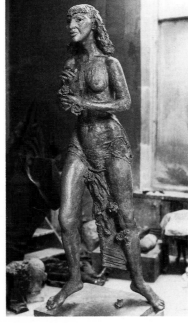

337

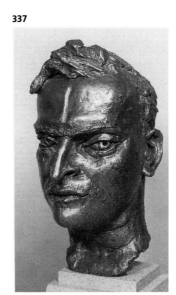

338 (1)

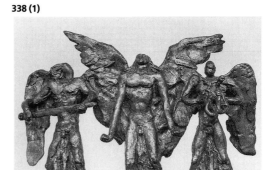

334 (1)

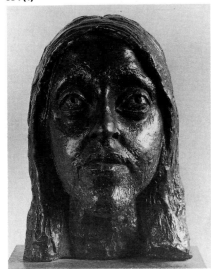

332 (1)

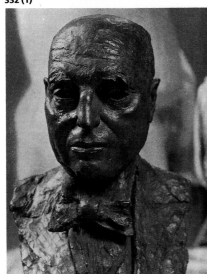

332 Denis Nowell Pritt

1942

bronze

Exhibition: Leicester Gal. 794, 1944, no. 20

Provenance: 1 Sitter; whereabouts unknown

Literature: Buckle, p. 428

Commission. Lawyer and MP for Hammersmith, 1935–50.

333 Mrs D. N. Pritt

1942

bronze

Provenance: 1 Sitter; whereabouts unknown

Literature: Buckle, p. 428

Commission. No description available.

334 St. Francis

1942

bronze, H 31.0

Provenance: 1 Walsall, Garman-Ryan Coll., 1972

2 Epstein Estate

Literature: Buckle, p. 272, pl. 415

The Countess of Berkeley (see no. 322) suggested a life-size figure of St. Francis for her villa overlooking Assisi, but only a study for the head was made.

335 Dr W. G. Whittaker

1942?

bronze, H 31.1

Provenance: 1 Family descent

2 Newcastle, King's College, Dept. of Music

Literature: Buckle, pp. 308–9, pl. 473 (dates 1946)

Commission. Composer and musicologist. Sittings took place at the Onslow Court Hotel in about 1942, though casting was delayed. (I am indebted to Dr Chalmers Burns for this information.)

336 Girl with Gardenias (Kathleen)

1943

bronze, H 190

Exhibitions: Leicester Gal. 794, 1944, no. 1; London, Battersea Park, Sculpture in the Open Air, 1948, no. 9

Provenance: 1 J. Epstein; Aberdeen CAG, 1948

Literature: Epstein 1955, ill.; Buckle, pp. 268–71, pls. 407–9 (dates 1941)

337 Yehudi Menuhin

1943

bronze, H 35.6

Inscription: *Epstein*

Exhibition: Leicester Gal. 823, 1945, no. 2

Plaster: NY, Jewish Museum, 1966

Provenance: 1 V. Waddington; S. Philipson, 1946

2 F. H. Lowe (Laing AG 1948)

3 Wellington, NAG

4 M. Gallati, pre-1961; Christie's 18.7.69 (167); Christie's 12.6.70 (199)

5 E. P. Schinman; whereabouts unknown

6 L. Goodman; Sotheby's 22.6.64 (56)

7 Sotheby's 14.7.65 (83); P. Coll.

8 A. Mather; Christie's 12.11.65 (199); P. Coll.

9 Sotheby's 23.4.69 (143); C. J. Sawyer; N. J. Ebsworth

10 Lady; Sotheby's 15.12.71 (62)

11 K. Valentin; NY, Christie's 8.11.79 (65)

12 P. Coll.; Phillips', 6.83

Literature: Buckle, p. 285, pl. 438; Schinman, p. 96, ill.

Violinist. Sotheby's sale catalogue of 22.6.64 states that there was an edition of eight casts.

340

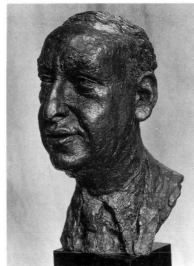

341 (2)

342 (2)

339 (2)

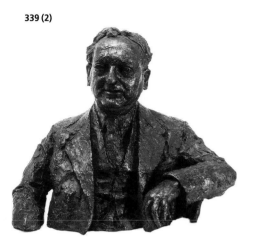

343

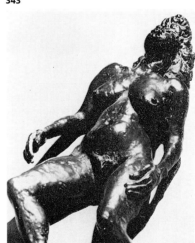

344

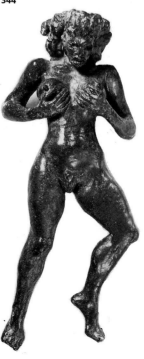

338 Lucifer, Belial and Beelzebub
1943
bronze, H 33.0
Inscription: *Epstein*
Exhibition: Leicester Gal. 850, 1947, no. 24
Provenance: 1 Birmingham auction, 1949;
P. Coll.
2 Lady Cochrane; Sotheby's 14.12.66 (13)
3 (signed) Sotheby's 16.6.76 (90); J.
Constable
Literature: Buckle and Lady Epstein, pl. 63
(related drawing, P. Coll.); Buckle, p. 287,
pl. 444
Maquette related to the Lucifer relief and
monumental Lucifer (see nos. 362, 363).

339 Philip Sayers
1943
bronze, H 60.0
Inscription: *Epstein 1943*
Provenance: 1 Sitter; family descent; NY,
W. Irving Gal.
2 Sotheby's 22.6.77 (74)
Commission. Irish JP.

340 Unknown Man
1943
bronze
Provenance: no record
Laib negative dated 1943.

341 Nude Study A (Betty Peters)
1943–5
bronze, L 72.4
Exhibition: Leicester Gal. 850, 1947, no. 12
Plaster: (H 10.0, L 73.0) Israel, Ein Harod,
1965
Provenance: 1 J. Epstein, 1950; Dr M.
Evans
2 J. Epstein, 1957–8; L. Chalette; Dr &
Mrs A. Lejwa; NY, MOMA, 1959
3 L. Goodman; NY, PB 6.5.59 (40), ill.

4 E. P. Schinman; whereabouts unknown
5 Sotheby's 1.5.68 (63); P. Coll.
6 M. Reach; Sotheby's 17.7.68 (121); S.
Alpen
Literature: Buckle, p. 281, pl. 428; Schin-
man, p. 105, ill.

342 Nude Study B (Betty Peters)
1943–5
bronze, L 58.4
Exhibition: Leicester Gal. 850, 1947, no. 13
Provenance: 1 J. Epstein, 1950s; Dr M.
Evans
2 J. Epstein, 1957–8; L. Chalette; Mr &
Mrs A. Lejwa; NY, MOMA, 1958
3 Leicester Gal.; G. Halsband; NY, SPB
18.5.72 (28), ill.
4 E. P. Schinman; whereabouts unknown
Literature: Buckle, p. 281, pls. 429–30;
Schinman, p. 105, ill.

343 Nude Study C (Betty Peters)
1943–5
bronze
Exhibition: Leicester Gal. 850, 1947, no. 14
Provenance: 1 P. Coll., early 1960s
Literature: Buckle, p. 281, pls. 431–2

344 Nude Study D (Betty Peters)
1943–5
bronze, L 34.0
Exhibition: Leicester Gal. 850, 1947, no. 15
Provenance: 1 L. Goodman; Sotheby's
22.7.64 (55)
2 NY, SPB 19.5.65 (147); S. Ryan
3 H. Rose; Sotheby's 15.12.65 (126); P.
Coll.
4 Sotheby's 17.7.68 (104)
5 Sotheby's 22.4.70 (330); L. F. Dye
6 Lady Epstein; V. Smith; V. Arwas
Literature: Buckle, p. 281, pl. 433

345

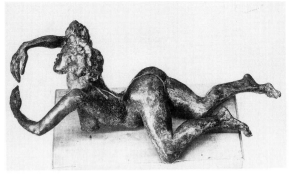

347

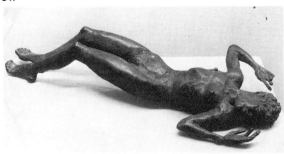

349

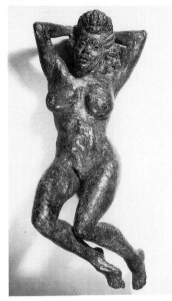

346

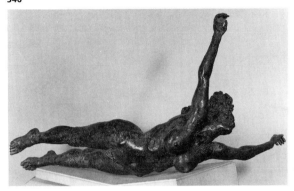

348

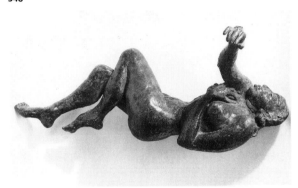

345 Nude Study G (The Swimmer)
1943–5
bronze, L 63.5
Exhibition: Leicester Gal. 850, 1947, no. 18
Provenance: 1 Rindler; NY, PB 21.3.62 (39); P. Coll.
2 E. P. Schinman; whereabouts unknown
Literature: Buckle, p. 281, pl. 434; Schinman, p. 105, ill.

346 Nude Study H
1943–5
bronze
Exhibition: Leicester Gal. 850, 1947, no. 19
Literature: Buckle, p. 281, pl. 435

347 Nude Study I (Marie Tracey)
1943–5
bronze, L 55.9
Exhibition: Leicester Gal. 850, 1947, no. 20
Provenance: 1 Sotheby's 28.3.62 (153), called *Reclining Negress*?
2 S. Box; Sotheby's 1.11.67 (161); P. Coll.
3 Sotheby's 17.7.68 (105)
Literature: Buckle, pp. 281–3, pl. 436

348 Nude Study J
1943–5
bronze, L 58.5
Exhibition: Leicester Gal. 850, 1947, no. 21
Provenance: 1 S. Box; Sotheby's 1.11.67 (162), ill.
2 K. Kendrick; Christie's 1.3.68 (56)
Literature: Buckle, p. 283, pl. 437.
Not Marie Tracey but probably the same model as *Mexican Girl* (no. 369).

Further Nude Studies E, F, K, L, M, N, O, P, Q and R were exhibited at the Leicester Galleries in 1947, but since they were neither reproduced nor described they cannot be identified. The following Nude Studies, all attributable to this period, are previously unpublished.

349 Nude Study (Betty Peters)
bronze
Provenance: whereabouts unknown
Bronze photographed by H. Wild.

350 Nude Study (Betty Peters)
bronze
Provenance: 1 Leicester Gal., 1947; H. Rubinstein; Dublin, Waddington's, *c*.1954; S. Brody
Nude reclining on back, left leg straight, right leg flexed outwards, both arms bent so that forearms and hands point upwards.

351 Nude Study (Betty Peters)
bronze, L 50.0
Provenance: 1 A. Ackworth; Christie's 12.3.82 (137), ill.

352 Nude Study
bronze, L 63.0
Provenance: 1 L. Goodman; Sotheby's 22.7.64 (54); P. Coll.
2 Christie's 7.3.86 (285); Y. Solomon

353 Nude Study (Mexican Girl)
bronze, L 51.0
Provenance: 1 Sotheby's 16.11.77 (56)

354 Girl from Baku
1944
bronze, H 56.5
Inscription: *Epstein*
Exhibition: Leicester Gal. 802, 1944, no. 16
Plaster: destroyed 1982

351 (1)

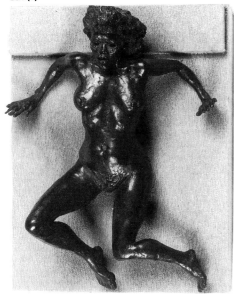

352 (2)

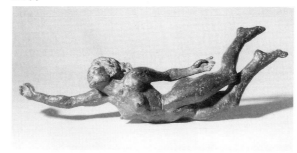

353 (1)

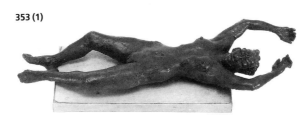

354

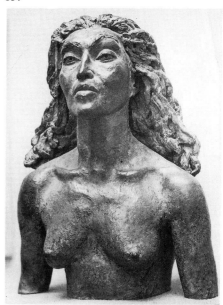

Provenance: 1 M. Oyved; A. F. Thompson; Nottingham Castle Museum, 1956
2 (signed) Mr & Mrs D. S. Gilmore; Detroit IFA, 1961
3 (signed) S. Samuels; Sotheby's 16.3.77 (72)
4 J. E. Posnansky (Ben Uri Gal. 1959)
5 London, Tooth's; P. Coll., 1960
6 L. Goodman; Sotheby's 22.7.64 (57); Leicester Gal.
7 H. Kaye; NY, SPB 8.4.64 (52), ill.
8 E. P. Schinman; whereabouts unknown
9 P. Coll.; Sotheby's 15.5.85 (157), ill.; P. Coll.
10 LA, Dalzell Hatfield Gal.; V. Steele Scott; SF, Butterfield's 3.5.81 (198), ill.
Literature: Buckle, p. 285, pl. 439; Schinman, p. 101, ill.

355 First Portrait of Esther (with long hair) (plate 29)
1944
bronze, dark-green patina, H 47.0
Inscription: *Epstein*
Exhibition: Leicester Gal. 792, 1944, no. 10 *Esther Amaryllis*
Plaster: (H 48.0) Israel, Ein Harod, 1965
Provenance: 1 Epstein Estate; Walsall, Garman-Ryan Coll, 1981
2 J. Epstein; P. Coll.
3 Lady Cochrane; Sotheby's 19.7.69 (59); P. Coll.
Literature: Buckle, p. 293, pls. 449–55
Esther, the daughter of Epstein and Kathleen Garman, died in 1954.

356 First Portrait of Kitty (with curls)
1944
bronze, H 38.0
Inscription: *Epstein*
Exhibition: Leicester Gal. 794, 1944, no. 3

Plaster: Jerusalem, Israel Museum, 1966
Provenance: 1 A. Haskell; FAS; Sydney, Artarmon Gal.; P. Coll.
2 W. P. Hodgson; Jackson; Huddersfield AG, 1951
3 London, Tooth's, 1959/60; Sir J. Lyons
4 L. Goodman; NY, PB 25.1.61 (41), ill.; E. J. Arnold
5 Sotheby's 13.12.61 (166)
6 Lady Cochrane; Sotheby's 14.12.66 (12)
7 Walsall, Garman-Ryan Coll., 1973
8 Sotheby's 7.6.78 (98)
9 Mrs M. Sagall; Sotheby's 19.11.80 (361)
10 LA, Dalzell Hatfield Gal.; V. Steele Scott; SF, Butterfield's 3.5.81 (196), ill.
11 NY, Forum Gal.
Literature: Epstein 1955, ill.; Buckle, pp. 297–9, pls. 456–8, 637

357 Fifth Portrait of Leda (pouting)
1944
bronze, H 26.6
Exhibition: Leicester Gal. 794, 1944, no. 13?
Plaster: (H 23.0) Israel, Ein Harod, 1965
Provenance: 1 Sitter
2 Epstein Estate; Mrs P. J. Lewis, 1959
3 Auckland CAG
4 Christie's 14.12.60 (105)
5 L. Goodman; Christie's 23.3.62 (111), ill. = cast 9?
6 E. C. Meadows; Christie's 24.4.64 (200); P. Coll.
7 W. M. Bolton; Sotheby's 22.7.64 (87)
8 Lady Cholmondley; Sotheby's 16.12.64 (49); E. Littler; Eisenberg-Robbins; Washington, MAA, 1973
9 E. P. Schinman: whereabouts unknown
Literature: Buckle, p. 285, pl. 440; Schinman, p. 102, ill.
Six casts were made in 1944.

356 (plaster)

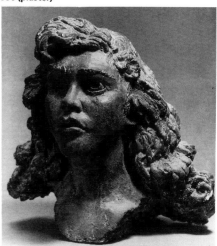

357 (plaster)

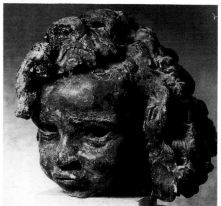

362 back view, detail

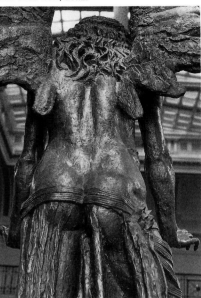

360

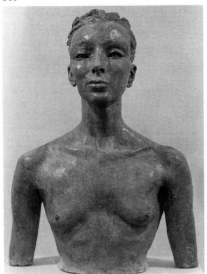

361 (1)

359 (3)

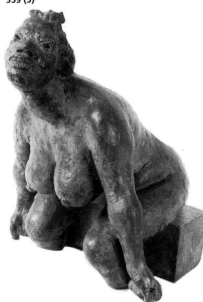

358 (1)

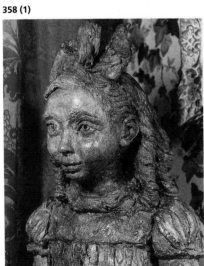

358 Girl with a Bow
1944
plaster
Provenance: Sir L. Bagrit (during sculptor's lifetime)
Literature: Buckle, p. 299, pl. 459
Identity of sitter unknown.

359 Malvinia
1944
bronze, H 40.0
Exhibition: Leicester Gal. 794, 1944, no. 2
Provenance: 1 (signed) NY, PB 21.3.62 (42), ill.
2 (unsigned) Gentleman; Sotheby's 15.12.65 (121)
3 (signed *Epstein*) Sotheby's 12.4.67 (84a)

360 Princesse Nadejda de Braganza
1944
bronze, green patina, H 61.0
Inscription: *Epstein*
Exhibition: Leicester Gal. 850, 1947, no. 36
Plaster: (H 63.2) Melbourne, NG Victoria, 1971
Provenance: 1 Gen. d'Aftier de la Vignerie; Paris, Centre Georges Pompidou, 1950
2 E. P. Schinman; NY, Christie's 13.4.83 (180), ill.
Literature: Buckle, p. 287, pl. 441; Schinman, p. 103, ill.
Commission.

361 Fall of Lucifer
1944
bronze, H 62.2, L 89.5
Exhibition: Leicester Gal. 794, 1944, no. 11
Provenance: 1 J. Doughty, 1944; J. Epstein; E. P. Schinman; Dr M. Evans
Literature: Buckle, p. 288, pls. 442 (related drawing), 445; Schinman, p. 97, ill.

362 Lucifer (plate 32)
1944–5
bronze, H 315, wingspan 193
Exhibition: Leicester Gal. 823, 1945, no. 1
Provenance: 1 The Seven Pillars of Wisdom Trust; Birmingham MAG, 1947
Literature: Epstein 1955, p. 231; Buckle, pp. 288–93, pls 446–8; Silber, pp. 28–32, no. 45
The head is based on *Israfel* (no. 199). Related drawings, Birmingham MAG and A. Mathews. 'I worked on it with great concentration for the greater part of a year' (Epstein).

Closely related to nos. 338 and 361, both of which are also based on Book 1 of Milton's *Paradise Lost*. Lucifer seems to be depicted at the moment of his arrival in Hell:

He above the rest
In shape and gesture proudly eminent
Stood like a tower; his form had not yet lost
All her original brightness, nor appeared
Less than archangel ruined, and the excess
Of glory obscured: as when the sun new risen
Looks through the horizontal misty air
Shorn of his horns, or from behind the moon
In dim eclipse disastrous twilight sheds
On half the nations, and with fear of change
Perplexes monarchs. Darkened so, yet
 shone
Above them all the arch angel: but his face
Deep scars of thunder had entrenched, and
 care
Sat on his faded cheek, but under brows
Of dauntless courage, and considerate
 pride
Waiting revenge

The half-draped 'skirt', taken over from the maquette, is now embellished with the grooved and broken girdle (modelled by using children's plasticine straight from the packet); this feature, vaguely suggestive of the ruin of Lucifer's angelic vestments, is

364

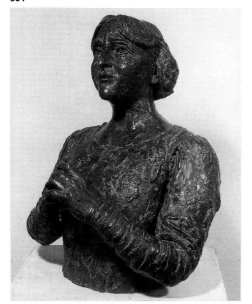

366 (1)

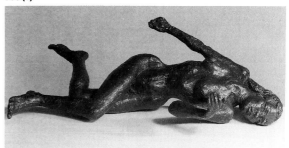

365 (1)

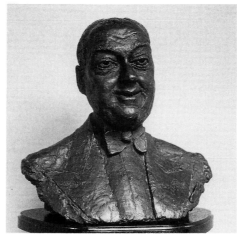

367

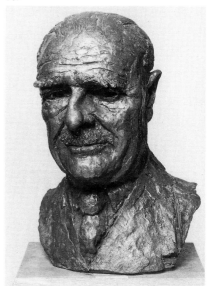

368

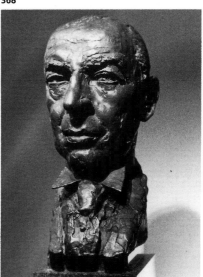

also the distant descendant of the Indian-style harness Epstein had used in his early *Maternity* (no. 23).

363 The Rt. Hon. Ernest Bevin (plate 30)
1945
bronze, H 26.0
Plaster: (H 26.0) Jerusalem, Israel Museum, 1966
Provenance: 1 War Artists' Advisory Committee; Tate, 1946
2 Transport and General Workers' Union
Literature: Epstein 1955, p. 230, ill.; Buckle, pp. 276–8, pl. 425; Chamot *et al.* 1964, I, p. 169
Commissioned, April 1945, by War Artists' Advisory Committee. Trade Union leader, MP, Minister of Labour 1940–5.

364 Dame Myra Hess
1945
bronze, H 61.0
Inscription: *Epstein*
Provenance: 1 London, Royal Academy of Music, 1946
2 (sand cast) Leicester Gal.; C. Gross
3 Sotheby's 26.4.61 (26)
4 Sotheby's 22.7.64 (70)
Literature: *Royal Academy of Music News*, 1945; Buckle, p. 306, pl. 467 (dates 1946)
Commissioned at the suggestion of the Griller Quartet and paid for by public subscription. Commemorating her war-time piano recitals at the National Gallery.

365 Vecchi
1945
bronze, H 44.0
Inscription: *Epstein 1945*
Provenance: 1 Sitter; P. Coll.
Commissioned by group of patrons. Owner

of Hungaria Restaurant, Lower Regent Street, where Epstein often ate.

366 Juanita Forbes (nude study)
1945
bronze, L 50.8
Provenance: 1 Sitter; V. Waddington, *c.*1950; F. Forbes; Mrs K. Stickney
2 A. Haskell; FAS, 1977; LA, Feingarten Gal.
3 Sotheby's 14.7.65 (85)
4 Lady Cochrane; Sotheby's 14.12.66 (14)
5 M. Gallati; Christie's 18.7.69 (169); L. F. Dye
6 Mr & Mrs P. Joseph; NY, SPB 5.4.67 (63), ill.
Literature: Buckle, p. 300, pls. 461–2

367 Sir Archibald Wavell
1945
bronze, H 45.7
Inscription: *Epstein*
Plaster: destroyed 1982
Provenance: 1 London, IWM, 1945
Literature: Buckle, p. 278, pl. 426 (dates 1943)
Commissioned by War Artists' Advisory Committee. Field Marshal.

368 Viscount Waverley (Sir John Anderson)
1945
bronze, H 35.5
Inscription: *Epstein*
Plaster: destroyed 1982
Provenance: 1 Port of London Authority
2 Sussex, West Dean, memorial to sitter
3 London, IWM
Literature: Buckle, p. 300, pl. 46
Commissioned, August 1945, by War Artists' Advisory Committee. Administrator and statesman, Chairman of Port of London Authority 1948–58.

370 (1)

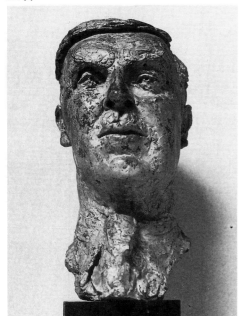

371 (early cast)

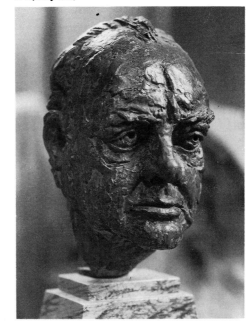

372 (1)

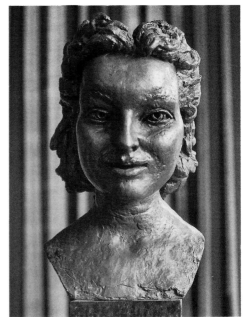

369 (plaster)

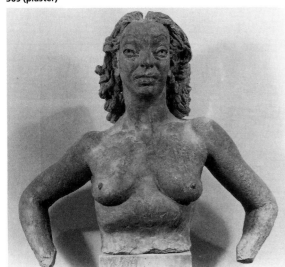

369 Mexican Girl
1945–6
bronze
Exhibition: Leicester Gal. 850, 1947, no. 35
Provenance: 1 Sir E. Hayward, Hayward Bequest, Carrick Hill
Literature: Buckle, p. 428 (dates 1945)
May also have been the model for some *Nude Studies* (e.g. no. 348).

370 Sir John Heathcote Amory
1946
bronze, H 39.5
Inscription: *Epstein*
Provenance: 1 Lady Amory

371 Sir Winston Churchill
1946
bronze, H 31.0
Inscription: *Epstein*
Exhibitions: Leicester Gal. 850, 1947, no. 40; Leicester Gal. 1191, 1960, no. 43 (last of 12)
Plaster: Jerusalem, Israel Museum, 1966
Provenance: 1 London, IWM, 1946
2 Leicester Gal.; Cape Town, NG S. Africa, 1947
3 C. A. Jackson; Oldham AG, 1948
4 J. McNaughton; P. Coll.; Christie's 15.5.66 (82), ill.; Cambridge, Churchill College
5 M. Benjamin; Paris, Centre Georges Pompidou, 1953
6 R. H. Jackson; Memphis, Dixon Gal., 1960
7 E. P. Schinman; whereabouts unknown
8 Fulton, Miss., Churchill Museum
9 Washington, Hecht's Store; The White House
10 J. Epstein; M. Benjamin; Christie's 1.3.68 (65), ill.; P. Coll.
11 Dr I. Epstein, *c*.1950; Dr M. Evans

12 Christie's 6.12.63 (56); Marquis of Bath
13 Dr. I. Epstein; P. Coll.; NY, SPB 11.12.63 (26), ill.;
14 L. Goodman; Sotheby's 22.7.64 (58)
15 (red-gold patina) P. Coll.; NY, SPB 19.5.66 (12), ill.
16 Gentleman; Sotheby's 14.12.66 (32); P. Coll.; Sotheby's 4.11.83 (120), ill.
17 W. B. Leeds; NY, SPB 5.4.67 (70), ill.; P. Coll.
18 P. Coll.; Sotheby's 19.7.67 (64)
19 NY, SPB 4.4.68 (133), ill.
20 Mrs A. Duckett; Sotheby's 8.7.70 (121), ill.; P. Coll.
21 NY, Berry Hill Gal.; H Hartford; NY, SPB 11.3.71 (28), ill.
22 P. Coll., 1960s; NY, SPB 23.10.75 (253), ill.; Christie's 9.11.84 (130), ill.
23 Mrs L. Jacobs, 1955; Sotheby's 22.6.77 (76)
24 J. Green; Sotheby's 16.11.77 (54)
25 P. Coll.
26 Sir E. Hayward, Hayward Bequest, Carrick Hill
27 P. Coll.
Literature: Epstein 1955, p. 230, ill.; Buckle, p. 302, pls. 463–4; Schinman, p. 52, ill.; 'The Case of the Multiplying Epsteins', *The Sunday Times*, 21.2.71
Commissioned, November 1946, by War Artists' Advisory Committee. British Prime Minister, 1940–5, 1951–5.

372 Jean Coucher
1946
bronze, gold patina, H 38.5
Inscription: *Epstein*
Provenance: 1 Sitter
Commissioned by the sitter's mother. It took three weeks; sitting for a half-day, three or four days a week.

373 (1)

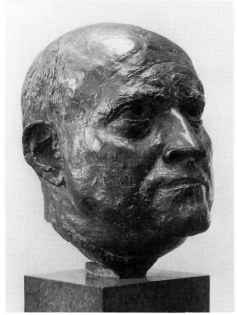

374 (1)

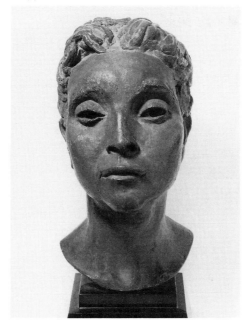

376

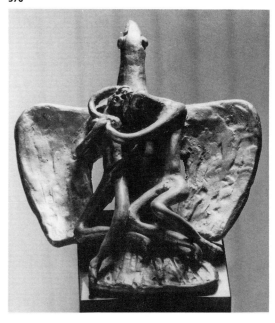

378 (4)

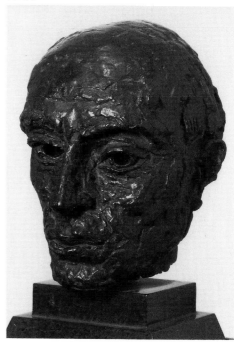

381 (1)

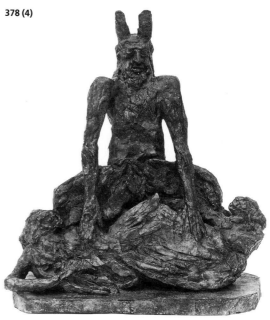

373 Frederick H. Silberman
1946
bronze, H 26.0
Provenance: 1 Mrs F. H. Silberman; Johannesburg AG, 1946
2 Sotheby's 21.11.62 (182)
Literature: Buckle, p. 428
Commission.

374 Anna Frankel
1946
bronze, H 44.5
Inscription: *Epstein*
Exhibitions: Leicester Gal. 850, 1947, no. 39; Leicester Gal. 1968 (4 of 6)
Plaster: destroyed 1982
Provenance: 1 Sotheby's 16.6.76 (62); P. Coll.
Literature: Buckle, p. 306, pl. 468
Wife of composer, Benjamin Frankel.

375 Jupiter and Semele
1946
bronze
Exhibition: Leicester Gal. 850, 1947, no. 5
Provenance: no record
Literature: Buckle, p. 305

376 Lovers on an Eagle's Back (Bird in Flight)
1946
bronze, H 10.5, L 20.0
Exhibitions: Leicester Gal. 350, 1946, no. 6; Leicester Gal. 1191, 1960, no. 35 (2nd of 6)
Provenance: 1 Epstein Estate; Prof. & Mrs W. Godley
2 Detroit, Graphic Art Assocs., 1968
Literature: Buckle, p. 305, pl. 466
Unrealized project for alabaster carving.

377 Narcissus
1946
bronze, H 13.3

Exhibition: Leicester Gal. 850, 1947, no. 10
Provenance: 1 Lady Cochrane; Sotheby's 14.12.66 (21); P. Coll.
Literature: Buckle, p. 305

378 Neptune
1946
bronze, H 34.0
Exhibition: Graphic Art Assocs. 1968, no. 23, ill.
Provenance: 1 Epstein Estate; Cardiff, NMW, 1983
2 V. Arwas; P. Coll.
3 E. P. Schinman; NY, SPB 12.6.78 (48), ill.
4 Sotheby's 19.11.80 (261)
Literature: Schinman, p. 84, ill.; Silber, no. 46, ill.
Related to *Lucifer, Belial and Beelzebub* maquette (no. 338).

379 Nightfarer
1946
bronze
Exhibition: Leicester Gal. 850, 1947, no. 7
Provenance: no record
Literature: Buckle, p. 305

380 Pasiphae (head of a child)
1946
bronze
Exhibition: Leicester Gal. 850, 1947, no. 8
Provenance: 1 S Granger; Sotheby's 1969?
Literature: Buckle, p. 305

381 First Portrait of Pandit Nehru (head)
1946
bronze, H 29.5 (plaster)
Exhibition: Leicester Gal. 850, 1947, no. 37
Plaster: (H 29.5) NY, MOMA, 1966
Provenance: 1 J. Epstein; A. F. Thompson; Derby CAG
Literature: Buckle, pp. 306–8, pl. 471

384 (1)

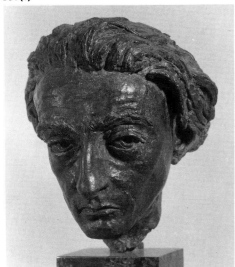

385 (4)

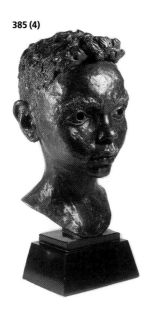

386

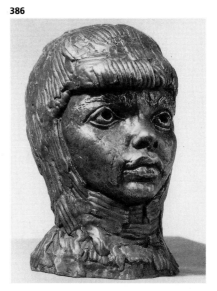

387 (1)

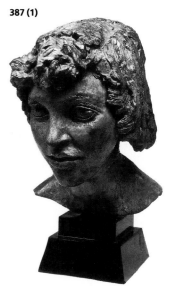

383

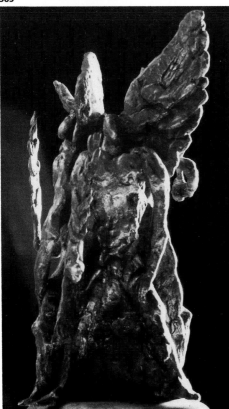

382 (5)

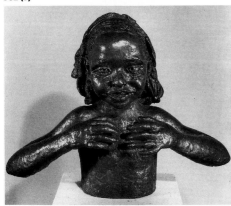

382 Ymiel Oyved
1946
bronze, H 38.0
Inscription: *Epstein*
Exhibition: Leicester Gal. 850, 1947, no. 2
Provenance: 1 (signed) Mrs M. Oyved; Jerusalem, Israel Museum, 1947
2 (signed) R. E. Smith, pre-1948; Sotheby's 12.4.67 (81)
3 P. Coll.; Jerusalem, Israel Museum, 1968; J. Steiglitz; Florida, SPB 24.3.80 (279), ill.; Dr M. Evans
4 Lady Cochrane; Sotheby's 14.12.66 (15)
5 Mrs L. Willner; E. Littler; Eisenberg-Robbins; Washington, MAA, 1973
Literature: Buckle, p. 306, pl. 470.

383 Guardians of Paradise (Angels with Flaming Swords)
1947
bronze, H 25.4
Inscription: *Epstein*
Exhibitions: Leicester Gal. 850, 1947, no. 22; Edinburgh 1961, no. 150 (dated 1949)
Provenance: 1 Epstein Estate (Edinburgh 1961)
2 Christie's 9.5.74 (39)
Literature: Buckle, p. 305, pl. 465

384 Ronald Duncan
1946
bronze, H 25.4
Exhibition: Leicester Gal. 850, 1947, no. 35
Plaster: destroyed 1982
Provenance: 1 Ronald Duncan Literary Foundation
Literature: Buckle, p. 306, pl. 469
Commission. Writer and critic. Produced in an edition of six.

385 Anthony
1947
bronze, H 31.0
Inscription: *Epstein*
Exhibition: Leicester Gal. 930, 1950, no. 17

Plaster: Brunswick, Bowdoin College, 1969
Provenance: 1 J. Epstein; Sir John & Lady Amory, *c*.1946
2 Sotheby's 4.11.59 (84)
3 Auction, Cranbourn Court; Eisenberg-Robbins; Washington, MAA, 1973
4 Phillips' 15.11.82 (120) = Phillips' 14.3.83 (99)
Literature: Buckle, p. 310, pl. 477

386 Anthony in a Balaclava Helmet
1947
bronze, H 33.0
Plaster: (H 31.0) Israel, Ein Harod, 1965
Provenance: 1 L. Goodman; NY, SPB 20.2.64 (59), ill.; P. Coll.
Literature: Buckle, p. 310, pl. 476

387 Second Portrait of Kitty
1947
bronze, H 31.8
Inscription: *Epstein*
Exhibitions: Leicester Gal. 931, 1950, no. 22; Tate 1952, no. 48 (dated 1947)
Plaster: Phoenix AM, 1966
Provenance: 1 Birmingham MAG, 1951
2 Hampstead School for Girls
3 L. Goodman; NY, PB 11.11.59 (29), ill.; NY, Weintraub Gal.
4 NY, French & Co.; Dr F. Elias; NY, SPB 19.5.66 (10), ill.
5 Christie's 8.6.79 (196)
6 Arundel, Armstrong-Davis Gal.; P. Coll., 1980
7 Epstein Estate
Literature: Epstein 1955, p. 203, ill.; Buckle, pp. 326–7, pls. 508, 638

388 Lucien Freud
1947
bronze, H 68.6
Inscription: *Epstein*
Exhibition: Leicester Gal. 931, 1950, no. 21
Plaster: (full bust) Oberlin, Allen Memorial

388 (plaster)

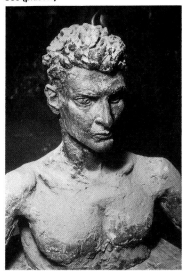

389 (1)

391 detail

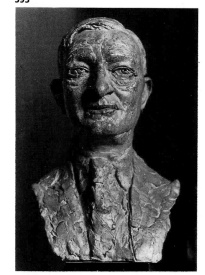

392 (1)

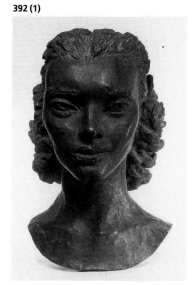

Museum, 1967

Provenance: 1 E. P. Schinman; whereabouts unknown

VERSION WITH HEAD ONLY, H 40.0:

2 B. Scharfer; NY, Christie's 11.3.78 (136); London, NPG

3 W. M. Bolton; Sotheby's 22.7.64 (88)

4 NY, Gal. 43; NY, PB 5.12.62 (25), ill.

5 London, Albion Fine Art (July 1981)

6 Christie's 12.3.82 (138)

7 Phillips' 28.6.82 (106)

8 LA, Dalzell Hatfield Gal.; V. Steele Scott; SF, Butterfield's 3.5.81 (161)

Literature: Buckle, pp. 308–9, pl. 475 (bust); Schinman, p. 85, ill.

Artist, married Kitty (see no. 387) in 1947.

389 Lord Lindsay of Birker

1947

bronze, H 54.0

Exhibition: Leicester Gal. 931, 1950, no. 20

Plaster: Keele University, 1966

Provenance: 1 Oxford, Balliol College JCR

Literature: Epstein 1955, p. 232; Buckle, p. 309, pl. 472

Commissioned by Balliol College. Master of Balliol and first Principal of University College of North Staffordshire 1949–52.

390 Gabriel Pascal

1947

bronze

Provenance: 1 whereabouts unknown

Literature: V. Pascal, *The Disciple and the Devil*, 1971, p. 133

Producer of films of G. B. Shaw's plays. Epstein refers to the work in a letter to P. Hornstein, 12.11.1948. A *New York Times Herald Tribune* picture article (by R. F. Crandell) of 1947 shows Epstein with the plaster.

391 Lazarus (plate 33)

1947–8

Hoptonwood stone, H 254

Exhibitions: Leicester Gal. 931, 1950, no. 1; London, Battersea Park, Sculpture in the Open Air, 1951

Provenance: Oxford, New College Chapel, 1952

Literature: Epstein 1955, pp. 231–2; Buckle, pp. 311–15, pls. 478–81

Purchased at the suggestion of A. H. Smith, Warden of New College (see no. 449), in 'one of the happiest issues of my working life' (Epstein).

392 Linda Christian

1948

bronze, green patina, H 36.9

Inscription: *Epstein*

Exhibition: Leicester Gal. 1021, 1953, no. 5

Provenance: 1 Sitter; Christie's 27.10.72 (176)

Literature: Buckle, p. 316, pl. 484

Actress.

393 David Goldblatt

1948

bronze

Provenance: 1 whereabouts unknown

Reference is made to its completion, April 1948, in Epstein to P. Hornstein, 29.4.1948. Apparently commissioned by a Huguenot (refugee?) group and presented to the sitter on 2 May 1948.

394 Isaac L. Myers

1948

bronze, H 33.0

Inscription: *Epstein*

Provenance: 1 J. Epstein; Memphis, Brooks MA, 1950

Literature: Buckle, p. 309, pl. 474 (dates 1949)

Commission. American tobacco manufacturer. Referred to in Epstein to P. Hornstein, 14.6 and 6.7.1948.

393

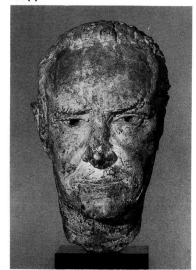

394 (1)

397 (1)

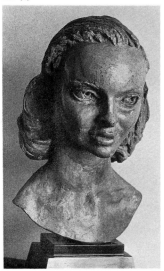

398 (1)

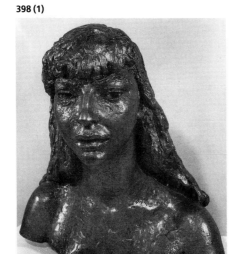

399

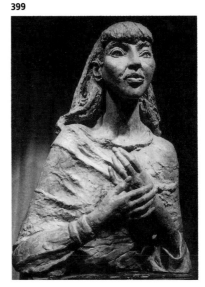

400

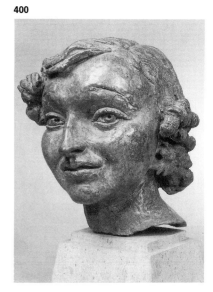

396 (1)

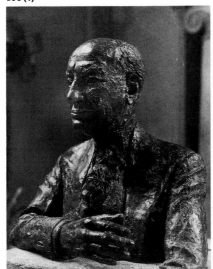

395 (plaster)

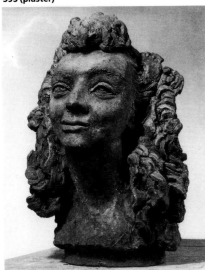

395 Helen Esterman
1948
bronze, H 39.0
Inscription: *Epstein*
Exhibitions: Leicester Gal. 931, 1950, no. 19
Helen; Leicester Gal. 1968 (3 of 6)
Provenance: **1** P. Coll.; Christie's 10.3.67
(74)
2 Sotheby's 23.4.69 (93)
3 V. Waddington; Lady Carberry; Christie's 19.3.71 (175)
4 Nobleman; Sotheby's 19.6.74 (117); P. Coll.
Literature: Buckle, p. 315, pl. 483
Buckle states wrongly that the unique bronze is in Winnipeg AG.

396 Franklin Dyall
1948
bronze, H 53
Provenance: **1** Sitter's family; London, Garrick Club, 1953
Literature: Buckle, pp. 316–17, pl. 487
Commissioned by sitter. Actor and friend of Epstein.

397 Second Portrait of Joan Greenwood
1948
bronze, H 38.1
Exhibition: Leicester Gal. 931, 1950, no. 18
Plaster: Hull University, 1965
Provenance: **1** V. Waddington, *c.*1948;
Miss H. F. Campbell
2 E. P. Schinman; whereabouts unknown
3 J. Parker; Sotheby's 26.11.69 (312)
4 (signed *Epstein*) Sotheby's 9.12.70 (82)
Literature: Buckle, p. 316, pl. 485; Schinman, p. 86, ill.

398 Second Portrait of Esther
1948
bronze, H 47.0 (head and shoulders)
Exhibition: Leicester Gal. 931, 1950, no. 4
Esther (head and shoulders)
Plaster: (head and shoulders only, H 44.0)
NY, Jewish Museum, 1966
Provenance: VERSION WITH HEAD AND
SHOULDERS ONLY:
1 Mrs H. Elidale; E. Littler; Eisenberg-Robbins; Washington, MAA, 1973
2 Lady Epstein, 1964; NY, SPB 7.4.73 (59) ill.
Literature: Buckle, p. 315, pl. 482 (full bust)

399 Seventh Portrait of Kathleen (half-length in shawl)
1948
bronze, H 73.7
Plaster: Jerusalem, Israel Museum, 1966
Provenance: **1** Lady Epstein; Edinburgh CAG, 1962
2 E. P. Schinman; whereabouts unknown
3 Leicester Gal.; V. Steele Scott, SF, Butterfield's 3.5.81 (112), ill.
Literature: Buckle, pp. 318–21, pls. 490–2, 499; Schinman, p. 53, ill.

400 Muriel Jackson
1948
bronze, H 25.4
Provenance: **1** E. P. Schinman; whereabouts unknown
2 Lady Cochrane; Sotheby's 14.12.66 (16)
3 P. Coll.; NY, SPB 22.10.76 (337), ill.;
P. Coll.
4 Phillips' 25.3.86 (119)
Literature: Buckle, p. 428; Schinman, p. 54, ill.

401

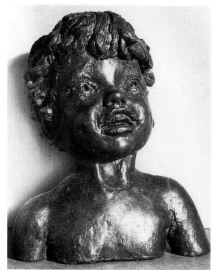

402 (plaster)

403 (plaster)

404 (plaster)

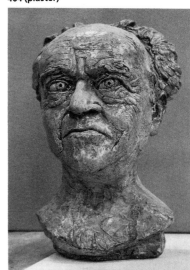

405

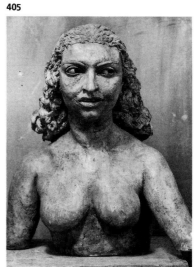

Commission. Wife of Robert Jackson, Epstein's dealer in Manchester.

401 Peter Laughing
1948
bronze, H 30.5
Plaster: (H 33.0) Israel, Ein Harod, 1965
Provenance: 1 FAS
 2 NY, PB 11.1.62 (75), ill. = casts 3/4?
 3 NY, SPB 13.5.77 (680), ill.
 4 NY, SPB 2.4.81 (83), ill.
Literature: Buckle, p. 318, pls. 488–9
Commission, according to Buckle. See also no. 454.

402 Selig Brodetsky
1948
bronze
Plaster: destroyed 1982
Provenance: 1 Sitter; whereabouts unknown
Literature: Buckle, p. 360, pl. 564 (dates 1953); *Encyclopaedia Judaica*, 4, pp. 1392–3
Commission. Professor of Mathematics at Leeds, President of Board of Deputies of British Jews 1939–49, President of Hebrew University, Jerusalem 1949–52. Referred to in Epstein to P. Hornstein, 14.6.1948.

403 George Prinz
1948
bronze
Provenance: 1 whereabouts unknown
Literature: Buckle, p. 429 (dates 1949)
Commission. Epstein was about to start work on this in May 1948 (Epstein to P. Hornstein). Only a poor-quality H. Wild contact print appears to survive.

404 Ernest Bloch
1948–9?

bronze, H 40.6
Exhibition: Leicester Gal. 931, 1950, no. 3
Plaster: (H 40.0) Jerusalem, Israel Museum, 1966
Provenance: 1 Lady Epstein, 1960s; P. Coll.
Literature: Epstein 1955, pp. 233–4, ill.; Buckle, p. 325, pl. 504
Composer.

405 Princess Desta
1948–9
bronze, H 53.3
Exhibitions: Leicester Gal. 931, 1950, no. 6; Leicester Gal. 1968 (1 of 6)
Plaster: destroyed 1982?
Provenance: 1 Leicester Gal.; P. Coll., 1950
 2 E. P. Schinman; whereabouts unknown
 3 Tel Aviv Museum
Literature: Buckle, p. 331, pl. 512; Schinman, p. 83, ill.
Half-Belgian niece of the Empress of Abyssinia. Referred to in Epstein to P. Hornstein, 7.12.1948 and 23.1.1949. See no. 406.

406 Princess Menen
1948–9
bronze, H 54.0
Exhibition: Leicester Gal. 931, 1950, nos. 8, 9 (with earrings)
Plaster: destroyed 1982
Provenance: 1 (without earrings) Lady Epstein, 1962; LA, Dalzell Hatfield Gal.; V. Steele Scott; Washington, NGA, 1973
Literature: Buckle, p. 331, pl. 513
Half-Belgian niece of the Empress of Abyssinia. Referred to in Epstein to P. Hornstein, 7.12.1948 and 23.1.1949. See no. 405.

406 (1)

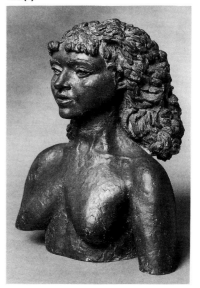

409 (1)

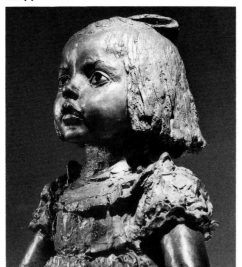

410 (3)

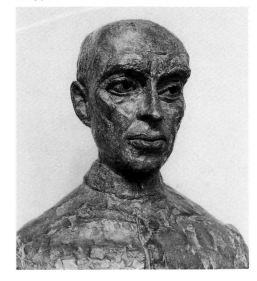

408

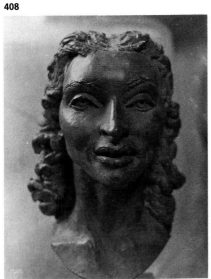

407

407 Third Portrait of Esther (with flower)
1949
bronze, H 62.0
Exhibitions: Leicester Gal. 931, 1950, no. 5; Leicester Gal. 1191, 1960, no. 44
Plaster: Jerusalem, Israel Museum, 1966
Provenance: 1 Walsall, Garman-Ryan Coll., 1972
2 A. Haskell; whereabouts unknown
3 Queensland AG, 1953
4 NY, French & Co.; Dr F. Elias; NY, SPB 19.5.66 (11), ill.
5 E. P. Schinman; whereabouts unknown
6 Sir E. Hayward; Hayward Bequest, Carrick Hill
Literature: Epstein 1955, p. 190, ill.; Buckle, pp. 326–8, pls. 509–11; Schinman, p. 82, ill.

408 Lady Madeleine Lytton
1949
bronze
Exhibition: Leicester Gal. 931, 1950, no. 13
Plaster: destroyed 1982
Provenance: 1 Sitter; whereabouts unknown
Literature: Buckle, p. 326, pl. 505
Commission. Friend of Kathleen Garman (see no. 399).

409 Judith Margulies
1949
bronze, H 20.3
Inscription: *Epstein*
Exhibition: Leicester Gal. 931, 1950, no. 23
Plaster: Jerusalem, Israel Museum, 1966
Provenance: 1 A. Margulies
2 P. Hawkins; Christie's 14.11.75 (151)
Literature: Buckle, p. 326, pl. 509

410 Second Portrait of Pandit Nehru (bust)
1949
bronze, H 39.4
Exhibition: Leicester Gal. 1191, 1960, no. 45 (dated 1949)

Provenance: 1 L. Goodman; Christie's 23.3.62 (112), ill.
2 E. P. Schinman; whereabouts unknown
3 Adelaide, AG S. Australia, 1957
Literature: Buckle, pp. 324–5, pl. 324; Schinman, p. 80, ill.
Usually dated 1949, but Epstein refers to its completion in October 1948 (Epstein to P. Hornstein, 31.10.1948).

411 Siobhan
1949
bronze, H 34.3
Inscription: *Epstein*
Plaster: (H 33.0) Caracas, Museo de Bellas Artes, 1966
Provenance: 1 J. Epstein, 1954; Dr M. Evans
Literature: Buckle, p. 326, pl. 506
Commission.

412 Master Stewart (Babe with Arms)
1949
bronze, H 25.4
Inscription: *Epstein*
Plaster: (H 27.0) Jerusalem, Israel Museum, 1966
Provenance: 1 J. Epstein, late 1950s; Dr I. Epstein; Dr M. Evans
2 S. N. Steen (Edinburgh 1961; King's Lynn 1963)
3 C. R. Ribbauds (1964)
4 L. Goodman; Christie's 26.4.63 (170), ill.
5 E. P. Schinman = NY, SPB 28.3.79 (111), ill.
VERSION WITH HEAD ONLY, H 18.0:
6 Leicester Gal.; NY, SPB 8.4.70 (67), ill.
7 St. Louis, Schoenberg Coll.; NY, Christie's 20.5.81 (457)
8 (signed) Sotheby's 6.2.85 (494), ill.
Literature: Epstein 1940, ill.; Buckle, p. 323, pl. 502; Schinman, p. 54, ill.
Commission. Schinman wrongly states that it is based on the daughter of Michael Stewart. King's Lynn 1963, no. 15, also identified it as the portrait of a girl.

411 (1)

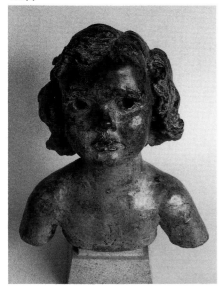

412

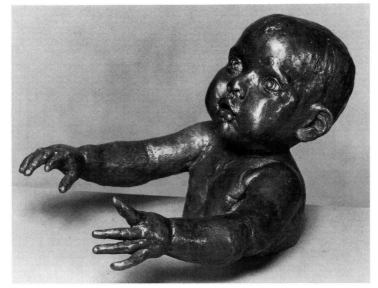

413 Elizabeth Tindall-Lister
1949
bronze, H 47.0
Exhibition: Leicester Gal. 931, 1950, no. 25
Plaster: destroyed 1982
Provenance: 1 Sitter
Literature: Buckle, p. 331, pl. 515
Commission.

414 Victor (plate 35)
1949
bronze, H 17.5
Inscription: *Epstein*
Exhibition: Leicester Gal. 931, 1950, no. 11
Little Nigger Boy
Plaster: Jerusalem, Israel Museum, 1966
Provenance: 1 Miss J. Horner; Leeds CAG, 1973
2 J. Epstein, 1950s; Dr I. Epstein; Dr M. Evans
3 Prof. Lawrence; NG Ghana, 1950s
4 L. Goodman; NY, PB 14.12.59 (39)
5 M. Langworthy; Sotheby's 22.7.64 (75)
6 S. Box; Sotheby's 1.11.67 (156)
7 H. Crookenden; Christie's 13.5.66 (85)
8 Epstein Estate (Edinburgh 1961)
9 Sotheby's 11.12.68 (66); P. Coll.
10 NY, SPB 12.12.68 (5)
11 Educational institution; Sotheby's 14.7.71 (125); P. Coll.
12 P. Coll.; NY, SPB 15.6.79 (50), ill.
13 (signed *JE*) NY, Christie's 13.4.83 (186), ill.
14 Christie's 10.6.83 (201)
15 Sydney, D. Jones Gal., 1966; Sydney, P. Coll.
Literature: Buckle, p. 323, pl. 500
Son of the West African cook who worked for the Epsteins in 1949.

415 Bracha Zefira (plate 37)
1949
bronze
Exhibition: Leicester Gal. 931, 1950, no. 14
Plaster: destroyed 1982
Provenance: 1 Dr & Mrs H. Taylor (Ben Uri Gal. 1959)

Literature: Buckle, p. 331, pl. 514
Yemeni singer.

416 Ralph Vaughan Williams, OM (plate 36)
1949
bronze, green patina, H 39.5
Inscription: *Epstein*
Exhibition: Leicester Gal. 931, 1950, no. 15
Plaster: Jerusalem, Israel Museum, 1966
Provenance: 1 (signed) Leicester Gal.; ACGB, 1950
2 (signed) Leicester Gal.; Birmingham MAG, 1951
3 (signed) Kensington AG; Southampton AG, 1952
4 (signed) C. A. Jackson; Manchester CAG, 1952
5 (signed) J. Epstein; A. F. Thompson, 1950s; Leicester Gal.; London, NPG, 1970
6 J. C. Whittaker (Bolton AG, 1954)
7 Leicester Gal.; Sir R. Mayer, 1950s
8 J. Epstein; Bedford, Cecil Higgins AG, 1959
9 Sotheby's 11.11.59 (78)
10 (signed) London, P. Coll.; NY, PB 9.12.59 (37), ill.
11 T. S. Barlow; Sotheby's 12.7.61 (95)
12 (signed) R. E. Smith; Sotheby's 15.4.64 (102)
13 L. Goodman; Sotheby's 22.7.64 (79); London, Tooth's, 1966
14 W. M. Bolton; Sotheby's 16.12.64 (113); E. Littler; Eisenberg-Robbins; Washington, MAA, 1973
15 (signed) M. Oliphant; Sotheby's 26.11.69 (330); London, Agnew's
16 Leicester Gal., 1968; P. Coll.; Sotheby's 27.6.79 (73); P. Coll.
17 Leicester Gal., 1968; P. Hawkins; Sotheby's 7.6.78 (111)
Literature: Epstein 1955, p. 234, ill.; Buckle, pp. 334–5, pls. 519–20 (dates 1950)
Commission. Composer. Epstein had just started work on the sculpture in February 1949 (Epstein to P. Hornstein, 9.2.1949).

413 (1)

417

419

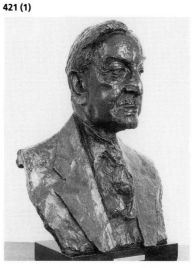

421 (1)

423 (1) at Festival of Britain, 1951

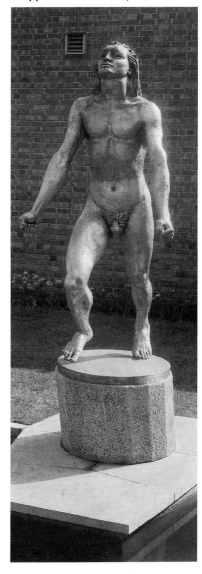

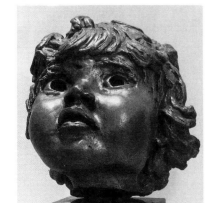

418

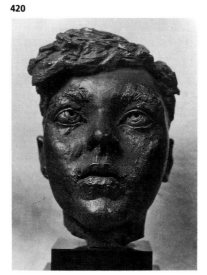

420

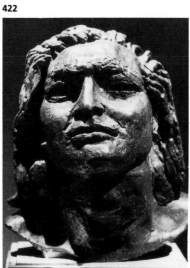

422

417 Jill Balcon
1949
bronze
Exhibitions: Leicester Gal. 931, 1950, no. 9; Leicester Gal. 1968 (4 of 6)
Provenance: 1 whereabouts unknown
Literature: Buckle, p. 316, pl. 486 (dates 1949)
Daughter of Michael Balcon (see no. 237), actress. Executed in autumn 1949, when the portrait of Vaughan Williams had just been completed.

418 Ann Freud
1949–50
bronze, H 21.5
Exhibition: Leicester Gal. 931, 1950, no. 16 *Ann Lucia Freud*
Plaster: Jerusalem, Israel Museum, 1966
Provenance: 1 E. Freud (1961)
2 Epstein Estate
3 NY, Silberman Gal., 1956
4 Mrs A. Backus (Ben Uri Gal. 1959)
5 J. Mitchell; NY, SPB 7.10.72 (60), ill.; P. Coll.

Literature: Buckle, p. 337, pls. 521–2 *Anne Freud*
Elder daughter of Lucien Freud and Epstein and Kathleen's elder daughter, Kitty.

419 Roland Joffe
1949–50
bronze, gold patina, H 21.0
Exhibition: Leicester Gal. 931, 1950, no. 10
Plaster: (H 22.0) Israel, Ein Harod, 1965
Provenance: 1 Walsall, Garman-Ryan Coll., 1972
2 P. Coll.
Literature: Buckle, p. 337, pl. 524
Son of Mark Joffe (see no. 456), he lived with the Epsteins. Sculpted when he was six.

420 Fourth Portrait of Jackie
1949–50
bronze, H 34.5 (including base)
Exhibitions: Leicester Gal. 931, 1950, no. 12?; Leicester Gal. 1968 (2 of 6)
Plaster: destroyed 1982
Provenance: 1 Sotheby's 7.6.78 (101)
Portrait shows Jackie aged about fourteen.

After Mrs Epstein's death (1947) he spent more than a year in the USA living with Peggy Jean and Norman Hornstein. Laib negative dated early 1950.

421 Lord Samuel
1950
bronze
Exhibition: Leicester Gal. 1021, 1953, no. 1
Provenance: 1 London, Reform Club
Literature: Buckle, p. 340, pl. 529

422 Chinese Boy
1950
bronze
Exhibition: Leicester Gal. 1191, 1960, no. 46 (1 of 6)
Plaster: destroyed 1982
Literature: Buckle, p. 331, pls. 516–17
Boy used as model for *Youth Advancing* (no. 423).

423 Youth Advancing
1949–50
bronze, H 208

424

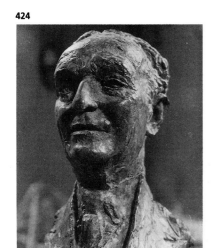

426

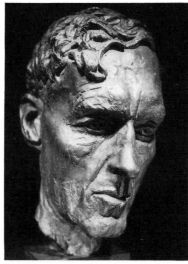

428

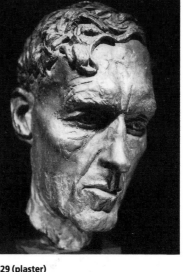

430 (plaster)

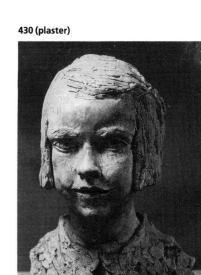

425 (1)

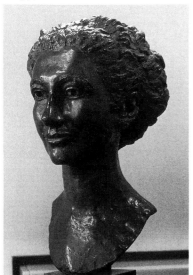

427 (plaster)

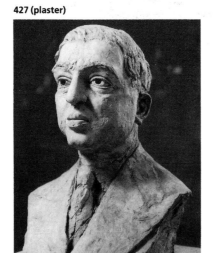

429 (plaster)

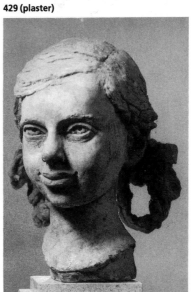

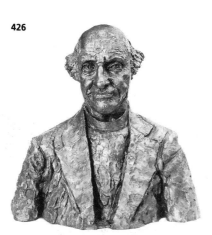

Exhibition: London, Festival of Britain, 1951
Provenance: 1 Manchester CAG
Literature: Epstein 1955, p. 234, ill.; Buckle, p. 345, pl. 536
Commissioned for the Festival of Britain exhibition on the South Bank, London. Modelled on half-Chinese boy (see *Chinese Boy*, no. 422).

424 Duncan (?)
1950?
bronze
Provenance: 1 whereabouts unknown
Laib negative with name and date, April 1950.

425 Marion Abrahams
1950
bronze, H 43.0
Inscription: *Epstein*
Provenance: 1 P. Coll.
Commissioned by Dr Abrahams.

426 Dr Hewlett Johnson
1950

bronze, H 50.8
Inscription: *Epstein*
Plaster: destroyed 1982
Provenance: 1 Sitter; Sotheby's 4.12.63 (98), ill.
Literature: Buckle, pp. 418, 429; London, V & A, *Felix H. Man: 60 Years of Photography*, 1983, p. 11 (shows Epstein with sitter and portrait, wrongly dates 1939)
Commission. Dean of Canterbury 1931–63, nicknamed 'The Red Dean'. He conducted Epstein's funeral service at Putney Vale Cemetery, 24 August 1959.

427 Gaekwar of Baroda
1950
bronze
Provenance: 1 Sitter; whereabouts unknown
Literature: Buckle, p. 340, pl. 531
Commission.

428 Professor Patrick Blackett
1950
bronze

Exhibition: Leicester Gal. 1021, 1953, no. 14
Plaster: University of Sussex, 1966
Provenance: 1 Sitter; whereabouts unknown
Literature: Epstein 1955, p. 235; Buckle, p. 341, pl. 532
Experimental physicist, winner of Nobel prize in 1948.

429 Diana Coppinger Hill
1950
bronze
Provenance: 1 Sitter; whereabouts unknown
Literature: Buckle, p. 337, pl. 523
Commission.

430 Christine Hughes
1950
bronze, green patina, H 34.0
Inscription: *Epstein*
Provenance: 1 Mr & Mrs P. Hughes; Mrs I. Hughes
Literature: Buckle, p. 339, pl. 527
Commission.

433 (plaster)

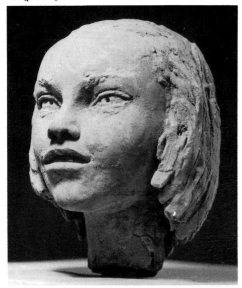

434

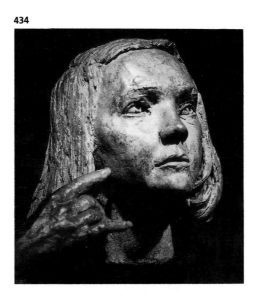

435 (plaster)

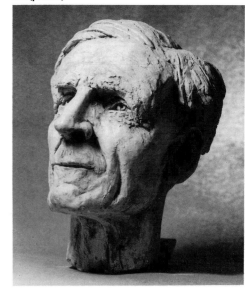

432 (1)

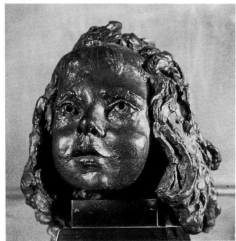

431 (plaster)

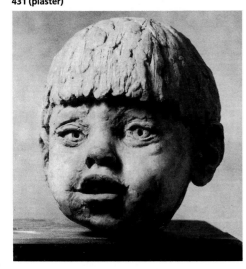

431 Christopher Hughes
1950
bronze, H 18.5
Inscription: *Epstein*
Provenance: 1 Mr & Mrs P. Hughes; Mrs I. Hughes
Literature: Buckle, p. 339, pl. 528
Commission.

432 Isobel Hughes
1950
bronze, H 26.0
Inscription: *Epstein*
Provenance: 1 Mr & Mrs P. Hughes; Mrs I. Hughes
Literature: Buckle, p. 339, pl. 525
Commission. Head subsequently used for one of the door handles for Cavendish Square (see no. 454).

433 Penelope Hughes
1950
bronze, green patina, H 23.0
Inscription: *E*
Provenance: 1 Mr & Mrs P. Hughes; Mrs I. Hughes
Literature: Buckle, p. 339, pl. 526
Commission.

434 Gwen, Lady Melchett of Landford
1950
bronze, H 35.6
Exhibition: Leicester Gal. 1021, 1953, no. 16
Plaster: (H 30.0) Israel, Ein Harod, 1965
Provenance: 1 Sitter (1963)
2 P. Coll.
Literature: Buckle, p. 332, pl. 518
Commission. Widow of the Second Lord Melchett.

435 Dr Bethel Solomons
1950
bronze
Plaster: destroyed 1982
Provenance: 1 whereabouts unknown
Literature: Buckle, p. 340, pl. 530
Commission. Head of Rotunda gynaecological hospital, Dublin.

436 Marcella Barzetti
1950
bronze, H 29.0
Exhibition: Leicester Gal., New Year, 978, 1952, no. 136
Plaster: (H 29.0) Jerusalem, Israel Museum, 1966
Provenance: 1 Sotheby's 5.7.83 (193); Y. Solomon
Literature: Buckle, p. 342, pl. 533

437 Maquette for Madonna and Child
1950
lead, halo in bronze, H 33.0
Inscription: *Epstein*
Exhibition: Leicester Gal. 1191, 1960, no. 50 (last of 12)
Plaster: Epstein Estate; Cardiff, NMW, 1983
Provenance: 1 L. Osman, 1950
2 J. Epstein; ACGB, 1953
3 Leicester Gal., 1957; J. H. Hirshhorn; Washington, Hirshhorn Museum, 1966
4 J. Epstein; Mrs P. J. Lewis
5 Auckland CAG
6 Sotheby's 26.4.61 (27)
7 Sotheby's 13.12.61 (165)
8 Epstein Estate; B. Lipkin
9 Sotheby's 21.11.62 (183)
10 L. Goodman; Sotheby's 22.7.64 (60)
11 E. P. Schinman; whereabouts unknown
12 Lady Cochrane; Sotheby's 14.12.66 (17); Lord Primrose
13 Detroit IFA, 1969
14 Dr J. Schwarz; NY, SPB 16.4.69 (33),

437 (16)

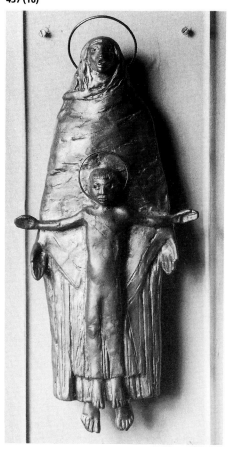

436 (1) a

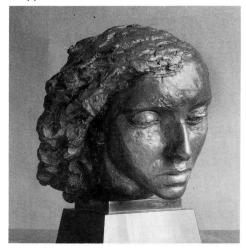

436 (1) b

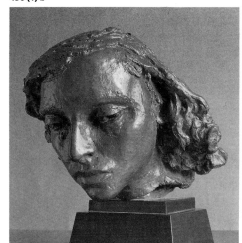

ill.; E. Halpert; NY, SPB 15.3.73 (169); NY, Forum Gal.

15 Miss M. McEvedy; Sotheby's 18.7.73 (74); Taubman

16 Walsall, Garman-Ryan Coll., 1973

17 Sotheby's 14.3.79 (62); P. Coll.

Literature: Buckle, p. 350, pls. 534–5; Schinman, p. 84, ill.

See no. 438.

438 Madonna and Child, former Convent of the Holy Child Jesus, Cavendish Square, London (plate 34)

1950–2

lead, H c.390

Plaster: (head and shoulders) Oberlin, Allen Memorial Museum, 1967

Literature: Osman in *Architectural Association Journal*, 70, 1954, pp. 7–19; Epstein 1955, pp. 235–6; Ireland, ill; Buckle, pp. 350–3, pls. 543–5

The architect, Louis Osman, was asked to design a connecting bridge over the mews which separated the two Palladian buildings occupied by the Convent. At the same time he rebuilt the right-hand house, which had been gutted during the war. From the outset he considered sculpture necessary to the building but decided against carving in low relief in favour of a modelled piece. The void below the arch and the wall against which the sculpture was to be sited presented problems for any sculptor since the figure 'should have levitation of its own, not being concerned with gravity' (Osman, p. 10).

In spite of having no authority or money to commission a sculpture at this stage, Osman asked Epstein to prepare a maquette, specifying only that the figure should be cast in lead, a considerable quantity of which was available from the destroyed roof of the damaged building. The maquette was produced

within a week (see no. 437) and approved by the nuns without the sculptor's name being disclosed.

The problem was now money as the Convent could provide only £500. At first Osman's requests for funding to the Arts Council and the Contemporary Art Society were unsuccessful, but the Arts Council, encouraged by the the enthusiasm of Sir Kenneth Clark, changed their minds and wrote to the Convent, congratulating them on their enlightened patronage of Epstein and enclosing a cheque for £500. A crisis developed. The nuns were alarmed at the choice of Epstein and refused to approve the sculpture which Epstein meanwhile had almost completed. Osman, with the bridge half-built, offered to resign, thus putting pressure on the community. The Mother Superior and one of the nuns visited the studio and studied the plaster alone for some time. The head had at this stage an outgoing, eager expression, based upon a portrait of Kathleen Garman, but the nuns requested a more meditative interpretation of the Madonna's head and Epstein duly substituted a head based on the portrait of his pianist friend, Marcella Barzetti (see no. 436). After he had been called before the community and catechized on his attitude to the work, a stipulation to which he consented, the nuns gave their final approval to the scheme.

A public appeal for money brought a slow response, but the work continued. Gaskin's Foundry cast the work in lead, but before it could be placed on the wall a bronze skeleton was required to support its mass on the wall and provide an inner rigid framework for the figure. The sculpture was finally unveiled by R. A. Butler, then Chancellor of the Exchequer, on 14 May 1953.

The buildings are now occupied by Heythrop College, University of London.

438 *in situ*

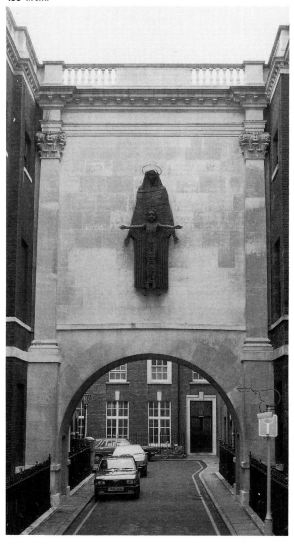

442 (3)

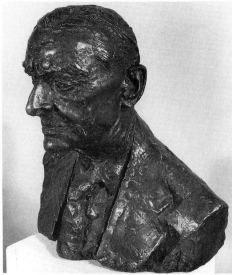

443 (1)

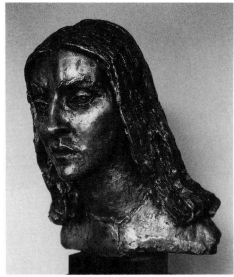

444

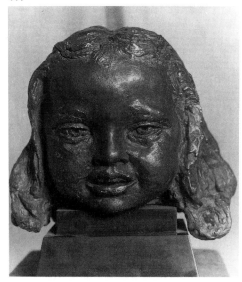

441 (1)

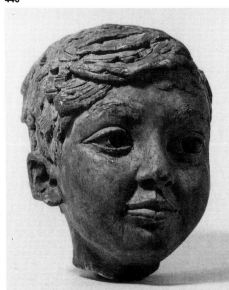

440

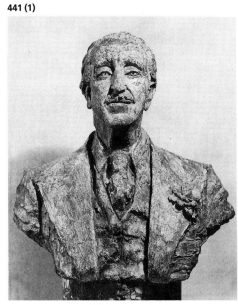

439 Mrs Elsie Steele ('Ripple')
1950–9?
bronze, H 32.5
Provenance: 1 Sitter's sister; Christie's 19.7.68 (114)

440 Prince of Baroda
1951
bronze, H 22.8
Plaster: Plainfield, Vermont, Goddard College
Provenance: 1 E. P. Schinman = NY, Christie's 17.2.82 (69), ill.?
Literature: Buckle, p. 353, pls. 546–7; Schinman, p. 81, ill.
Described in Christie's sale catalogue as the first of six casts.

441 Louis Colville Gray Clarke
1951
bronze, green patina, H 53.2
Plaster: destroyed 1982
Provenance: 1 Cambridge, Fitzwilliam Museum, 1951
Literature: Buckle, p. 355, pl. 551
Commissioned by the Friends of the Fitzwilliam Museum, Cambridge. Director of the Museum.

442 Thomas Stearns Eliot, OM
1951
bronze, green patina, H 48.3
Inscription: *Epstein*
Exhibition: Leicester Gal. 1021, 1953, no. 15
Plaster: London, NPG, 1965
Provenance: 1 London, Faber & Faber, 1953
2 Mrs T. Hanley; Austin, HRC, 1959
3 Sotheby's 4.11.59 (77); C. J. Sawyer; L. Goodman; Sotheby's 22.7.64 (62); C. J.

Sawyer; E. Littler; Eisenberg-Robbins; Washington, MAA, 1973
4 Leicester Gal., 1955; J. H. Hirshhorn; Washington, Hirshhorn Museum, 1966
5 P. Coll.; NY, PB 5.12.62 (26), ill.; NY, El Dieff
6 Walsall, Garman-Ryan Coll., 1973
Literature: Epstein 1955, p. 235; Buckle, pp. 348–9, pls. 540–2
Commissioned by Ashley Dukes. Poet and playwright.

443 Elizabeth (Keen)
1951
bronze, silver patina, H 34.3
Inscription: *Epstein*
Exhibition: Leicester Gal., New Year, 978, 1952, no. 135
Provenance: 1 J. Epstein; Dr I. Epstein; Dr M. Evans
Literature: Buckle, p. 428 (*Elizabeth*, dates 1949)
Actress, spotted by Epstein and asked to model. A photo in the *Illustrated London News*, 12.12.1952, p. 31, shows the sitting.

444 Judith Lade
1951
bronze, H 26.6
Exhibitions: Edinburgh 1961, no. 112; Leicester Gal. 1968 (3 of 6)
Provenance: 1 J. Lade (Edinburgh 1961)
Literature: Buckle, p. 429
Commission.

445 W. Somerset Maugham (plate 38)
1951
bronze, H 39.0
Inscription: *Epstein*
Exhibition: Leicester Gal., New Year, 978, 1952, no. 134

446 (plaster)

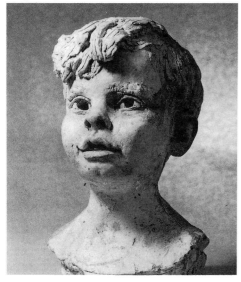

447 (1)

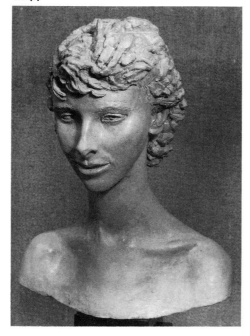

448 (1)

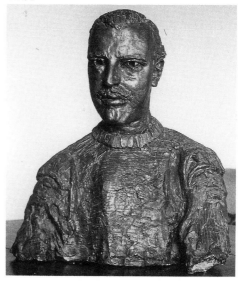

449 (1)

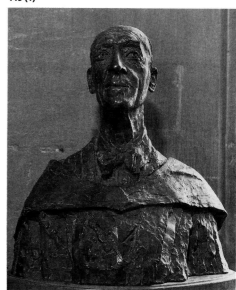

450

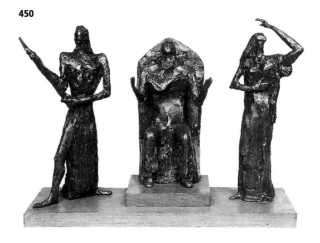

Plaster: Phoenix AM, 1966
Provenance: 1 Sitter; Tate, 1952
 2 L. Goodman; NY, PB 18.5.60 (44), ill.
 3 L. Goodman; Sotheby's 22.7.64 (61); C. J. Sawyer = cast 4?
 4 NY, El Dieff; Austin, HRC, 1964
 5 K. Hall; Christie's 19.6.64 (17); S. Box
 6 J. H. Hirshhorn; Washington, Hirshhorn Museum, 1966; Christie's 13.6.86 (296)
 7 Sonnenberg Coll.; NY, SPB 5.9.79 (1504)
Literature: Epstein 1955, p. 235; Buckle, p. 354, pls. 549–50
HRC records indicate an edition of ten.

446 Robert Rhodes
1951
bronze, H 39.4
Exhibition: Leicester Gal. 1968 (edition of 6 sold out)
Plaster: (H 33.4) Melbourne, NG Victoria, 1971
Provenance: 1 Mrs G. Rhodes (Ben Uri Gal. 1959)
 2 D. Hughes; E. Littler; Eisenberg-Robbins; Washington, MAA, 1973
 3 M. Orman; NY, SPB 22.10.76 (340), ill.; Dr. M. Evans
 4 Gentleman; Sotheby's 7.6.78 (99); Schmidt & Bodner
 5 NY, Christie's 17.2.82 (42), ill.
Literature: Buckle, p. 353, pl. 548

447 Lady Anne Tree
1951
bronze, H 46.0
Exhibition: Leicester Gal. 1021, 1953, no. 17
Plaster: Epstein Trustees, on loan to Sheffield, Graves AG
Provenance: 1 Sitter
 2 Mrs R. Tree
Literature: Buckle, p. 347, pl. 539
Commission.

448 Michael Tree
1951
bronze, H 61.0
Provenance: 1 Sitter
Commissioned immediately after the bust of Lady Anne Tree (see no. 447).

449 Alic Halford Smith
1951–2
bronze, H 61.0
Exhibition: Leicester Gal. 1953, 1021, no. 18
Provenance: Oxford, New College
Literature: Buckle, p. 345, pl. 535
Commissioned by New College, Oxford. Warden of New College 1944–58 and Vice-Chancellor of Oxford University 1954–8, he was responsible for the purchase of *Lazarus* (no. 391) for New College.

450 Maquettes for Social Consciousness
1951–2
bronze, H 35.5
Provenance: ALL THREE FIGURES:
 1 Lady Cochrane; Sotheby's 14.12.66 (18)
 2 NY, Christie's 21.10.80 (106), ill.
MOURNER ONLY, H 32.5:
 3 J. Epstein; A. F. Thompson; Birmingham MAG, 1981
 4 Sotheby's 15.12.65 (105); Leicester Gal.
 5 NY, Yamet Arts; NY, SPB 25.3.71 (61)
WARRIOR WITH SWORD ONLY, H 33.6:
 6 P. J. B. Payne; Sotheby's 14.7.65 (80)
SEATED MOTHER ONLY:
 7 Sotheby's 23.4.69 (92)
Literature: Buckle, pp. 346, 368–75, pls. 537–8 (plasters)
Commissioned by Fairmount Park Trust, Philadelphia. See no. 451.

451 a *in situ*

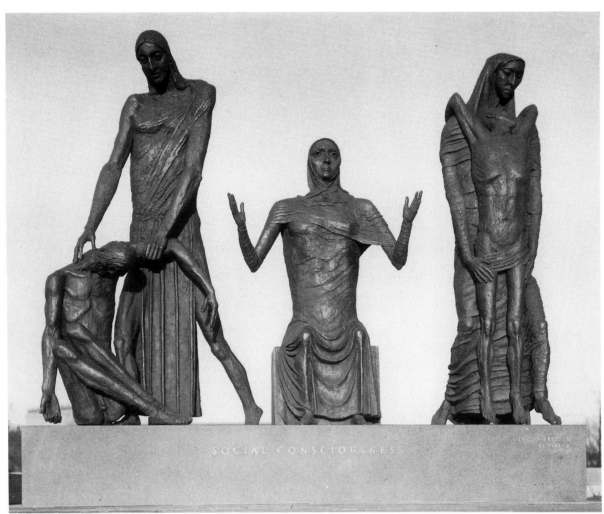

SOCIAL CONSCIOUSNESS

451 Social Consciousness, Fairmount Park, Philadelphia, sited on the West Terrace of the Philadelphia Museum of Art (plates 39, 40)

1951–3

bronze group (cast by Morris Singer, October 1953–February 1955, the heads *cire perdu*, the torsos sand cast), max. H 371, stone plinth 538 × 252

Inscription: *A grand, sane, towering, seated Mother, / Chair'd in the adamant of Time* (Walt Whitman, *America*), added to stone plinth in 1972

Literature: Fairmount Park Association Archives (FPAA), held by the Historical Society of Pennsylvania; Ireland (illustrates work in progress); Buckle, pp. 346, 368–75, pls. 582–6, 590–1; Tancock in *Sculpture of a City*, pp. 266–73

The Ellen Phillips Samuel Memorial, of which *Social Consciousness* was originally intended to be part, was begun in 1914. Designed as a series of large bronzes and carvings set on terraces along East River Drive on the bank of the Schuylkill River, Philadelphia, the ambitious memorial was to be 'emblematical of the history of America' (FPAA). The Memorial was administered by the committee of the Fairmount Park Association. Two campaigns in 1933 and 1940 had achieved two-thirds of the planned series of twenty sculptures; some were groups embodying

concepts such as the Birth of a Nation and Welcoming to Freedom, while others were single figures of typical Americans—Miner, Ploughman, Immigrant.

Following the Third International Sculpture Exhibition held in Fairmount Park in 1949, R. Sturgis Ingersoll on behalf of the Fairmount Park Association invited six sculptors to complete the monument by carrying out sculptures on the themes of Social Consciousness and Constructive Enterprise (bronze groups), Poet, Inventor, Labourer and Preacher (carved figures). These subjects were offered to G. Marcks, J. Lipschitz, J. de Creeft, K. der Harootian, A. Ben Shmuel and W. Raemisch respectively. The sculptors came from a variety of countries, but all except Gerhard Marcks were then living and working in the USA. Although other work by the German, Marcks, was already installed in Fairmount Park, his proposal for Social Consciousness failed to satisfy the committee; from the outset he had been doubtful about the feasibility of creating a coherent ensemble from the work of six sculptors and, after attempting one revision of his original design, stated that he could modify it no further. Marcks' group, comprising two standing figures—a man with his arm over his female companion's shoulder—was thought by the committee to be inappropriate and inadequate to express the 'practical

Christianity' that the theme implied.

Marcks' contract was terminated amicably in February 1951, and Ingersoll approached Epstein that very day (FPAA, Ingersoll to Marcks, Ingersoll to Epstein, 16.2.1951). Ingersoll, who already owned work by Epstein, had sent him details of the project in 1949 but he had replied so late that the six had already been selected (FPAA, Epstein to Ingersoll, 5.3.1951).

Now, starting a year behind the rest, Epstein's invitation to undertake Social Consciousness included photographs of the sketch models already submitted by the other five and a sketch plan showing the proposed layout (FPAA, plan supplied by Harleson, Hough, Livingston & Larson, architects). Social Consciousness, flanked by the stone figures of the Poet and the Preacher, was intended to balance Lipschitz's group, which would be similarly flanked by the other two carvings, on a broad terrace facing the river.

Epstein greeted the commission with enthusiasm, agreeing that a group of figures was appropriate to the expression of the theme. The contract was signed in June, and in August he visited Philadelphia to inspect the site. The three small maquettes (see no. 450) show that from the outset he envisaged a triad, a seated figure flanked by two standing, but of these only the central, seated one bears any resemblance to the final work. The seated

451 b at the foundry

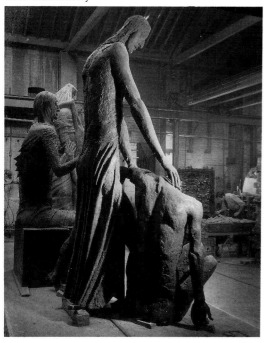

451 c at the foundry

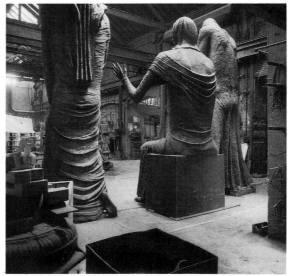

452

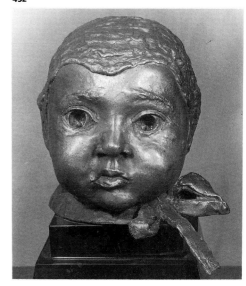

figure would be about 10 feet tall, he told Ingersoll, the flanking figures 12–13 feet, which brought them just within the 13-foot maximum upon which the committee had decided (FPAA, Epstein to Ingersoll, 14.3.1952). Such was the scale of the figures that there was insufficient room in the Hyde Park Gate studio and Epstein was lent a studio at the Royal College of Art. By November he had started work on the central figure which was to be 'a figure of judgment…seated in eternity' (FPAA, Epstein to Noble, 18.4.1952).

Already he had dropped the idea, included in his maquette, of placing this figure on a throne with a bas-relief on the back. Meanwhile his ideas about the flanking figures were undergoing radical revision. By April, as he considered the need both to 'develop the human and compassionate side of the group' and 'to bring the three parts into a co-ordinated whole', each of the flanking figures became a pair (FPAA, Epstein to Noble, 18.4.1952). In September he told Ingersoll, 'the group to the left of the fateful, seated figure is of a great "Consoler", a gentle and saving hand extended to help the afflicted and down-hearted of the world' (FPAA, Epstein to Ingersoll, 12.9.1952). At that time he intended the figure on the right to be 'one of gladness and optimism', but by the following April it too had developed into a pair and its character had changed: 'the symbol should be easily

understood. It is the Mother receiving her man-child, a figure supporting man who turns with confidence towards the great supporting mother as the soul turns finally with utmost surrender to those powers that guide and support us.' (FPAA, Epstein to Ingersoll, 16.4.1953.)

All three plasters were ready by September 1953 and despatched to Singer's Foundry (FPAA, Epstein to Ingersoll, 4.9.1953). In the meantime the committee, though delighted with the report of Epstein's group given by Henri Marceau, Director of the Philadelphia Museum, after a visit to his studio, were increasingly worried that the site designed for it was unsuitable (FPAA, Marceau to Ingersoll, 22.10.1953). The scale and expanse of Epstein's group would not balance with Lipschitz's more compact composition. The architects suggested an alternative site for the Epstein on a terrace above East River Drive. Their worries were soon compounded by the fact that Lipschitz's studio had just burnt down, destroying his quarter-size model so that he was forced to start again from scratch.

By the time casting of Epstein's group was completed in February 1955, the committee agreed that not only must they find a new site, apart from the Samuel Memorial, but that it should be installed promptly since it was unfair to expect the elderly sculptor to have his work put away in store for several years

while they waited for Lipschitz. A temporary site on the West Terrace immediately outside the neo-classical Museum of Art was selected and a wooden plinth erected. The sculptor, who attended the unveiling on 7 March 1955, professed himself pleased both by their placing on the plinth and by their appearance on the terrace, silhouetted against the sky. The committee agreed. Accordingly the wooden plinth was replaced by a stone one in 1957, and the inscription added, in fulfilment of an idea discussed by Epstein and Ingersoll, in 1972.

452 First Portrait of Annabel Freud (with bonnet)

1952

bronze, H 18.0

Inscription: *Epstein*

Exhibition: Leicester Gal. 1021, 1953, no. 7

Plasters: 1 Jerusalem, Israel Museum, 1966

2 Epstein Estate

Provenance: 1 Lady Epstein; B. Lipkin

2 Lady Cochrane; Sotheby's 14.12.66 (19)

3 NY, SPB 28.5.76 (531B), ill.

VERSION WITHOUT BONNET:

4 Leicester Gal., 1955; J. H. Hirshhorn; Washington, Hirshhorn Museum, 1966

Literature: Epstein 1955, ill.; Buckle, p. 363, pl. 568 (dates 1953)

Second daughter of Kitty and Lucien Freud.

455

456 (plaster)

457 (plaster)

458 (1)

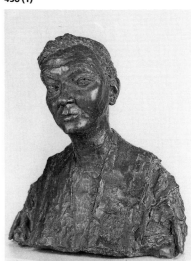

454 a

454 b

454 c

454 d

453

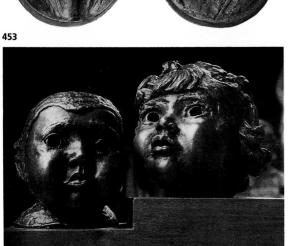

453 Ann and Annabel Freud (The Sisters)
1952
bronze, H 19.0
Exhibition: Leicester Gal. 1191, 1960, no. 49 *Sisters*
Provenance: 1 Walsall, Garman-Ryan Coll., 1973
2 S. Box; Sotheby's 1.11.67 (166)
3 E. P. Schinman; whereabouts unknown
4 NY, SPB 23.10.75 (254), ill.
Literature: Schinman, p. 77, ill.
See *Annabel (with bonnet)* (no. 452) and *Ann* (no. 416).

454 Four Door Handles
1952
bronze, 10.2 × 8.7 (oval)
Exhibitions: Edinburgh 1961, no. 152; Tate 1961, no. 85
Provenance: 1 London, Cavendish Square, Convent of the Holy Child Jesus, now Heythrop College
2 Coventry Cathedral
3 L. Osman, 1950
4 Mr & Mrs L. Schachter (Edinburgh 1961)
C ONLY:
5 Lady Epstein; B. Lipkin
Literature: Buckle, pp. 376–7, pls. 592–9
Commissioned by Louis Osman for the Convent of the Holy Child Jesus, Cavendish Square. A was based on Peter (see no. 401), B on Ian Hornstein (see no. 326), C on Annabel Freud (see no. 452), D on Isobel Hughes (see no. 432).

455 Minda Bronfman
1952
bronze
Provenance: 1 Sitter; whereabouts unknown
Literature: Buckle, p. 355, pl. 552
Commission. Heiress to a Canadian whisky fortune, later Baroness Ginsberg.

456 Mark Joffe
1952
bronze, H 30.0
Exhibition: Leicester Gal. 1021, 1953, no. 8
Provenance: 1 J. Epstein; P. Coll.
2 J. Epstein; A. F. Thompson; Watford Museum, 1982
Literature: Buckle, p. 355, pl. 556
Publisher, whose son lived with the Epstein family for some time. See *Roland Joffe* (no. 419).

457 Gina Lollobrigida
1952
bronze, green patina, H 63.0
Exhibitions: Leicester Gal. 1021, 1953, no. 3; Leicester Gal. 1968 (1 of 6)
Plaster: destroyed 1982
Provenance: 1 Sitter; whereabouts unknown
2 P. Coll., 1953
Literature: Buckle, p. 355, pl. 554
Commission. Actress.

458 Dame Hilda Lloyd (née Rose)
1952
bronze, H 56.0

459 (3)

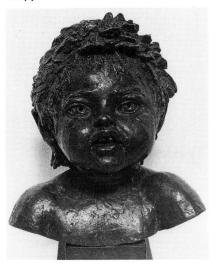

460 (1)

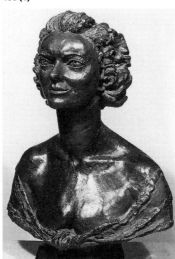

461 (plaster)

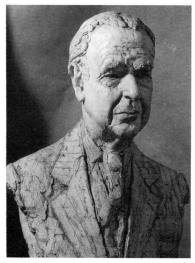

462

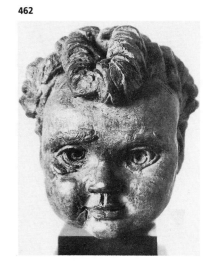

463

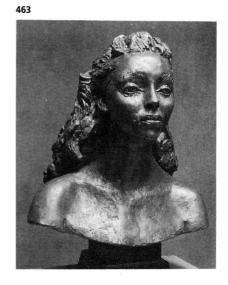

Inscription: *Epstein*
Provenance: 1 Birmingham University, Medical School
Literature: Buckle, p. 355, pl. 555
Commissioned by Birmingham University. Professor of Obstetrics and Gynaecology, awarded DBE in 1951.

459 Portland Mason
1952
bronze, H 34.0 (including base)
Exhibition: Leicester Gal. 1021, 1953, no. 11
Provenance: 1 Sotheby's 10.3.82 (130), ill.; P. Coll.
2 L. Goodman; Sotheby's 22.7.64 (63); P. Coll.
VERSION WITH HEAD AND TOP OF SHOULDERS ONLY, H 27.5:
3 O. Hughes-Jones; Bury AG, 1954, called *Young Bacchus*
Literature: Buckle, p. 355, pl. 553

460 Anna Neagle
1952
bronze, H 58.4
Provenance: 1 Sitter; Christie's 24.4.64 (198), ill.; P. Coll.; Christie's 17.11.78 (105), ill.; Dame A. Neagle-Wilcox
Literature: Buckle, p. 428 (dates 1949)
Commission. Actress.

461 Lord Simon of Wythenshawe
1952

bronze
Plaster: destroyed 1982
Provenance: 1 Sitter; whereabouts unknown
Literature: Buckle, p. 356, pl. 557
Commission. Authority on birth control.

462 Second Portrait of Annabel Freud (with curls)
1953
bronze, H 21.0
Inscription: *Epstein*
Exhibition: Leicester Gal. 1021, 1953, no. 6
Plaster: Phoenix AM, 1966
Provenance: 1 L. Goodman; NY, PB 14.1.59 (31), ill.; NY, SPB 19.5.78 (353), ill.; P. Coll.
2 Lady Cochrane; Sotheby's 14.12.66 (20)
3 J. Epstein, 1950s; Dr I. Epstein; Dr M. Evans
4 Lady Epstein; B. Lipkin
5 Sotheby's 23.4.69 (145)
6 Sotheby's 7.6.78 (100)
7 NY, Christie's 13.4.83 (183), ill.
Literature: Buckle, p. 362, pl. 569

463 Sandra Dorne
1953
bronze, H 54.4 (including base)
Inscription: *Epstein*
Exhibition: Leicester Gal. 1021, 1953, no. 12
Plaster: destroyed 1982
Provenance: 1 R. A. Shuck; Sotheby's 8.3.78 (98), ill.; P. Coll.

466 (4)

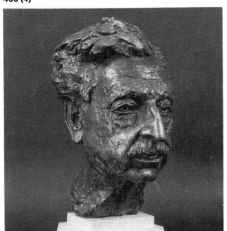

467 (plaster)

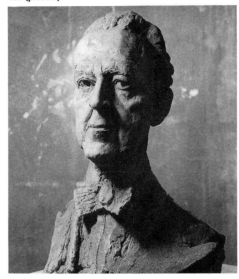

469

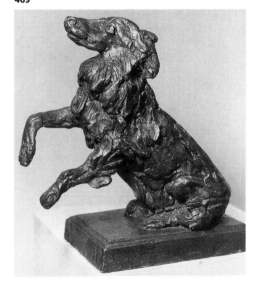

465 (1)

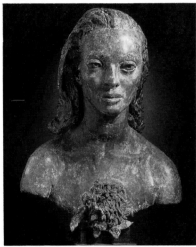

464

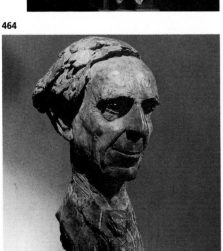

464 Lord Russell
1953
bronze, H 42.0
Inscription: *Epstein*
Exhibition: Leicester Gal. 1021, 1953, no. 13
Plaster: Jerusalem, Israel Museum, 1966
Provenance: 1 Countess Russell (1963)
2 Leicester Gal., 1955; J. H. Hirshhorn; Washington, Hirshhorn Museum, 1966
3 Sonnenberg Coll.; NY, SPB 5–9.6.79 (1505), ill.
4 J. L. Shulman Estate; NY, SPB 19.6.80 (121), ill.
Literature: Buckle, p. 361, pl. 567
Commission. Philosopher, received Nobel Prize in 1950. Produced in an edition of six.

465 Mai Zetterling
1953
bronze, H 53.3
Exhibitions: Leicester Gal. 1021, 1953, no. 4; Leicester Gal. 1968 (1 of 8)
Plaster: destroyed 1982
Provenance: 1 F. Pleasants; LA, County MA, 1963
Literature: Buckle, p. 363, pl. 570
Actress.

466 Sholem Asch
1953
bronze, H 37.0
Inscription: *Epstein*
Exhibition: Leicester Gal., Fame and Promise, 1070, 1955, no. 143

Plaster: (H 39.0) Israel, Ein Harod, 1965
Provenance: 1 L. Goodman; NY, PB 15.4.59 (23); NY, El Dieff; Austin, HRC
2 (gold patina) Lady Epstein, 1960; P. Coll.; Christie's 13.5.66 (84)
3 Jerusalem, Israel Museum, 1972
4 Mrs W. C. Treuhaft; Cleveland MA, 1983
5 London, Brook Street Gal.; NY, SPB 15.5.68 (58), ill.
6 (dark-brown patina) NY, Christie's 13.4.83 (185), ill.
Literature: Buckle, p. 360, pl. 565

467 Lionel Fraser
1953
bronze, H 52.0
Inscription: *Epstein*
Provenance: 1 Sitter; Mrs C. E. Fraser (on loan to Shroder-Waggs)
Literature: Buckle, p. 360, pl. 566
Commissioned by sitter. Merchant banker.

468 Daughter of W. Steed Ellis
1953?
bronze
Provenance: 1 whereabouts unknown

469 Frisky
1953
bronze, H 31.0
Exhibitions: Leicester Gal., New Year, 1104, 1957, no. 123; Leicester Gal. 1191, 1960, no. 52 (4 of 12)

470 (plaster)

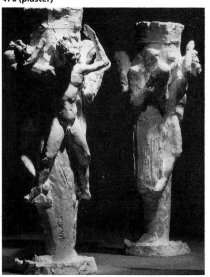

471

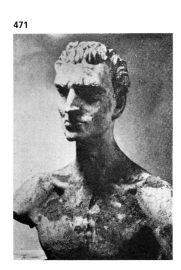

472 (1)

473 (1)

Provenance: **1** Walsall, Garman-Ryan Coll., 1973
2 Epstein Estate; B. Lipkin
3 FAS
4 Lady Epstein; Christie's (Aldeburgh Festival) 23.3.61 (3)
Literature: Buckle, p. 363, pl. 572
Epstein's Shetland sheepdog. Lady Epstein stated that her cast was fourth of an edition of six.

470 Mace Head
1953
plaster
Provenance: Buckle illustrates two plasters
Literature: Buckle, p. 363, pl. 571
Commission for Singapore never realized.

471 Terence O'Regan
1953
bronze
Provenance: **1** Sitter; whereabouts unknown
Literature: Buckle, p. 360, pl. 563
Commission. Actor.

472 Professor James Walter Macleod
1953
bronze, H 33.0
Inscription: *Epstein*
Provenance: **1** Leeds University, School of Medicine
Literature: Buckle, p. 429 (dates 1952)

Professor of Bacteriology, Dean of Faculty of Medicine, Leeds University, 1949–52.

473 Sir Stafford Cripps
1953
bronze
Plaster: destroyed 1982
Provenance: **1** London, St. Paul's Cathedral, crypt
Literature: Buckle, p. 365, pl. 575 (dates 1954)
Commission. Cast by Morris Singer, December 1953–May 1954.

474 Maquette for Christ in Majesty
1953
lead, H 63.5
Inscription: *Epstein*
Exhibitions: Leicester Gal., New Year, 1130, 1958, no. 116; Leicester Gal. 1191, 1960, no. 53 (dated 1955, last of 12)
Provenance: **1** Leicester Gal., 1958; J. H. Hirshhorn; Washington, Hirshhorn Museum, 1966
2 Sotheby's 6.4.60 (68); P. Coll.
3 S. Eckman; Sotheby's 1.11.67 (166)
4 Lord Beaumont; Sotheby's 20.12.67 (93); B. Sandelson
5 F. Dark; Christie's 4.6.71 (150), ill.
6 Sotheby's 12.11.75 (103)
Literature: Buckle, p. 365, pl. 573 (dates 1953)
Maquette for *Christ in Majesty* at Llandaff (no. 475).

474

478

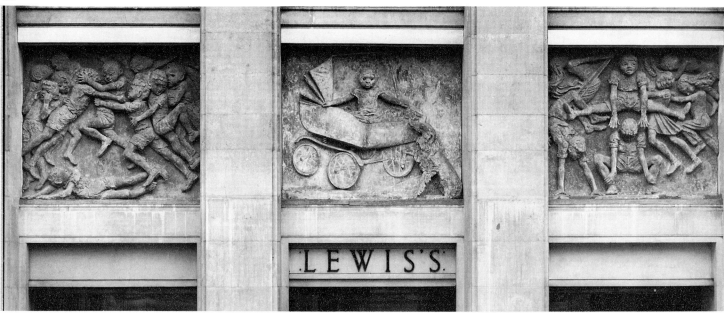

477 (plaster)

475

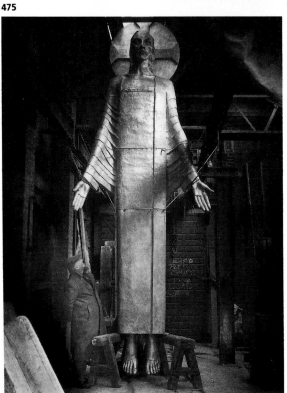

475 Christ in Majesty, organ loft, Llandaff Cathedral, Wales (plate 44)

1954–5

aluminium (cast by Morris Singer), H *c.*430

Exhibition: Edinburgh 1961, no. 212 (plaster)

Plaster: NY, Church of Riverside Drive

Literature: Llandaff Cathedral Archives; Ireland, ill.; Buckle, 1963, pp. 365, 385–7, pls. 587, 610–12

Llandaff Cathedral had been seriously damaged by a landmine in 1941. George Pace, the architect charged with the reconstruction and restoration of the cathedral, had designed a giant arch to support the cylindrical organ loft. Epstein was formally commissioned to undertake the Maiestas figure for the organ loft in October 1953. 'Tomorrow I will formally commission Epstein and send him the drawing and the model' (Pace to Dean Simon, 27.10.1953).

The sculpture was paid for by £3,500 from the stained-glass compensation fund, but it was originally intended that the sculpture should be in gilt plaster only. However, by December, both Pace and Epstein had decided that the sculpture should be cast in aluminium which would be light, possess far greater durability and would also have the soft, silvery colour they agreed was most in keeping with the building. The finish, Pace wrote, 'would not be bright like a polished saucepan but could be dealt with to give the sort of patina that is desirable' (Pace to Dean, 21.12.1954). This would cost £1,500, but the Dean promised to recommend it to the Chapter: 'Epstein has charged little enough; we ought to be prepared to sanction £1,500 to preserve his work' (Dean to Pace, 31.12.1954).

Epstein was at work on the figure through the latter part of 1954, first at Hyde Park Gate,

and later in the larger studio at the Royal College of Art, where he worked all through Christmas on this and *Liverpool Resurgent* (no. 476). Even in the studio the scale of the figures was so great that it was difficult to get a feel for the relationship of parts to the whole; Epstein enlisted the help of Geoffrey Ireland, then teaching photography at the College, in having wide-angle photographs taken as he worked. The sculpture was cast by Morris Singer between April 1955 and Spring 1956. Pace told the Dean that the finished casting was 'quite magnificent. There is not the slightest vestige of a saucepan! In fact the texture and finish are almost indistinguishable from lead' (Pace to Dean, 26.3.1956). It was unveiled on 10 April 1957.

476 Liverpool Resurgent, Lewis's Store, Liverpool (plate 42)

1954

bronze (cast by Morris Singer), H *c.*540

Provenance: VERSION WITH TORSO ONLY, H 213:

1 E. P. Schinman; whereabouts unknown

Literature: Buckle, pp. 366–7, 390–2, pls. 579, 581, 600, 619–20

Commissioned in 1954 by F. J. Marquis, First Baron Woolton, to adorn the porticoed entrance to the new Lewis's Store, at the junction of Ranelagh and Renshaw Streets, Liverpool. The old store had been destroyed by bombing on 3 May 1941, and the figure standing on the prow of a ship symbolized 'Liverpool rising from the flames of war', according to the *Liverpool Echo* report of the unveiling, which took place on 20 November 1956.

Epstein was working simultaneously on the Llandaff *Christ in Majesty* (no. 475) and this figure in August to October 1954. In November he was able to move into a studio

479 (1)

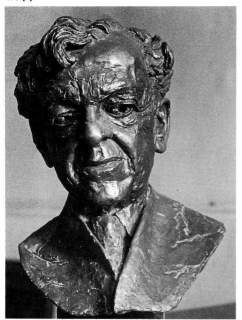

480 (2)

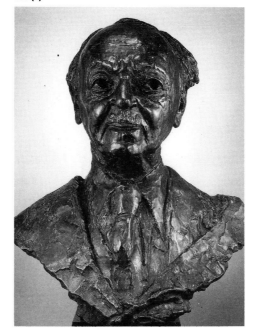

481 (1)

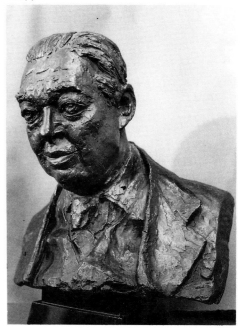

482 (1)

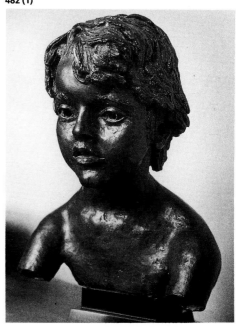

at the Royal College of Art, and in January reported that the work was ready for casting in plaster (Epstein to P. Hornstein, 4.8.1954, 3.9.1954, 27.10.1954, 17.1.1955).

He began work on the ship's prow plinth in October 1955, after his return from the USA, and was assisted by his regular plaster moulders, Bill Olds and Jan Smith (Epstein to P. Hornstein, 20.10.1955). Casting took place at Singer's from November 1955 to October 1956.

477 Ship's Prow with Figures
1954
plaster
Literature: Buckle, p. 366, pl. 580
Preliminary idea for the Lewis's façade, Liverpool (nos. 477, 479). The figure in front of the prow may be influenced by Alfred Stevens' allegorical figures of Truth and Falsehood and Valour and Cowardice on the Wellington tomb, St. Paul's Cathedral.

478 Liverpool Reliefs: Children Fighting, Baby in a Pram, and Children Playing (plate 41)
1955–6
cement fondu, H 101, W 183
Provenance: Liverpool, Lewis's store, main entrance
Literature: Buckle, pp. 391–2, pls. 619, 621–3; Ireland (illustrates work in progress)
Added to commission for *Liverpool Resurgent* (no. 476) at Epstein's suggestion and expense. The central panel, *Baby in a Pram*, was modelled on Annabel and Frisky (see nos. 452, 469).

479 Dr J. J. Mallon
1954
bronze, H 42.0
Inscription: *Epstein*
Plaster: destroyed 1982

Provenance: 1 London, Toynbee Hall
2 E. P. Schinman; whereabouts unknown
Literature: Buckle, p. 365, pl. 577; Schinman, p. 78, ill.
Commission. Warden of Toynbee Hall, 1919–54.

480 Dr Elias A. Lowe
1954
bronze
Inscription: *Epstein*
Plaster: Family collection
Provenance: 1 Sitter; J. Lowe; NY, Metropolitan Museum, 1956
2 NY, Pierpoint Morgan Library
3 Family collection
4 Family collection
Literature: Buckle, p. 360, pl. 562 (confuses sitter with Ludwig Loewy, see no. 485)
Commissioned, according to Buckle, by Princeton University. Palaeographer. Referred to in Epstein to P. Hornstein, 10.11.1954.

481 Lord Braintree
1954
bronze
Provenance: 1 P. Coll.
Literature: Buckle, p. 365, pl. 578
Commission. Managing Director of Crittall Ltd.

482 Charles Lane
1954
bronze, gilt patina, H 38.0
Inscription: *Epstein*
Plaster: Ottawa, NG Canada, 1966
Provenance: 1 P. Coll.
2 Mrs J. Byrne; Christie's 20.12.74 (130)
3 Phillips' 25.3.86 (118), ill.
Literature: Buckle, p. 365, pl. 576
Commission. Doctor, nephew of Lord Rothschild.

486 (1)

487

485

484 (1)

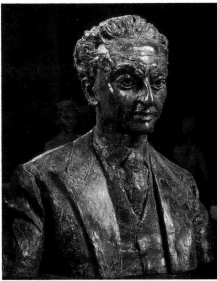

483

483 Jan Christian Smuts, Parliament Square, London (plate 43)

1953–5

bronze, over life-size

Exhibitions: Leicester Gal. 1191, 1960, ex-cat. *Head of Smuts* (2 of 3); Leicester Gal. 1968, head only (edition of 6 sold out)

Plasters: (head only, H 53.0) **1** NY, Jewish Museum, 1966

2 Melbourne, NG Victoria, 1971

Provenance: VERSION WITH HEAD ONLY, H 51.0:

1 B. Rose; Jerusalem, Israel Museum, 1966

2 E. P. Schinman; whereabouts unknown

3 Sotheby's 20.6.62 (165); C. J. Sawyer; Christie's (date unknown)

Literature: Buckle, p. 274, 388, pls. 588–9, 618; Schinman, p. 75, ill.

Commissioned by Office of Works in spring 1953 (Epstein to R. Sturgis Ingersoll, 16.3.1953). South African Prime Minister, 1919–24, 1939–48. The whole figure was cast by Gaskin's, early 1955, but the head alone was cast by Morris Singer, March–May 1957. By February 1956 the sculpture was await-ing its plinth of South African granite. Unveiled 7 November 1956.

484 Bishop Woods of Lichfield

1955

bronze, H 99.0 (plaster)

Plaster: (H 99.0) Melbourne, NG of Victoria, 1971

Provenance: **1** Lichfield Cathedral

Literature: Buckle, p. 409, pls. 650–1

Commissioned by Bishop Woods' exec-utors. A bas-relief was originally con-templated; Epstein and Kathleen visited Lichfield to discuss it (16.1.1955). The bust was displayed higher and in a different position from that intended. For this reason Epstein declined to attend the unveiling. Cast by Morris Singer, February–June 1958.

485 Ludwig Loewy

1955

bronze, H 66.0

Inscription: *Epstein*

Provenance: **1** Loewy Engineering Co., now Bournemouth, Davy McKee (Poole) Ltd.

2–6 five other casts made for members of Loewy family (Sitter's brother to R. Buckle, 1964)

Literature: Buckle, p. 360, pl. 562 (wrongly identifies sitter as Dr Elias Lowe, see no. 480, and dates 1953)

The posthumous portrait is referred to in Epstein to P. Hornstein, 17.1.1955: 'I have only two small snapshots to work from so I will have to perform a miracle and imagine the subject.' G. Ireland enlarged the snaps to a usable size.

486 American Girl (Juleen)

1955

bronze, H 34.5

Exhibition: Leicester Gal. 1968 (3 of 6)

Plaster: destroyed 1982

Provenance: **1** L. Goodman; Sotheby's 22.7.64 (65); London, Black-Nadeau

2 P. Coll.; NY, SPB 24.10.74 (366), ill.; P. Coll.

Literature: Buckle, p. 429

487 Nancy Rodgers

1955

bronze

Provenance: **1** Sitter; whereabouts un-known

Literature: Buckle, p. 429

Commission. Daughter of Richard Rodgers. Only a poor H. Wild contact print survives.

488 Franklin Medal

1955

bronze

Provenance: **1** W. S. Churchill

489 (1)

488 a

488 b

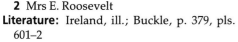

490 *in situ*, 1958

2 Mrs E. Roosevelt
Literature: Ireland, ill.; Buckle, p. 379, pls. 601–2
Commissioned for presentation 11 January 1956. Recto, Benjamin Franklin; verso, Prometheus head with stolen rays of the sun with which he made fire.

489 Maquette for Trades Union Congress War Memorial

1955
bronze, H 53.2
Inscription: *Epstein*
Exhibition: Edinburgh 1961, no. 156
Provenance: 1 Bolton AG (by courtesy of the TUC, 1958)
Literature: Buckle, p. 381, pl. 606
Epstein declined to take part in a competition for the memorial in December 1954, but accepted a direct invitation the following March. The sum of £16,000 had been put aside for sculpture; Epstein's group, a war memorial, was intended for the central courtyard of the new building, while Bernard Meadows was commissioned to carry out a bronze group for the forecourt. The model was produced between March and May that year, before Epstein's departure for the USA. The maquette was accepted and Epstein was formally offered and accepted the commission in August while he was still in America. The contract, drawn up on 7 November 1955, specified that Epstein 'shall execute a carving in stone chosen and provided by the architect [David du R. Aberdeen] of the TUC Memorial Building, after the plaster model accepted by the Congress.' See no. 490.

490 Trades Union Congress War Memorial, Congress House, Great Russell Street, London (plates 45, 46)

1956–7
Roman stone, block 300 × 150 × 120
Literature: Buckle, pp. 403–6, pls. 644–6

The contract of 7 November 1955, specified that Epstein should start work as soon as the stone was on site and had a year to complete the work for which he would be paid £5,000, one third on the acceptance of the model, one third after six months' work and one third upon completion.

The block was put in place in February and by the beginning of March he had begun work. For the first time he employed assistants to bolster the stone. Even so, as he reported to his daughter:

(1 March) I have let myself in for some devilish hard work as this particular block is as hard as granite and tools just break on it...(30 April) I go every morning by cab as I found the bus too slow and I was losing time. I find myself tired out at about 1.30 and go back and have lunch and a rest. I am making good progress and if it weren't for the terrific noise of building going on all about me I would feel all right. I have this stone in a hut in position in the open court of the building and lock it up when I leave otherwise the press would be in taking photographs.

The carving was complete by Christmas 1956, but the building was not finished until late in the following year and was only formally opened on 27 March 1958, when Epstein was in hospital, seriously ill with thrombosis and pleurisy.

491 Barnett Janner

1955–6
bronze, H 46.0
Inscription: *Epstein*
Plaster: destroyed
Provenance: 1 Lady Janner
Literature: Buckle, p. 428
Commission. Solicitor, Labour MP for Leicester NW, President of the Board of Deputies of British Jews 1955.

491 (1)

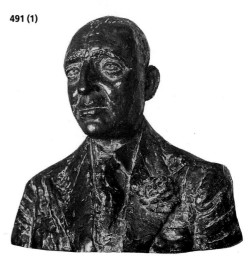

494 (plaster)

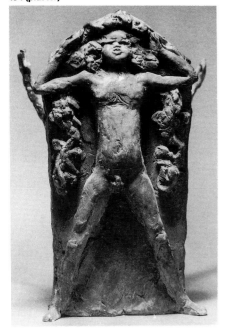

493 (1)

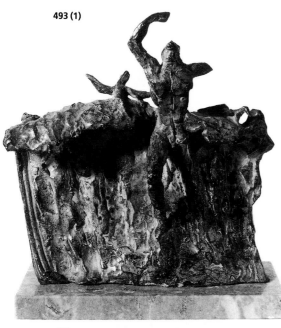

492

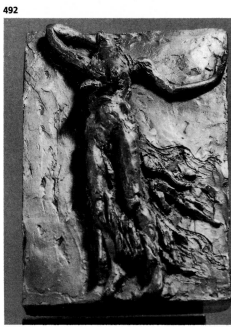

496 (1)

492 The Wave
1956
bronze, H 30.5
Provenance: 1 Lady Cochrane; Sotheby's 14.12.66 (25); P. Coll.; Y. Solomon
Literature: Buckle, p. 380, pl. 603
Cast after 1959 by Lady Epstein.

493 The Muse
1956
bronze relief, H 29.9
Exhibition: Edinburgh 1961, no. 154
Provenance: 1 Lady Cochrane; Sotheby's 14.12.66 (24); P. Coll.; Y. Solomon
Literature: Buckle, p. 380, pl. 605
Cast after 1959 by Lady Epstein.

494 Young Bacchus
1956
bronze relief, H 28.0, w 15.2
Provenance: 1 E. P. Schinman; whereabouts unknown
Literature: Buckle, p. 380, pl. 604; Schinman, p. 76, ill.
Cast after 1959 by Lady Epstein. Modelled on the reverse of the Seated Mother maquette for *Social Consciousness* (no. 450).

495 Professor Sir James Gray
1956
bronze, H 63.5
Inscription: *Epstein*
Plaster: destroyed 1982
Provenance: 1 Cambridge University, Dept. of Zoology
Literature: Buckle, p. 387, pl. 614; Cambridge, Fitzwilliam Museum, *Cambridge Portraits*, 1978, no. 72
Commission. Professor of Zoology, Cambridge University, 1927–59.

496 The Hon. Robert Hesketh
1956
bronze, H 45.0 (plaster)
Plaster: (H 45.0) Jerusalem, Israel Museum, 1966
Provenance: 1 Christian Lady Hesketh
2 Epstein Estate
Literature: Buckle, p. 388, pl. 617
Commissioned by Lady Hesketh, but Epstein given choice of which of three sons to sculpt.

497 Marquess of Normanby
1956
bronze, H 54.3
Provenance: 1 P. Coll.
Literature: Buckle, p. 387, pl. 613
Commission.

498 Monument to William Blake
1956
bronze, H 54.0
Exhibition: Leicester Gal. 1191, 1960, no. 56 (2 of 3)
Plaster: (H 54.0) Jerusalem, Israel Museum, 1966
Provenance: 1 London, Westminster Abbey, Poets' Corner
2 E. P. Schinman; whereabouts unknown
Literature: Buckle, p. 400, pls. 639–40; Schinman, p. 78, ill.
Commissioned by Blake Society. Unveiled October 1957.

499 Dr Streen
1956
bronze, H 38.0
Inscription: *Epstein*
Provenance: 1 Bullock; NY, PB 23.3.61

497 (1)

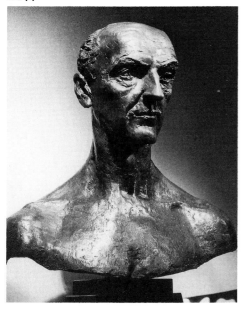

(65), ill.; P. Coll.; NY, SPB 7.4.73 (60), ill.
Commission. Montreal surgeon.

498

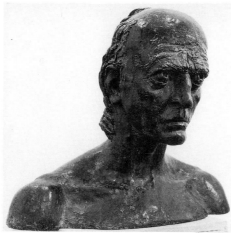

500

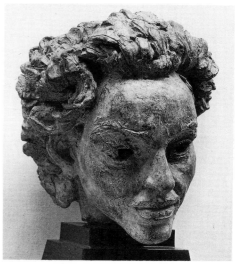

500 Rosalyn Tureck
1956
bronze, H 28.0
Inscription: *Epstein*
Exhibition: Leicester Gal., New Year, 1104, 1957, no. 125
Plaster: NY, MOMA, 1966
Provenance: 1 Sitter
2 Greater London Council, Royal Festival Hall, 1956
3 A. Haskell; FAS, 1975; Sydney, D. Jones Gal.
4 L. Goodman; NY, PB 26.5.61 (28), ill.; Mr & Mrs G. Friedland; Philadelphia MA, 1962
5 P. Rydzerenski, 1958; P. Coll.; Christie's 23.6.75 (121); Mrs B. Kahn
6 NY, Continental Gal.; NY, SPB 7.10.72 (61), ill.; P. Coll.
Literature: Ireland, ill.; Buckle, p. 383, pl. 609
Commission. Concert pianist.

501 The Hon. Wynne Godley
1956
bronze, H 50.0
Exhibition: Leicester Gal. 1191, 1960, no. 55
Plaster: Israel, Ein Harod, 1965
Provenance: 1 Viscount Astor (Edinburgh 1961)
2 L. Goodman; NY, PB 15.4.59 (24)
3 E. P. Schinman; whereabouts unknown
4 Mrs M. Rubin; NY, SPB 11.2.71 (85), ill.; H. Gutfreund; NY, SPB 17.7.81 (55), ill.
5 Epstein Estate
6 (= cast 4?) J. Lawrence (*Architectural Digest*, October 1981)

501

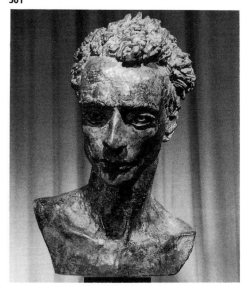

Literature: Buckle, p. 383, pls. 608, 649; Schinman, p. 55, ill.
Younger son of the Third Lord Kilbracken, second husband of Kitty (see no. 508). Model of the head of *St. Michael* (no. 503).

502 Maquette for St. Michael and the Devil
1956
bronze, H 53.5
Plaster: (H 54.0) Israel, Ein Harod, 1965
Provenance: 1 L. Goodman; Sotheby's 22.7.64 (66); Lord Beaumont; Sotheby's 12.11.75 (102)
2 Lady Cochrane; Sotheby's 14.12.66 (23); P. Coll.; Sotheby's 4.11.83 (124), ill.
3 NY, PB 12.12.61 (29)
4 E. P. Schinman; whereabouts unknown
Literature: Buckle, p. 393, pl. 624; Schinman, p. 55, ill.
Commissioned for Coventry Cathedral, November 1955. See no. 503.

503 St. Michael and the Devil, Coventry Cathedral (plate 48)
1956–8
bronze, H 594 (St. Michael) 1066 (overall)
Exhibition: Edinburgh 1961, no. 230 (plaster)
Literature: Buckle, pp. 393–5, 407, 420–1, pls. 647–8, 662–3; Ireland, ill. (in studio); B. Spence, *Phoenix at Coventry*, 1962, pp. 67–73, ill.
Commissioned, in spite of the reservations of some of the committee at entrusting a Christian theme to a Jewish sculptor. Head and wings of St. Michael modelled by January 1957 when Spence visited the studio. Delivered to foundry (Singer) April 1958. Unveiled 24 June 1960 by Lady Epstein. Related drawing, Birmingham MAG.

502 (clay)

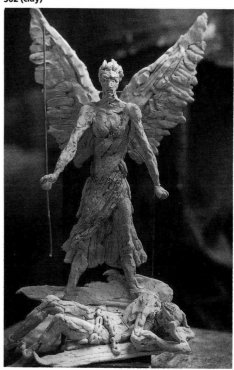

506 (1)

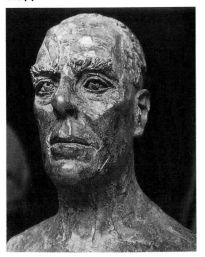

507 (plaster)

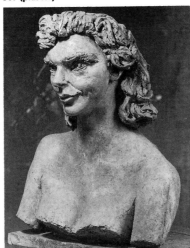

508

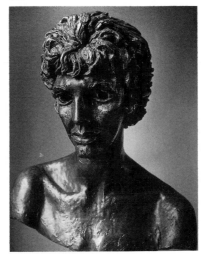

509 (1)

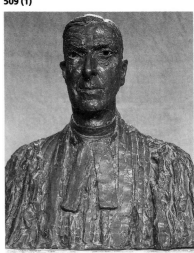

505

504

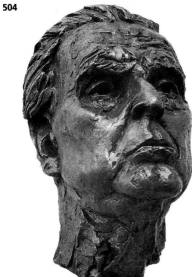

504 Dr Otto Klemperer

1957
bronze, H 36.9
Inscription: *Epstein*
Exhibition: Leicester Gal. 1191, 1960, no. 57 (3 of 6)
Plaster: (H 40.0) Jerusalem, Israel Museum, 1966
Provenance: 1 Greater London Council, Royal Festival Hall, 1958
2 Lord Harewood (1963)
3 Earl of Drogheda; Christie's 14.7.67 (131)
4 E. P. Schinman; whereabouts unknown
Literature: Buckle, p. 397, pls. 622–3 (dates 1957); Schinman, p. 58, ill.
Commissioned by Greater London Council for Festival Hall. Conductor.

505 Maria Donska

1957
bronze, H 42.0
Inscription: *Epstein*
Plaster: destroyed 1982
Provenance: 1 Sitter
2 J. Epstein; Southport, Atkinson AG, 1959
Literature: Buckle, p. 396, pl. 631
Commission. Pianist friend of Epstein. She frequently played at his home.

506 Sir Wilfred Edward le Gros Clark, FRS

1957
bronze, green patina, H 40.0
Inscription: *Epstein*
Plaster: Ithaca, Cornell University, 1966
Provenance: 1 Oxford University, School of Human Anatomy
Literature: Buckle, p. 397, pl. 630
Commission. Professor of Anatomy, Oxford University, 1934–62.

507 Virginia, Marchioness of Bath

1957
bronze, H 57.0
Inscription: *Epstein*
Provenance: 1 Longleat, Marquess of Bath
Literature: Buckle, p. 397, pl. 629
Commission. Formerly Virginia Parsons, niece of Iris Tree (see no. 60) and cousin of Marie Beerbohm (see no. 57).

508 Third Portrait of Kitty (with short hair)

1957
bronze, H 49.5
Plaster: (H 57.0) Israel, Ein Harod, 1965
Provenance: 1 Sitter; Epstein Estate
2 E. P. Schinman; whereabouts unknown
3 Sir E. Hayward; Hayward Bequest, Carrick Hill
4 Hon. Mrs W. Godley; Sydney, D. Jones Gal., *c.*1960; Dr N. Behan; Brisbane, Queensland AG, 1978
Literature: Buckle, p. 398, pls. 634–5; Schinman, p. 57, ill.

509 John Lowe

1957
bronze, H 61.0
Inscription: *Epstein*
Plaster: Ottawa, NG Canada, 1966
Provenance: 1 Oxford, Christ Church
Literature: Buckle, p. 387, pl. 615 (dates 1956)

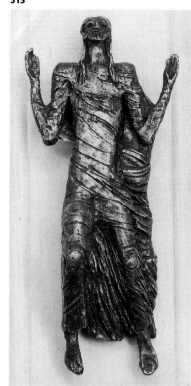

513

510 (1)
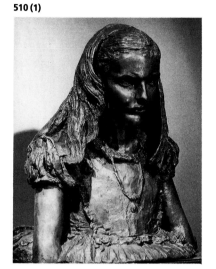

511
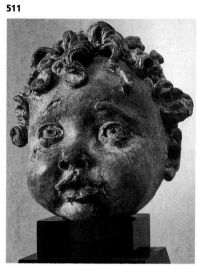

512 (1)
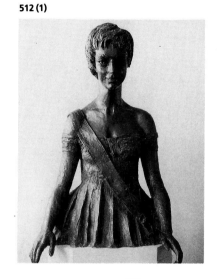

514
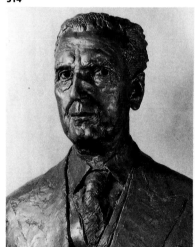

515 (1)
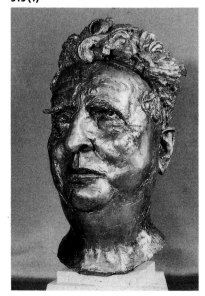

Commissioned for Christ Church by Mr Israels and Sir Simon Marks. Presented to the college 23 May 1958. Dean of Christ Church, 1939–59.

510 Lady Lepel Phipps
1957
bronze, H 50.8
Inscription: *Epstein*
Plaster: Jerusalem, Israel Museum, 1966
Provenance: 1 P. Coll.
Literature: Buckle, p. 401, pl. 641 (plaster)
Commissioned by the Marquess of Normanby. Portrait of his eldest daughter.

511 Tabitha
1957
bronze, H 22.8
Plaster: Oberlin, Allen Memorial Museum, 1967
Provenance: 1 J. Epstein, 1950s; Dr I. Epstein; Dr M. Evans
2 E. P. Schinman; whereabouts unknown
3 L. Goodman; Christie's 26.4.63 (169); P. Coll.
4 Lady Cochrane; Sotheby's 14.12.66 (22)
5 Sotheby's 11.12.68 (65)
Literature: Buckle, p. 401, pl. 642; Schinman, p. 56, ill.

512 HRH Princess Margaret
1958
bronze, H 92.0
Exhibition: London, Royal Academy, Summer Exhibition, 1960
Plaster: destroyed 1982
Provenance: Keele University, 1959
Literature: Buckle, p. 403, pl. 643

Commission. Sittings took place in February 1958, but were broken off when Epstein was taken ill. Cast by Morris Singer, November 1959–April 1960.

513 Maquette for Ascension of Christ
1958–9
lead, H 34.9
Provenance: 1 Lady Epstein; B. Schiff, 1966
2 Lady Cochrane; Sotheby's 14.12.66 (26)
3 L. Goodman; Sotheby's 22.7.64 (67)
Maquette for Crownhill Church, Plymouth, commissioned together with designs for stained glass by the architect, Frank Potter, and the Revd Eric Turnbull. Unfinished at sculptor's death. Produced in an edition of six according to Lady Epstein

514 Sir William Haley
1958
bronze, H 63.0
Inscription: *Epstein*
Provenance: 1 Sitter
2 London, Broadcasting House
Literature: Buckle, p. 410, pl. 652
Commission. Director-General of the BBC, 1944–52, and subsequently editor of *The Times*.

515 Professor Charles McInnes
1958
bronze, H 38.0
Provenance: 1 Bristol CAG, 1959
Literature: Buckle, p. 410, pl. 653
Commissioned by subscribers. Professor of Imperial History, Bristol University, 1943–57.

516(1)

518(1)a

518(1)b

517(1)

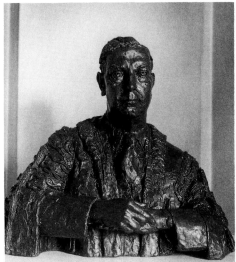

519 (plaster)

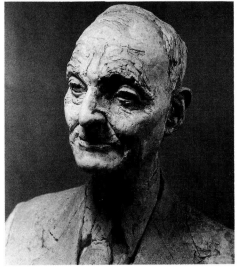

520

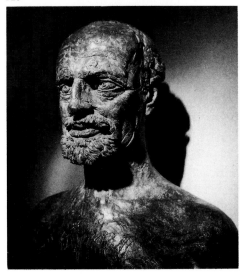

516 Archbishop Geoffrey Francis Fisher

1959
bronze, H 63.5
Exhibition: Leicester Gal. 1191, 1960, no. 58
Provenance: 1 London, Lambeth Palace
Literature: Buckle, p. 412, pl. 656
Archbishop of Canterbury, 1945–61.

517 Sir Russell Brain, Bt. FRS

1959
bronze, H 73.7
Inscription: *Epstein*
Provenance: 1 London, Royal College of Physicians
Literature: Buckle, p. 412, pl. 657 (dates 1959)
Commissioned by Royal College of Physicians. Neurologist, President of RCP 1950–7.

518 David Lloyd George

1959
bronze, H 63.5
Exhibition: Edinburgh 1961, no. 130 (plaster)
Plaster: (H 73.8) Epstein Estate; Cardiff, NMW

Provenance: 1 Leicester Gal.; J. W. McConnell; Fredericton, New Brunswick, Beaverbrook AG, 1964
VARIANT, H 24.0:
2 Epstein Estate
Literature: Buckle, p. 411, pl. 654
Life-size posthumous portrait commissioned by Office of Works for House of Commons. Unfinished at Epstein's death, but two variant studies were modelled.

519 Ivan Sanderson

1959
bronze
Provenance: 1 Sanderson & Co.; whereabouts unknown
Literature: Buckle, p. 413, pl. 658
Commission. Head of textile firm.

520 Basil Spence

1959
bronze, H 45.0
Inscription: *London Art Foundry* (stamp)
Plaster: University of Sussex, 1966
Provenance: 1 London, RIBA
2 Lady Spence
Literature: B. Spence, *Phoenix at Coventry*,

1962, pp. 72–3; Buckle, pp. 413–14, pl. 659
Commissioned by the RIBA. Architect of Coventry Cathedral, for which Epstein executed *St. Michael* (no. 503). Awarded OBE 1948, knighted 1960.

521 Maquette for Bowater House Group

1958
bronze, H 28.0, base 33.7 × 10.8
Exhibition: Leicester Gal. 1191, 1960, no. 61
Provenance: 1 H. Samuel, 1961; Bowater Corporation
Literature: Buckle, p. 395, pl. 628
Commissioned by Bowater to be placed outside their new headquarters building adjoining Hyde Park. See no. 522.

522 The Bowater House Group, Edinburgh Gate, Knightsbridge, London (plate 47)

1958–9
bronze
Literature: Buckle, pp. 395, 420–3, pls. 664–7
Commissioned by Sir Harold Samuel of Land Securities Investment Trust (then owners

521 (1)

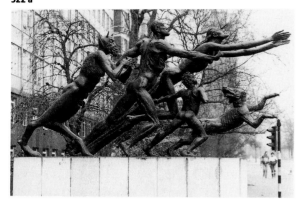

522 a

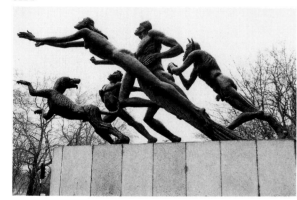

522 b

523 (1)

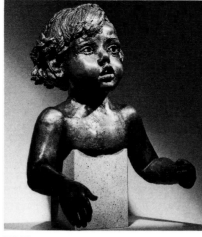

524 (1)

526 (2)

527

528 (1)

of Bowater House) for presentation to the Crown. The sculpture was designed to stand facing the south side of Hyde Park against a road arch running under the newly built Bowater House (Guy Morgan and Partners, architects), so that the group faces and is flanked by roads. Epstein was given a free hand with the choice of subject and never gave the work a title, with the result that it is variously known as 'The Pan Group', 'The Return of Spring' and 'Rites of Spring' as well as the title given above. Presumably the maquette (no. 521), which closely resembles the final group and which still belongs to the Bowater Corporation, was approved by Eric Bowater. It represents a mother, father and child moving towards the open spaces of the park away from the bustle of the city, encouraged by Pan and led on by their dog.

Epstein began work on the mother in January 1958, just as *St. Michael and the Devil* (no. 503) was nearing completion. According to Lady Epstein, work on the group was completed on the day of his death, 19 August 1959. It was cast by Singer's between November 1959 and May 1961, but the exact date of installation is unknown since there was no

unveiling ceremony. It is now in the care of the Department of the Environment.

523 Lady Sophia Cavendish
1959
bronze, H 45.1
Exhibition: Leicester Gal. 1191, 1960, no. 59
Plaster: Jerusalem, Israel Museum, 1966
Provenance: 1 Duke of Devonshire
Literature: Buckle, p. 414, pl. 660
Commissioned by the Duke of Devonshire.

524 Lady Evelyn Phipps
1959
bronze, H 54.6
Exhibition: Leicester Gal. 1191, 1960, no. 60
Plaster: (H 42.0) Israel, Ein Harod, 1965
Provenance: 1 P. Coll.
Literature: Buckle, p. 414, pl. 661
Commissioned by the Marquess of Normanby. Portrait of his younger daughter.

525 Dr Weiss
date unknown
bronze, H 29.2
Provenance: 1 E. Neild; Christie's 10.3.72 (101)

526 Epstein's Left Hand
date unknown
bronze, L c.19.0
Plaster: Epstein Estate
Provenance: 1 Lady Epstein; P. Coll. ; NY, SPB 24.10.74 (362a)
2 Lady Epstein; P. Coll.; Sotheby's 16.3.77 (84)
3 P. Coll.
Probably cast after 1959.

527 Woman taking off her Dress
date unknown
stone, 144 × 108 × 20.0
Provenance: Lady Epstein; London, Roper Gardens
This unfinished piece is now located near the site of Epstein's Cheyne Walk studio (1907–12). It stands on a circular plinth designed by Stephen Gardiner, and was unveiled by Sir Casper John, 3 June 1972.

528 Nude Study
date unknown
bronze, green patina, L 64.0
Plaster: B. Lipkin
Provenance: 1 Epstein Estate

Unpublished Sources

FPAA: Fairmount Park Association Archive held by the Historical Society of Pennsylvania, Philadelphia.

Holden: Assorted typescripts, press cuttings, Memoirs, etc., by Charles Holden, currently held by Adams Holden Pearson, London, but destined for the Library of the Royal Institute of British Architects.

Hornstein: Correspondence from Epstein to his daughter, Peggy Jean Hornstein (Mrs P. Lewis), 1947–58, quoted by courtesy of Mrs Lewis.

HRC: Henry Ransom Humanities Research Center, University of Texas at Austin, holds correspondence from Epstein to B. van Dieren, Lady Ottoline Morrell, H. P. Roché, Harold Munro, Hugh Walpole, Ronald Duncan and others.

RSPB: Records of the W. H. Hudson Memorial Committee held by the Royal Society for the Protection of Birds.

Published Sources

Adams, L., *Art on Trial from Whistler to Rothko*, New York, 1976

Arts Council of Great Britain (Tate Gallery), *Epstein* (Introduction by P. James), 1952

Arts Council of Great Britain (Tate Gallery), *Epstein. Arts Council Memorial Exhibition* (Introduction by J. Rothenstein), 1961

Arts Council of Great Britain (Hayward Gallery), *Vorticism and its Allies* (organized by R. Cork), 1974

Aumonier, W. (editor), *Modern Architectural Sculpture*, The Architectural Press, 1930

Babson, J. F., *The Epsteins: A Family Album*, Taylor Hall, London, 1984

Bagnold, E., *Enid Bagnold's Autobiography (from 1889)*, Heinemann, 1969

Barman, C., *The Man Who Built London Transport; A Biography of Frank Pick*, David & Charles, 1959

Beattie, S., *The New Sculpture*, Yale University Press, 1983

Beckett, J., 'Cubism and Sculpture in England before the First World War', in S. Nairne and N. Serota (editors), *British Sculpture in the Twentieth Century*, London, 1981, pp. 48–61

Belgion, M., 'Meaning in Art', *Criterion*, 9, 1930, pp. 201–16

Black, R., *The Art of Jacob Epstein*, World Publishing Company, New York and Cleveland, 1942

Bolitho, H., *Twelve Jews*, London, 1934

Brookner, A., review of ACGB exhibition at Tate Gallery, 1961, *Burlington Magazine*, 103, 1961, p.523

Brown, O., *Exhibition: The Memoirs of Oliver Brown*, Evelyn, Adams & Mackay, London, 1968

Buckle, R., *Jacob Epstein Sculptor*, Faber & Faber, 1963

Buckle, R., and Lady Epstein, *Epstein Drawings*, Faber & Faber, 1962

Campbell, R., *Light on a Dark Horse; An Autobiography (1901–1935)*, Hollis & Carter, London, 1951

Casson, S., *Some Modern Sculptors*, Oxford University Press, 1928

Chamot, M., D. Farr and M. Butlin, *The Modern British Paintings, Drawings and Sculpture* (Tate Gallery Catalogues), 2 volumes, 1964

Cheney, S., *A Primer of Modern Art*, New York, 1966 (1st edition, 1922)

Coburn, A. L., *More Men of Mark*, Duckworth, 1922

R. Cole, *Burning to Speak; The Life and Art of Henri Gaudier-Brzeska*, Phaidon, 1978

Cooper, D., 'Primitivism and Bombast', *New Statesman*, 27 October 1961, pp. 622–4

Cork, R., *Vorticism and its Allies*, Arts Council of Great Britain, 1974

Cork, R., *Vorticism and Abstract Art in the First Machine Age*, 2 volumes, Gordon Fraser, London, 1976

Cork, R., 'The Cave of the Golden Calf', *Artforum*, 21, 1982, pp. 56–68

Cork, R., 'Wyndham Lewis and the Drogheda dining-room', *Burlington Magazine*, 126, 1984, pp. 611–18

Cork, R., *Art Beyond the Gallery in Early Twentieth Century England*, Yale University Press, 1985

Cournos, J., 'The Sculpture of Jacob Epstein', *Fortnightly Review*, 107, 1917, pp. 1010–19

Craven, T., *Modern Art: The Men, the Movements, the Meaning*, Simon & Schuster, 1934

Deghy, G., and K. Waterhouse, *Café Royal: Ninety Years of Bohemia*, Hutchinson, 1955

Ede, H. S., *Savage Messiah*, Heinemann, 1931

Edwards, G., 'Sunflower by Jacob Epstein', *Art Bulletin of Victoria*, 24, 1983, pp. 63–6

Epstein, J., *Let There Be Sculpture*, Michael Joseph, 1940. Revised and expanded as *Epstein: An Autobiography*, Hulton, London, 1955

Farr, D., *English Art 1870–1940*, Oxford University Press, 1978

Farr, D., and A. Bowness, *London Group*, Tate Gallery, 1964

Farrington, J., *Wyndham Lewis*, Lund Humphries, 1980

Feibleman, J. K., *Philosophers Lead Sheltered Lives*, George, Allen and Unwin, 1952

Fierens, P., *Sculpteurs d'aujourd'hui*, Paris, 1933

Fothergill, J., *Innkeeper's Diary*, Chatto & Windus, 1931

Fry, R., 'The Allied Artists at the Albert Hall', *The Nation*, 20 July 1912, pp. 583–4

Fry, R., 'The Allied Artists', *The Nation*, 2 August 1913, pp. 676–7

Fry, R., 'Mr Epstein's Sculpture at the Leicester Galleries', *New Statesman*, 26 January 1924, pp. 450–1. Reprinted as 'Mr. Epstein's Sculpture', *Dial*, 76, 1924, pp. 502–6. Reprinted with revision as 'Mr Epstein and the Cultured', in *Transformations*, Chatto & Windus, 1926, pp. 136–56. Reprinted as 'Mr Epstein's Sculpture', in V. S. Pritchett (editor), *Turnstile One*, 1948, pp. 65–9.

Fry, R., 'The Hudson Memorial', *Dial*, 79, 1925, pp. 370–3. Reprinted with slight revision in *Transformations*

Fry, R., 'Sculpture and the Public', *New Statesman*, 10 December 1932, pp. 717–18

Fusco, P., and H. W. Janson, *The Romantics to Rodin: French Nineteenth-Century Sculpture*, Los Angeles County Museum of Art, 1980

Geist, S., *Brancusi. A Study of the Sculpture*, London, 1968

Geist, S., *The Kiss*, Harper & Row, 1978

Gertler, M. (N. Carrington, editor), *Mark Gertler Selected Letters*, Rupert Hart-Davis, 1965

Gibson, A., *Postscript to Adventure*, Dent, 1930

Gill, E., *Autobiography*, Jonathan Cape, 1940

Gill, E. R., *The Inscriptional Work of Eric Gill*, Cassell, 1964

Golding, L., 'Jacob Epstein', in *Great Contemporaries*, London, 1935

Goldwater, R., *Primitivism in Modern Art*, 1938 (revised edition, Vintage Books, New York, 1967)

Gordon, D. E., *Modern Art Exhibitions, 1900–1916*, 2 volumes, Prestel–Verlag, Munich, 1974

Grant, J., *Harold Munro and the Poetry Bookshop*, Routledge & Kegan Paul, 1967

Gray, C., *Musical Chairs, or Between Two Stools*, Home & Van Tahl, London, 1948

Hamnett, N., *Laughing Torso; reminiscences*, London, 1932

Hapgood, H., 'Four Poets of the Ghetto', *The Critic*, 26, 1900. Reprinted in a limited edition of 100 by the Oriole Press, Berkeley Heights, New Jersey, where the original publication is incorrectly given as 1905

Hapgood, H., 'Foreign Stage in New York', *Bookman*, 11, 1900

Hapgood, H., 'The Picturesque Ghetto', *Century Magazine*, xciv, 1917

Hapgood, H., *The Spirit of the Ghetto*, Funk & Wagnalls, New York, 1902, reprinted 1909. Several subsequent editions, including one with preface and notes by H. Goulden, Funk & Wagnalls, 1965, and Harvard University Press, 1967

Harries, M. and S., *The War Artists*, Michael Joseph, 1983

Harrison, C., *English Art and Modernism 1900–1939*, Allen Lane and Indiana University Press, 1981

Haskell, A., *The Sculptor Speaks, Jacob Epstein to Arnold Haskell. A series of conversations on Art*, Heinemann, 1931

Hind, C. L., *The Post Impressionists*, Methuen, 1911

Holroyd, M., *Augustus John: A Biography*, 1974 (revised edition, Penguin, 1976)

Hulme, T. E. (H. Read, editor), *Speculations*, London, 1924

Hulme, T. E. (S. L. Hynes, editor), *More Speculations*, University of Minnesota Press, 1975

Hutton, C., 'Charles Holden', in *Dictionary of National Biography, 1951–1960*, Oxford University Press, 1971

Ireland, G. (introduction by L. Lee), *Epstein. A Camera Study of the Sculptor at Work*, Andre Deutsch, 1957

John, A., *Autobiography* (incorporating *Chiaroscuro* and *Finishing Touches*), Jonathan Cape, 1975

Jones, A. R., *The Life and Opinions of Thomas Ernest Hulme*, Gollancz, 1960

Kapp, E. X., *Personalities: Twenty-Four Drawings*, Martin Secker, 1919

Lewis, W. (W. K. Rose, editor), *The Letters of Wyndham Lewis*, Methuen, 1963

Lewis, W. (W. Michel and C. J. Fox, editors), *Wyndham Lewis on Art*, Thames & Hudson, 1969

Loewy, E. (translated by J. Fothergill), *The Rendering of Nature in Early Greek Art*, Duckworth, 1907

Mannin, E., *Confessions and Impressions*, London, 1930

Muñoz Marín, M. L. de, 'The typical American soldier lives in Puerto Rico', *The University of Puerto Rico Bulletin*, 1937, pp. 188–91

Marter, J. M., R. K. Tarbell and J. Wechsler, *Vanguard American Sculpture 1913–1939*, Rutgers University, 1979

May, B., *Tiger-Woman; Mystery*, Duckworth, 1929

Mitter, P., *Much Maligned Monsters: History of European Reactions to Indian Art*, Oxford University Press, 1977

Moore, H. (P. James, editor), *Henry Moore on Sculpture*, Macdonald, 1966

Moore, H. (photographs by D. Finn), *Henry Moore at the British Museum*, British Museum Publications, 1981

Morris, L., and R. Radford, *The Story of the Artists International Association*, Museum of Modern Art, Oxford, 1983

Moskowitz, H., 'The East Side in Oil and Crayon', *Survey*, 28, 1912

Nairne, S., and N. Serota (editors), *British Sculpture in the Twentieth Century*, Whitechapel Art Gallery, London, 1981

Neve, C. (introduction by J. Rothenstein), *Leon Underwood*, Thames & Hudson, 1974

Osman, L., 'Architect, Sculptor and Client, with special reference to Epstein's Madonna and Child', *Architectural Association Journal*, 70, 1954, pp. 7–19

Oyved, M., 'The two Jacobs. An Impression of Jacob Epstein', *Quest*, 18, 1927, pp. 405–10

Oyved, M., *The Book of Affinity*, Heinemann, 1933

Parkes, K., *Sculpture of To-Day*, London, 1921

Parkes, K., *The Art of Carved Sculpture*, London, 1931

Pearson, H., *Bernard Shaw*, Collins, 1942

Pound, E., *Gaudier-Brzeska*, London, 1916

Pound, E., 'Epstein, Belgion and Meaning', *Criterion*, 9, 1930, pp. 470–5

Pound, E. (D. D. Page, editor), *The Letters of Ezra Pound*, Faber & Faber, 1951

Powell, L. B., *Jacob Epstein*, Chapman & Hall, 1932

Prebble, J., 'Epstein, a profile', *Illustrated London News*, 12 December 1953, p. 31

Ramsden, E. H., *Twentieth Century Sculpture*, Pleiades, London, 1949

Read, H., *Henry Moore Sculptor*, Zwemmer, 1934

Reid, B. L., *The Man from New York: John Quinn and His Friends*, Oxford University Press, New York, 1968

M. Ross (editor), *Robert Ross. Friend of Friends*, Jonathan Cape, 1952

Rothenstein, J., *Men and Memories, 1900–1922*, Faber & Faber, 1932

Rubin, W. (editor), *'Primitivism' in 20th Century Art*, 2 volumes, New York, 1985

Rutter, F., *Art in my Time*, Rich & Cowan, 1933

Schinman, E. P. and B. A. (editors), *Jacob Epstein. A Catalogue of the Collection of Edward P. Schinman*, Farleigh Dickinson University Press, 1970

Schneier, J., *Sculpture in Modern America*, University of California, 1948

Sheridan, C., *Nuda Veritas*, London, 1927

Shewring, W. (editor), *The Letters of Eric Gill*, Jonathan Cape, 1947

Sichel, P., *Modigliani: A Biography*, London, 1967

Silber, E., *Rebel Angel; Sculpture and Watercolours by Sir Jacob Epstein (1880–1959)*, Birmingham Museum and Art Gallery, 1980

Speight, R., *William Rothenstein, The Portrait of the Artist in his Time*, Eyre & Spottiswoode, 1962

Speight, R., *The Life of Eric Gill*, Methuen, 1966

Spielmann, M. H., *British Sculpture and Sculptors of To-Day*, Cassell, 1901

Taft, L., *The History of American Sculpture*, 1902, revised 1924, reprinted, Arno Press, 1969

Tancock, J., 'Social Consciousness', in N. B. Wainwright (editor), *Sculpture of a City: Philadelphia's Treasures in Bronze and Stone*, Fairmount Park Association (Walker Publishing), 1974, pp. 266–73

Thistlewood D., *Herbert Read: Formlessness and Form*, Routledge & Kegan Paul, 1984

Thorp, J., *Eric Gill*, Cape, 1929

Van Dieren, B., *Epstein*, John Lane, 1920

Vaughan, P., *Doctors' Commons*, Heinemann, 1959

Vickers, H., *Gladys Duchess of Marlborough*, Weidenfeld & Nicholson, 1979

Vogel, S., and F. N'diaye, *African Masterpieces from the Musée de l'Homme*, Abrams and The Center for African Art, New York, 1985

Wees, W. C., *Vorticism and the English Avant-Garde*, Manchester University Press, 1972

Wellington, H., *Jacob Epstein*, (Contemporary British Artists, A. Rutherston, editor), Benn, 1925

Wellington, H. (Foreword), *Epstein. Seventy-Five Drawings*, J. Saville, 1929

Wilenski, W. H., *The Modern Movement in Art*, Faber & Faber, 1927

Wilenski, W. H., *The Meaning of Modern Sculpture*, Faber & Faber, 1932

Wilkinson, A. G., *Gauguin to Moore; Primitivism in Modern Sculpture*, Art Gallery of Ontario, 1981

Wilson, S., 'A Newly Discovered Sketch by Jacob Epstein for the Tomb of Oscar Wilde', *Burlington Magazine*, 117, 1975, pp. 726–9

Wilson, S., '"Rom", an early carving by Jacob Epstein', *Burlington Magazine*, 119, 1977, pp. 352–4

Wittkower, R., *Sculpture. Process and Principles*, Penguin, 1977

Zilczer, J., *'The Noble Buyer': John Quinn, Patron of the Avant-Garde*, Hirshhorn Museum of Art, Washington, 1978

Zilczer, J., 'The dispersal of John Quinn's Collection', *Connoisseur*, 202, 1979, pp. 22–7

Zilczer, J., 'The Theory of Direct Carving in Modern Sculpture', *Oxford Art Journal*, 1981, pp. 44–9

Exhibitions

One-man shows and other exhibitions in which Epstein's work appeared prominently. Numbers of sculptures (s) and drawings and watercolours (D) are given where available.

c.1898 Hebrew Institute, New York, exhibition, of which Epstein was one of the organizers, showing paintings and drawings by ghetto artists, including his own sketches and paintings (Hapgood 1902, p. 259; Epstein 1940, p. 13).

1913–14 (December–January) Twenty-One Gallery, Adelphi, London, *Drawings and Sculpture by Jacob Epstein* (2 editions of handlist) 5–8s, 8D

1914 informal exhibition at 40 Wilton Crescent, London, home of Kathleen, Countess of Drogheda

1914 (March) Goupil Gallery, London, *First Exhibition of Works by Members of the London Group* 3s

1915 (March) Goupil Gallery, *Second Exhibition of Works by Members of the London Group* 4s

1916 (February–March) National Portrait Society, Grosvenor Gallery, London, 5th Annual Exhibition 4s

1917 (February–March) Leicester Galleries, exh. no. 238, *The Sculpture of Jacob Epstein* 26s

1917 (April–May) National Portrait Society, London, Grosvenor Gallery, 6th Annual Exhibition 7s

1917 (October) Leicester Galleries, exh. no. 246, *Exhibition of Watercolours and Drawings by a group of artists serving with His Majesty's forces, including recent sculpture by Jacob Epstein* 5s

1919 (February–April) National Portrait Society, 8th Annual Exhibition 6s

1920 (February) Leicester Galleries, *Recent Sculpture by Jacob Epstein* 16–20s

1922 (March) The Sculptors Gallery, New York, *Seven*

English Modernists 22s (lent by John Quinn)

1924 (January–February) Leicester Galleries, exh. no. 365, *Recent Sculpture by Jacob Epstein* 27s

1924 (April) Scott & Fowles Gallery, New York, *Sculptures by Jacob Epstein* (lent by John Quinn)

1926 (June–July) Leicester Galleries, exh. no. 415, *New Work in Sculpture by Jacob Epstein* 14s

1927 (November) Ruskin Gallery, Birmingham, *Bronze Sculpture by Jacob Epstein* 9s

1927 (November–December) Ferargil Gallery, New York, *Sculpture by Jacob Epstein* 45s

1928 (October–November) Godfrey Phillips Gallery, London, *Drawings by Epstein* 8s, 75D

1929 (February) Ruskin Gallery, Birmingham, *Drawings by Epstein* 13D

1930 XVII Esposizione Internationale dell'Arte, Venice (individual shows by Epstein, Moore, Skeaping, Sickert, Rothenstein and Philpot) 9s, 2D

1931 (February) Leicester Galleries, exh. no. 508, *New Sculpture by Jacob Epstein* 15s

1931/32? Cooling Galleries, New Bond Street, London, *Works by Jacob Epstein* 13s, unspecified D

1932 (February–March) Redfern Gallery, London, *Illustrations to the Old Testament by Epstein* 54D

1933 (May) Leicester Galleries, exh. no. 553, *Carvings and Bronzes by Jacob Epstein* 29s

1933 (June) Leicester Galleries and Alex, Reid & Lefevre, 18 St James's Square, London, *Carvings and Bronzes by Jacob Epstein* 28s, 39D

1933 (December) A. Tooth & Sons, London, *Watercolours of Epping Forest* 1s, 33D

1934 (March) Redfern Gallery, London, *Watercolours of Epping Forest*

1935 (March) Leicester Galleries, exh. no. 600, *Carving and Bronzes by Jacob Epstein* 20s

1936 (December) A. Tooth & Sons, London, *Flower Paintings by Jacob Epstein* 1s, 39D

1937 (October–December) Leicester Galleries, ex. no. 662, *Sculpture by Jacob Epstein* 24s

1938 (December) A. Tooth & Sons, London, *Drawings by Jacob Epstein for 'Les Fleurs du mal' of Charles Baudelaire* 37D

1939 (January) Zwemmer's, Charing Cross Road, London, *Epstein. Catalogue of a Retrospective Exhibition of Drawings and a few Bronzes* 6s, 31D

1939 (June–July) Leicester Galleries, exh. no. 704, *New Sculpture and Drawings of Children by Jacob Epstein* 9s, 30D

1940 (May) The Famous Galleries, 215 W57th Street, New York, *Epstein's Masterpiece Adam and other of his famous works* 13s

1940 (October) Leicester Galleries, exh. no. 730, *Flower Paintings and some new Bronzes by Jacob Epstein* 3s, 32D

1942 American-British Art Center, New York, *Paintings by members of the ABAC and sculpture by Jacob Epstein* 10s

1942 (February) Leicester Galleries, exh. no. 752, *Jacob and the Angel and new Bronzes by Jacob Epstein* 14s, 1D

1942 Temple Newsam House, Leeds, *Matthew Smith and Jacob Epstein*

1942 (December) Leicester Galleries, exh. no. 764, *Jacob Epstein. Paintings of Dahlias, Sunflowers and Landscapes* 1s, 30D

1943 (August) Lakeland Garage, Church Street, Windermere, *Sculpture in bronze by Jacob Epstein and an Exhibition of Paintings by Contemporary British Artists (in support of the Merchant Navy Comforts Fund)* 21s

1944 (May–June) Leicester Galleries, exh. no. 794, *'Girl with Gardenias' and some other recent sculpture by Jacob Epstein* 21s

1944 (December) Leicester Galleries, exh. no. 802, *Flowers and Epping Forest Landscapes by Jacob Epstein* 70D

1945 (May–June) American-British Art Center, New York, *Jacob Epstein. Watercolours and Sculpture* 3s, 14D

1945 (October–November) Leicester Galleries, exh. no. 822–3, *Jacob Epstein and Mervyn Peake* 2s, 55D

1947 (February–March) Leicester Galleries, exh. no. 849–50, *Landscapes by Ethelbert White and New Sculpture by Jacob Epstein* 40s

1948 Laing Art Gallery, Newcastle-upon-Tyne, *Loan Collection of Works by Jacob Epstein* 20s

1950 (March) Leicester Galleries, exh. no. 930–1, *A New Carving, Lazarus, and other recent work by Jacob Epstein and Paintings by Ethelbert White* 25s

1952 (September) Midland Group Gallery, Nottingham, *Drawings by Josef Herman, Sculpture by Jacob Epstein* 7s

1952 (September–November) Tate Gallery, London, *Epstein* (organized by the Arts Council of Great Britain) 59s, 20D

1953 (June) Leicester Galleries, exh. no. 1021, *Recent Portraits by Jacob Epstein* 18s

1954 (February–March) Bury Art Gallery, *Works by Epstein, Sickert and Steer* 11s, 3D

1954 (May–June) Queensland National Art Gallery, Brisbane, *Epstein and Sickert* 7s

1954 (October–November) Bolton Art Gallery, *Portraits in Bronze by Sir Jacob Epstein* 38s

1958 (April–May) James Graham & Sons, Madison Avenue, New York, *Epstein. A retrospective exhibition of bronze portraits and children's heads* 19s

1959 (November–December) Ben Uri Gallery, London, *Sir Jacob Epstein 1880–1959. Exhibition of Bronzes* 30s

1959–1960 Derby and Leicester Art Galleries, Nottingham, *Bronzes and Drawings by Epstein from the Arnold F. Thompson Collection* 17s, 5D

1960 Arts Council of Great Britain, *The Epstein Collection of Tribal and Exotic Sculpture* 347 items

1960 (June–July) Leicester Galleries, exh. no. 1191, *Fifty Years of Bronzes and Drawings by Sir Jacob Epstein (1880–1959)* 62s, 35D

1960 Art Exhibitions Bureau, London, *Sir Jacob Epstein 1880–1959* 10s

1961 (March–April) Auckland Art Gallery, New Zealand, *Epstein* 31s, 17D

1961 (August–September) Waverley Market, Edinburgh, *Epstein Memorial Exhibition* 170s, 55D

1961 (November–December) Tate Gallery, London, *Epstein Memorial Exhibition* (organized by the Arts Council of Great Britain) 89s, 45D

1962 Arts Council of Great Britain Welsh Committee, touring to Llandaff, Swansea and Haverfordwest, *Epstein* 26s, 12D

1963 (June–September) Middleheim Open Air Museum, Antwerp, 7e Biennale voor Beeldhouwkunst 12s

1962–3 Midland Area Service touring exhibition, *Epstein; Sculpture and Drawings* 28s, 17D

1963 (July–August) St. Margaret's Church, Kings Lynn, *Sculpture and Drawings by Jacob Epstein* 25s, 10D

1964 (June–July) Graves Art Gallery, Sheffield, *Epstein. Bronzes and Drawings* 26s, 12D

1965 (April) The Hecht Company Downtown Store, Washington, DC, *Epstein, a retrospective exhibit and sale of the sculpture of the late Sir Jacob Epstein* 31s (this exhibition was followed by similar exhibitions of sculpture at stores owned by the Mays Company in Macy's, New York, May's, Cleveland, and Famous-Barr, St. Louis)

1965 (July–September) New Metropole Arts Centre, Folkestone, *Jacob Epstein; Sculpture and Drawings* 68s, 50D

1965 (September–October) Rye Art Gallery, *Jacob Epstein; Sculpture and Painting*

1966 (September–October) Mercury Gallery, London, *Jacob Epstein* 23s, 24D

1967 Weintraub Gallery, New York, *Epstein 1880–1959* 75s, 50D

1967 (February–April) Farleigh Dickinson University, Rutherford, NJ, *The Works of Sir Jacob Epstein from the Collection of Mr Edward P. Schinman* 90s, 52D

1967 (May–June) Reading Public Museum and Art Gallery, USA, *Bronze Sculptures and Drawings by Sir Jacob Epstein* 13s, 20D

1967 (September–October) Gaerlick's Gallery, Detroit, *Sir Jacob Epstein, Bronzes* 29s

1968 Leicester Galleries, sale of sculptures from the Epstein Estate, 27s (some in multiple casts)

1968 Graphic Art Associates, London and Detroit, *Epstein; Sculpture and Drawings* 51s, 25D

1968 Dunkelman Gallery, Toronto, *Jacob Epstein. Retrospective Exhibition of Sculptures and Drawings*

1968 (September–December) New Jersey State Museum, Trenton, *Works by Sir Jacob Epstein from the Collection of Mr Edward P. Schinman* 89s, 44D

1968–9 (December–February) Gallery of Modern Art, Columbus Circle, New York, *Sir Jacob Epstein. Sculptures, Watercolors and Drawings from the Collection of Edward P. Schinman* 21s, 6D

1971 (June–July) Leicester Galleries, exh. no. 1387 *Sculpture and Drawings from 1900 to 1932 by Sir Jacob Epstein (1880–1959)* 26s, 12D

1971 (October–November) Lowe Art Museum, University of Miami, *The Works of Sir Jacob Epstein from the Collection of Mr Edward P. Schinman*

1971 (December) Danenberg-Roman Galleries, New York, *The Works of Jacob Epstein from the Collection of Mr Edward P. Schinman*

1973 (October–November) Anthony d'Offay Gallery, London, *Jacob Epstein. The Rock Drill Period* 1s, 17D

1973–4 (December–January) Corcoran Gallery of Art, Washington, DC, *Sculpture of Jacob Epstein. The Eisenberg–Robbins Collection* 35s

1974–9 Smithsonian Institution Travelling Exhibition Service (25 venues throughout the USA), *The Sculpture of Jacob Epstein* 35s

1975 (October–November) Joe and Emily Lowe Art Gallery, Syracuse University, New York, *Jacob Epstein* 42s, 8D

1976 (May) David Jones Art Gallery, Sydney, *Jacob Epstein: Portraits in Bronze* 28s

1977 (August–October) National Gallery of Canada, Ottawa, *Sir Jacob Epstein 1880–1959* 11s, 1D

1980 (October–November) Birmingham Museum and Art Gallery, *Rebel Angel; Sculpture and Watercolours by Sir Jacob Epstein (1880–1959)* (organized by E. Silber), 29s, 22D

1980 (November–December) Ben Uri Gallery, London, *Epstein Centenary 1980* 37s, 27D

1980 (November–December) Tate Gallery, London, *Sir Jacob Epstein Centenary*, 14s (listed, only 11 exhibited), 3D (none exhibited)

1986 (March–May) Birmingham Museum and Art Gallery, *A Sculptor's Drawings: Jacob Epstein* 7s, 31D

Index of Works

General Index

Sources of Illustrations

Numbers refer to catalogue entries, unless otherwise identified as figures, plates, or page references.

The publishers have endeavoured to credit all known persons holding copyright or reproduction rights for the pictures in this book, and wish to thank all the public, private and commercial owners and institutions concerned, the photographers and photographic archives, and the copyright holders.

The works of Jacob Epstein, Adrian Allinson, Eric Gill, Wyndham Lewis and Henry Moore are © 1986 the artists or their estates, the works of Brancusi are © ADAGP, 1986. Particular thanks are due to Miss Beth Lipkin, Richard Buckle and Christopher Phillips, who lent many of the photographs reproduced in this book; to Ben Read and Joan Hervey of the Witt Library, which now owns the Paul Laib negatives; to Mary Ambrose, Lizzie Barker, M.J. Ebsworth, J.K. Feibleman, Dr Terry Friedman, Mrs Iris Hughes, Mrs Hilary Prior, Gordon Roberton, Sir Robert and Lady Sainsbury, Bernice Sandelson, Martin Schweig, Peter Smith, Mrs R. Stickney, Morgan Wells, Mr Woolf, and the following, for their help in obtaining photographic material, and/or the permission to use it:

Susan Evans: 44b, 411, 443; Helmet Gernsheim: pl. 32; Chris Honeywell: pls. 43, 47; 58, 327, 389, 391, 421, 436a, b, 438, 449, 509, 522a, b; E.O. Hoppé: 40b; Geoffrey Ireland: endpapers, frontispiece, pls. 37, 39, 40, 41, 45, 46, 49; 34, 141, 451b, c, 454a, b, c, d, 475, 485, 488a, b, 496, 502, 506, 508, 517; Ida Kar: 447, 452, 463; Paul Laib: pls. 6, 15, 16, 17, 21, 24, 25, 27, 30, 36; p. 6; 26, 41, 44a, 89, 93, 94, 116, 143, 144, 147, 157, 160, 164, 166, 168, 177, 178, 180, 184, 187, 197, 202, 206, 207, 216, 219, 220, 229, 230, 233, 237, 238, 239, 241, 243, 245, 248, 249, 250, 251, 255, 256, 260, 264, 266, 268, 270, 271, 272, 278, 280, 281, 282, 284, 285, 287, 296, 301, 302, 305, 322, 326, 332, 336, 340, 358, 371, 393, 396, 402, 408, 417, 420, 424, 444; Sandra Lousada: 453; James Mortimer: 15, 72, 86, 101, 104, 133, 188, 204, 235, 289, 299, 317, 319, 321, 345, 419, 462, 474, 498, 504, 518a; L.B. Powell: pl. 28; Martin Schweig: 212; Evelyn Silber: back jacket; 27, 35, 146, 169, 174, 208, 247, 308, 320, 362, 365, 370, 372, 397, 403, 425, 432, 448, 479, 482, 491, 495, 521, 527; Hans Wild and Lawrence Brooman: pls. 2, 3, 9, 20, 29, 31; 3; 5, 8, 9.8, 9.6, 12, 21, 22, 23b, 30, 38, 59, 69, 79, 87, 88, 120, 130, 135, 136, 140, 142, 149, 153, 154, 170, 181, 186, 201, 205, 213, 214, 222, 223, 227, 228, 231, 236, 240, 254, 259, 262, 275, 277, 286, 290, 292, 297, 300, 306, 312, 325, 328, 329, 344, 349, 356, 357, 361, 368, 376, 383, 386, 388, 395, 399, 403, 405, 407, 409, 412, 413, 422, 427, 428, 429, 430, 431, 433, 434, 435, 440, 446, 456, 457, 461, 464, 467, 469, 470, 473, 477, 487, 492, 494, 497, 505, 507, 510, 514, 519, 520, 523, 524.

Aberdeen Art Gallery and Museums: 138; Collection – The Art Gallery of South Australia, Adelaide, South Australian Government Grant, 1957: 410; From the collections of the Harry Ransom Humanities Research Center. The University of Texas at Austin: 146, 253; The Baltimore Museum of Art: pl. 8 (Alan and Janet Wurtzburger Collection, BMA 1966.55.7); 150 (The Jacob Epstein Collection. BMA 1951.123); Birmingham Museums and Art Gallery: back jacket, figs. 4, 22; 13, 29, 122, 128, 129, 172, 192, 234, 242, 291, 338, 362,

378, 387; Birmingham University: 458; Bolton Museum and Art Gallery: 314, 489 (by courtesy of the T.U.C.); Bristol City Museum and Art Gallery: 515; Collection of the Albright-Knox Art Gallery Buffalo, New York. Gift of Lady Kathleen Epstein, 1966: 163; Bury Art Gallery and Museum: 459; Fitzwilliam Museum, Cambridge: pl. 26; 103, 203, 441; Cambridge University: 495; Cardiff, National Museum of Wales: 20, 25, 102, 155, 518b, 528; Cardiff, Stanley Travers; by permission of The Dean and Chapter of Llandaff Cathedral: pl. 44; The Cleveland Museum of Art, Gift of Mrs William Treuhaft: 466; Derby Art Gallery: 381; Copyright © Founders Society Detroit Institute of Arts: 37 (City of Detroit Purchase), 74 (Gift of Mrs Stevenson Scott); Doncaster Museum and Art Gallery: 161; Dublin, Hugh Lane Municipal Gallery of Modern Art: 258; Dumfries Museum: 191; Dundee Museums and Art Galleries: 151; National Galleries of Scotland, Edinburgh: 64 (by courtesy of the Duke of Hamilton), 295; Glasgow Art Gallery and Museum. The Burrell Collection: 90; The Museum, Charterhouse, Godalming (photo: Roger Smeeton); by permission of the Headmaster: 265; By permission of the Rt. Hon. the Earl of Harewood: 288; Dr & Mrs Martin Evans, Hewlett, N.Y.: 44, 411, 443; Jerusalem, Israel Museum: 174, 208, 217, 247, 404; The Johannesburg Art Gallery: 19, 373; Copyright, University of Keele: 211, 512; Knighteshayes, Devon, courtesy of Lady Amory: 370; Leeds City Art Galleries: figs. 20, 23 (The Henry Moore Centre for the Study of Sculpture): pls. 5, 35; 24, 119, 276, 323; Courtesy of the University of Leeds: 472; Leicestershire Museums and Art Galleries: 126; The Walker Art Gallery, Liverpool: 162; The University of Liverpool: fig. 26; LONDON: © Courtesy Anthony d'Offay Gallery, London: front jacket, figs. 13, 14; pls. 7, 22, 23; 33, 43; Barnaby's Picture Library (by courtesy of Coventry Cathedral): pl. 48; Courtesy of Ben Uri Art Society:156; BBC Hulton Picture Library: half-title page; imprint page; pp. 8, 62, 114, 228; 218; Reproduced by Courtesy of the Trustees of the British Museum: figs. 9, 15, 16; Christie's: fig. 17; 65, 269, 351, 352, 392, 460; A.C. Cooper: front jacket; fig. 17; 9.15,16, 36, 43, 57, 65, 68, 91, 107, 109, 131, 134, 139, 145, 152, 156, 159, 195, 200, 261, 269, 283, 309, 310, 337, 351, 352, 364, 367, 385, 392, 400, 450, 460, 483, 516; Courtesy of the Courtauld Institute of Art, Witt Library: pls. 15, 17, 21, 24, 30, 36; p. 6; 44a, 93, 111, 143, 144, 147, 166, 168, 177, 187, 197, 206, 207, 219, 220, 233, 237, 249, 250, 255, 266, 268, 278, 280, 282, 284, 296, 301, 305, 322, 332, 336, 340, 371, 393, 396, 402, 408, 417, 420, 424, 444; Fine Art Society Ltd.: fig. 12; By courtesy of Heythrop College, University of London, and the sisters of the Society of the Holy Child Jesus: pl. 34; 438; Imperial War Museum: 63, 71, 100, 324, 331; London Transport Executive: 4, 15, 36, 41, 57, 61, 68, 72, 86, 89, 91, 101, 104, 107, 109, 117, 131, 132, 133, 134, 139, 152, 157, 159, 160, 164, 167, 176, 178, 180, 184, 195, 196, 200, 204, 216, 221, 229, 230, 238, 239, 241, 243, 244, 245, 251, 256, 260, 261, 267, 271, 274, 279, 283, 285, 287, 289, 298, 299, 303, 311, 317, 318, 319, 321, 337, 345, 354, 360, 364, 366, 367, 369, 384, 400, 401, 418, 419, 447, 450, 452, 453, 462, 463, 474, 483, 498, 500, 504, 511, 518a; Copyright London Transport Executive: pls. 18, 19; 189a & b; The Mansell Collection: 60; Phillips: 110, 385; Reform Club: 421; Royal Commission on Historical Monuments

(England): pl. 1; 9a, b; Royal Festival Hall: 273; Sir Robert and Lady Sainsbury: 308, 320; Sotheby's: 99, 114, 118, 179, 193, 198, 209, 339, 353, 359, 374, 426, 459, 486, 493, 526; Sport and General Press Agency (by courtesy of the T.U.C.): 490; The Tate Gallery, London: figs. 6, 7, 8; pls. 11, 14; 18, 45, 54, 55, 185; By courtesy of the Trustees of the Victoria and Albert Museum: 9.4,2,12, 10; Yonty Solomon: 436; Los Angeles County Museum of Art, Gift of Frederick Pleasants through the Contemporary Art Council: 465; City of Manchester Art Galleries: 70, 73, 105, 165; Copyright: Granada TV, Manchester: 194; Melbourne, reproduced by permission of the National Gallery of Victoria: 9.17; Memphis Brooks Museum of Art, Memphis, TN; Gift of the Artist 50.11: 394; The Minneapolis Institute of Arts, Gift of Messrs. Samuel Maslon, Bruce B. Dayton, Charles H. Bell, Francis D. Butler, John Cowles, and Anonymous Donor: 46; Much Hadham, courtesy of The Henry Moore Foundation: figs. 24 (photographer: Errol Jackson), 25; New Haven, Courtesy of Yale University Art Gallery: 56; New York, Courtesy of The Brooklyn Museum, Gift of Adolph Lewisohn: 127; Collection, The Museum of Modern Art, New York: pl. 10 (Gift of A. Conger Goodyear); 53a (Gift of Constance B. Cartwright), 341, 342 (both: Gift of Dr and Mrs Arthur Lejwa in memory of Leon Chalette); New York, The Pierpont Morgan Library: 480; Copyright owner, the University of Newcastle upon Tyne, courtesy of the Department of Music: 335; Nottingham Castle Museum: 28; The National Gallery of Canada, Ottawa: pl. 12; 66 (Gift of the Hon. A.C. Hardy, Brockville, Ontario, 1948); Oxford, The Ashmolean Museum: 106, 124; Oxford, by kind permission of the Dean and Archivist, Balliol College: 389; Oxford, The Governing Body, Christchurch: 509; Oxford, by kind permission of the Bursar, New College: 391, 449; Paris, Photographie Bulloz: fig. 27; Philadelphia Museum of Art: fig. 11 (The Louise and Walker Arensberg Collection), 95 (Bequest of Lisa Norris Elkins (Mrs. William M. Elkins)), 451 (on deposit from the Commissioners of Fairmount Park; The Ellen Phillips Samuel Memorial); Museum of Art, Carnegie Institute, Pittsburgh, Gift in memory of Mr and Mrs George Magee Wyckoff from Mr and Mrs Frederick L. Cook, Mr and Mrs N. Barry Durfee, Jr., and Mr and Mrs George M. Wyckoff, Jr.: fig. 2; Plymouth City Museum and Art Gallery: 137; Providence, Museum of Art, Rhode Island School of Design: 75; The Department of English, University of Reading: 40b; Art Gallery of New South Wales, Sydney: 76; Art Gallery of Ontario, Toronto, Gift of Lady Epstein on behalf of the Epstein Estate, 1967: 304; Garman-Ryan Collection, Walsall Museum and Art Gallery: figs. 1, 3, 5, 10; 6, 40a, 112, 334, 437; Washington: Hirshhorn Museum and Sculpture Garden, Smithsonian Institution: 48; Washington, National Museum of African Art, Smithsonian Institution: fig. 28; 16, 115, 121, 123, 307, 382, 398, 442; Washington, National Gallery of Art: 84 (Gift of Rupert L. Joseph 1960), 252 (Anonymous Gift 1982), 406 (Gift of Virginia Steele Scott 1973); National Portrait Gallery, Smithsonian Institution, Washington, D.C.; Gift of the John Dewey Foundation: 182; Donated to Watford Museum from the collection of Mr A.F. Thompson: 77; York City Art Gallery: 183a, b

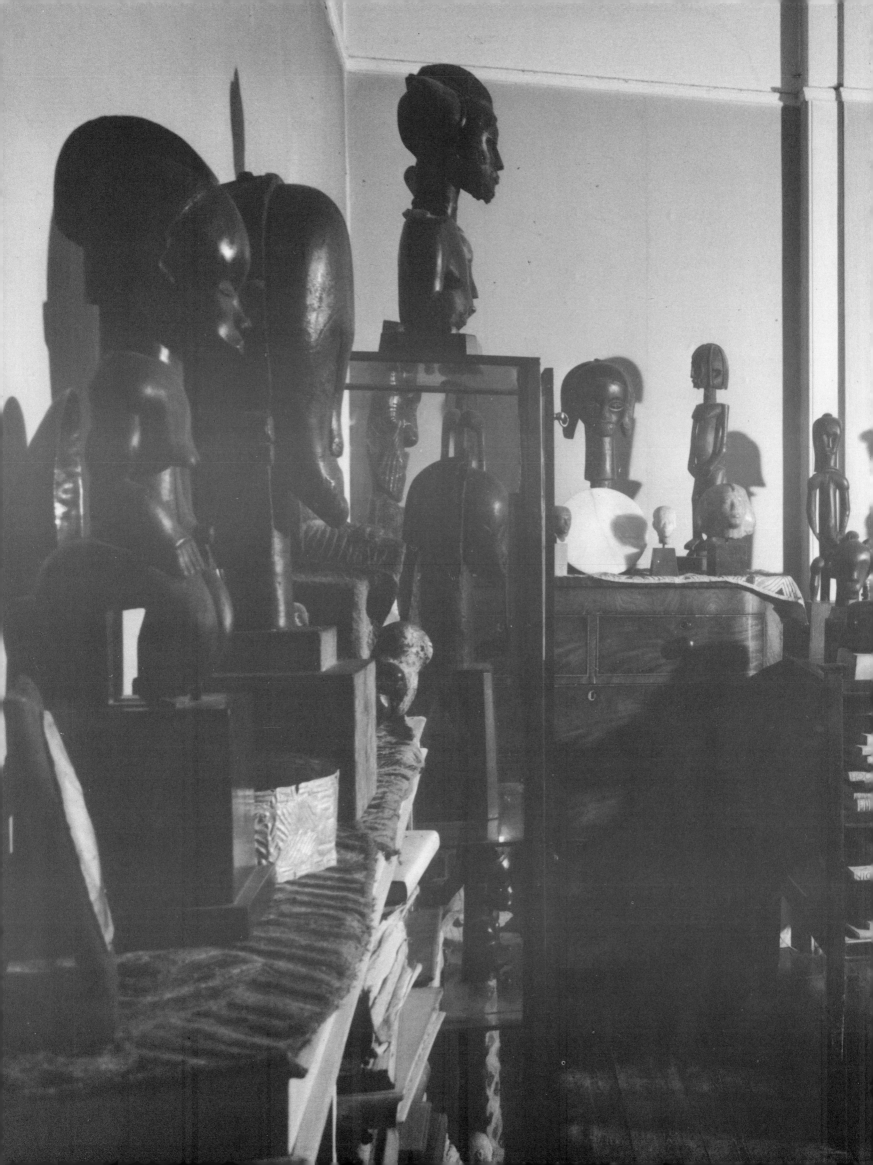